FASHION
GERMANY

MARTINA RINK

FASHION GERMANY

PRESTEL/ MUNICH · LONDON · NEW YORK

/CONTENTS

APPENDIX

Making of

"Hello Martina, call me back when you have time!" It was Peter Lindbergh's pleasant voice with its Rhineland accent on my voicemail – I would never have thought that a photographic legend could be so warm and uncomplicated.

A book project is like a family. You live and work together, the project develops and we develop with it. *Fashion Germany* is an illustrated volume with many highs and occasional lows. In the course of this project I have met some wonderful people, many of whom, with their contributions, have become part of this book: a selection of the most fascinating and groundbreaking fashion personalities that Germany has to offer, nationally and internationally. Along with established big names in the fashion world, this book features young talents from all areas of fashion. What they all have in common is the pursuit of new expression, mastery and perfection.

There are many more people whom I would have liked to introduce, but who for various reasons could not participate – among them high-profile personalities like the legendary Helmut Newton, who sadly died in 2004. All other creative minds will know that these lines are meant for them!

Milestones

It was thanks to Markus Mahren that I was able to meet Peter Lindbergh in Berlin – a unique experience that still fills me with gratitude today. Adrian J. Margelist and I met at the MCM Pop-Up Store opening event in Munich, thanks to Chris Häberlein, and we clicked straightaway. I see books as "must-have" objects – the same goes for MCM Accessories. This is exactly what connects us and epitomizes this very special cooperation between us all.

The star make-up artist Yasmin Heinz has told me the naked truth at difficult moments, and a pure and authentic friendship has developed between us as a result of her honesty.

People like Josef Voelk and Emmanuel de Bayser already believed in me without reservation when I was involved in an earlier project, a book about Isabella Blow. Since then they have supported me and allowed me to present my works in a very special context, the cult institution THE CORNER in Berlin.

Prestel also provides an ideal environment for me. It is an honour to work with this publisher, where everything is just right, particularly the team, into which

I was warmly welcomed thanks to Andrew Hansen, and with whom I share a passion for creating books. As a sign of confidence, I was allowed to choose my own designer and art director: Paul Sloman, who had already successfully designed my first book. I see Paul and his talent as an essential ingredient for creating successful books. The person who consistently arouses my amazement and admiration is Prestel's programme manager Claudia Stäuble, the greatest organizational talent I have ever known.

Magic pictures

The one very particular image by Andreas Ortner. Once seen, it was immediately clear: that's it, that's the cover! For months we couldn't see enough of this photo, and the publishers completely agree. What is so special about this image is that one could interpret it in so many ways: it fits with Germany, the blonde woman could be any woman who embodies us nationally and internationally. To top it all off is the closing section with photos by Peter Lindbergh; Anna Bauer, who uses Polaroids to record exceptional moments of the "who's who" in the industry; and highly talented photographers such as Felix Lammers, Vincent Peter and many others. When I receive emails from my guest authors and open the attached images, I get a tingling sensation as if I were opening Christmas presents.

Challenge

My goal is to see German fashion and the people behind it from a different perspective – all the successful designers, photographers, hair and make-up artists, models, PR agents, buyers, bookers, art directors, creative directors, illustrators and other outstanding personalities who are active worldwide, on both sides of the footlights. Germany is often underestimated with respect to fashion. There are some incredibly talented people in this country who are internationally successful and work all year round at the top of their profession without receiving much public attention. I would like to help free Germany from its unassuming undercover image and reveal the large pool of individual creativity that exists. We are recognized for qualities such as punctuality, precision, accuracy. What is becoming increasingly clear is our ability to successfully take on leading roles.

German companies, it is said, are not fashion-friendly. There are exceptions. The flagship corporation Mercedes-Benz offers a spectacular catwalk to German and international stars and designers in Berlin, and sends out invitations worldwide to shows in Miami, Istanbul,

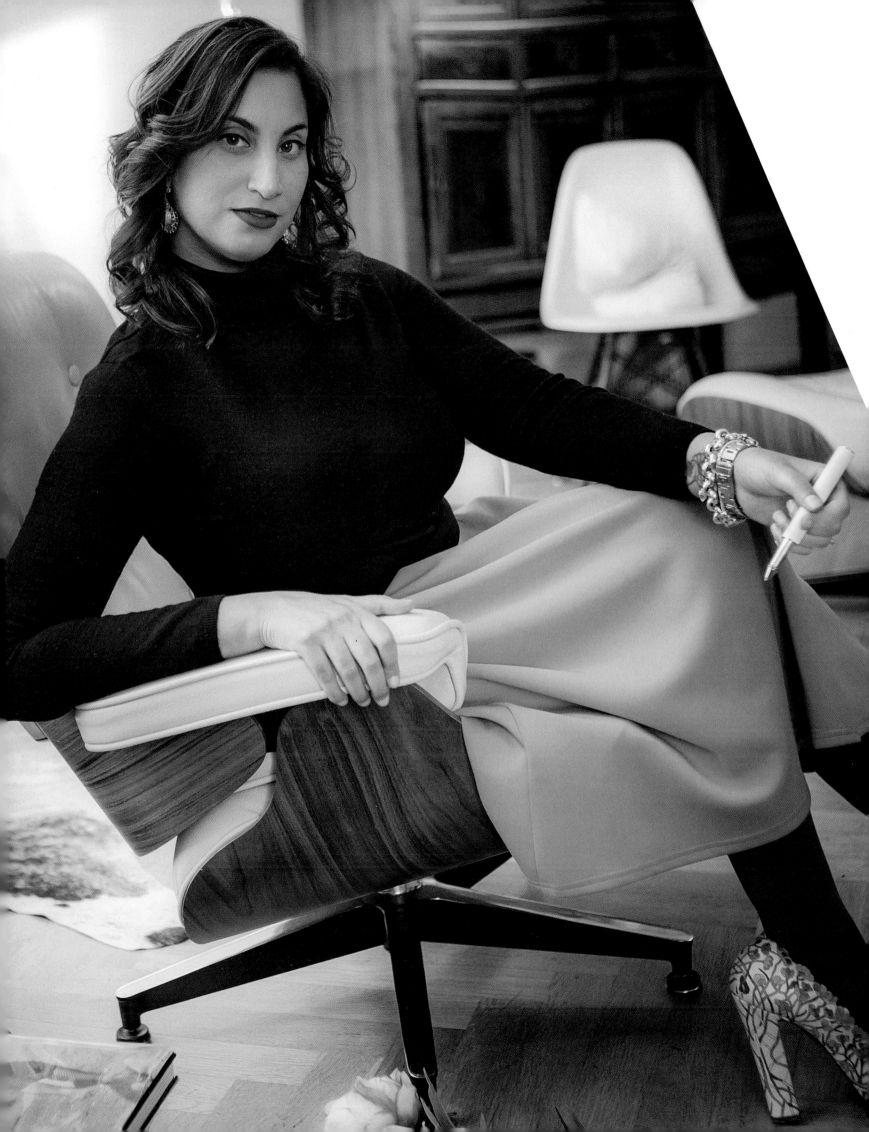

Stockholm and New York. People who are on the same wavelength meet, visions are shared and something magical and new comes into being. This process must not stop; our talents are being cultivated abroad, and perhaps soon we will be able to welcome them back to Germany.

About

All I can do is books. Books that don't sit on the shelf gathering dust but can be admired in beautiful public places or on a private coffee table. Books that trigger emotions thanks to the successful teamwork of all who participate. I make books with soul, with quite individual ingredients. When I begin a book, I already see it in my mind's eye as a finished object. I don't deviate much from this image. I want to make books with staying power. Books that accompany and shape people. I see myself as a sort of conductor, someone who makes a success out of bringing fabulous people together, like a good party. I want to celebrate people and companies. Earlier, I wanted to be a PR person. My mentor Isabella Blow was always against it. She knew how to express this in her own inimitable way: "You'll never be a PR, darling!" Just as well that I didn't know how to use Excel!!!

Opposite page top left: Harriet Verney, Martina Rink and Tim Noble; top right: Jasmin Khezri and Martina Rink; bottom left: sketch by Karl Lagerfeld for a piece of the Mon Dupont collection, which Lagerfeld created exclusively for S.T. Dupont in 2011; bottom right: Martina Rink and Josef Voelk

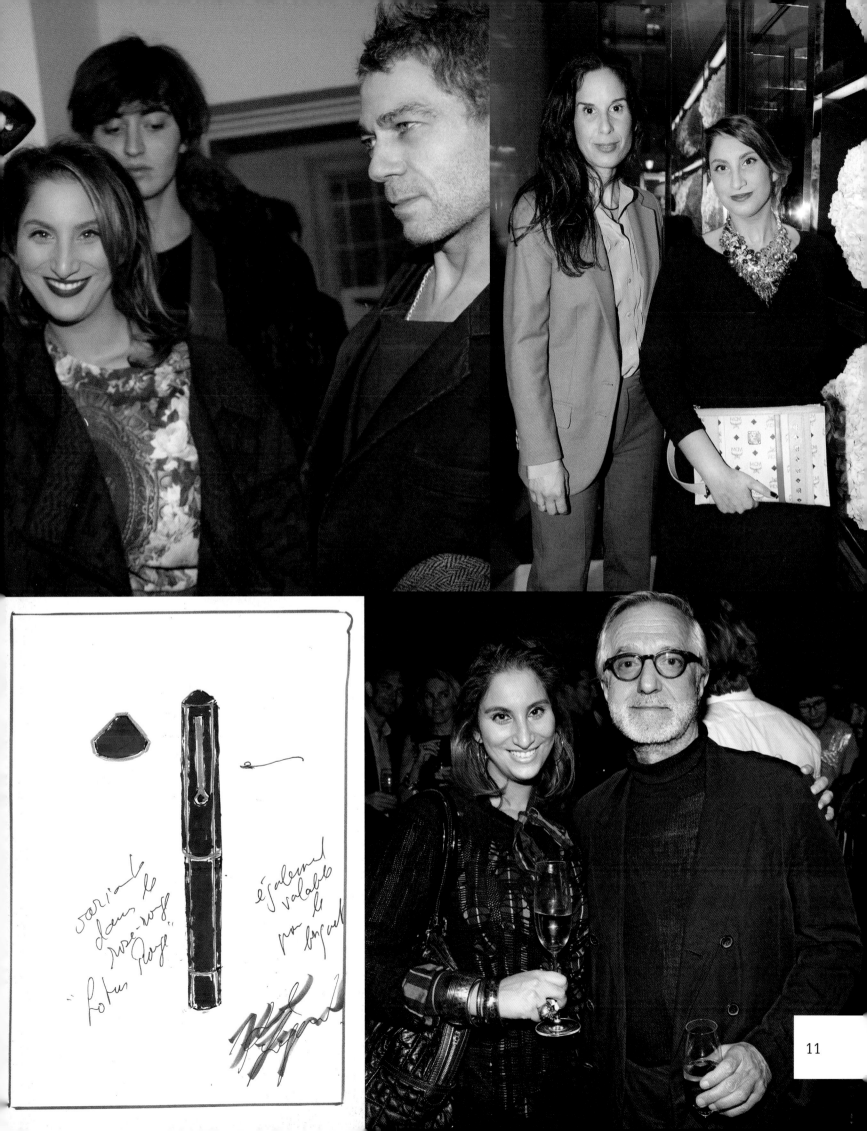

What's the first thing that springs to mind when you hear the words "fashion", "luxury", and "Germany"?

Separately, these words have their own distinct – and not necessarily related – meanings. When I think of fashion I think of something meant for others, while for me, luxury is private and personal. Germany is provenance, and a place that inspires deep appreciation for nature, craft and design.

Who or what inspires you?

I draw inspiration from a number of sources. I spend a lot of time looking at art and architecture – visiting galleries, museums and interesting buildings – and am always inspired by what I see. Nature informs my work, especially in terms of colour. But I'm also inspired by the everyday, surrounded by people and culture, and find it's simply a matter of keeping your eyes open. It's important for me to understand the real-life needs of Bottega Veneta's clients, so I'm always watching how men and women live and function, day to day.

What skills do Germans benefit from in the international fashion industry?

I have a German's inherent love of both nature and craft – which were reinforced by the Waldorf school I attended as a child. Nature serves as a virtually limitless source of inspiration, and craft is essential to the Bottega Veneta ethos. Yet I also believe that being German in an industry that is heavily Italian and French (and increasingly British and American) lends itself to a slightly outsider perspective.

How important is craftsmanship in your life for Bottega Veneta?

Craftsmanship is crucial to Bottega Veneta – it lies at the heart of the brand. Everything we produce is made by artisans of exceptional ability, training and commitment. Personally, I believe craftsmanship is a link – to history and tradition, to place and to one another.

Do you still work with companies in Germany? If yes, which ones and for what products?

Collaborations are very important to our brand, and a number of our products are in fact produced in collaboration with other very prestigious partners, such as KPM Berlin for porcelain. Additionally, for fine jewellery,

we work with a small, renowned manufacturer, Victor Mayer. As Bottega Veneta has evolved into a true luxury lifestyle brand, we have sought partners who are experts in their field, and who share the same values as we do, to effectively merge the vision I have for a new category and the know-how of the partner. While both are German, most importantly we felt the collaborative efforts would result in products consistent with our commitment to quality, craftsmanship, functionality and timelessness.

What are your personal goals for the future?

I'm always looking to expand the Bottega Veneta portfolio, with the introduction of new or augmented product lines. This, of course, depends on the needs and desires of our customers.

What is your secret for survival in the fashion world?

There really isn't one answer, though it's important to stand for something and then stay true to that identity.

What does luxury mean to you?

I have always believed that luxury is defined by the individual. For me, something is luxurious if it's elusive, of the highest quality possible and personally meaningful.

When will you be in Germany next – for what project or event?

I don't have set plans at this moment but I hope to be back very soon.

Top right: Craftsmanship at Bottega Veneta; bottom right: Tomas Maier and Nine D'Urso behind the scenes of the shooting with Bruce Weber for the women's fragrance advertising campaign

_____/**TOMAS MAIER**/ CREATIVE DIRECTOR/ BOTTEGA VENETA

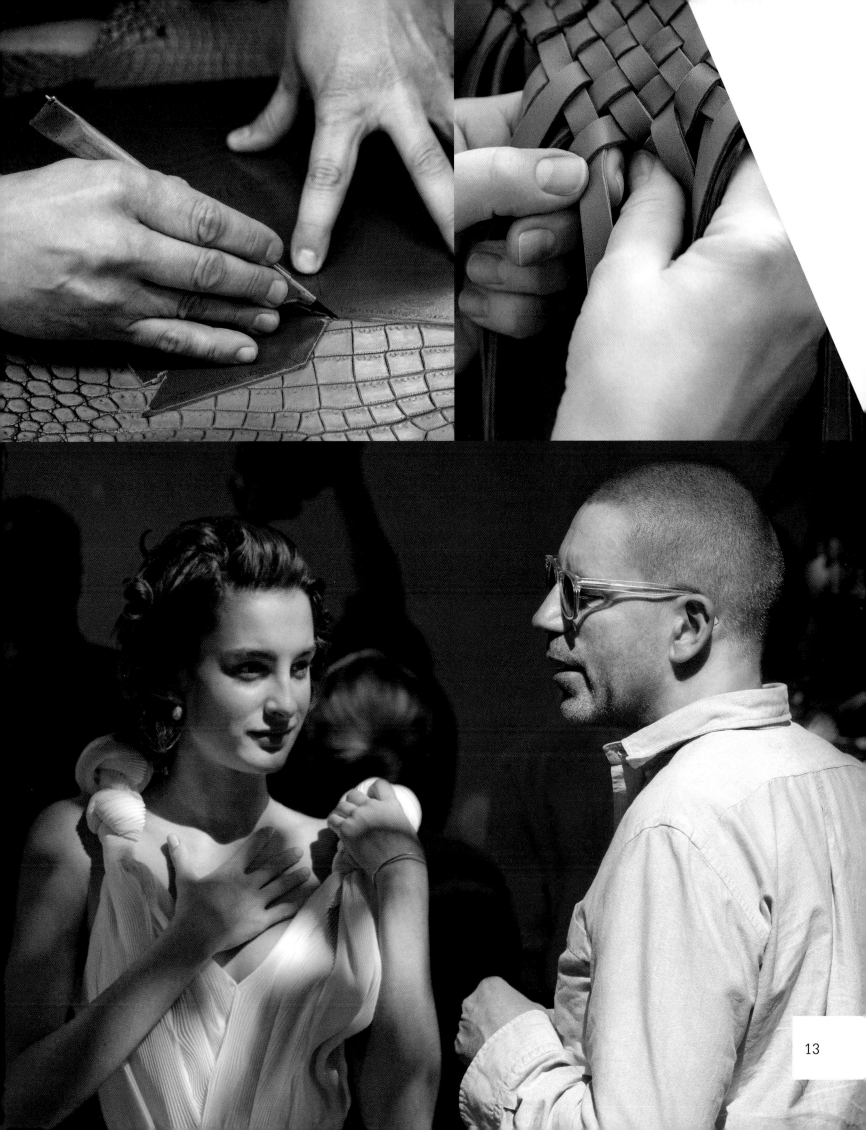

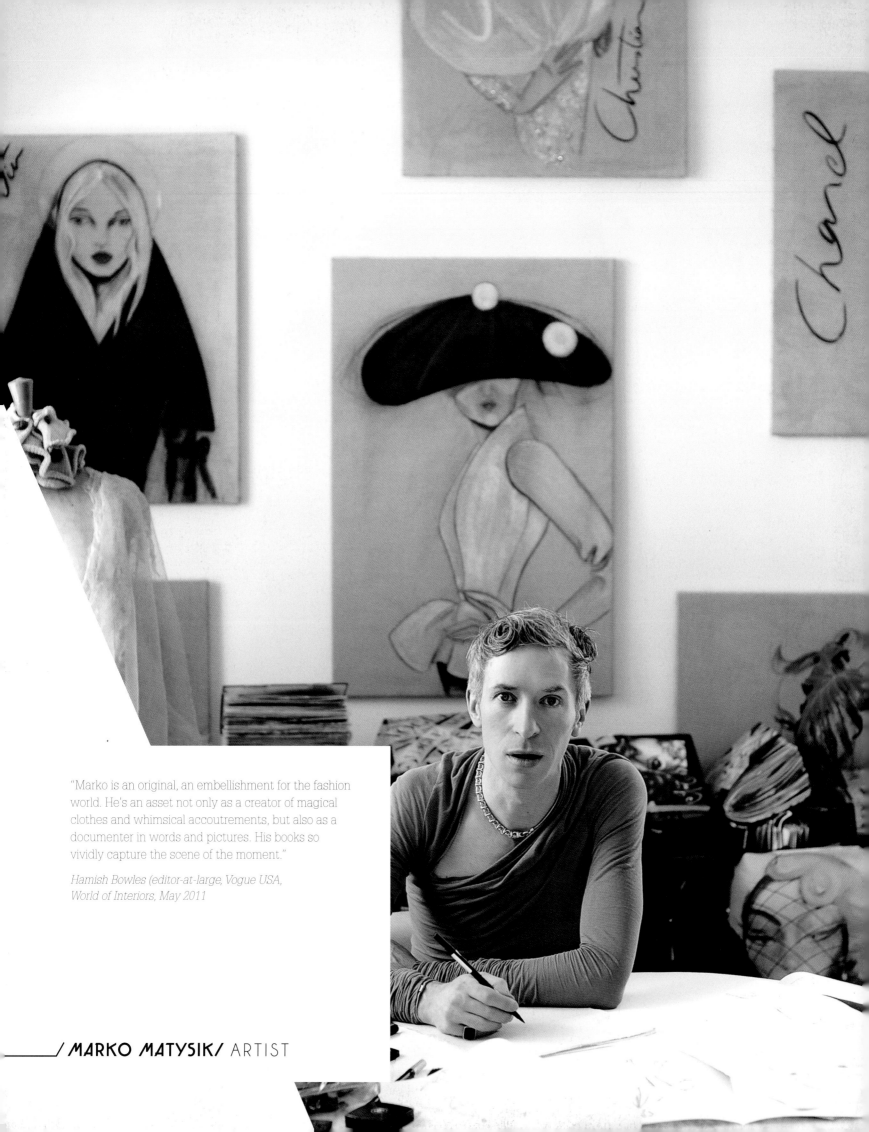

"Marko is an original, an embellishment for the fashion world. He's an asset not only as a creator of magical clothes and whimsical accoutrements, but also as a documenter in words and pictures. His books so vividly capture the scene of the moment."

Hamish Bowles (editor-at-large, Vogue USA, World of Interiors, May 2011

____/ MARKO MATYSIK/ ARTIST

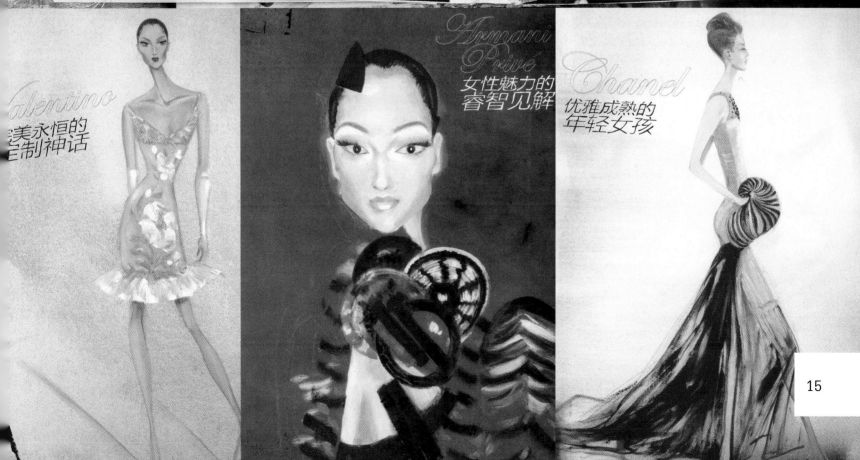

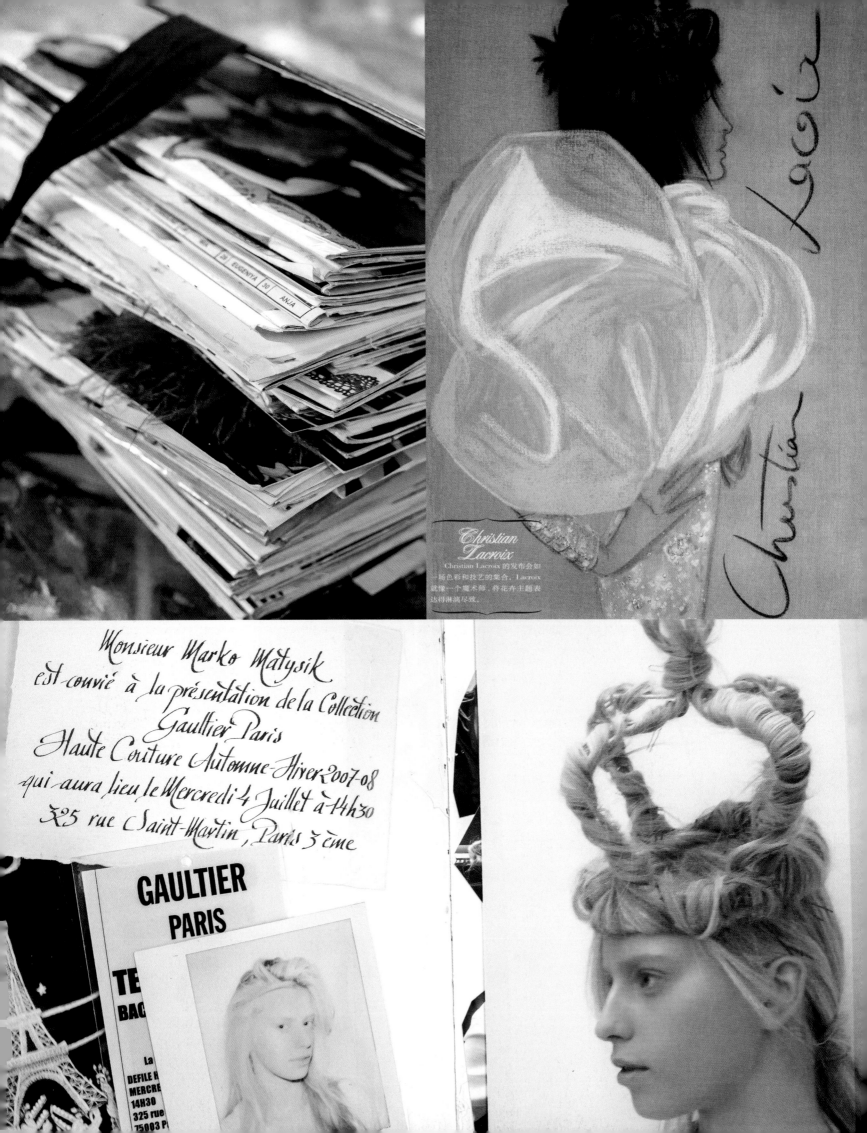

Christian Lacroix

Christian Lacroix 的发布会如
一场色彩和技艺的集合，Lacroix
就像一个魔术师，将花卉主题表
达得淋漓尽致。

Monsieur Marko Matysik
est convié à la présentation de la Collection
Gaultier Paris
Haute Couture Automne-Hiver 2007-08
qui aura lieu le Mercredi 4 Juillet à 14h30
325 rue Saint-Martin, Paris 3ème

GAULTIER
PARIS

TE
BA

La
DEFILE
MERC
14H30
325 rue
75003 P

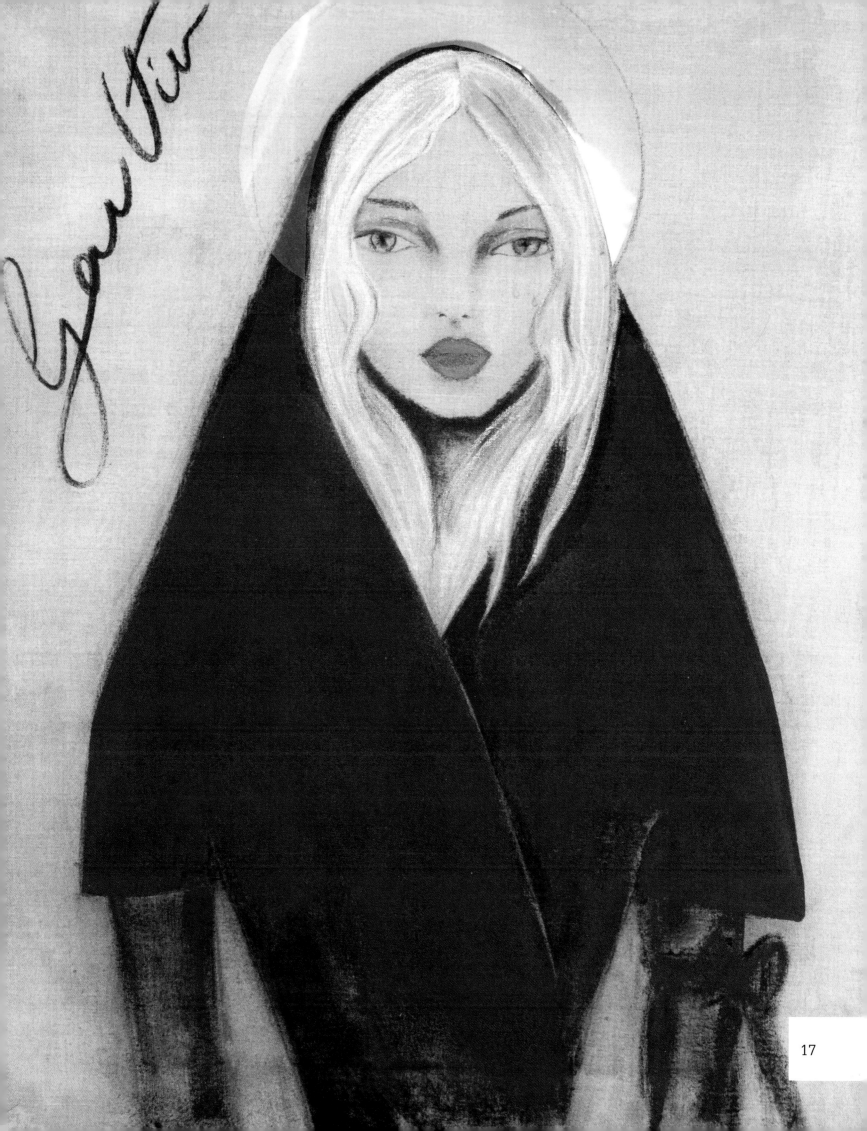

17

Beauty comes from honesty and is always defining itself anew. It comes from within; I am responsible for the outside. But beauty does not mean perfection, because that can quickly get boring, and I look out for that. Being creative is the constant search for expression and visions, as well as their realization. I find inspiration everywhere.

_____/ YASMIN HEINZ / MAKE-UP ARTIST

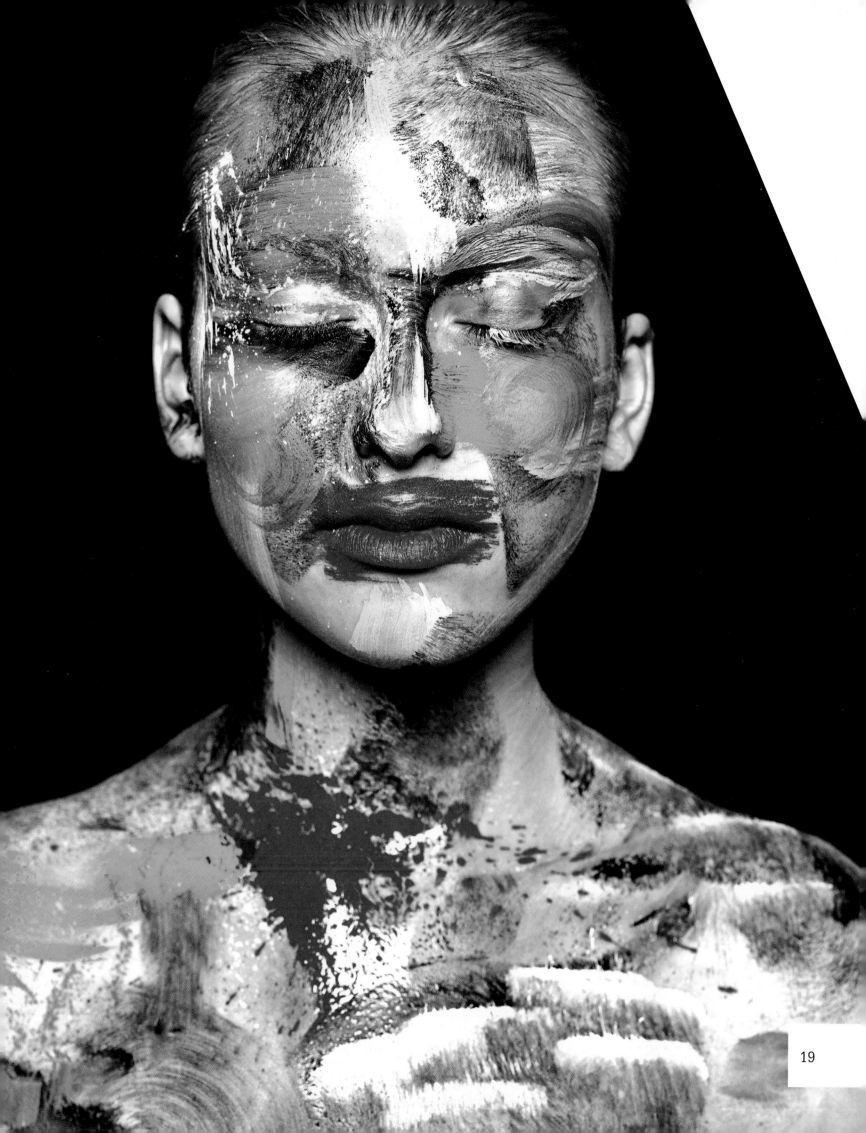

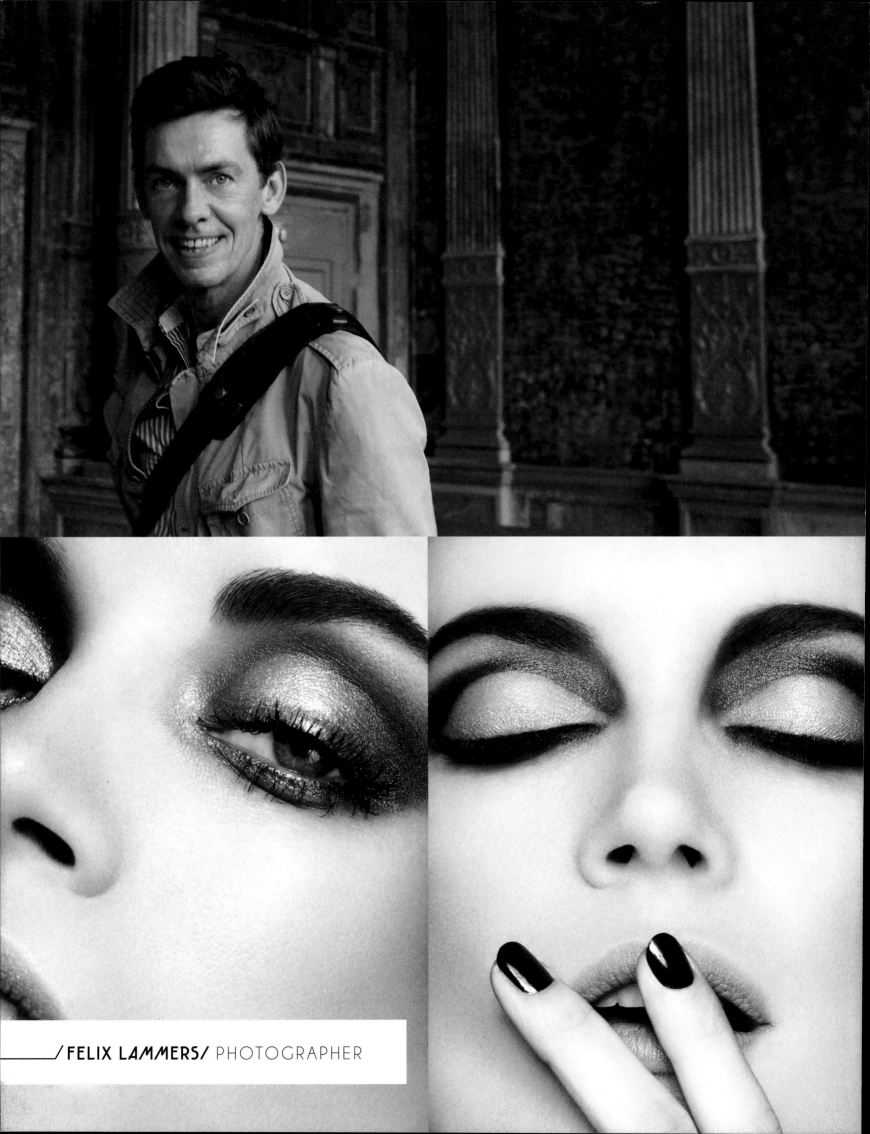

/FELIX LAMMERS/ PHOTOGRAPHER

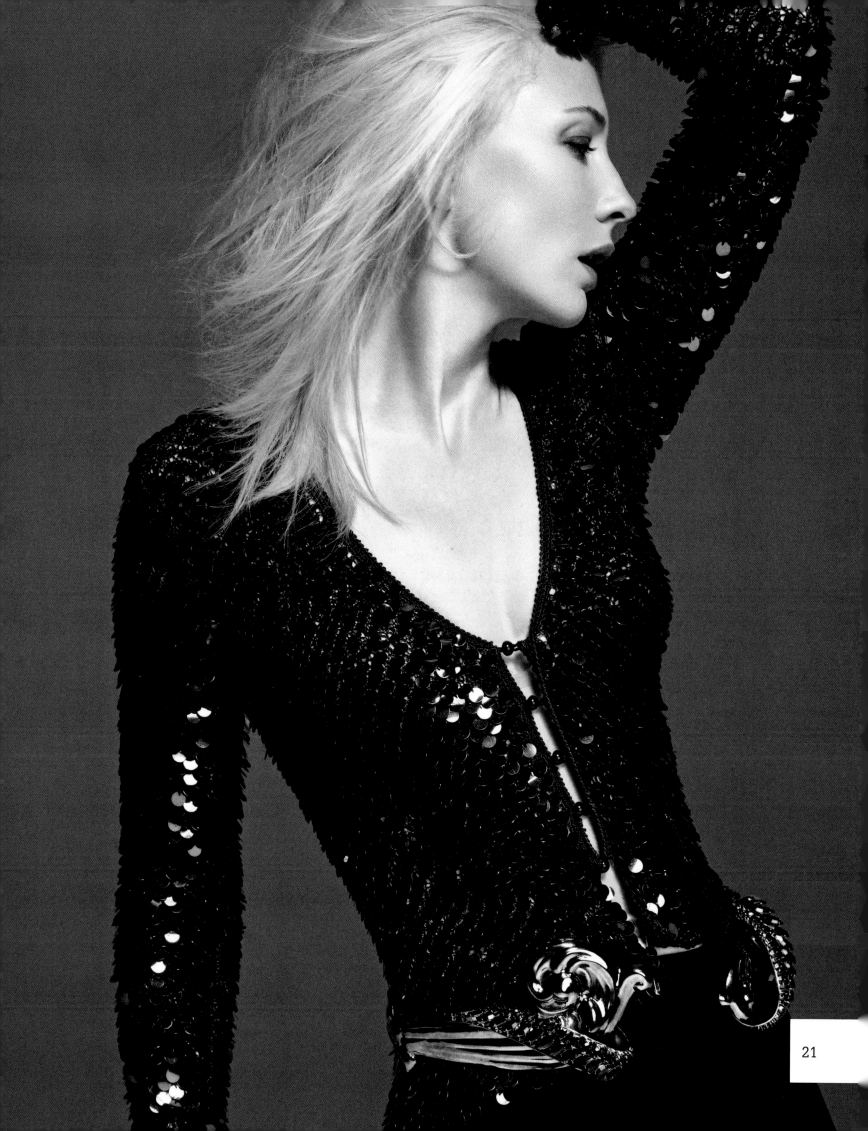

What's the first thing that springs to mind when you hear the words "fashion", "lifestyle", "luxury" and "Germany"?
The collaboration between Kostas Murkudis and Carsten Nicolai.

Who or what inspires you?
I find a lot of inspiration in material samples that we collect and keep. Also we study manufacturing technologies that are related to the materials. It can take some time until we come up with a new idea or take things further. Materials such as pulp, liquid wood, expanded metal, rattan or cork have recently been the starting point within the design process. Also new lighting technologies are a source of inspiration and it is about how we use materials and technologies.

What skills do Germans benefit from in the international fashion industry?
I find it difficult to think in categories with regards to German identity in relation to the international fashion industry. I haven't noticed any advantages in terms of skills that are related to Germans.

Your personal fashion work highlight?
My latest work is what interests me. I never look back and I like to look into the future.

What advice would you give German creatives wishing to beak through into the international fashion industry?
Believe in what you do and keep your integrity. Remain passionate about what you do and never lose the sparkle.

What does a typical working day look like for you?
There is a lot of administration involved in a typical working day. If I am working on something creative I like to spend at least half a day on a subject.

What three objects would you take with you to an island?
My laptop, sound sticks and my iPhone.

Anyone (company, project, institution) you would love to design for that would be a huge design challenge?
Comme des Garçons.

What is your favourite store design?
LN-CC in London.

Top left: portrait of Torsten Neeland; top right: T-shirt-range for House of Liza / Farfetch; centre left: cork hanger, produced by Multicork Solutions, dimensions: H: 35 cm, L: 45 cm, W: 3 cm, launched during Ambiente Frankfurt, February 2014; centre right: House of Liza, Vintage Fashion Store, London, 2012, display detail by Jonathan Griggs; bottom left: clothes rails Urban Nomad 1 and 2, turned solid untreated and stained maple, dimensions: H: 135 cm, W: 550 cm, L: 124 cm, launched during the 2014 IMM Cologne Furniture Fair; bottom right: Pierre Cardin Concept Fashion Store, Düsseldorf, 2014, in collaboration with Moysig Retail Design GmbH

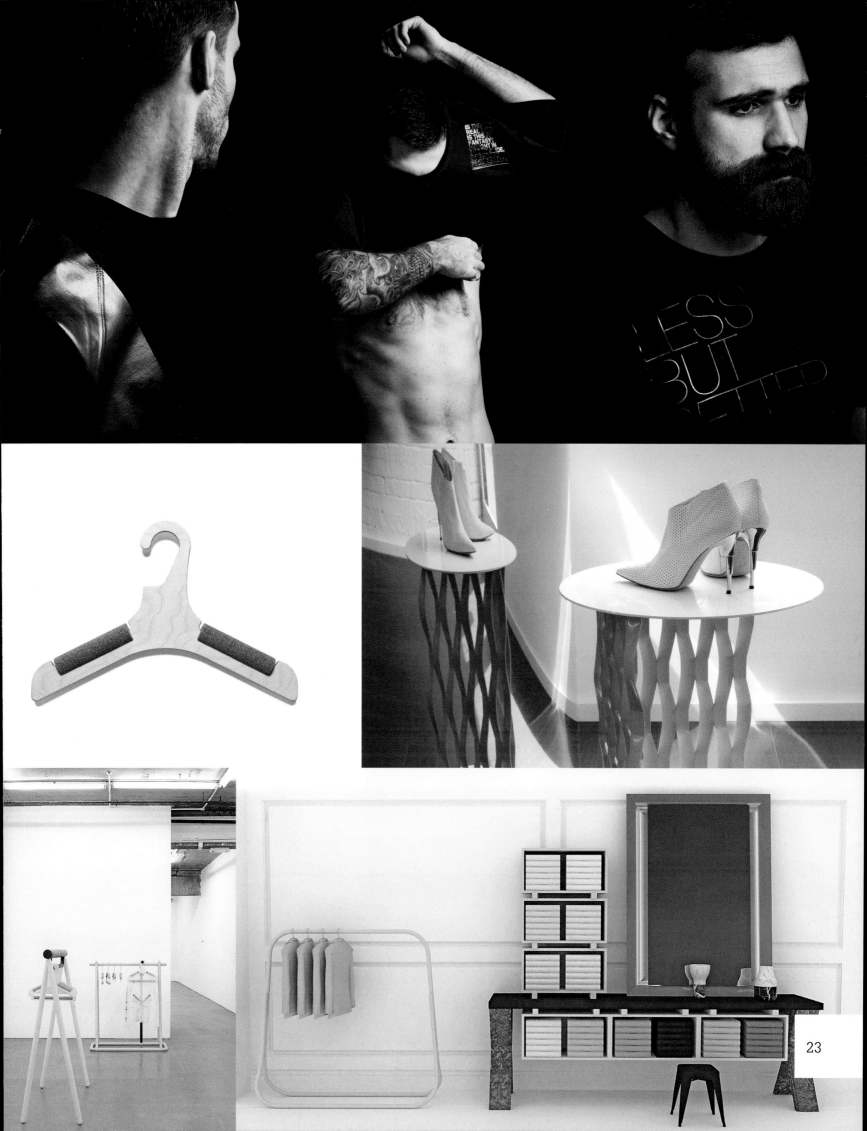

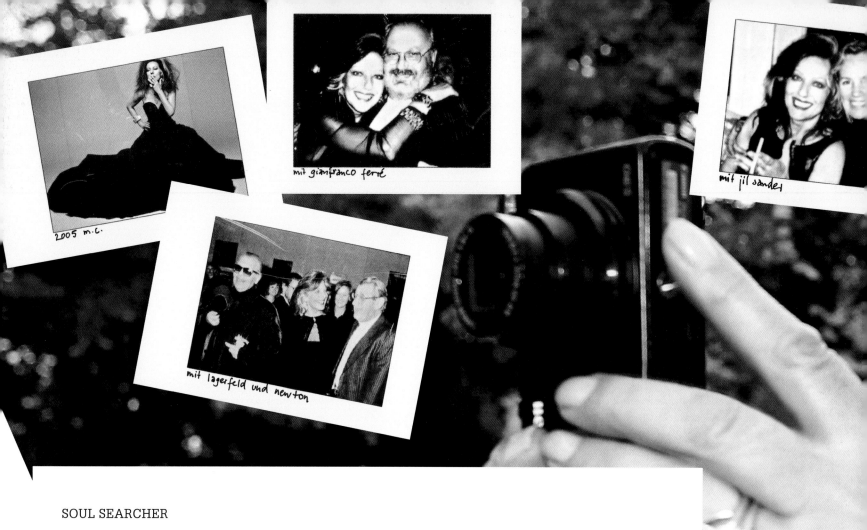

2005 m.c.

mit gianfranco ferré

mit jil sander

mit lagerfeld und newton

SOUL SEARCHER

The few great fashion magazines that shape style and celebrate elegance operate in some mysterious way undemocratically. True glamour is not the result of rankings and polls. If it curries favour left and right, it loses its commanding nature. In the twenty-four years during which Angelica Blechschmidt was in charge of German Vogue, her editorship was temperamental, debating, progressive. But no one ever doubted who had the last word. The editor-in-chief, who already owned her first Rolleiflex at the age of twelve, and once dreamed of assisting the great Dior, knew all the facets of her job. After studying in Hamburg she worked as a draughtswoman, graphic artist, art director and on concepts for campaigns and magazines. Anyone who learns their craft so intensively sometimes runs the risk of wanting to do everything herself. Her former colleagues could tell a thing or two about Blechschmidt's impatience, her talent for being the first to recognize a problem – and to solve it. About her insistence on perfection. Her contempt for the eight-hour day and the deadline.

What are real style and winning elegance? Angelica Blechschmidt, who even after her departure from Vogue has not eased up to become a musing theoretician, would struggle to find definitions. But there is a revealing word that she uses and has used in the past, when she has fallen for a person or a thing. It is "inspired", and what she means is that the interior can once again be found in the exterior. This enthusiastic search for inspiration has made her the friend of many fashion creators – Jil Sander and Joop, Lagerfeld and Versace, Vivienne Westwood and Ferré, Alberta Ferretti and Dorothee Schumacher. Her new, free life in Potsdam and Berlin has sharpened her euphoric gaze even further. In the capital she became a recluse, quite different from the many whose unmoved coolness wafts through so many Berlin parties and gallery openings. She says what she thinks and feels: ambassador of a world whose inhabitants are convinced that appearance and reality should be one.

Henri Lee

/ANGELICA BLECHSCHMIDT/ EDITOR-IN-CHIEF GERMAN VOGUE 1980–2003

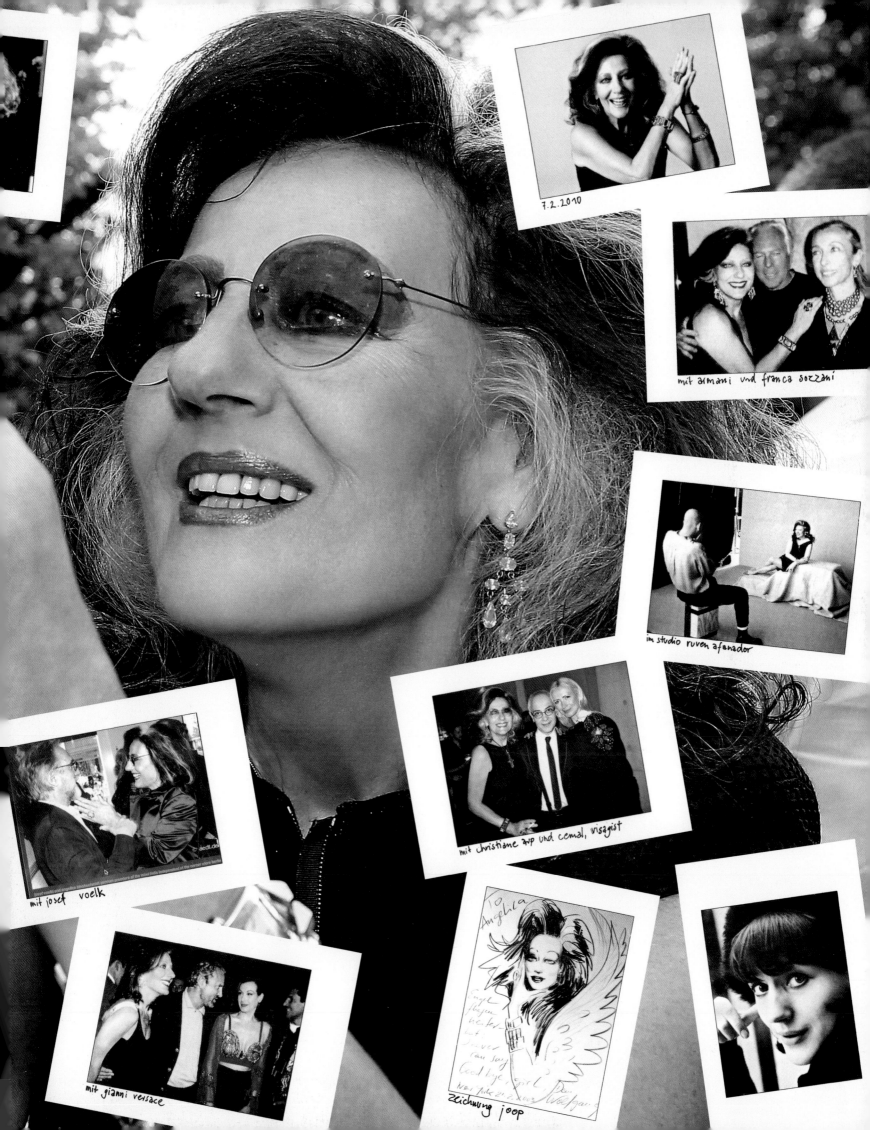

7.2.2010

mit armani und franca sozzani

im studio ruven afanador

mit christiane arp und cemal, visagist

mit josef voelk

mit gianni versace

To Angelika

Zeichnung joop

Susanne Tide-Frater is fashion director for Victoria Beckham. Since the inception of the ready-to-wear line in 2008 she has been in involved in building up the brand and the product line. In 2010 she joined the shopping platform Farfetch, which links 300 trendy boutiques from ten European fashion metropolises in one online shop, as brand and strategy director.

What makes Farfetch different from other online shops?

Farfetch is not actually an online retailer, as we don't buy any products. It is a platform which brings the best, independent fashion boutiques of the world together under one roof. Within a few minutes you can buy from shops in London, Milan, L.A. or New York. Among our 300 partners are names like L'Eclaireur in Paris, but also new start-ups such as Hostem London and now Voo in Berlin. The individual style of a boutique is important to us, but so are the personalities that shape it.

You were formerly creative director at the long-standing department store Harrods. How is the work for a department store different from that for an online shop?

In the department store there is a sensory component: the customer can touch products, try them on, see the colours. At first I doubted whether this experience could be translated online. Today I know that it is perfectly possible with the help of videos, descriptions and the telling of stories about the designers and their work. This was my new challenge: to bring an online shop to life and make it as colourful and interesting as a department store – only by other means. The advantage is that online one can take a fashion journey around the world in a very short time, and experience the various boutiques, their style and their very personal choice of products.

Do you think online shops will ever replace the classic high street shops?

I don't think the classic shopping street will ever be replaced. But we will alternate seamlessly between online and offline or classical shopping. Depending upon your mood and needs. We will get to know our sizes better and our taste, and thus be able to make quicker decisions in the online shop. I have observed an enormous development in the last two years.

What is the most important item in your wardrobe?

In winter, an amazing coat or jacket. This year I have constantly been wearing a long coat by Balenciaga. In summer, of course, a dress that will take me from morning to late at night: it has to be superbly cut, with the right colour or print. I love the young British designers like Peter Pilotto and Christopher Kane, but also the sexy dresses by Victoria Beckham.

What essential items of clothing should a woman have in her wardrobe?

A cool coat; trousers or leggings that go with everything; a dress; a fitted masculine-feminine shirt, for example by Jil Sander; a cashmere pullover for travel and the layered look; and last but not least, a pair of fantastic high-heeled shoes, either sandals or boots. The perfect wardrobe.

Do you have any good advice for women who are still looking for their style?

Don't be afraid to experiment! I know a lot of women who keep spending money on the same sort of item. Sometimes you have to do something a bit different and try out unusual looks. The result can be very liberating and pleasurable!

What is the best advice you have ever received?

"Embrace your femininity!"

Susanne Tide-Frater was interviewed by Tanja Fox for Glamour.de.

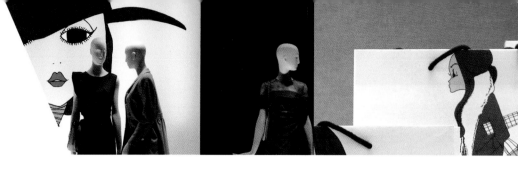

Jasmin Khezri interviews IRMA

Hello, IRMA. On the way to this interview appointment I have already met you several times. In Tokyo, when I got on the plane and was leafing through Japanese Elle, I noticed your beauty column; on the stopover in Paris I discovered a face lotion called Eau Précieuse with a drawing of you on the duty-free shelf; and just now on the way from the hotel to the café I saw IRMA looking at me wide-eyed from the huge display window of the luxury boutique Theresa in Munich. You are practically everywhere – who are you actually, and what are you doing here?

I have the great fortune to be an "illustrative character", a drawn figure, which makes me applicable worldwide; my appearance never changes completely, but adapts to the client's requirements. I look around me, observe and then take my drawings and texts to the international women's magazines, fashion houses, beauty businesses or my website, www.irmasworld.com. I sketch a lot, collect and translate visually.

Tell me about Irma's Diary on the irmasworld.com website.

That's where you can see what IRMA is doing and what inspires her. In irmasdiary.com IRMA travels the world, collecting stories. At IRMA'S SHOP, you can order, among other things, limited-edition prints, and with a click on IRMA'S GUEST EDITORS, you access specialists from all over the world writing about their respective fields. There is deliberately no advertising; IRMA decides independently about what, and whom, she writes.

That almost sounds like the contents of a women's magazine.

The subjects are things that interest women and move them, except that they are prepared differently from a typical women's publication. You only see drawings of IRMA, but of course there are also photos, texts, interviews, collages, etc.

Then IRMA is not just an illustration, but a ... lifestyle icon?

You could say that, but I don't like that description at all. The German edition of Glamour calls me a trend scout, because since it first came out I have written my columns under the title of "Irma's Tips", showing what people should look at, what they should read or of course what IRMA is wearing at the moment, how she makes herself up, lives her life and what is on her mind.

How do you manage to be internationally up-to-date?

I'm used to travelling, not staying in the same place for more than a couple of years, and quickly getting used to other people, languages and lifestyles. If you don't know any other way of life, it's hardly ever an effort to live in other cultures. I always try to keep my lightness of touch.

How and where do you work?

I travel a great deal, and always with a lot of sketchbooks, various kinds of paper, pencils, ink and brushes.

At the moment, my studio is in Munich. Luckily it has big windows, so the light is fantastic even in winter, and the room is panelled in old wood. On the walls hang my sketches and on the shelves I try to keep an archive in order. There's a large scanner, and in the middle is a very large table where I work.

When I'm working on a new project, I first make a number of different sketches that have to do with the topic, and then I create the outline and do the final artwork in black ink. I look at a lot of pictures, clippings and sometimes films related to the subject before I start.

To keep things in balance, I often prefer peace and quiet and taking a long walk with my dog, Polly – but it could also be an evening sampling the nightlife of Berlin or London, or I may cook something from one of the many cookbooks that I collect.

___/ JASMIN KHEZRI/ JOURNALIST, ILLUSTRATOR AND ARTIST/ IRMASWORLD

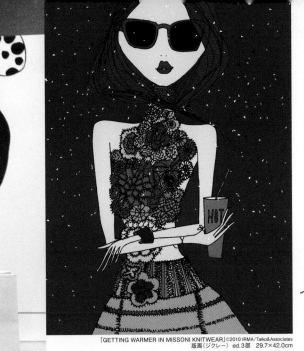
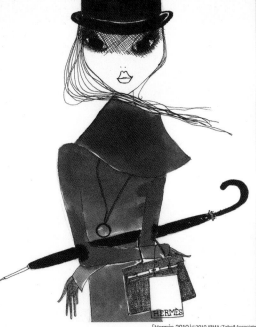

「GETTING WARMER IN MISSONI KNITWEAR」©2010 IRMA/Taiko&Associates
版画（ジクレー）ed.3部　29.7×42.0cm

「Hermès 2010」©2010 IRMA/Taiko&Associates
ミクストメディア　30.6×33.9cm

版画（ジクレー）ed.3部　34.0×48.0c

10F/W IRMA FASHION ILLUSTRATION EXHIBITION
10F/W イルマ ファッションイラストレーション展
10月13日(水)〜19日(火)〈最終日4時30分終了〉
伊勢丹新宿店本館5F＝アートギャラリー　作家来日トーク＆サイン会：10月16日(土)午後2時〜3時

ISETAN
伊勢丹　新宿
www.isetan.co.jp

新宿店は、年内休まず毎日夜8時まで営業いたします。

Insider beauty
クチュール・ジム＆エステで一気にスリム！

洞窟マグマスパ内でのエクササイズでデトックスしたあと、フランス発コスメ、
サンパーのトリートメントを受けられるスペシャルコラボ情報をキャッチ。
効率よくきれいを叶えると評判のメニュー内容に迫る！

Illustration IRMA/taiko&associate

one...
昨年のオープン時から、エンターテインメント型トレーニングジムとして話題を呼んでいる「ジャングルジム」。37℃に保たれたマグマスパ内で行われる完全パーソナルのトレーニングは、体に負担をかけることなく、効率的に代謝を高めながら筋肉を鍛え、最高の効果を得られるともっぱらの評判だ。そのジャングルジムが、フランスのスキンケアブランド「サンパー」とのコラボメニューを開発中と聞きつけた。サンパーといえば、パリの有名マダム御用達の高級コスメ。もともとは美容外科医が手術後の肌にも安心して使ってもらえるように開発したもので、フィトアロマセラピーと最先端のテクノロジーが融合された実力派。スパも好評で、過去に一度受けたトリートメントでは、オリジナルの手技とコスメの相乗効果がすばらしく、至福の時間と確かな肌実感を経験した記憶がある。マグマスパでのパーソナルトレーニングで老廃物を出し切り、毛穴が開いた状態で、サンパーの極上トリートメント……考えるだけでワクワクする！

two...
訪れたジャングルジムは、南麻布の閑静な住宅街にある、トレーニングスタジオとは思えないレンガづくりのおしゃれな一軒家。なかに一歩入ると、あまりの異空間に驚く。サイの剥製やヨーロッパのアンティーク家具、シカの角で作られたシャンデリア、壁にはアフリカ産のトライバルな面とヨーロッパの絵画。そしてチェンジングルームには、巨大なバッファローの剥製が壁から飛び出してきたのようにレイアウトされている！ 実はここの内装を手がけたのは、世界に誇るディズニーシーのインディ・ジョーンズ担当チームだというのだから、なんて贅沢！「エクササイズが苦手で、義務に感じたり、ダイエットのために一時的に運動する人が多いなか、ライフスタイルの一部として、楽しみながらトレーニングを続けられるように考えた空間です」というオーナーの計らいどおり、確かにディズニーリゾートで遊んでいるかのように気持ちが昂る。さすがエンターテインメント型ジム。トレーニングもゲストに負担がかからないように配慮されているようで、最初に行うストレッチは、マグマスパの温かい空間で、ただ寝ていればいいというもの。その私の体をトレーナーが引っ張り、持ち上げ、ねじり……ただ身を委ねているだけでどん

どん伸ばされていく。温まった空間のおかげで、普段より体が伸びるし、すでに発汗しているのがわかる。引き続きマグマスパ内で行われるトレーニングは、どんな体になりたいのかによってメニューを作成。恥ずかしげもなく、カーヴィーなメリハリボディをオーダーしてみる。まずは第二の心臓といわれるふくらはぎを活性化するためのステップ運動を5分ほど行う。この軽いウォーミングアップのあとにオリジナルメニューの筋トレに。おそらく私のボディラインと体力もしっかり計算しているのだろう。ヒップ、ハムストリング、腹部、二の腕など、絞るべきポイントを的確に攻めつつも、決して無理のない内容というのがすばらしい。さらにトレーニングはトレーナーがふたりがかりで、掛け声をかけてくれるのだから、俄然やる気がわいてくる。気がつくと大量の汗！ 運動でこんなに汗をかいたのは、本当に久しぶりだ。心地よい疲労感に包まれながら、再度ストレッチへ。すると筋トレに行ったときよりも、体が驚くほど柔軟になり、巡りがよくなっているではないか。改めてマグマスパ内のトレーニング効果を実感。その後、軽くシャワーを浴び、いよいよサンパーのトリートメントに。

three...
トリートメントルームもディズニーチームが手がけたエンターテインメント感溢れるおしゃれな空間。フェイス、ボディのピンポイントな悩みに対応した施術をオーダーメードで受けることに。メリハリボディが目標の私は、ボディの下半身を中心にケアすることに。サンパーが誕生したフランスではエステティシャンが国家資格付けられており、筋肉のつき方やリンパの流れなど看護師並みの知識をもった方が手技を習得するのが一般的。そのフランス仕込みによる内容は、通常のドレナージュとは異なり、両手を使ってもんだり、軽くこするなどユニークだ。これらは体の組織のしくみを考えた……で、詰まりやすいセルで、運動とと……メの浸透もよく、い…。そして何より…したようだ。翌E「やせた？」と声を

エディターY
ダイエットとアンチエイジングがライフワークのアラフォー編集長。BMI18、見た目年齢マイナス8歳を目標に、ありとあらゆる美容法にトラ

JUNGLE GYM
サンパー・コラボレーションメニュー
（トレーニング60分、トリートメント60分）
¥35,000　会員制（入会金¥315,000）
東京都港区南麻布3-5-20 Jハウス
☎03-6277-4706　営10:00〜22:00
無休　要予約

29

The Corner is synonymous with an interesting development in the field of fashion. You took a brave step and moved to Berlin in order to be able to offer high-end fashion and international design. Why?

JV: In the first place, what we have to offer has developed out of our professional experience. I was managing director of Armani Germany and already living in Berlin. The city fascinated me even then. We thought that this location was the perfect platform for us to realize our vision, which was to offer an exciting mix of international fashion.

You don't stock any German labels. Is that a strategic decision?

EdB: We actually want to emphasize the internationality of Berlin. This involves offering international fashion. But we have also always tried to integrate the newcomers from Germany, and introduce them gradually to consumers. We choose labels that have a very clear identity – which we find somewhat lacking in many designers from Berlin. Suzy Menkes told us in a conversation: "When I come to Berlin, I'm looking for something completely different than in Paris and London." So are we. And we strive to support this very specific, design-oriented fashion scene in Berlin.

A typical client of The Corner is ...

JV: ... well informed, an international traveller, art-oriented and very open-minded and courageous. By the way, we have many clients from other German cities.

What has been the biggest risk in your business life?

JV: Berlin itself. When we began, this city was not exactly an El Dorado of fashion and lifestyle. The risk was in growing with Berlin – and being responsive to it.

You have been here for a long time now. What has surprised you in Germany?

EdB: In France, fashion and lifestyle are very much present in all aspects of life. I found it surprising that this was the less the case in Berlin. I remember that the people who came into the store in the beginning used to ask in amazement: "Is this a museum or gallery?"

JV: I was on the move in the film and art scene before, and came to Berlin well prepared [laughs]. But I agree with Emmanuel here – in Paris, Milan, Los Angeles and New York a sophisticated lifestyle and luxury have quite a different status.

What has been your biggest fashion sin, or faux-pas?

JV: There are no "no-gos". It all depends on how one wears it – and who wears it. But I think it's more difficult today to dress well than it was five or ten years ago. The selection is immense, and also people don't think enough about who they really are and what suits them. There is great stylistic freedom, but good style calls for time and analysis. We try to provide guidance to our clients, without trying to lecture them.

So that means you would decline to sell a dress to a customer?

EdB: Absolutely. Our best advertising has not come from the press or events, but from word of mouth. The word gets around that we are honest and professional.

Where do you see The Corner in five to ten years?

JV: We always have some project or other going. Life for us does not mean standing still. We will continue to look after the three stores, and also expand. Our potential is far from exhausted.

Interview by Natasha Binar

/JOSEF VOELK AND EMMANUEL DE BAYSER/ OWNERS OF THE CORNER BERLIN

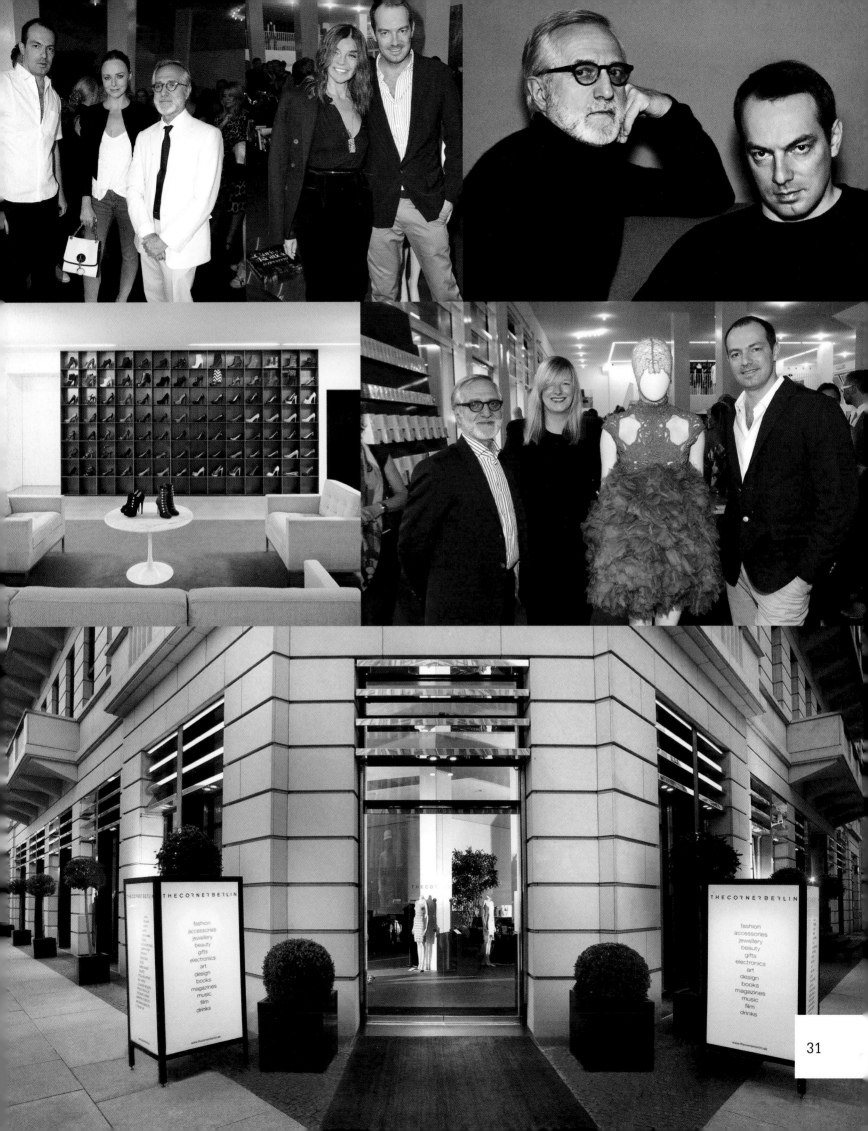

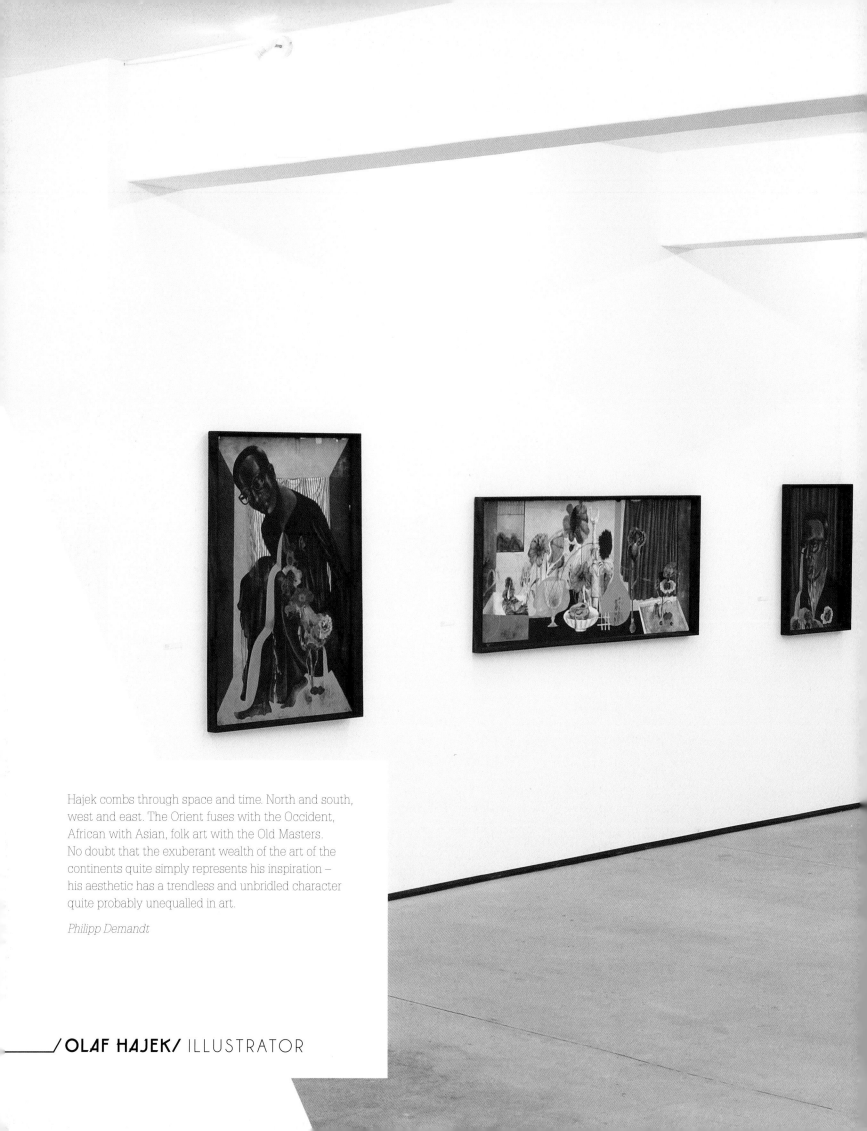

Hajek combs through space and time. North and south, west and east. The Orient fuses with the Occident, African with Asian, folk art with the Old Masters. No doubt that the exuberant wealth of the art of the continents quite simply represents his inspiration – his aesthetic has a trendless and unbridled character quite probably unequalled in art.

Philipp Demandt

/OLAF HAJEK/ ILLUSTRATOR

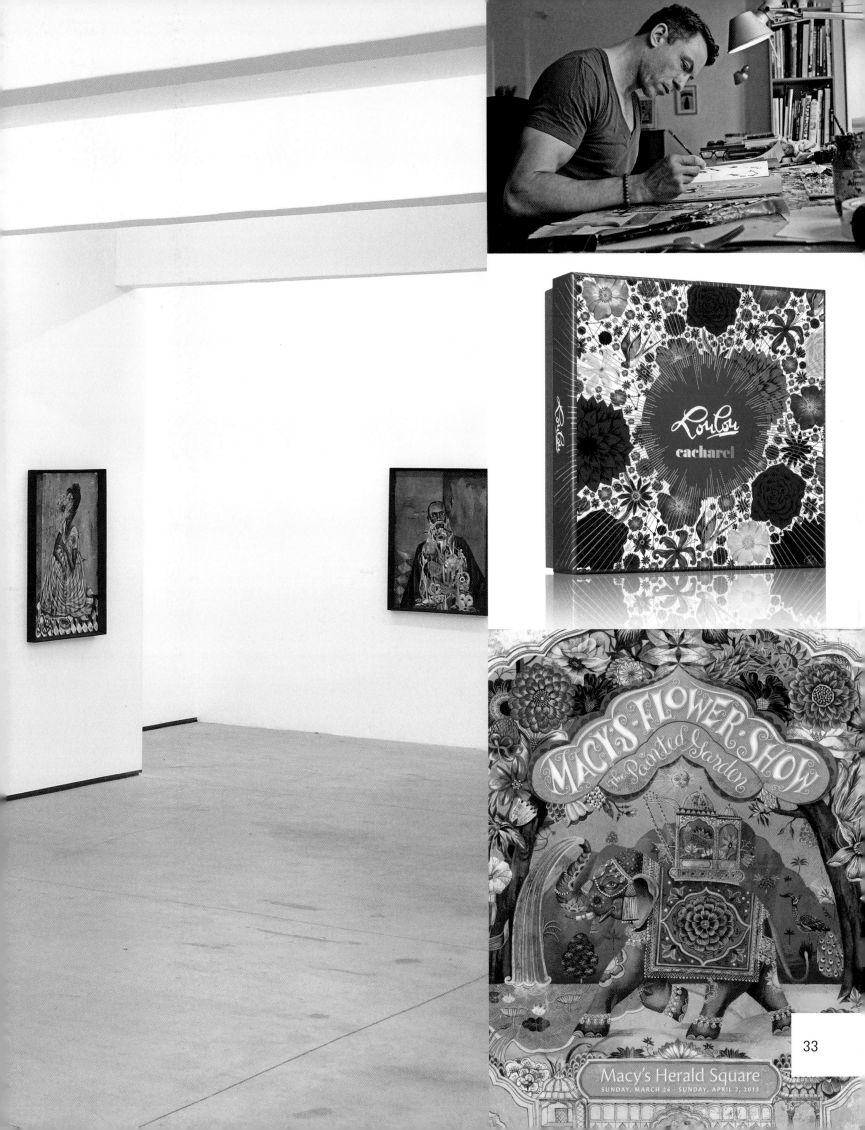

33

For many years Dirk Schönberger presented his own collection of men's fashion in Paris. He subsequently moved for a short time to the Holy Fashion Group, whose label JOOP! was in trouble, and finally signed on as creative director of the Sport Style Division at adidas.

You once said in an interview that Germans were afraid of fashion. Has that changed?
A nice comment. It has a good ring. The comment in itself of course is taken out of context. The question is: How is fashion classified in Germany? For me, fashion has acquired a different social significance from before. Fashion and access to fashion have become much more democratic today. I don't know if Germans are afraid of fashion, but fashion is still seen as mere consumption.

But for you, fashion means something quite different …
Fashion has suddenly become within reach for everyone. Anyone today can dress extremely fashionably. I grew up in the eighties: punk, new wave, romantics. Fashion was defined by trends. After the eighties, sports- and streetwear promptly established themselves. We are much more relaxed about our looks than before.

Is fashion functional for you?
No, absolutely not. But this is exactly why people in Germany talk about fear of fashion – here, fashion is still seen as functional. But I believe that fashion has a quite different significance, it has to do with subtle things, nuances. The traditional look in its original form doesn't exist any more. I find the idea of democratic fashion very appealing.

Our generation doesn't look like our fathers any more. And the next generation will do things differently too.

You work for one of the most exciting brands that offers a great deal of room for individuality – adidas. What does adidas stand for, in your perception?
Everything made by adidas is focused on sport. In different ways, even emotionally, but it's always about sport. I find it interesting to work with a brand that has the attitude of a designer brand but is commercial at the same time – and combines street relevance with total popularity. adidas is very traditional and future-oriented at the same time, and combining the two is a constant challenge for me.

Do you pay attention to the younger generation of creatives in Germany?
Yes, with great curiosity and admiration. I think it's fantastic that so much has been made possible in Berlin, precisely for young designers – they can present themselves at Fashion Week, have a platform of their own, appear professionally, think more internationally and more commercially. I'd like to see an initiative to support a showcase for young German fashion designers abroad. That's what we did in Antwerp, we packed our bags and left for Paris. It may be brutal, but only by measuring oneself against international standards can one really grow and be properly assessed.

Interviewed by Natasha Binar

/ DIRK SCHÖNBERGER/ DESIGNER AND CREATIVE DIRECTOR/ ADIDAS

What comes to mind when you hear the words "Germans" and "fashion"?
I think of Jil Sander, clear lines, perfect quality luxurious fabrics, Karl Lagerfeld, the maverick showman of fashion, and the new guard like Achtland, always perfectly tailored and elegant with an architectural twist.

In your opinion, the German fashion industry stands for …
Quality, perfect execution, not necessarily trend-driven but certainly reliable.

How did you get into fashion?
By accident. I had started a PR agency and was focused on events and artists and then Strenesse came along and changed everything for us, followed by Stella McCartney and Derek Lam, and we never looked back.

What has been the greatest project/brand your company BPCM has launched or looked after since 1999, and why?
Derek Lam, who came to us with half a collection in sketches and asked for PR support, and helping him and Jan build the company was extremely gratifying. But there have been a lot of designers since then that I am proud of, like Suno, Wes Gordon, Irene Neuwirth and Preen.

Describe BPCM in three words:
Strategic. Efficient. Game-changer.

Do you look after German clients or brands? And if you do, is there any difference in handling their account to others?
We look after Rimowa and Stylebop.com. The only difference in handling them is that I understand immediately where they are coming from and I love the way they work. They always stand by their word and do what they say and say what they don't want to do.

What is a typical business day during New York Fashion Week?
Get up at 7 a.m., quickly shower and get dressed before my baby wakes up, make breakfast with Cosmo sitting on the kitchen counter watching me, wake up Laszlo, give the kids breakfast and get my older son ready for school, take him to school, head to the office, organize my day and check my schedule, and then anything can happen, from presentations, to strategy meetings, calls in the morning to European clients, calls to journalists about various stories we need to place, collection previews, etc., and before I know it I rush home for 6.30 p.m. to put my kids to bed, and some days I collapse on the sofa with my husband and other days I head out again for dinners, events, and so on.

Who or what inspires you?
People, their energy, New York and that everything is possible in this country, creativity in clients and my team.

What is your personal secret to how you survive in this always faster developing fashion industry?
Just keep going, and when there is a break – enjoy it!

Who is your favourite brand/designer?
Too many to name. I really don't have one. There are a lot of new designers I admire. And many brands that have found their perfect voice.

The future will bring …
Hopefully health, happiness and many more exciting projects.

What comes to mind when you hear the words "Germans" and "fashion"?

Other things are more important to German people, but there's a steadily growing interest. That's why it is exciting to work for German Interview magazine as an international fashion director. It is fun to influence the taste of Germans in fashion and style. And I admire the Germans who made it abroad, like Karl Lagerfeld, Helmut Newton, Peter Lindberg and Katja Rawles.

In your opinion, the German fashion industry stands for …

It stands for minimalistic styles such as Jil Sander and Strenesse. And for the quality of materials and handcrafting.

How did you get into fashion?

Even growing up in in my little town Heidelberg I was always passionate about arts and fashion. I was convinced at an early age that I would one day move to Paris. My childhood plan was to study fashion there – which is why I chose French as a foreign language at school. When I was nineteen I moved to Paris to study fashion design and ended up, accidentally, becoming the fashion assistant to Carine Roitfeld. At this point, I knew I would never want to do anything other than be a stylist.

Why did you decide to move away from Germany?

For me, fashion was connected to Paris. As a young girl, I travelled a lot and had an interest in different cultures. For this reason I always knew I would move away from Germany – to satisfy my thirst for different cultures.

What has been the most exciting job you ever had and why?

The latest, most exciting job for me is the new position I have taken on at German Interview as the international fashion director.

Any fashion faux pas from the past that makes you laugh now?

When I was still assisting Carine Roitfeld, every day I wore super high heels – of course! On one occasion, we were in L.A. shooting on location in Death Valley. Carine showed up in flat sandals, Henry Duarte jeans and a simple T-shirt – which I was not expecting. I was shocked how she had morphed into the L.A. interpretation of her signature chic. I looked very out of place in my black pencil skirt and Prada heels – sometimes you have to adapt to your location.

Who and what inspires you?

Anything I see, hear or read can be a source of inspiration. It could be a person walking by on the street, a song I am listening to, a book I am reading. Of course the fashion shows are always a key inspiration.

If there were three things you could take with you to a desert island, what would they be?

Josephine and Elizabeth, my two daughters, and my husband Ben!

The future will bring …

Hopefully a lot of interesting young German designers who will get their chance, and, for myself, more adventures as an international fashion director.

_/ JULIA VON BOEHM/ STYLIST AND FASHION DIRECTOR

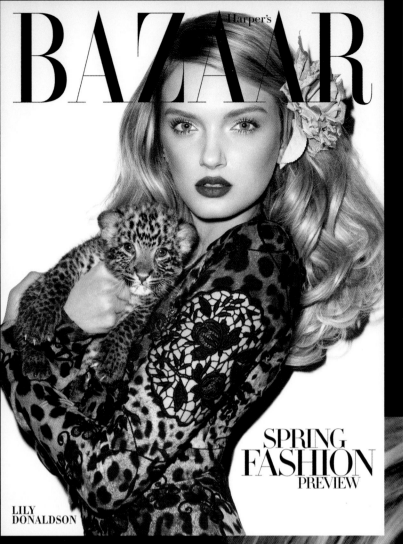

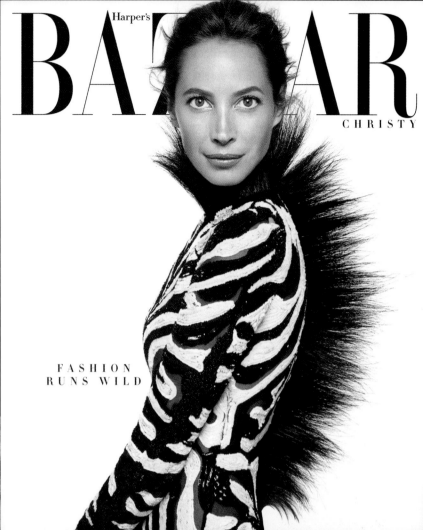

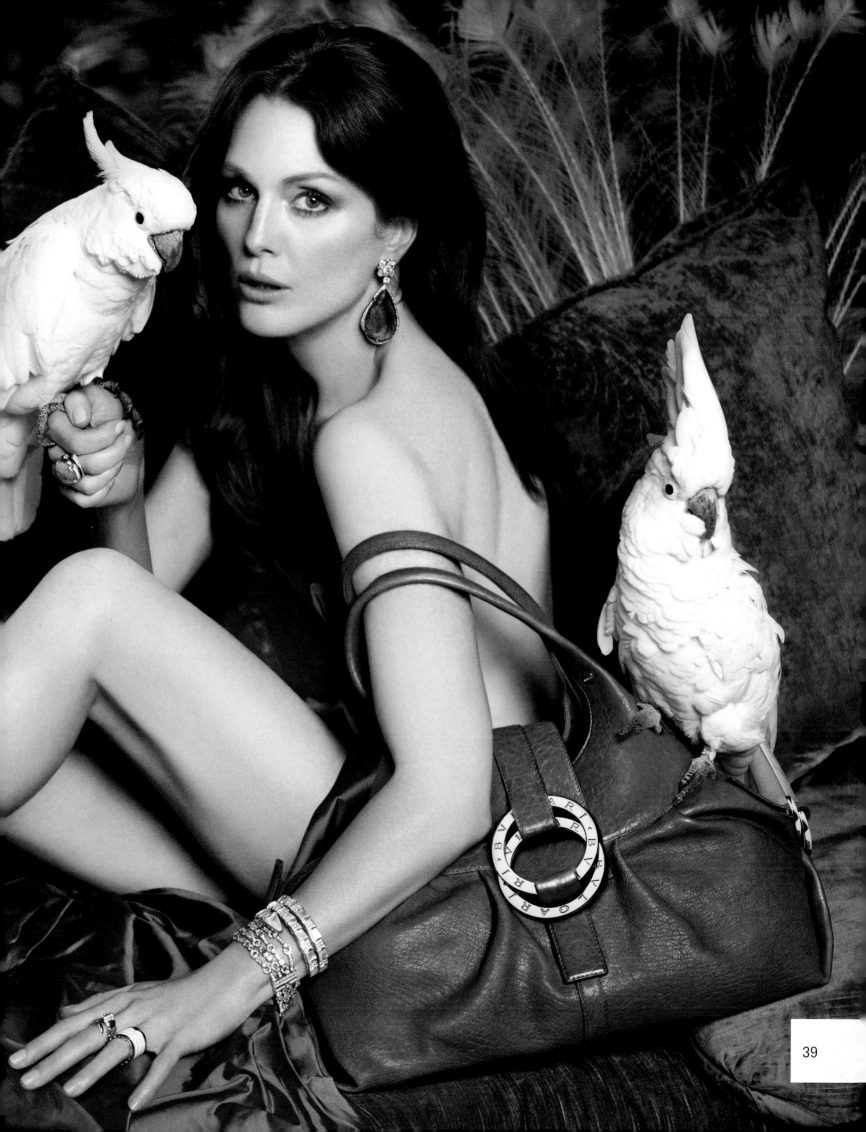

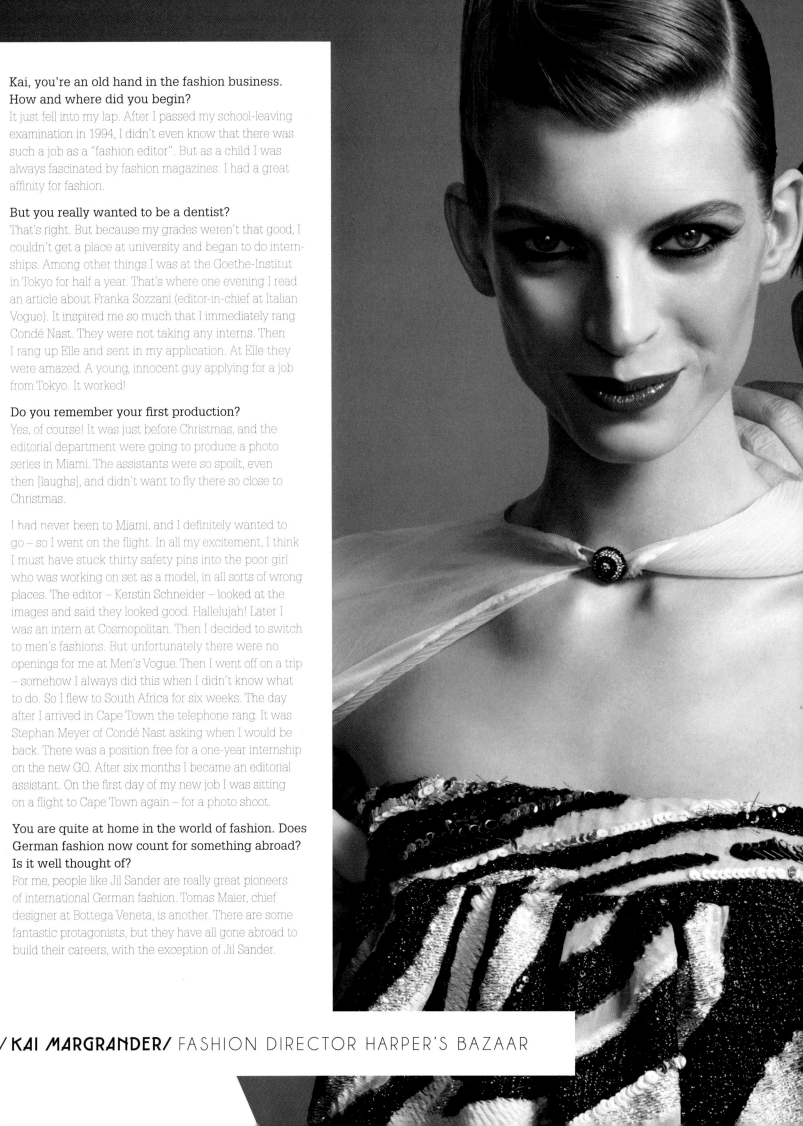

Kai, you're an old hand in the fashion business. How and where did you begin?

It just fell into my lap. After I passed my school-leaving examination in 1994, I didn't even know that there was such a job as a "fashion editor". But as a child I was always fascinated by fashion magazines. I had a great affinity for fashion.

But you really wanted to be a dentist?

That's right. But because my grades weren't that good, I couldn't get a place at university and began to do internships. Among other things I was at the Goethe-Institut in Tokyo for half a year. That's where one evening I read an article about Franka Sozzani (editor-in-chief at Italian Vogue). It inspired me so much that I immediately rang Condé Nast. They were not taking any interns. Then I rang up Elle and sent in my application. At Elle they were amazed. A young, innocent guy applying for a job from Tokyo. It worked!

Do you remember your first production?

Yes, of course! It was just before Christmas, and the editorial department were going to produce a photo series in Miami. The assistants were so spoilt, even then [laughs], and didn't want to fly there so close to Christmas.

I had never been to Miami, and I definitely wanted to go – so I went on the flight. In all my excitement, I think I must have stuck thirty safety pins into the poor girl who was working on set as a model, in all sorts of wrong places. The editor – Kerstin Schneider – looked at the images and said they looked good. Hallelujah! Later I was an intern at Cosmopolitan. Then I decided to switch to men's fashions. But unfortunately there were no openings for me at Men's Vogue. Then I went off on a trip – somehow I always did this when I didn't know what to do. So I flew to South Africa for six weeks. The day after I arrived in Cape Town the telephone rang. It was Stephan Meyer of Condé Nast asking when I would be back. There was a position free for a one-year internship on the new GQ. After six months I became an editorial assistant. On the first day of my new job I was sitting on a flight to Cape Town again – for a photo shoot.

You are quite at home in the world of fashion. Does German fashion now count for something abroad? Is it well thought of?

For me, people like Jil Sander are really great pioneers of international German fashion. Tomas Maier, chief designer at Bottega Veneta, is another. There are some fantastic protagonists, but they have all gone abroad to build their careers, with the exception of Jil Sander.

/KAI MARGRANDER/ FASHION DIRECTOR HARPER'S BAZAAR

Photographers like Peter Lindbergh, Juergen Teller, Helmut Newton – real top players in the industry – all have a German history. But German fashion, just like German magazines incidentally, is unfortunately not really taken seriously. You are always pigeon-holed. But that actually drives me on. I want to do my best not to confirm this reputation but to produce amazing series of international quality.

What are you particularly looking forward to in your new role as fashion director at Harper's Bazaar?
First of all, it's exciting to establish a brand like Harper's Bazaar on the German market. Harper's Bazaar has been going since 1867. It's the oldest fashion magazine in the world, and it has a very strong international identity in the luxury area. And I think there is still a place for this on the German market. The amazing thing is that with a strong DNA like that of Harper's Bazaar I still have a lot of room for interpretation.

What is your personal highlight from all these years of countless photo shoots?
In the late nineties I had a lovely experience with Julia Freitag. As Condé Nast assistants at the time, we were accompanying Mario Testino on one of his productions. It was very exciting. We came back to Munich on Monday morning and found two wonderful bouquets of white roses sent to us by name, with a personal card from Mario. Angelica Blechschmidt, the Vogue editor-in-chief at that time, pulled a long face [laughs]. No, seriously – that moment inspired me. Our job is not glamorous. It's extremely hard work, with bad backs and permanent jet lag. But moments like a bouquet from Mario make my work worthwhile, and then somehow glamorous. Despite all the hardship – I love my job. Because I'm paid for my dreams, for being able to live out my dreams creatively. Could there be a better job?

Kai Margrander with Luca Gadjus, photographed by Matthias Vriens–McGrath.

A shirt: back, front, a button placket, a collar, two sleeves. A simple garment? No. The head has to go through the sleeve, the button placket becomes a tuck that swirls around the chest instead of concealing it, and the sleeve becomes a collar. In the nineties, this shirt by the Belgian Martin Margiela awoke Jina Khayyer's interest in fashion – she was studying at the Deutsche Journalistenschule, with a course in painting at the WFK and the Bauhaus in Dessau already behind her – when she found a new sensibility, a new relevance in fashion thanks to Margiela and the aesthetic of the Antwerp Six. She wanted to translate this for Germany and make it known. A space came into being for texts on lifestyle and fashion that would be entertaining and smart, in control of their subject matter and language, such as architecture, art, literature and pop criticism. Jina Khayyer has occupied this space: she was in the original editorial section for the fashion page in the weekend edition of the Süddeutsche Zeitung – the first fashion page in a German daily newspaper – where Khayyer worked up to 2009 as a writer and where she decisively influenced the language of fashion. She was also on the original editorial staff of Glamour, the first pocket magazine, and a little later of Elle Girl, the first German magazine dedicated to young women, where she soon became deputy editor-in-chief. Before she was thirty, Jina Khayyer was working beyond the borders of Germany and running two fashion magazines at the same time – the fashion edition of Neon and the fashion specials of Weltwoche in Zurich – with the ambition to always bring the unusual, the eccentric but also the general to readers, and to treat both fashion and art in equal measure as contemporary culture. Since 2006 Khayyer has been living and working in Paris and writes in English and German for Die Zeit, 032c, The Gentlewoman, Fantastic Man, Purple Magazine, Monopol, The Germans, Neon and Pin-Up. Since January 2014 she has also been writing for the French daily newspaper Libération.

Maria Exner

_____ /JINA KHAYYER/ JOURNALIST AND CONSULTANT

What comes to mind when you hear the words "Germans" and "fashion"?

I have mixed feelings: bad taste vs. minimalist chic! Germany has produced some amazing and ground-breaking talent: Jil Sander, Karl Lagerfeld and Wolfgang Joop, to name just a few. The younger generation, such as Boris Bidjan Saberi, Tillmann Lauterbach or Damir Doma, also shows great promise.

In your opinion, the German fashion industry stands for ...

The German fashion industry bridges the gap between tradition and modernity. There are many traditional fashion houses, but at the same time Berlin supports its young, emerging designers better than any other city. Germany has a great reputation for excellent production quality and the "Made in Germany" label has great cachet that extends to fashion production.

How did you get into fashion?

I was born with it. I grew up with three fashionable ladies – my mother and my two older sisters – who helped me develop a sensibility for fashion. I moved to London when I was nineteen to study acting and I ended up hanging out with some sparkling personalities in London's fashion scene back then. My ability to empathize with different people is the most important skill for my role in PR and communications. My friends call me "the social tornado".

What kind of designer do you provide public relations for?

I come from a more artistic and high-fashion background that tends to be more avant-garde, but I don't really limit myself. I like to think outside the box and I appreciate authentic brands and designers with a clear vision.

What is your secret to making a designer a cult brand?

You need to analyze the DNA of your brand to build a strong image, but I really work in a very intuitive and organic way. I always need to match well with the designer or brand. We need to understand each other, like in a marriage. For me, it's everything or nothing: a commitment.

Who have you worked with in the past?

I started my PR career seven years ago at the top PR firm Totem. Then I started to work freelance for different designers. I was a bit of a "PR Gypsy" – I have lived and worked in Barcelona, London, Paris, New York and now in Berlin.

In Barcelona I helped my friend Boris Bidjan Saberi to build up his brand, which became a big success. His label is sold in the most exclusive stores worldwide. Now I am working with both established and young designers.

What city is Germany's fashion capital?

That's a tough call. Germany's fashion industry is still very much developing and doesn't have a single base. Munich is the capital of the fashion media, Berlin has the most international fashion week and Düsseldorf hosts more than 700 showrooms. It's hard to bring it all together.

Who inspires you?

My mother with her true and unconditional love. My father with his entrepreneurship and sense of spirituality. I feel pretty gifted because of them.

The future will bring ...

More multidisciplinary collaborations and joint ventures than ever. So, people, come together!

I was born in Romania, a member of a German minority, my mother tongue is German, and at home we spoke the Transylvanian Saxon dialect. So for Romanians I was a German. From my arrival in Frankfurt I somehow became a Romanian; there was this otherness, and then the accent! My Romanian one-way passport was withdrawn and transformed into the green German one with permission to travel. That cleared matters up – I am a German! As for the accent, that stays – forever and everywhere!

As a child it is not always easy to find your bearings in different cultures from one day to the next. Today I see this as a positive thing, and also as good fortune – my experiences have greatly influenced me, and my desire to pack my bags and set out into the world like Little Hans in the German nursery rhyme was from a very early age part of my bedtime fantasies.

Sewing machine and camera – from the age of twelve these were my companions. At first I was determined to become a designer. In the course of my studies and in the first year after graduation it quickly became clear to me that I am more of a storyteller. I had to decide – and I became a photographer!

I love to create fantasies, fixed on paper; what comes before and after, what cannot be depicted, can create the most wonderful stories in the minds of the beholders. As a designer one is obsessed with detail and works for six months on a collection. Photography in general is more fun, we seldom shoot for more than three days on one piece. We are like taxi drivers who are called and then move on.

As a creative person one always comes up against one's limits when trying to reinvent oneself and not just to keep repeating what one has already done a thousand times. A simple ground rule for extending one's own horizons is to start on one's journey and collect experiences.

Like so many before me: Paris. For the last few years I have lived with my wife by the Seine. From the German perspective, the sun shines at least one stop brighter here, and one feels much closer to "fashion heaven". In Paris, fashion is real, one senses it everywhere, it is part of society.

In my early days, when I was fascinated by technology, I used whole forests of lights, but today my favourite light is daylight and a few reflectors. You remain gloriously flexible and are not a slave to your method. The moment it starts to get complicated, you're doing something wrong.

It is important to accept new things and just as right to preserve what is good. The reputation of German creatives abroad is excellent: punctuality, discipline and outstanding organization are considered our most important strengths. We like to admire the lightness, spontaneity and informality of the French and Italians. But it's exactly the other way around – it's all true, and yet it's still different. I notice how I, too, have a very German habit – of comparing, evaluating and questioning.

I am very lucky: the language of photography is universal – it allows me to travel and work wherever I want to try my luck. But the limitations of one's own cultural sphere remain. In Paris, New York or London, the Germans mostly know Germans, the French know the French, and so on. It is much easier to get together professionally in a new environment – our work is the common denominator and helps us to build bridges. But it takes years to get closer privately and really understand the other person.

For me, there is no real alternative – I need and want this confrontation with new countries and cultures. It drives my creative process forward and keeps me enthusiastic about what I do.

/KRISTIAN SCHULLER/ PHOTOGRAPHER

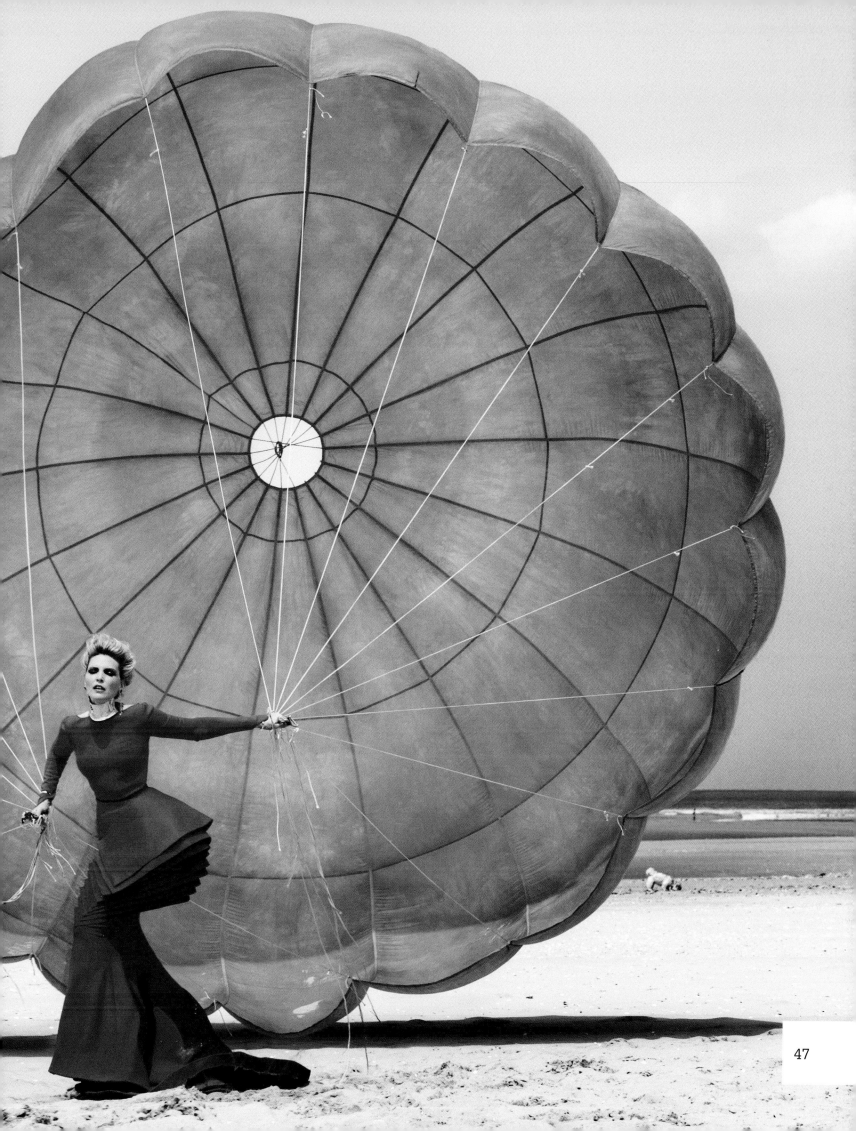

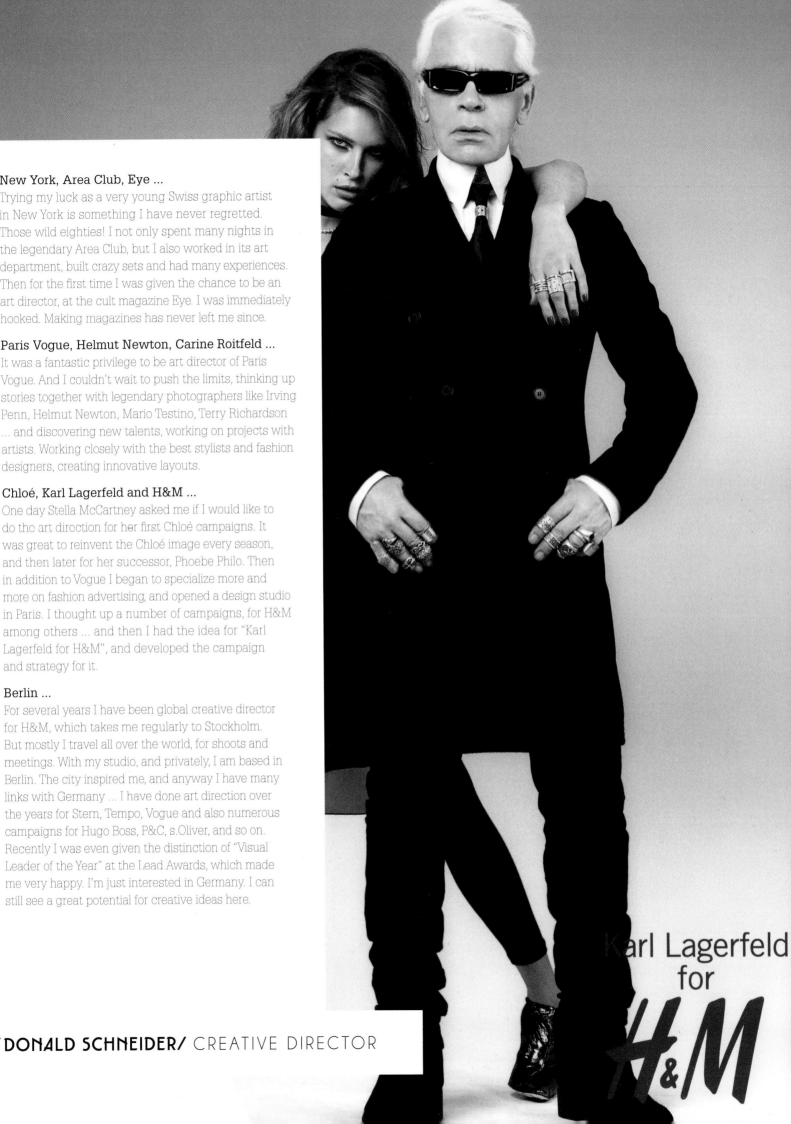

New York, Area Club, Eye ...

Trying my luck as a very young Swiss graphic artist in New York is something I have never regretted. Those wild eighties! I not only spent many nights in the legendary Area Club, but I also worked in its art department, built crazy sets and had many experiences. Then for the first time I was given the chance to be an art director, at the cult magazine Eye. I was immediately hooked. Making magazines has never left me since.

Paris Vogue, Helmut Newton, Carine Roitfeld ...

It was a fantastic privilege to be art director of Paris Vogue. And I couldn't wait to push the limits, thinking up stories together with legendary photographers like Irving Penn, Helmut Newton, Mario Testino, Terry Richardson ... and discovering new talents, working on projects with artists. Working closely with the best stylists and fashion designers, creating innovative layouts.

Chloé, Karl Lagerfeld and H&M ...

One day Stella McCartney asked me if I would like to do the art direction for her first Chloé campaigns. It was great to reinvent the Chloé image every season, and then later for her successor, Phoebe Philo. Then in addition to Vogue I began to specialize more and more on fashion advertising, and opened a design studio in Paris. I thought up a number of campaigns, for H&M among others ... and then I had the idea for "Karl Lagerfeld for H&M", and developed the campaign and strategy for it.

Berlin ...

For several years I have been global creative director for H&M, which takes me regularly to Stockholm. But mostly I travel all over the world, for shoots and meetings. With my studio, and privately, I am based in Berlin. The city inspired me, and anyway I have many links with Germany ... I have done art direction over the years for Stern, Tempo, Vogue and also numerous campaigns for Hugo Boss, P&C, s.Oliver, and so on. Recently I was even given the distinction of "Visual Leader of the Year" at the Lead Awards, which made me very happy. I'm just interested in Germany. I can still see a great potential for creative ideas here.

/DONALD SCHNEIDER/ CREATIVE DIRECTOR

Karl Lagerfeld for

H&M

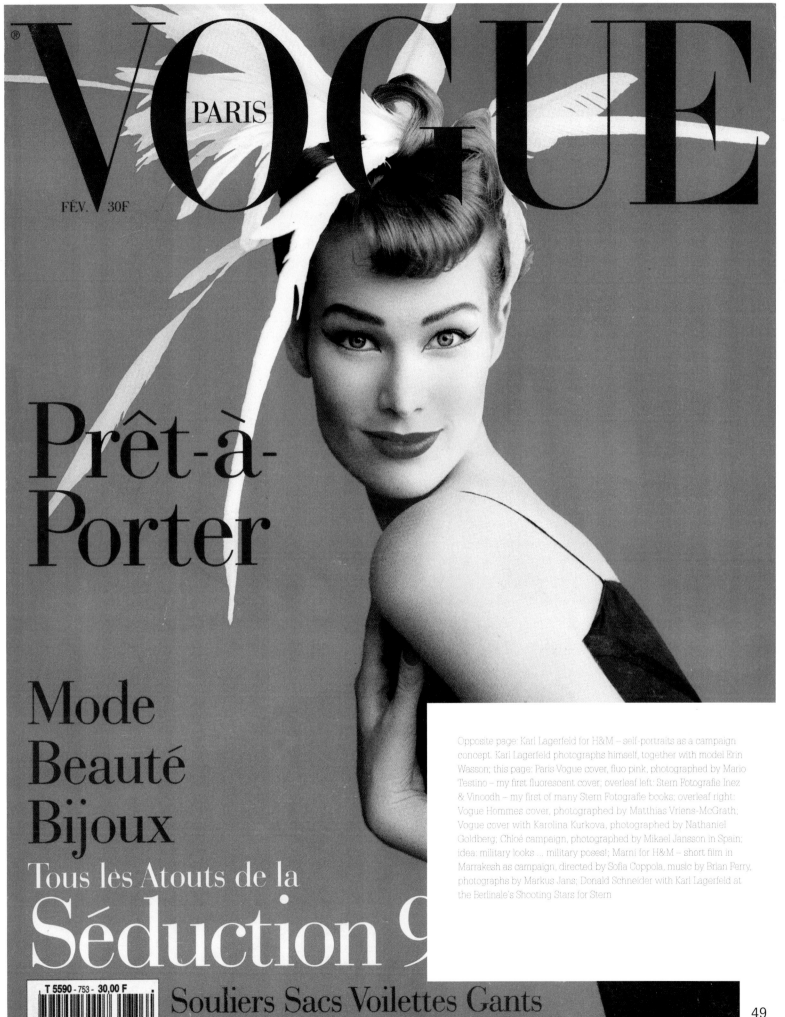

VOGUE
PARIS

FÉV. 30F

Prêt-à-Porter

Mode
Beauté
Bijoux
Tous les Atouts de la
Séduction 9

Souliers Sacs Voilettes Gants

T 5590 - 753 - 30,00 F

Opposite page: Karl Lagerfeld for H&M – self-portraits as a campaign concept. Karl Lagerfeld photographs himself, together with model Erin Wasson; this page: Paris Vogue cover, fluo pink, photographed by Mario Testino – my first fluorescent cover; overleaf left: Stern Fotografie Inez & Vinoodh – my first of many Stern Fotografie books; overleaf right: Vogue Hommes cover, photographed by Matthias Vriens-McGrath; Vogue cover with Karolina Kurkova, photographed by Nathaniel Goldberg; Chloé campaign, photographed by Mikael Jansson in Spain; idea: military looks … military poses!; Marni for H&M – short film in Marrakesh as campaign, directed by Sofia Coppola, music by Brian Ferry, photographs by Markus Jans; Donald Schneider with Karl Lagerfeld at the Berlinale's Shooting Stars for Stern

Inez van Lamsweerde
& Vinoodh Matadin

VOGUE HOMMES INTERNATIONAL

À FLEUR DE PEAU

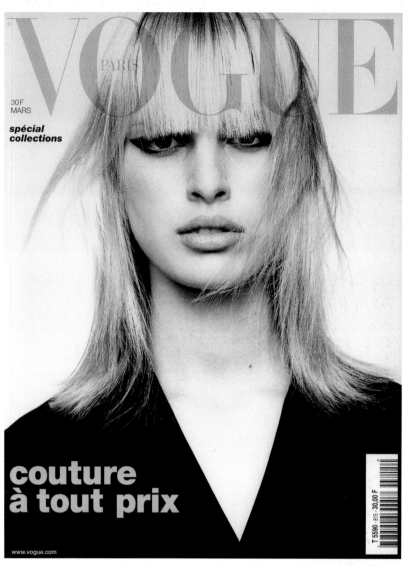

VOGUE PARIS

30F
MARS

spécial collections

couture
à tout prix

www.vogue.com

Chloé

MARNI at H&M

Now I'm sitting here, in New York. In my beautiful studio apartment in Brooklyn. I look out of the window and see the Empire State Building shining on the Manhattan skyline. Surreal? A little, sometimes. A New York moment. A sigh of relief and a smile. New York is fast, loud, self-confident, successful and sexy. Tomorrow a photo shoot for a big magazine. A top international team. A big team, in a very big studio. And more productions and meetings later. Still something surreal? Perhaps not any more, after living in New York for seven years. I love to work with creative people. With artists and designers who have passion. It's a rocky road in the fashion business. Is there a goal? I haven't arrived at it yet. I think that as an artist one should not have the feeling of having arrived. It's a wonderful journey, and I'm stopping off in an inspiring place. To be part of a team. To be able to pass on my knowledge and experience to young people. I have some very motivated assistants. That's the only way to do it, with passion and ambition. And with pleasure. The journey goes on, and every day brings something new.

Before I came to New York, I lived in Paris for five years. That was a valuable time. As a hairstylist I assisted the biggest names in our industry. At the best fashion shows, haute couture. I was hungry, for inspiration and fashion, art and photography. Those were beautiful years in Paris, but the journey had to go on and I don't regret a single day.

And now, when I write all this down, it sounds like a dream. A real dream come true for people with motivation, ambition, faith in their talent. Consistency. I meet a lot of Germans here too. And in Paris, London … There are these people who make their dream reality and are an inspiration for young designers and artists. Germany has a great deal of creative potential. I always enjoy being in Germany. I wish there were more support for young designers and artists. I would like to motivate them to use their talent and pass it on. We need fashion and art, to conjure up a smile on our faces or make us chuckle. They let us feel.

/DEYCKE HEIDORN/ HAIRSTYLIST

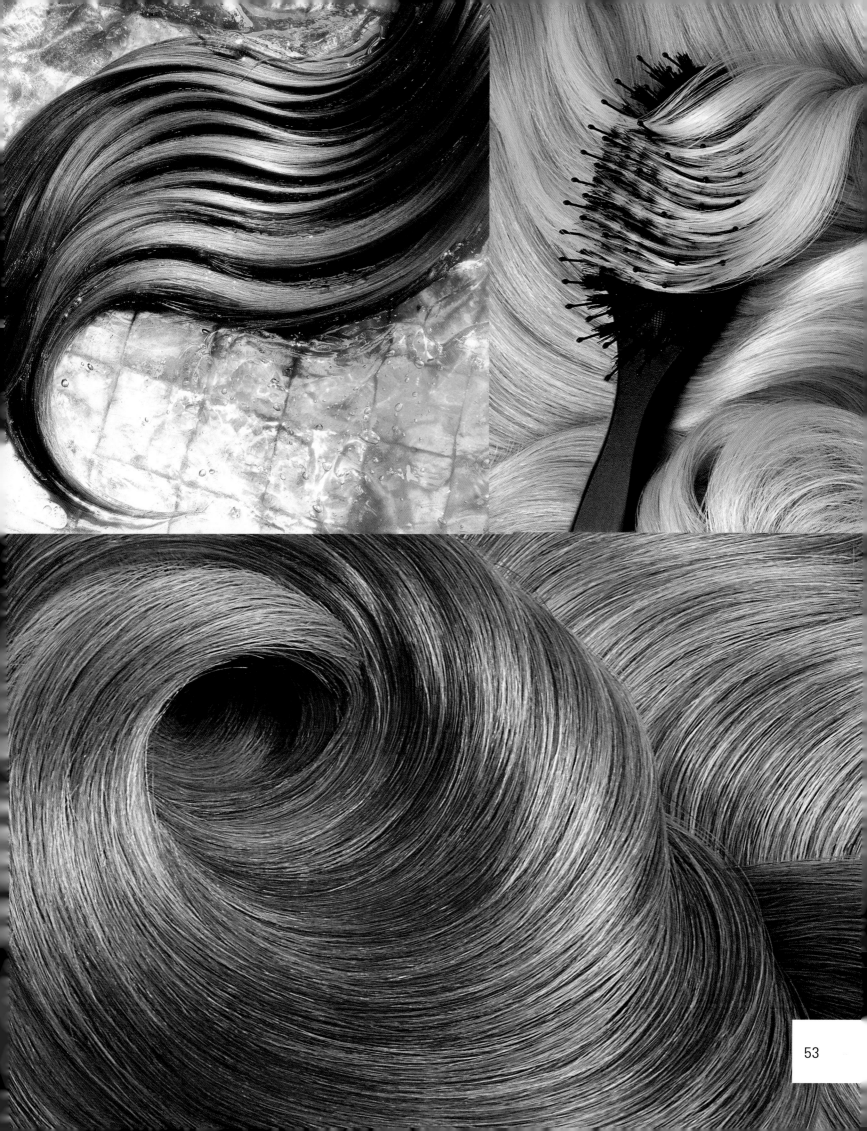

_____/ ANNA BAUER / PHOTOGRAPHER

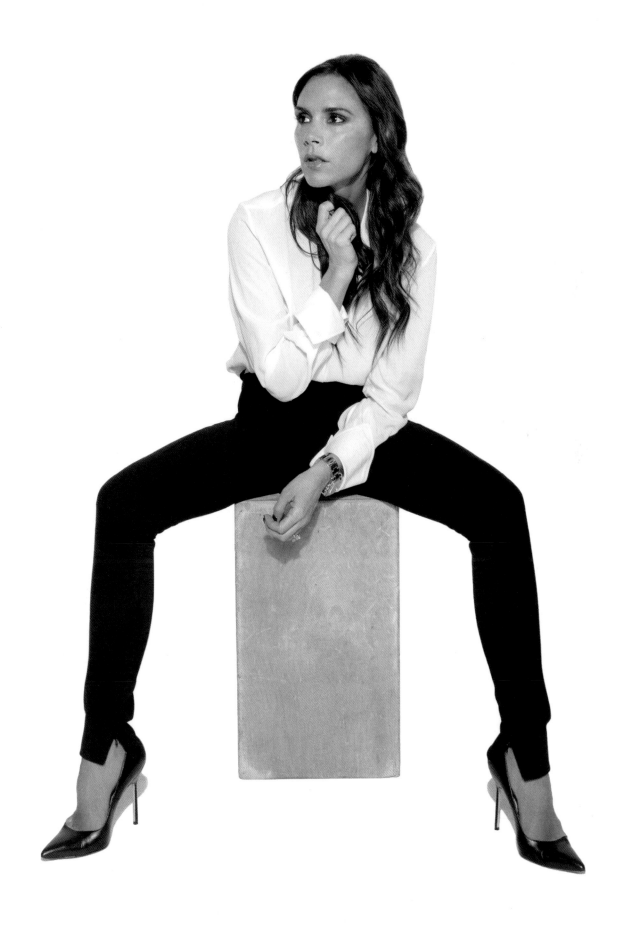

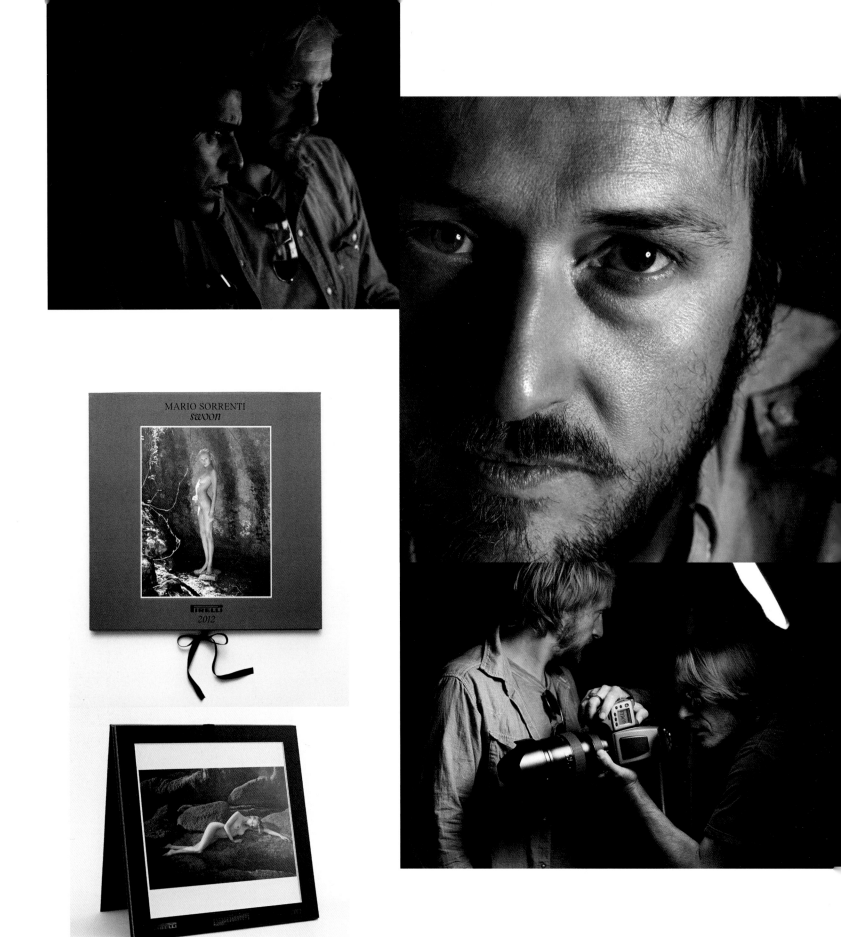

/ALEX WIEDERIN/ CREATIVE DIRECTOR/ BUERO NEW YORK

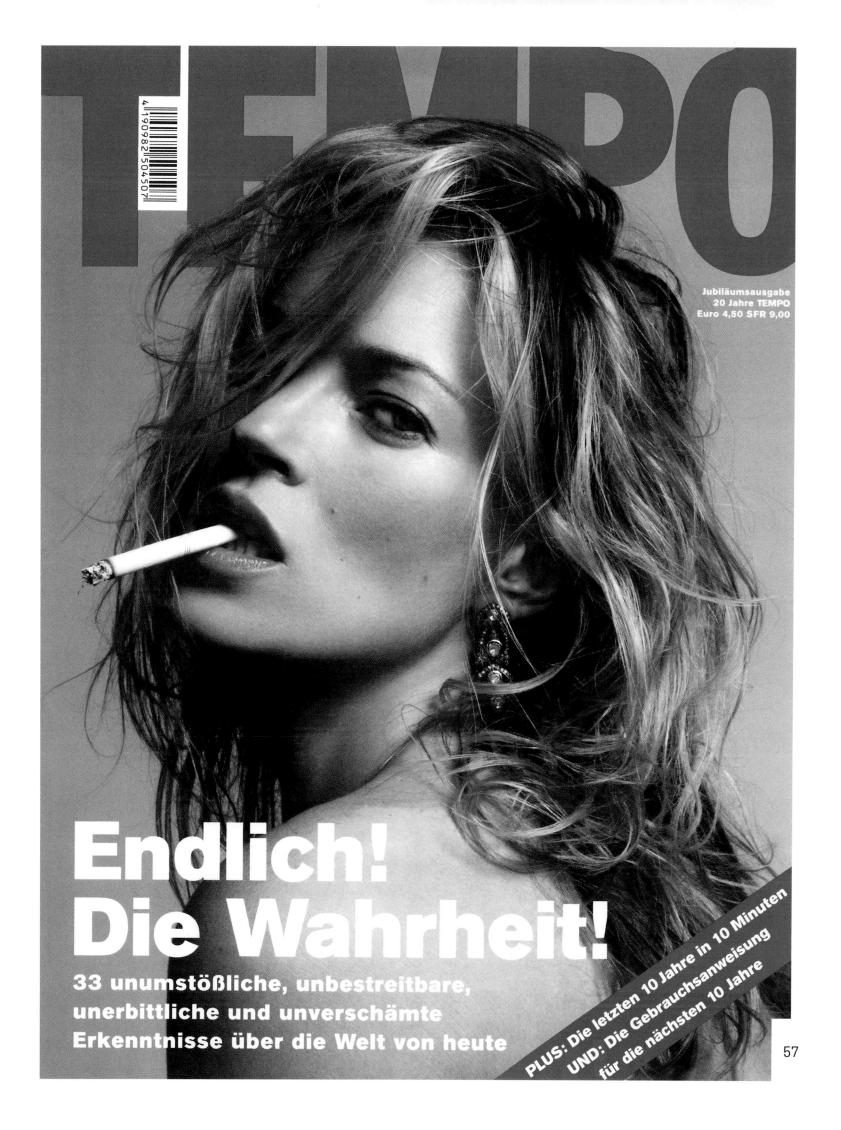

TEMPO

Jubiläumsausgabe
20 Jahre TEMPO
Euro 4,50 SFR 9,00

Endlich!
Die Wahrheit!

33 unumstößliche, unbestreitbare, unerbittliche und unverschämte Erkenntnisse über die Welt von heute

PLUS: Die letzten 10 Jahre in 10 Minuten
UND: Die Gebrauchsanweisung
für die nächsten 10 Jahre

57

Carine Roitfeld
irreverent

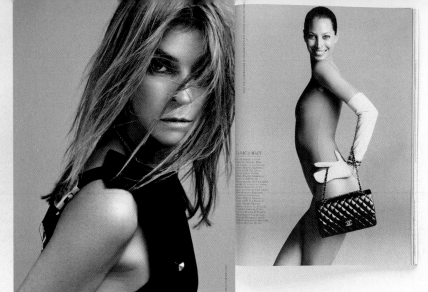

This is *Lara Stone's* tongue. It looks like *sashimi* mixed with venomous jewelry.

IN ANSWER TO LAUREN SANTO DOMINGO

"Some things go *in and out* of fashion; *what do you think is* perennially *sexy?*"

"I think that as seasons come and go, as a woman gradually ages, she needs to adjust her wardrobe, discreetly change certain things, and revise what constitutes her charm and attraction, without letting that work show. Nothing is perennially sexy in a woman, neither in her wardrobe, nor, sadly, in her body. She needs to regularly adjust one or the other—I would say every five years. Lowering the hemline to the knee, for example, and not wearing it above. Swapping tees for proper shirts."

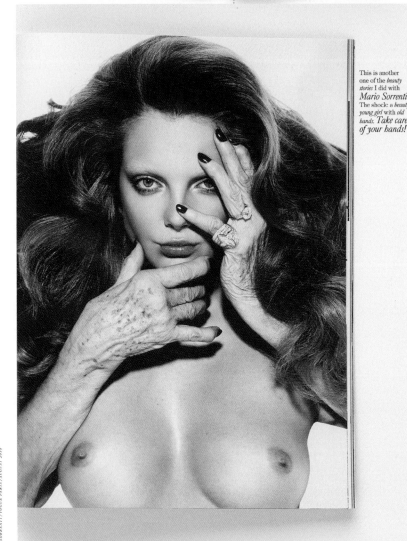

This is another one of the *beauty stories* I did with *Mario Sorrenti*. The shock: a *beautiful young girl* with *old hands. Take care of your hands!*

MARIO SORRENTI / VOGUE PARIS / AUGUST 2010

What comes to mind when you hear the words "German" and "fashion"?

Helmut Newton, Karl Lagerfeld, Peter Lindbergh, Ellen von Unwerth, Jil Sander and Wolfgang Joop – and the feeling that there should and certainly must be many more German designers, but unfortunately there is no real support for young talent in Germany. I don't mean financial support, but rather the openness of people to commit themselves to something new. At least that was the case in my day, and that was why I left Germany, but that is a long time ago now.

In your opinion, what does the German fashion industry stand for?

I don't believe there is a German fashion industry. There are individual firms that have made names for themselves in the clothing industry, such as Hugo Boss for suits and Marc O'Polo for casual wear. One could then say: but what about Jil Sander and other German designers showing their fashion on the catwalk? That's certainly true, but in my opinion this can't be seen as an industry because for that you need a consumer and a consciousness.

How did you get into fashion?

That's a difficult question. I don't even know if I can be classified as being in the fashion industry. I make images with photographers, and these are mostly fashion stories or campaigns. I love photography, and this means that I am of course very often confronted with fashion. And of course I like to think that I have a certain amount of taste and have therefore over the years accumulated some knowledge of tailoring and fashion design and developed it in my work with designers.

Describe your work in three words.

Communication. Design. Photography. Or quite simply: I love form.

What has been your greatest fashion faux pas?

I think the biggest mistake is to take fashion much too seriously; it takes all the space for play and freedom out of it. Fashion should be fun – for those who design it, but also for those who present it, photograph it, buy it and ultimately wear it.

What is your secret for survival in the fashion world?

Having family and friends and always knowing where one comes from.

What has been your most inspiring job so far?

I always find my inspiration in the jobs I do. So it's difficult to say what my most important job has been.

What has been your most challenging job, and why?

Every job is a challenge, and every challenge is very different. A very personal project in recent years has been the book for Carine Roitfeld. That was a big task because she in large part entrusted me to capture her life's work.

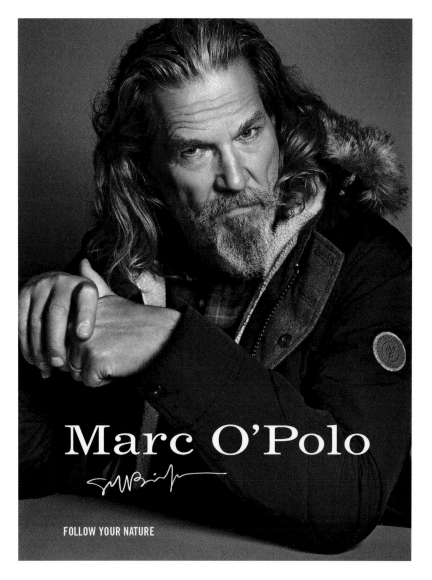

Marc O'Polo

FOLLOW YOUR NATURE

What person has most inspired you in your work or in the fashion industry in general?

No one single person. I am lucky in that I am often able to seek out projects and clients who inspire me. Beyond that, I surround myself with many people, such as my colleagues, the photographers with whom I work, friends and of course my family – they all give me the inspiration I need in my job.

What is currently happening at your think tank?

There's always a lot going on – at the moment we are working on a book for Jeremy Scott. We are also developing two new magazines, some campaigns, but there are also exciting projects in product design: from watches and spectacles to perfume bottles.

The future will bring ...

... hope.

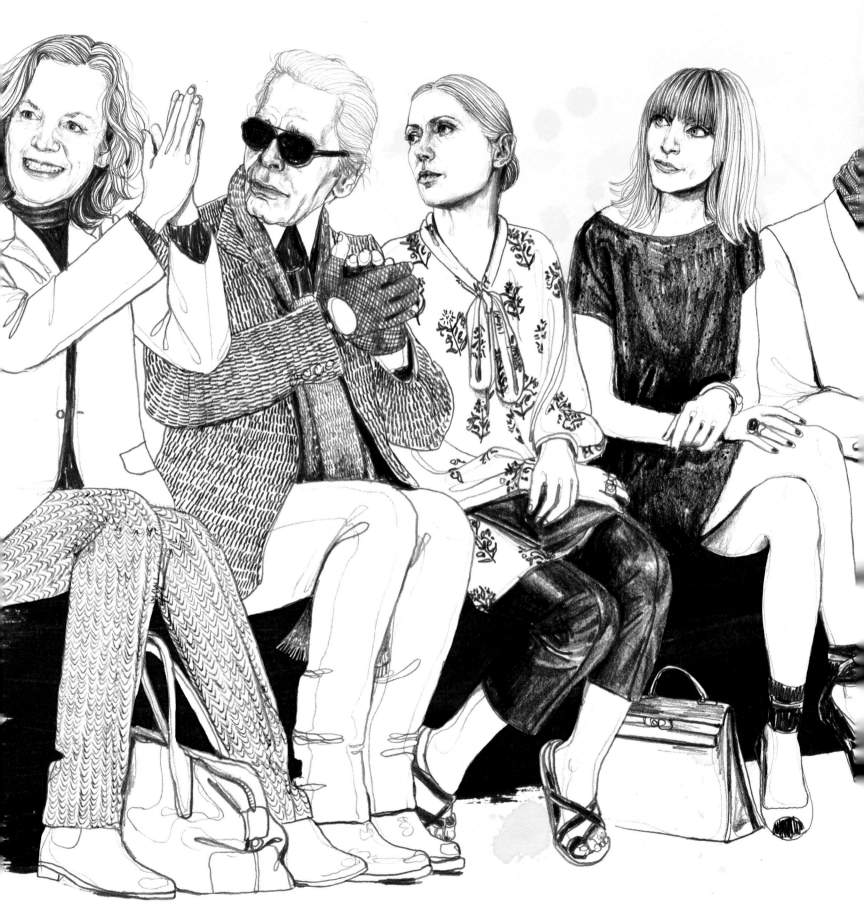

_____/SILKE WERZINGER/ FASHION ILLUSTRATOR

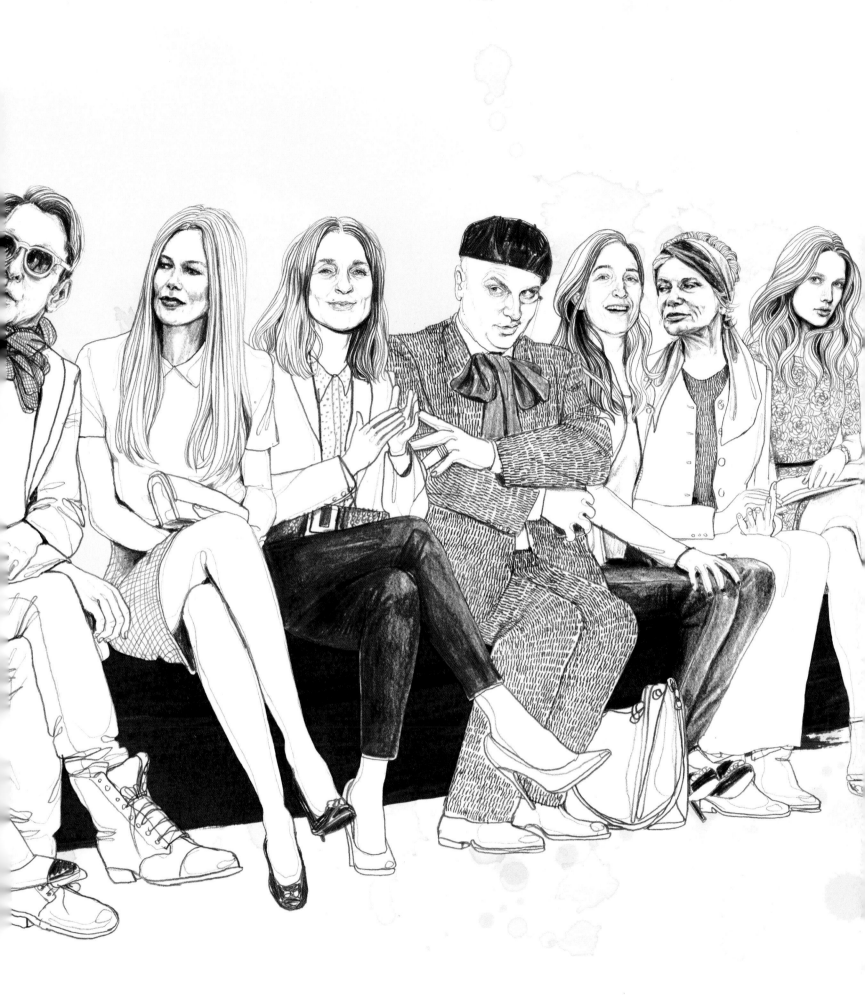

How did you get from MTV to fashion?

I quit at MTV and then for the first time in my life I have done something just for me, because I wanted to. I simply started knitting. Without fear, without doubts, without pretentions.
And then slowly - from this ease. came the success.
I was inexperienced but I had a vision and so I suddenly faced a whole fashion collection.
The recipe for my success: my conciousness!
I went the step from MTV to fashion without questioning myself.
I had faith in my power and will always keep that in mind

Any intention of showing internationally?

For sure!

Why?

Because we reached a point where it makes sense to expand and go beyond the German speaking countries. We want to open new markets because the our home territory has become a solid and successful base from where you can start growing slowly internationally.

What kind of women/men do you design for?

I always have a certain type of woman in mind when I design. She is confident, independent, with a modern uncomplicated and cosmopolitan style and a good sense for cool aesthetics.

Who inspires you?

Of course a town like Berlin and the people you see in daily life inspire me tremendously. However everything, starting with friends to my little daughter and all the things that surround me are affecting and influencing.

What is the secret to Lala Berlin becoming a cult brand?

Lala Berlin is a very contemporary label - we always took account to the "Zeitgeist" and always have been on the pulse of time.

The future will bring …

Don't worry about the future, live now and here - this might sound very superficial and non reflecting but it is deeper and takes a while to understand the meaning - for me it took almost 35 years!

/LEYLA PIEDAYESH/ DESIGNER/ LALA BERLIN

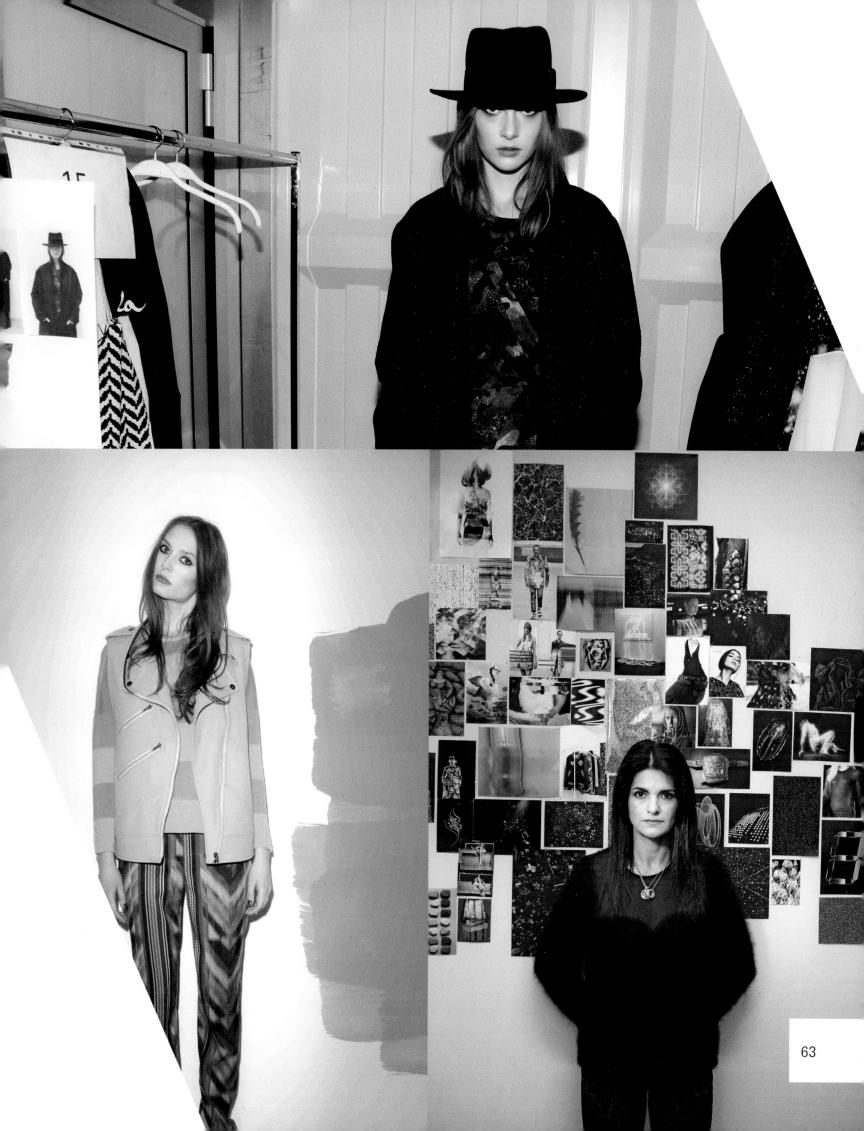

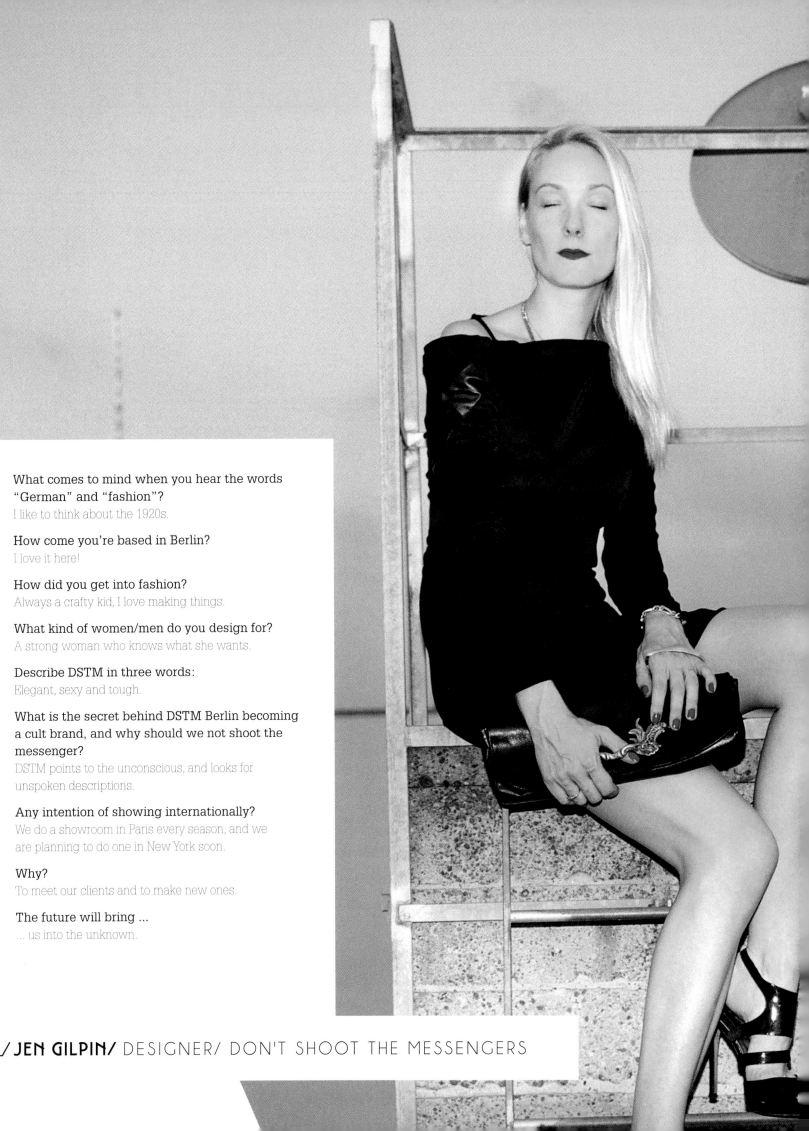

What comes to mind when you hear the words
"German" and "fashion"?
I like to think about the 1920s.

How come you're based in Berlin?
I love it here!

How did you get into fashion?
Always a crafty kid, I love making things.

What kind of women/men do you design for?
A strong woman who knows what she wants.

Describe DSTM in three words:
Elegant, sexy and tough.

What is the secret behind DSTM Berlin becoming
a cult brand, and why should we not shoot the
messenger?
DSTM points to the unconscious, and looks for
unspoken descriptions.

Any intention of showing internationally?
We do a showroom in Paris every season, and we
are planning to do one in New York soon.

Why?
To meet our clients and to make new ones.

The future will bring ...
... us into the unknown.

/ JEN GILPIN/ DESIGNER/ DON'T SHOOT THE MESSENGERS

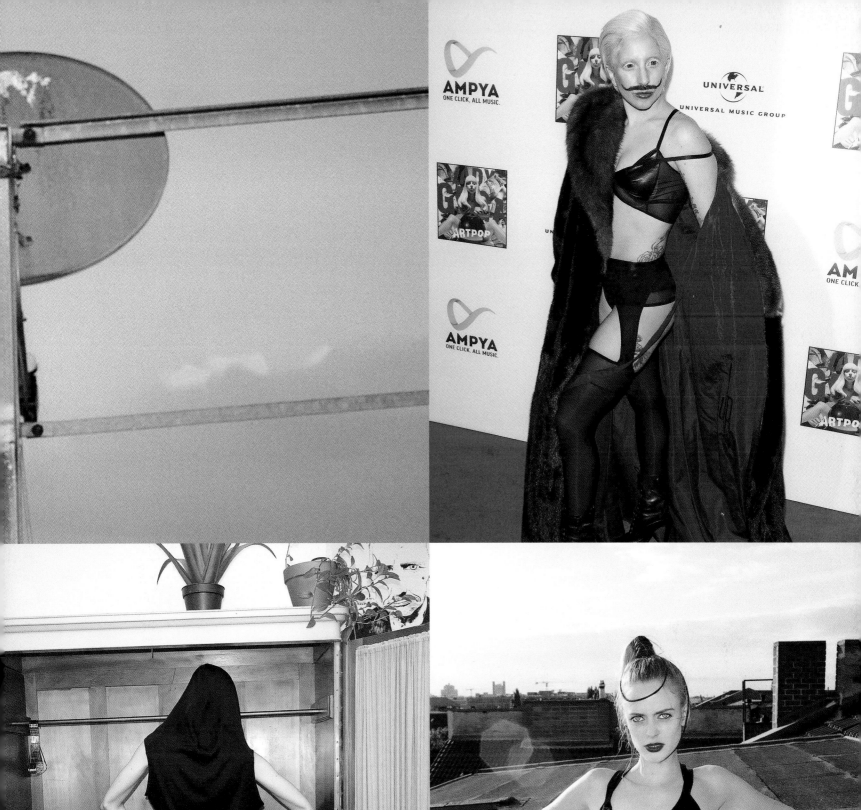

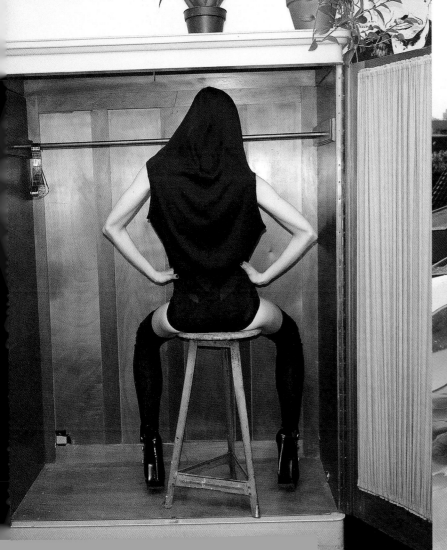

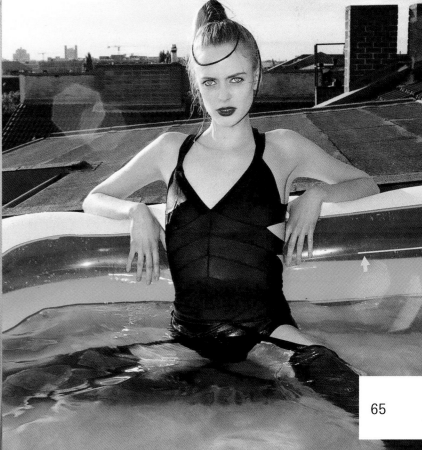

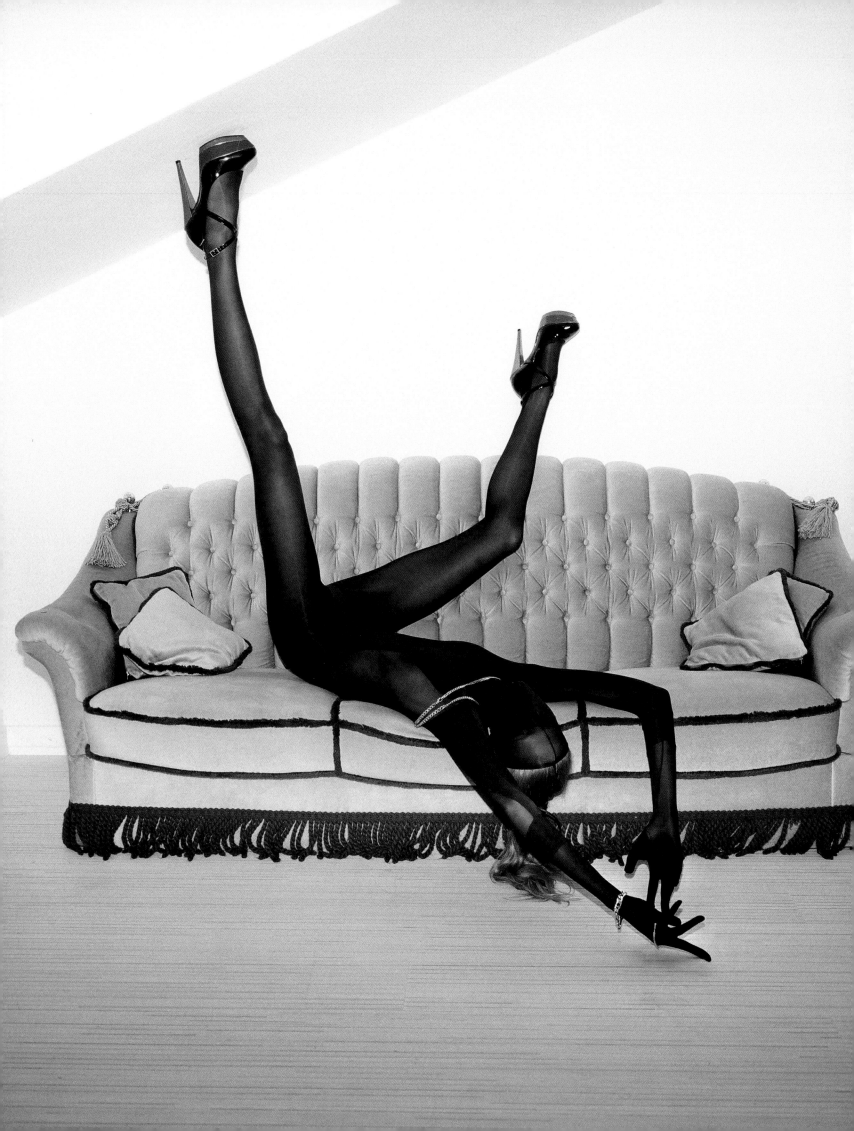

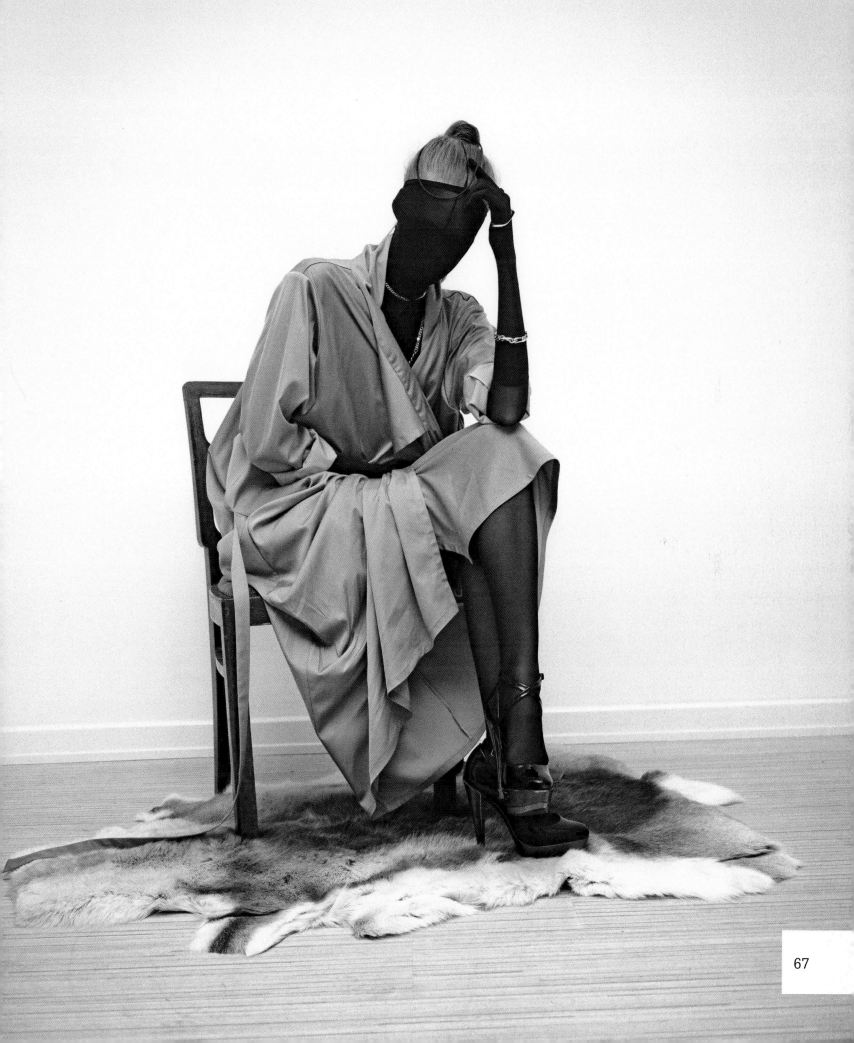

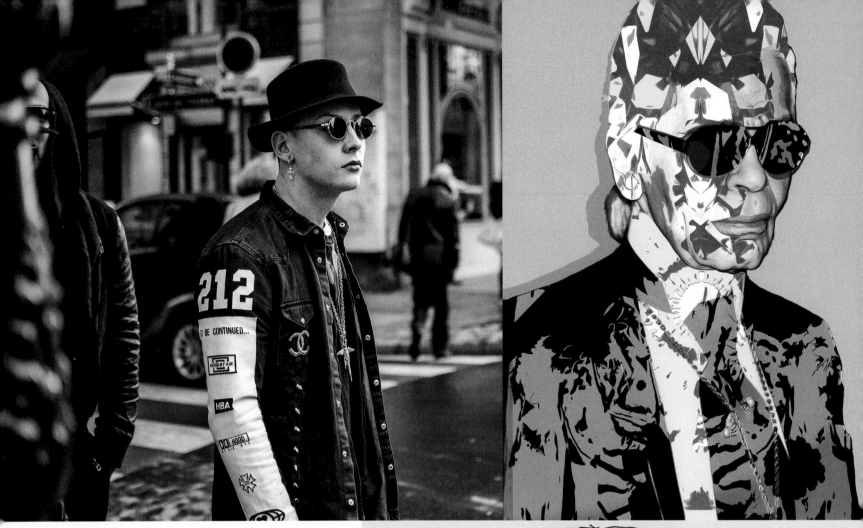

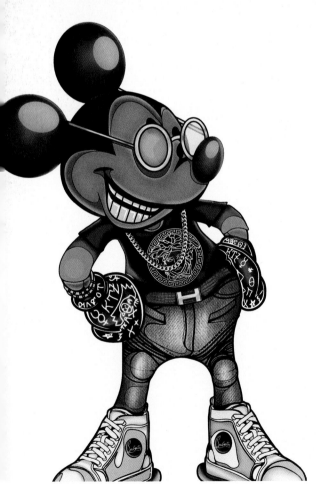

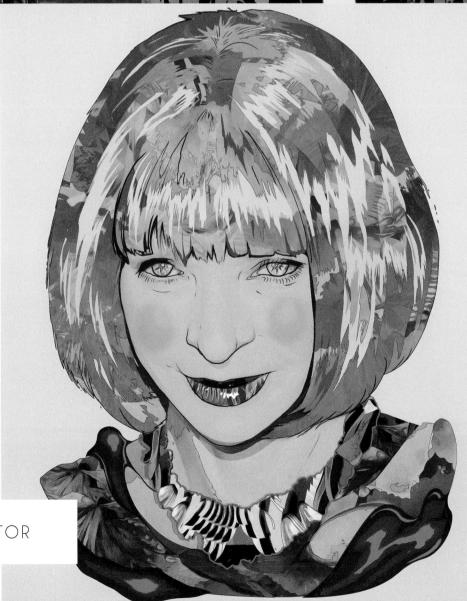

/ MAGOMED DOVJENKO/ ILLUSTRATOR

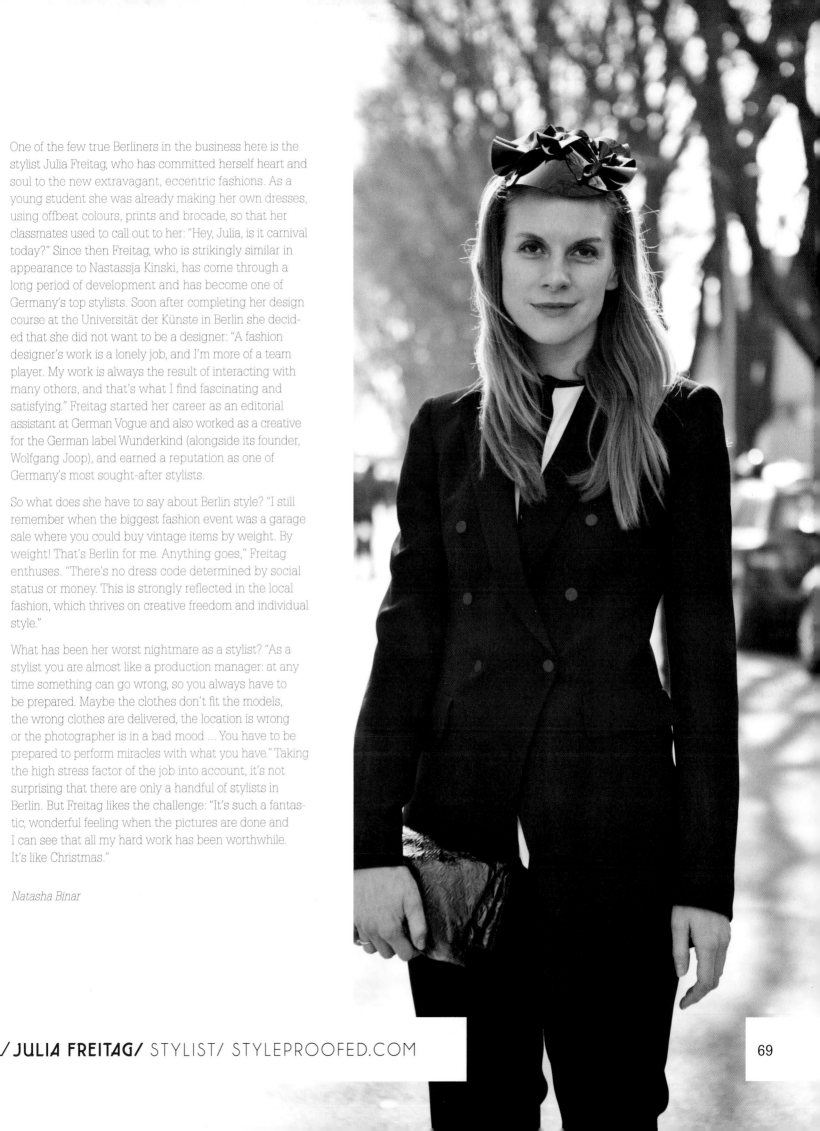

One of the few true Berliners in the business here is the stylist Julia Freitag, who has committed herself heart and soul to the new extravagant, eccentric fashions. As a young student she was already making her own dresses, using offbeat colours, prints and brocade, so that her classmates used to call out to her: "Hey, Julia, is it carnival today?" Since then Freitag, who is strikingly similar in appearance to Nastassja Kinski, has come through a long period of development and has become one of Germany's top stylists. Soon after completing her design course at the Universität der Künste in Berlin she decided that she did not want to be a designer: "A fashion designer's work is a lonely job, and I'm more of a team player. My work is always the result of interacting with many others, and that's what I find fascinating and satisfying." Freitag started her career as an editorial assistant at German Vogue and also worked as a creative for the German label Wunderkind (alongside its founder, Wolfgang Joop), and earned a reputation as one of Germany's most sought-after stylists.

So what does she have to say about Berlin style? "I still remember when the biggest fashion event was a garage sale where you could buy vintage items by weight. By weight! That's Berlin for me. Anything goes," Freitag enthuses. "There's no dress code determined by social status or money. This is strongly reflected in the local fashion, which thrives on creative freedom and individual style."

What has been her worst nightmare as a stylist? "As a stylist you are almost like a production manager: at any time something can go wrong, so you always have to be prepared. Maybe the clothes don't fit the models, the wrong clothes are delivered, the location is wrong or the photographer is in a bad mood ... You have to be prepared to perform miracles with what you have." Taking the high stress factor of the job into account, it's not surprising that there are only a handful of stylists in Berlin. But Freitag likes the challenge: "It's such a fantastic, wonderful feeling when the pictures are done and I can see that all my hard work has been worthwhile. It's like Christmas."

Natasha Binar

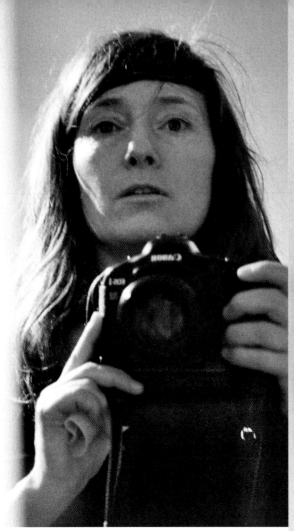

Above: Self-portrait of Schohaja;
right: Lara Stone

/SCHOHAJA/ PHOTOGRAPHER

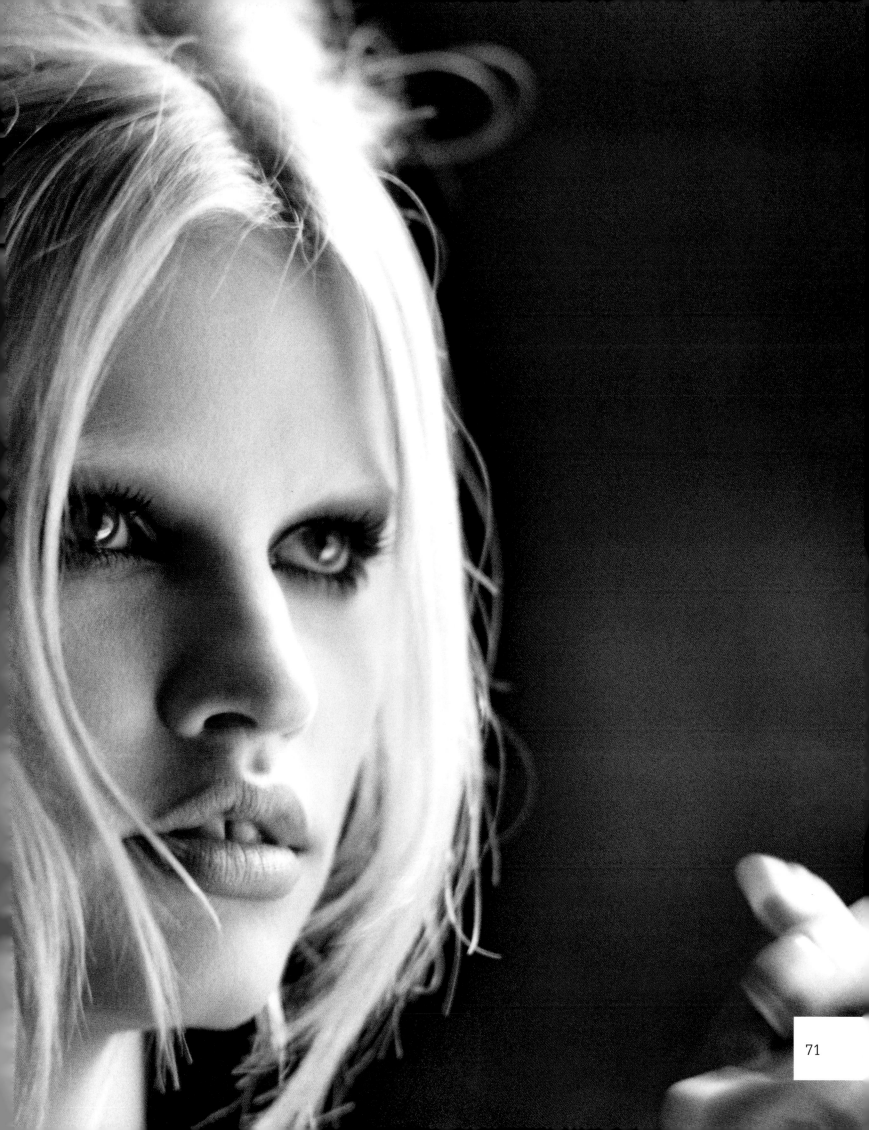

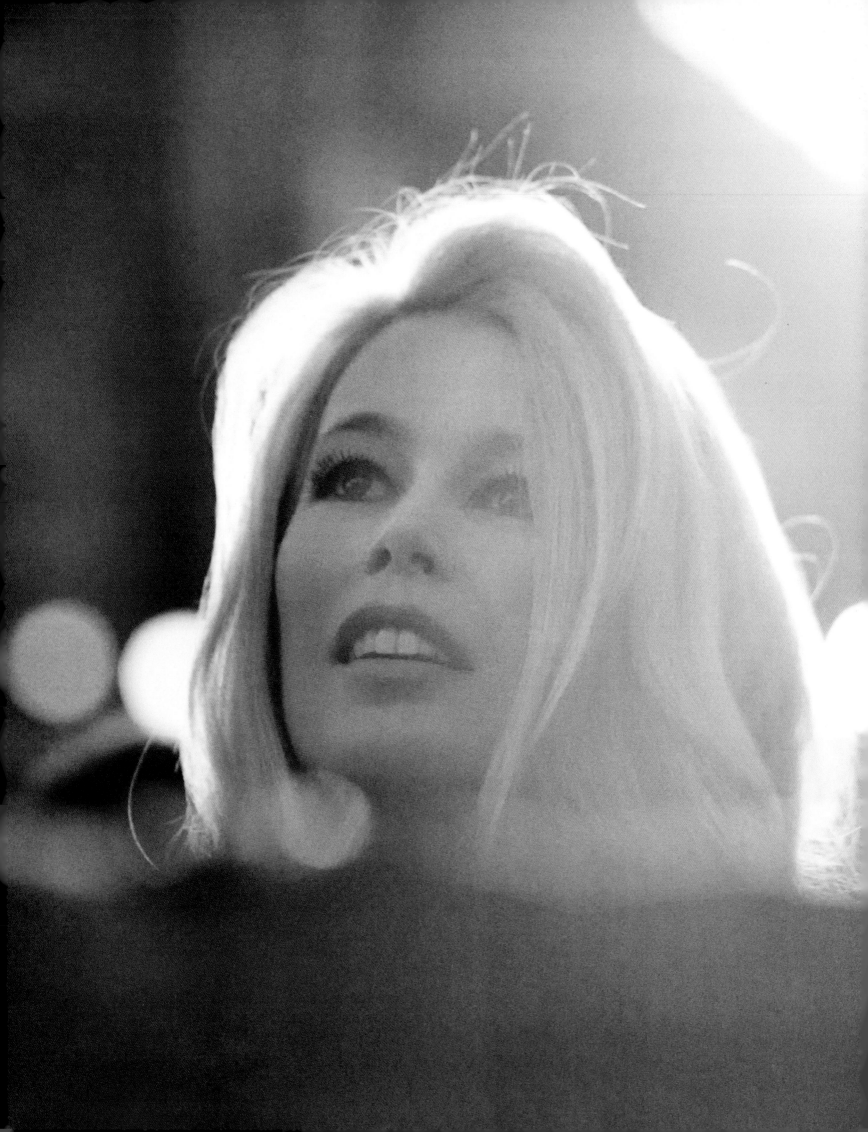

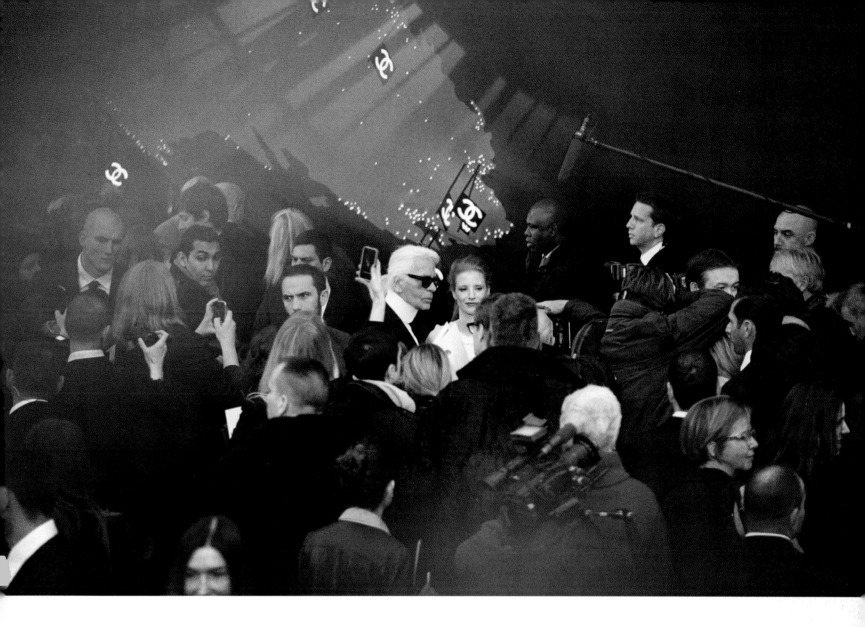

Left: Claudia Schiffer for V Magazine, above: Karl Lagerfeld
and Jessica Chastain for New York Times T Magazine

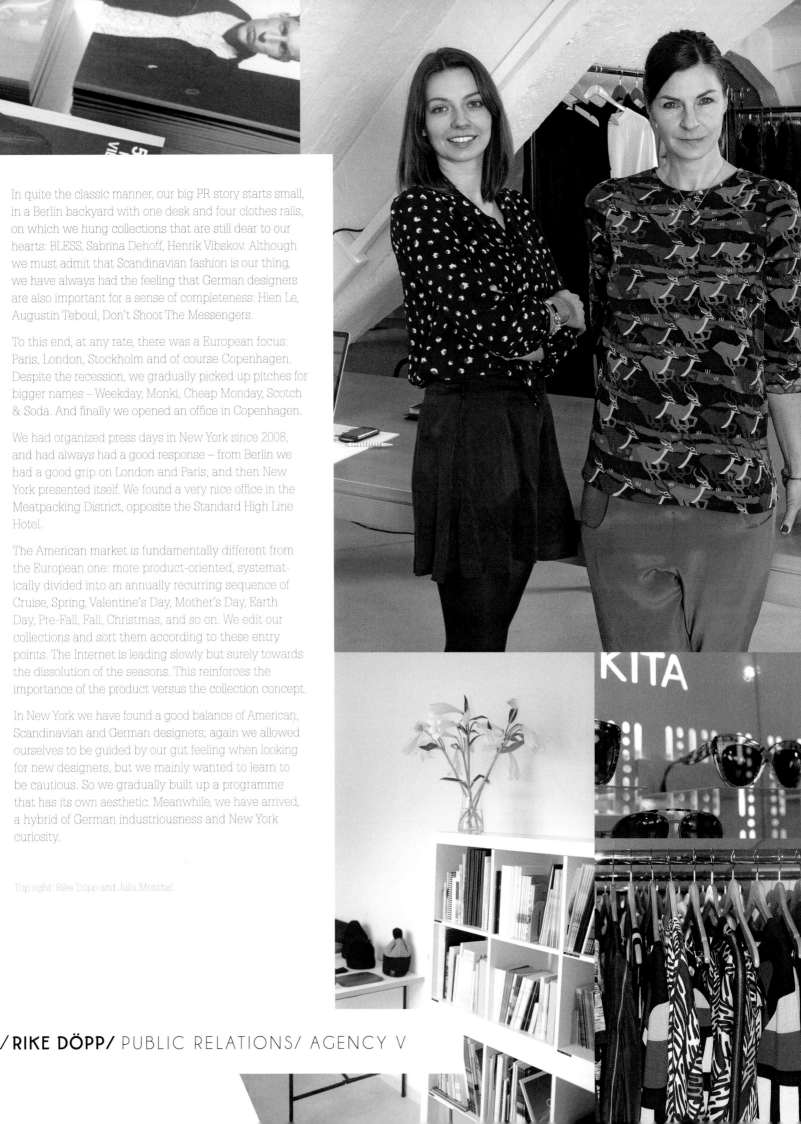

In quite the classic manner, our big PR story starts small, in a Berlin backyard with one desk and four clothes rails, on which we hung collections that are still dear to our hearts: BLESS, Sabrina Dehoff, Henrik Vibskov. Although we must admit that Scandinavian fashion is our thing, we have always had the feeling that German designers are also important for a sense of completeness: Hien Le, Augustin Teboul, Don't Shoot The Messengers.

To this end, at any rate, there was a European focus: Paris, London, Stockholm and of course Copenhagen. Despite the recession, we gradually picked up pitches for bigger names – Weekday, Monki, Cheap Monday, Scotch & Soda. And finally we opened an office in Copenhagen.

We had organized press days in New York since 2008, and had always had a good response – from Berlin we had a good grip on London and Paris, and then New York presented itself. We found a very nice office in the Meatpacking District, opposite the Standard High Line Hotel.

The American market is fundamentally different from the European one: more product-oriented, systematically divided into an annually recurring sequence of Cruise, Spring, Valentine's Day, Mother's Day, Earth Day, Pre-Fall, Fall, Christmas, and so on. We edit our collections and sort them according to these entry points. The Internet is leading slowly but surely towards the dissolution of the seasons. This reinforces the importance of the product versus the collection concept.

In New York we have found a good balance of American, Scandinavian and German designers; again we allowed ourselves to be guided by our gut feeling when looking for new designers, but we mainly wanted to learn to be cautious. So we gradually built up a programme that has its own aesthetic. Meanwhile, we have arrived, a hybrid of German industriousness and New York curiosity.

Top right: Rike Döpp and Julia Menthel

/RIKE DÖPP/ PUBLIC RELATIONS/ AGENCY V

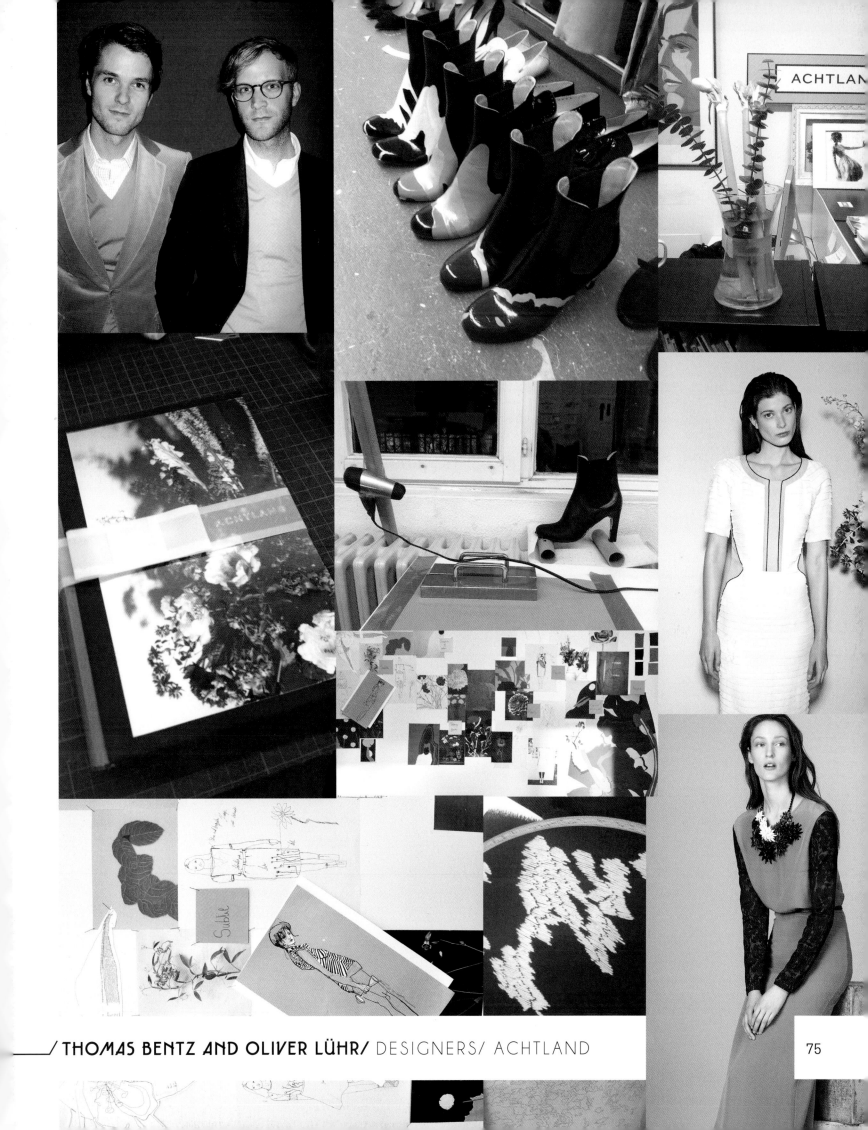

For the second time, ZEITmagazin has staged the conference "Fashion and Style" during Berlin Fashion Week.

We wanted to create a platform for all those concerned with fashion and style, for the makers in front of and behind the scenes. In a relaxed atmosphere, and above all as a prelude to Fashion Week, when everyone is still well rested, ZEIT-magazin offers a central place in which to exchange experiences and new ideas.

How did the conference come about?

The idea came to our style director, Tillmann Prüfer, and me at one of our Fashion Week parties. This is where we present our current Fashion Week issue and celebrate those who contributed to the issue. The guests are as diverse as our magazine: one finds fashion designers and the art scene, film directors and actors, musicians, renowned chefs and media professionals. At one of our parties a well-known designer told us that he always looked forward to these occasions, because he met not only people in his own field, but also exciting characters from other worlds, who gave him new ideas. And then we thought: "Let's continue the conversations during the day, when the music isn't so loud" [laughs].

Substance is another very important issue. In Germany, fashion – and this is reflected in the media – is not taken as seriously as in, for example, Italy, where fashion stories are found in a newspaper's business section. In Germany, on the other hand, fashion is found in the arts pages or the human interest section.

Much has changed in Germany. We experience this with our own readers.

In what way?

There is a new generation in Germany, which did not exist in the same numbers ten or twenty years ago, of readers who are as interested in a new exhibition in the Palais de Tokio in Paris as in the new Céline collection, who know as much about politics as about style and fashion, design and food and drink. At ZEITmagazin we are part of this development.

But isn't fashion still portrayed as exotic buffoonery in many media?

Of course this is still the case: two bizarre photos from the Paris shows are published under "Miscellaneous" with the motto: "just look at these crazy birds in the fashion world". But today this is only evidence of ignorance. Many serious media have already reacted to this

fact, for example the television channel Arte with its outstanding documentaries. Fashion blogs and websites such as Style.com, which are available to everyone, have also of course contributed to the general rise of knowledge about fashion.

I'll give you an example. A somewhat older friend told me recently that for a long time he did not take his daughter's passion for fashion seriously. The daughter, now twenty years old, studies and runs a fashion blog on the side. One day the two of them were eating out at a quite expensive restaurant, and suddenly his daughter began to analyze the other diners by their clothing. Table by table, look by look, she explained to her father the conscious or unconscious messages that the men and women were sending out. He was quite stunned. And he told me that it was not until that moment that it really became clear to him: if you speak the language of fashion, you understand the world a little bit better.

Now we have a new generation of fashion designers in Germany. What do you think of their chances of success here?

Fashion Week in Berlin has managed to ensure that twice a year in Germany the attention of a wider public is directed at the topic of fashion. This is a great achievement that no one should underestimate. In this respect, Berlin Fashion Week fulfils an important task on, if you will, the domestic front.

Fashion for you personally is …

… a means of expression and an attitude towards life. This is certainly thanks to the influence of my mother, who often took my brother and me shopping with her. My father afterwards always complained that she had again spent too much money on clothes. I remember when I was ten or eleven that I absolutely had to have Kangaroos trainers. Kangaroos were expensive, there were three models, and when I was in the shop with my mother, I pointed to the cheapest ones. What did my mother do? She instinctively picked up the most expensive model and said: "But these are much more beautiful." We made a secret pact and didn't tell my father what they really cost. I hope he can forgive me now [laughs].

What was your biggest fashion faux pas?

There have been quite a few. Thank goodness you haven't any photographic evidence and I won't give you any, but during the rave period, early to mid-nineties, there were many – what one might call – dark moments, if they hadn't been so violently colourful. My move to Munich in 1996 helped me a lot: the suits and

/CHRISTOPH AMEND/ EXECUTIVE EDITOR OF ZEITMAGAZIN

shirts from Helmut Lang's shop, which were so expensive that as young editors on jetzt-Magazin we could only afford to buy them in the sales, were considerably more subdued in terms of colour.

What is there that bothers you about your work?

Actually, like many boys, I wanted to become a professional footballer, and I was quite good, but at fifteen I had a bad injury, and that put an end to my dream. Then in 1990 I went to school in England, and a schoolmate who was doing a magazine for young people asked me if I would write an article about why one should not be afraid of a reunited Germany. I struggled terribly with this, but I still enjoyed thinking about it, getting my thoughts in order, explaining how things connected. From then on I always wanted to be a journalist. And today, to be able to edit ZEITmagazin, on the one hand with its high circulation and a readership of 1.5 million and its huge influence, and on the other hand with great creative freedom – nothing really bothers me about that.

What are you particularly proud of? What has been a personal highlight in your work?

In the magazines from London that I read so enthusiastically as a teenager, there were photos by a certain "Juergen Teller" that were different from the other images. Of course I'm pleased that today, almost two decades later, I have a such a trusting working relationship with him, whether as a photojournalist or a photographer for whole issues. I will never forget the time when Juergen wanted to photograph a special issue on women's fashion and was looking for a suitable model. He had already thrown out his concept several times when he rang our picture editor, Andreas Wellnitz, and said he had found the perfect model: a man! I have rarely seen Andreas Wellnitz looking nervous, but when he told me about it, he had gone rather pale. But we trusted Juergen, and he photographed a fantastic issue. By the way, the model was Andrej Pejić, and it was the first time he had been on a cover. The story went around the world, the cover was shown on an endless number of international websites and blogs, and it was debated on social and aesthetic levels. That's what pleases me: producing a story that hits a nerve.

What for you makes a good magazine?

A good magazine triggers something in you, motivates you and excites you, it entertains you, inspires you and unsettles you – and sometimes all these things in one issue.

Interviewed by Natasha Binar

Mirko Borsche began as a graffiti artist – and is the new art director of the lifestyle magazine Harper's Bazaar in Germany. Natasha Binar spoke to Mirko about his visions and challenges in this job.

"Fashion is totally out" – many people say …

What keeps on surprising me is this plus-minus paradigm. Either everything is totally fantastic or it's very bad. Out of this fear of wearing the wrong thing, a lot of people go for big labels, to be on the safe side. You hardly ever see a real fashion statement.

I was influenced by the eighties and nineties. Fashion was extremely important for your own identity: the punks, the psychobillies, the mods, new wavers, goths … Today it's different; we don't define ourselves just by fashion any more. An average citizen can spice up his/her wardrobe every two years, which is enough.

That's a good cue: German Harper's Bazaar. You are its new and first creative director. What influenced this decision?

I wouldn't have gone near any fashion magazine apart from Vogue or Harper's Bazaar – because I've always been interested in the exciting theme of luxury. I find a legendary brand like that very exciting, and I love to "dust things off". Harper's Bazaar is a solid, well-made magazine. The challenge to be able to play around on that level spurred me on.

Do you think there are enough readers in Germany who know how to value this standard?

I believe that firmly, yes. I also believe that there is still no single magazine that really does the job for people interested in fashion. There are thousands of magazines that are all well produced, but you don't learn much about fashion or the designers – it remains on the surface.

Margit Mayer is the editor-in-chief of German Harper's Bazaar. She is a very profound person with a strong character – and that in turn is reflected in the new magazine. There are good designers and a good public, but no vehicle for them. Harper's Bazaar could be that. All things considered, it's very exciting to be allowed to introduce a well-known brand here. The last magazine I launched was Neon – which is still a success. I'm really interested in producing a discerning, great blockbuster.

Do you think that a business focused on advertising clients represents a dead end in the creative sense? Because in the final analysis almost all magazines look alike and are conformist – and no one dares to say anything that doesn't fit into a pigeon-hole.

You simply have to make a new selection of what goes into the magazine. Sure, it's a business based on advertising clients. But how you position them, what sort of statements you communicate, makes an important difference.

You also have to be stylistically confident – that's what I hope for from my new editorial department. I prefer a clear, stylistically confident message to a loving mixture of everything.

What, in your opinion, is a good magazine?

One that touches me in some way. The most important thing is to have a story in the magazine that stays with you. A story that moves me and others. The more often stories like that turn up in a magazine, the more successful it is for me.

And for you, a well designed magazine is …

… appropriate for its target group. Most magazines look the same. There are many more "me too" products than independent magazines. Today we have Brand Eins and that has maintained its position on the market for fifteen years. A very cleverly worked-out concept with good visuals. There are not many magazines that you are proud to be seen with.

What does the future of media hold in store for us?

Not to be afraid of being bold. The only fear that publishers should have is that their magazines won't be read any more, because they are no longer exciting or interesting. If you want information fast, you go on the Internet. If you want well-crafted stories, you reach for good magazines. Quality will always prevail.

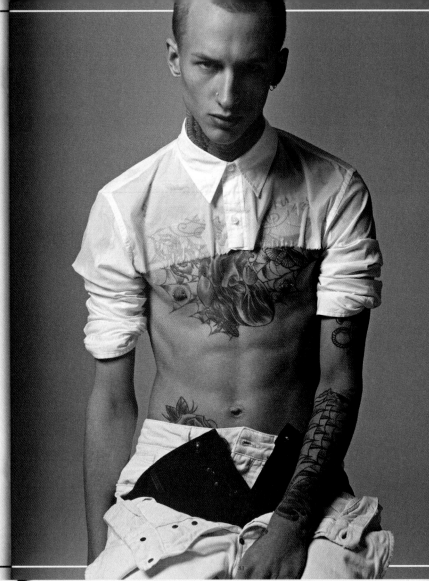

Harper's

BAZAAR

ROITFELD
& LAGERFELD
INSZENIEREN
HERBST-TRENDS
AN 25 STARS

WHY
DON'T
YOU
?

PUNKT-NYLONS
DER REICHE MANTEL
EGO-SCHMUCK
NOBLE LÄSSIGKEIT
WINTERLEDER

DIE NEUE N°1
WILDER
LUXUS

BEAUTY-DOPING
SIND STAMMZELLEN
UND EIGENBLUT
DIE ZUKUNFT DES
LIFTINGS?

GERMAN EDITION
€ 5.00 SEPTEMBER 2013
ÖSTERREICH: € 5.50
SCHWEIZ: SFR 9.00

HARPERSBAZAAR.DE

The German-Persian Boris Bidjan Saberi is represented in the trendiest multi-brand boutiques worldwide. Saberi is known for his mostly black, avant-garde menswear, which delights a diverse clientele with its craftsmanship and quality.

Damir Doma after his fashion show in Paris. From Traunstein, with Croatian roots, he has been showing his fashion in Paris for many years and is considered one of the most promising German avant-garde designers.

___/ **BORIS BIDJAN SABERI/** DESIGNER **DAMIR DOMA/** DESIGNER

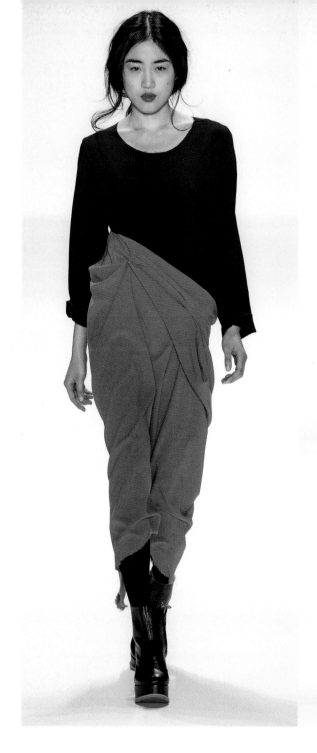
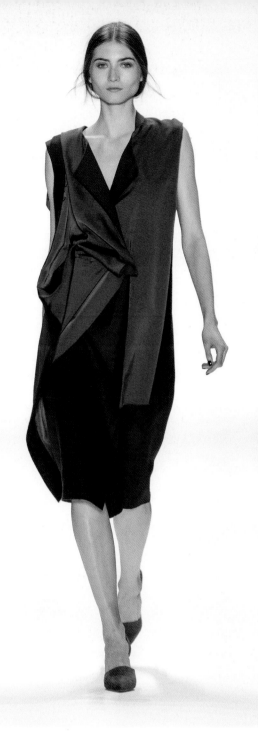
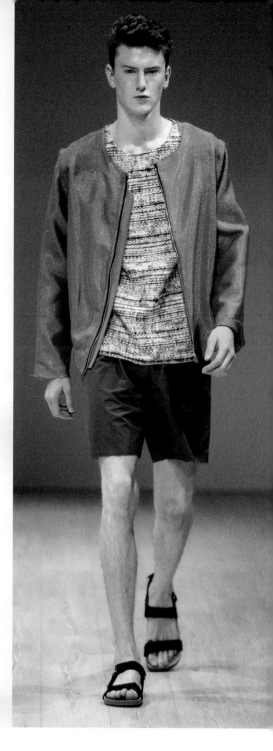

Michael Sontag is one of Germany's most well-known young designers. Since studying at the Weissensee Kunsthochschule in Berlin he has won a number of prizes, including the Textile Innovation Prize in 2009 and Start Your Fashion Business in 2010. Since 2009 Sontag has been showing his designs at the Mercedes-Benz Fashion Week in Berlin and delighting the fashion world with his artfully draped collections.

Vladimir Karaleev moved to Berlin after leaving school to study fashion at the Hochschule für Technik und Wirtschaft (HTW). In 2010 he founded his own label, and since 2011 he has been showing his collections at the Mercedes-Benz Fashion Week in Berlin. Karaleev's collections are sold not only in Germany, but also world-wide, in countries such as Italy, Japan, China, Lebanon and the US.

/MICHAEL SONTAG/ DESIGNER VLADIMIR KARALEEV/ DESIGNER 83

What comes to your mind when you hear the words "Germans" and "fashion"?

I believe that German fashion is highly underestimated and there is a lot of work to do to get rid of the dusty image of "Germans wearing white socks with sandals". I especially feel that German men have developed into one of the frontrunners in style, well put together, masculine, and a flexibility of looks you can experience walking through the streets of Berlin, Munich and Hamburg.

Apart from major successful German fashion labels like Hugo Boss, luxury labels like Escada, global sports brands like Adidas, and wonderfully crafted brands like Wunderkind, German fashion has a long way to go before it creates a look that can be described as German fashion. Back-in-time creators like Jil Sander and Wolfgang Joop were able to build brands that were exquisite and creative and ready for a global stage.

Today's media in German are likely to hype and write about fashion tsars and ask their opinion about bedding or the design of cooking utensils. It is not about their talent as designers.

How did you get into fashion?

I actually wanted to study biochemistry and ended up in fashion by chance.

Who is your target audience for Schön! Magazine?

The Schön! readers are the originals in the creative community, inventors in their choice of personal attire, taking pride of place in their artistic surroundings. The visionary, collector, professional and socialite: altogether they look to Schön! for creative inspiration. Our readers are intelligent, technically literate, well-groomed individuals who are members of the global community and enjoy a luxurious lifestyle.

Describe Schön! Magazine.

Schön! is an innovative, quarterly lifestyle publication. We cross boundaries to be the forerunner in delivering the latest in creative talent from all across the globe. Everything is stunning, beautiful and masterful, strikingly Schön! At Schön! we do more than simply inform – we reform. Established in 2009, Schön! started as an online magazine to showcase international creative talent. It rapidly grew into a luxurious printed publication with an annual global circulation of more than 92,000. Schön! is now distributed internationally in thirteen countries, with the main focus on the UK, US and Europe, while the online magazine is visited by a quarter of a million unique users from all over the world. We pride ourselves on the originality of our content, which features not only fashion, but also art, illustration, conceptual photography, top celebrities, iconic photographers and the legendary faces who make our creative world so exceptional. We have created something outstanding, something one of a kind: a timeless compilation of beautiful things ... Something Schön!

Do you work with other Germans in the fashion industry, and if yes, with whom?

Of course I work with Germans in the industry. Ellen von Unwerth, Wolfgang Joop and other brands like Hugo Boss are big supporters of my magazine. But you will also find many highly skilled Germans all around the globe involved in the creative production of editorials – and since we produce internationally, we don't usually ask where they are from.

Who inspires you?

I would say people and things in general, little situations, movies and my surroundings. I cannot pinpoint a single individual I am a fan of. I am inspired by art and architecture, by good ideas and ad campaigns.

The future will bring ...

Health, motivation, and lots of cash to produce incredible artworks to make people's lives more beautiful!

Top row, left to right: Rick Genest, photographed by Matthew Lyn, Isabelli Fontana photographed by Gustavo Zylberstajn, Cassandra Smith photographed by Miguel Starcevich; centre row, left to right: Rihanna photographed by Zoe McConnell, Sean O'Pry photographed by Jack Waterlot; Tony Ward photographed by Paul Scala; bottom row, left to right: Aline Weber photographed by Tiziano Magni, Gigi Hadid photographed by Rayan Ayash, portrait of Raoul Keil

/RAOUL KEIL/ EDITOR-IN-CHIEF SCHÖN! MAGAZINE

Skin.

Skin and skin and skin and hair, long, blonde hair that flows and falls, and that one wants to stroke at once, jewellery in itself, this hair, very self-confident, very certain, very beautiful, and on the skin, between the hair, a gleam, a breath, almost nothing, an inkling rather than a certainty, more an opportunity than an acknowledgement: Is that a necklace? And if it is a necklace, where does it begin and where does it end?

It's a game that Saskia Diez plays, and each of her pieces is an invitation to play along and ask oneself a few existential questions at the same time: What is the body? What does the body want? What is wrong with the body? Very sensual questions such as: What is touching me? Who is touching me? How does that feel? And quite direct questions such as: Who am I? Who do I want to be? What kind of a woman is revealing herself here, and what does she want?

It is not so much: What kind of a man might like this, and what does he want? First of all, for Saskia Diez, it's about the woman, and anyone who wants to call it feminism is beyond help.

They are self-assured, the necklaces, rings, bracelets by Saskia Diez, self-assured in a delicate, fragile, diffident way, and what could be more seductive than this diffidence, this fragility, this delicacy: Should I? Would I? May I? These are little dramas that are played out on the skin, stories of the present, narratives of egoistic eroticism. The chains, the earrings, the necklaces, the bangles don't say straight away: Look at me. They say: Understand me.

This is the intelligence, this is also the contemporaneity of Saskia Diez. She is interested in the difference between what we see and what we feel, which is where she finds her sensual minimalism. Sometimes it seems quite complicated, such as when chains of beads hang like a net around the body, and yet it is quite simple; and sometimes it seems quite simple, just a star, a necklace of wooden beads, and yet it is complicated. These are signs, and they do not always mean exactly what they show.

There is a sort of forlornness about these pieces, a desire in them to be recognized, the desire to write a story. Jewellery is always time standing still, jewellery is congealed memory, and the jewellery of Saskia Diez is like a memory that one cannot leave alone – but what this jewellery tells us is not necessarily a memory of something that has been; it is something like a future memory. It is the today that links itself with the tomorrow. It is the moment that stretches and extends itself and seeks after eternity.

It is in this ambivalence that Saskia Diez finds her aesthetic. In passing she finds a pattern, in waiting she finds a promise, in hesitation she finds clarity, conciseness and an almost forgotten elegance. In a certain way she turns around the principle of jewellery and reinterprets it. She has no message and no price. She has answers to questions that the person who wears her jewellery does not yet know.

This is the spiritual beauty of her designs. It is where the physicality of her creations comes from. There is a wanting in her pieces that seeks movement. There is a will in these pieces that seeks confirmation. They know more than they reveal, they speak to us if we listen, they do not separate the everyday and the evening, and at every moment they are as exciting as a touch, a breath, a hand.

On your skin.

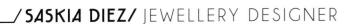

/SASKIA DIEZ/ JEWELLERY DESIGNER

No matter if it's a blazer, a shirt or a pair of trousers –
René Storck is an attitude, a sense of freedom. He believes
in clothes that last, that are not dated in a season. They
should even look better the year after they are bought.
The quality holds up. I think the people who wear his
clothes don't think of his clothes as "fashiony". They like
good clothes and they like to feel comfortable in them.
They can wear a tracksuit made out of the most beautiful
cashmere for going to parties. But what a tracksuit!
There's absolutely no bluff in his work.

Samuel Drira

/ RENÉ STORCK/ DESIGNER

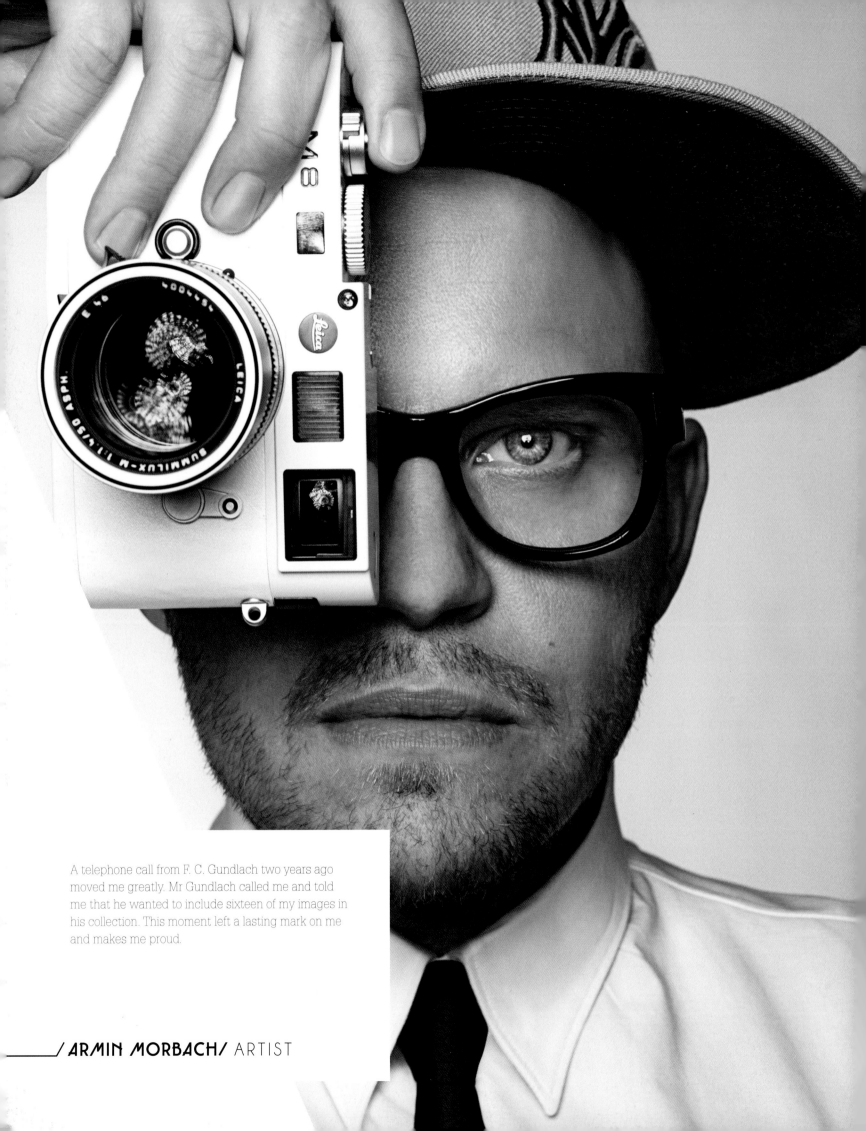

A telephone call from F. C. Gundlach two years ago moved me greatly. Mr Gundlach called me and told me that he wanted to include sixteen of my images in his collection. This moment left a lasting mark on me and makes me proud.

_____/ ARMIN MORBACH/ ARTIST

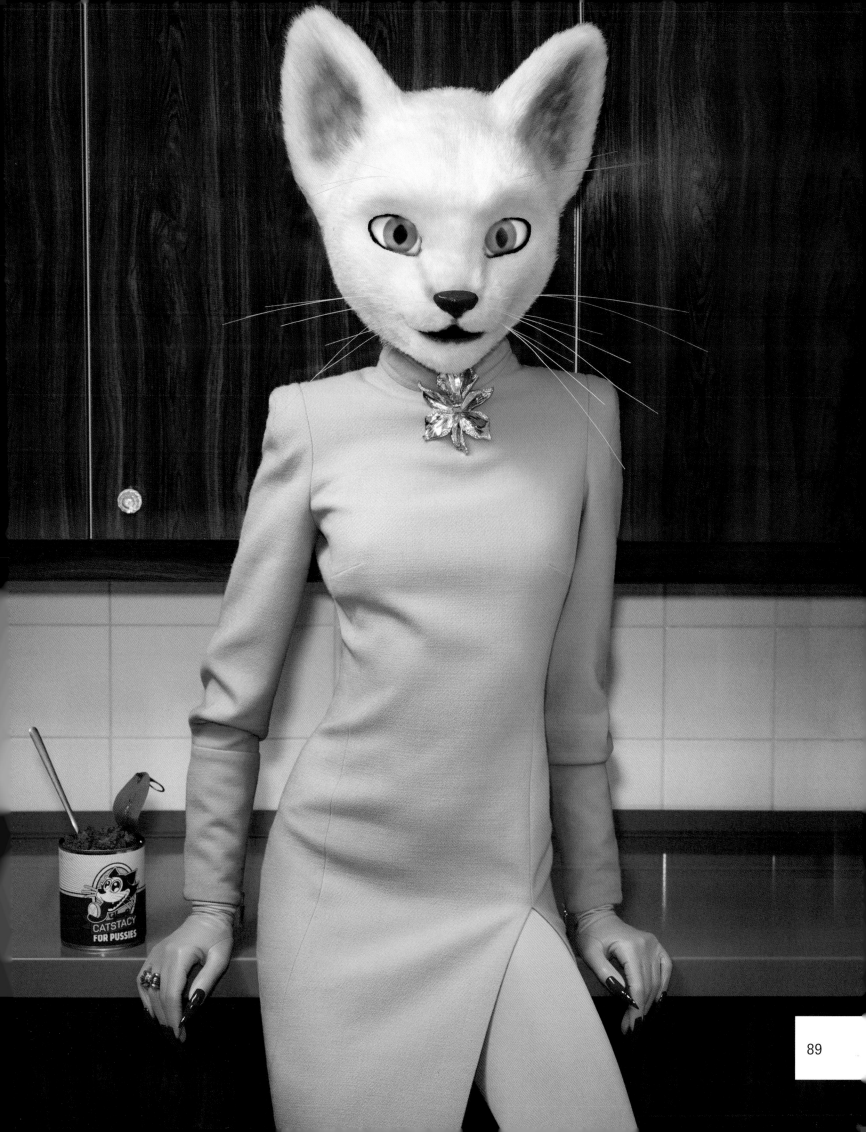

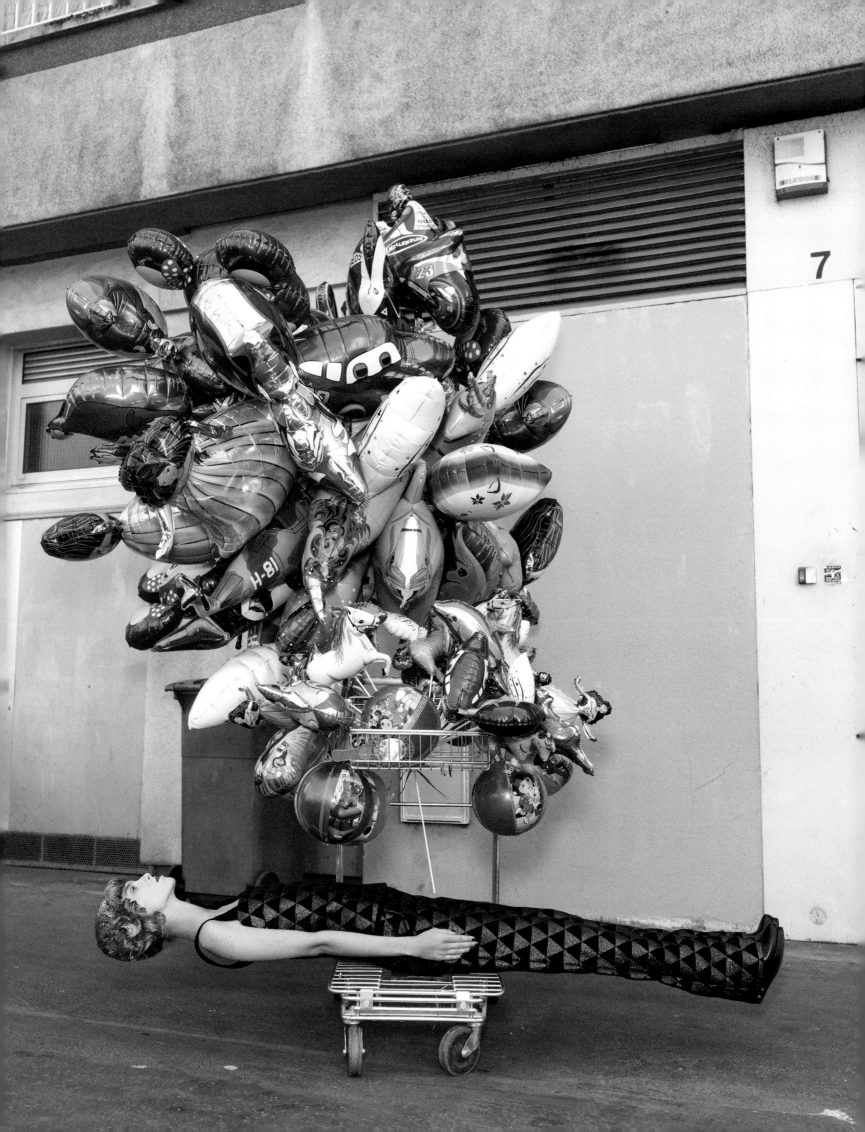

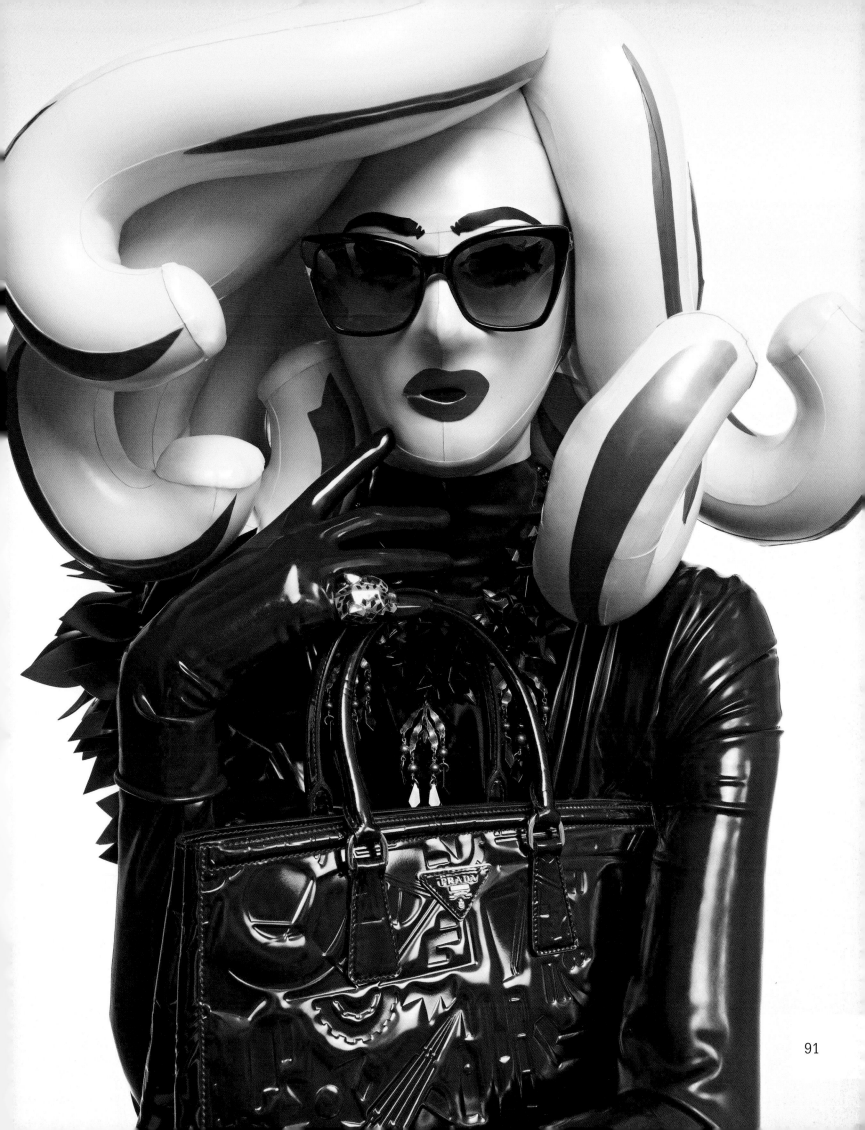

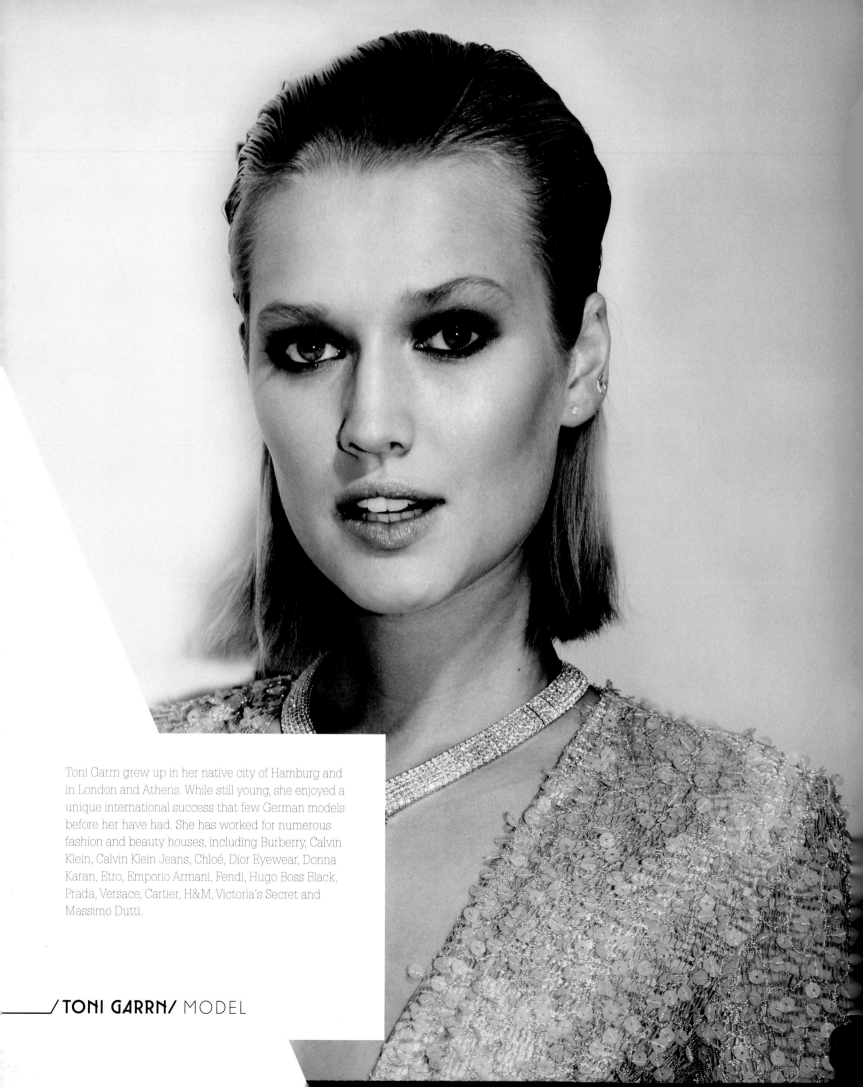

Toni Garrn grew up in her native city of Hamburg and in London and Athens. While still young, she enjoyed a unique international success that few German models before her have had. She has worked for numerous fashion and beauty houses, including Burberry, Calvin Klein, Calvin Klein Jeans, Chloé, Dior Eyewear, Donna Karan, Etro, Emporio Armani, Fendi, Hugo Boss Black, Prada, Versace, Cartier, H&M, Victoria's Secret and Massimo Dutti.

____/ TONI GARRN / MODEL

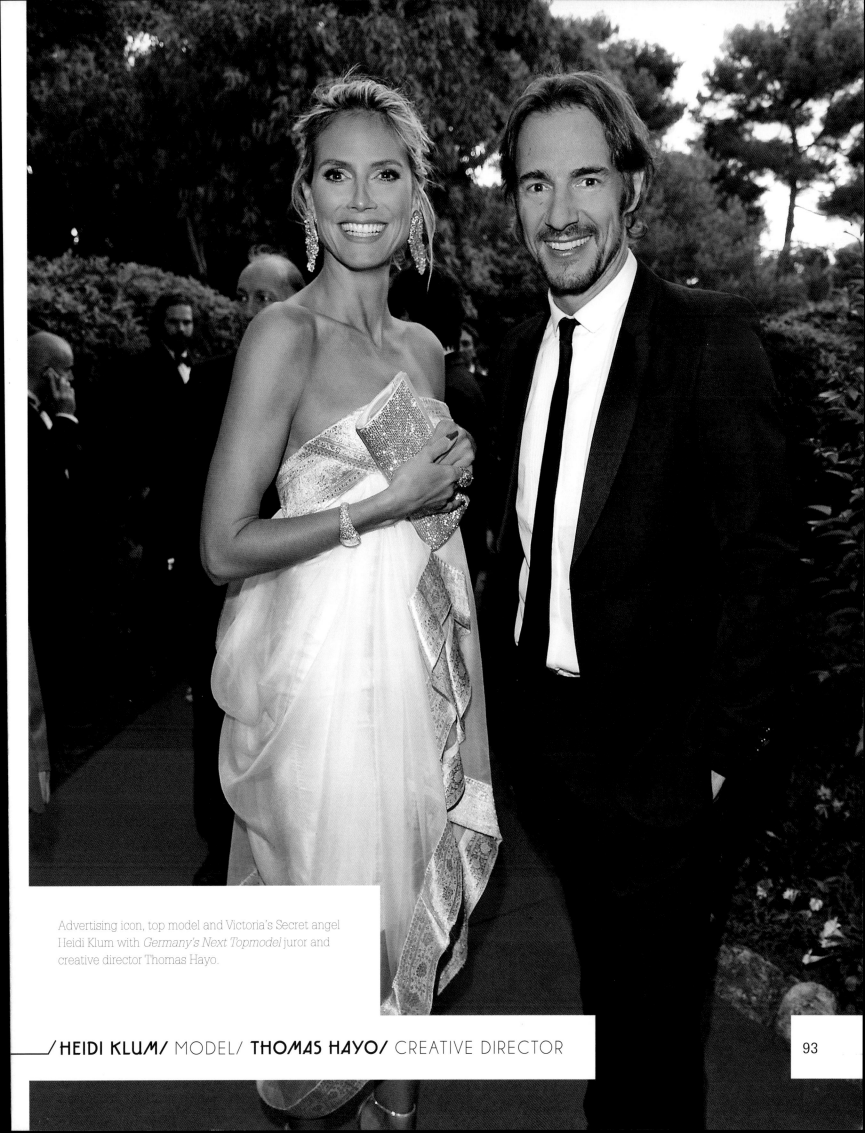

Advertising icon, top model and Victoria's Secret angel
Heidi Klum with *Germany's Next Topmodel* juror and
creative director Thomas Hayo.

What comes to mind when you hear the words "Germans" and "fashion"?
On the one hand we think about a bit stricter, cleaner look à la Jil Sander – elegant but more on the rigid side. On the other hand there is this whole other approach that is more glitz and fun – with Diamond Skull T-shirts and sexy dresses. I think you are either one or the other in Germany.

In your opinion, the German fashion industry stands for …
The German fashion industry stands for professionalism and longevity, but since Berlin – Mercedes-Benz Fashion Week – we feel that there is next to the established brands also a rise of young and exciting labels that will hopefully prove themselves as well.

How did you get into fashion?
We started out as models and did international catwalk shows and editorials with renowned photographers such as Mario Testino. We quickly realized that we loved it behind the scenes much better and asked one of the designers we modelled for if we could assist him. He was based in London, so we moved here and eventually we went to Central Saint Martins. The rest is history.

What kind of woman do you design for?
The Felder Felder woman has more than one side to her personality and she is not afraid to show them all. She can be quite playful and girly one moment and the next she is both sophisticated and elegant. With Felder Felder, we encourage her to express herself completely without losing herself.

Describe Felder Felder in three words:
Modern. Sexy. Elegant.

What obstacles do you find as a designer team?
People always ask us if it isn't difficult to work as twins, but we cannot imagine it any other way. On the contrary, we wonder: Isn't it difficult if you are all by yourself?

Who inspires you?
All the women and girls out there who have more than one side to their personality, no matter if they are famous or not. Our mother is, for example, a very big influence. She is the ultimate Felder woman.

Who wears Felder Felder?
We call ourselves lucky to have a following of very inspirational women: Rita Ora, Rihanna, Florence Welsh, Gwyneth Paltrow, Poppy and Cara Delevingne … but it makes us the most proud if we walk down the street and we spot a Felderized girl.

Where do you see yourself in five years?
We hope to see our business growing and hope to be able to offer a variety of things which we have in the Felder world: glasses, accessories, furniture, music, yoga and sportswear, homewear… the list is long.

The future will bring …
A happy and healthy life with our family and friends, beautiful houses, licensing deals, a lot of sun … #getfelderized

/ANNETTE AND DANIELA FELDER/ DESIGNERS AND DJS/ FELDER FELDER

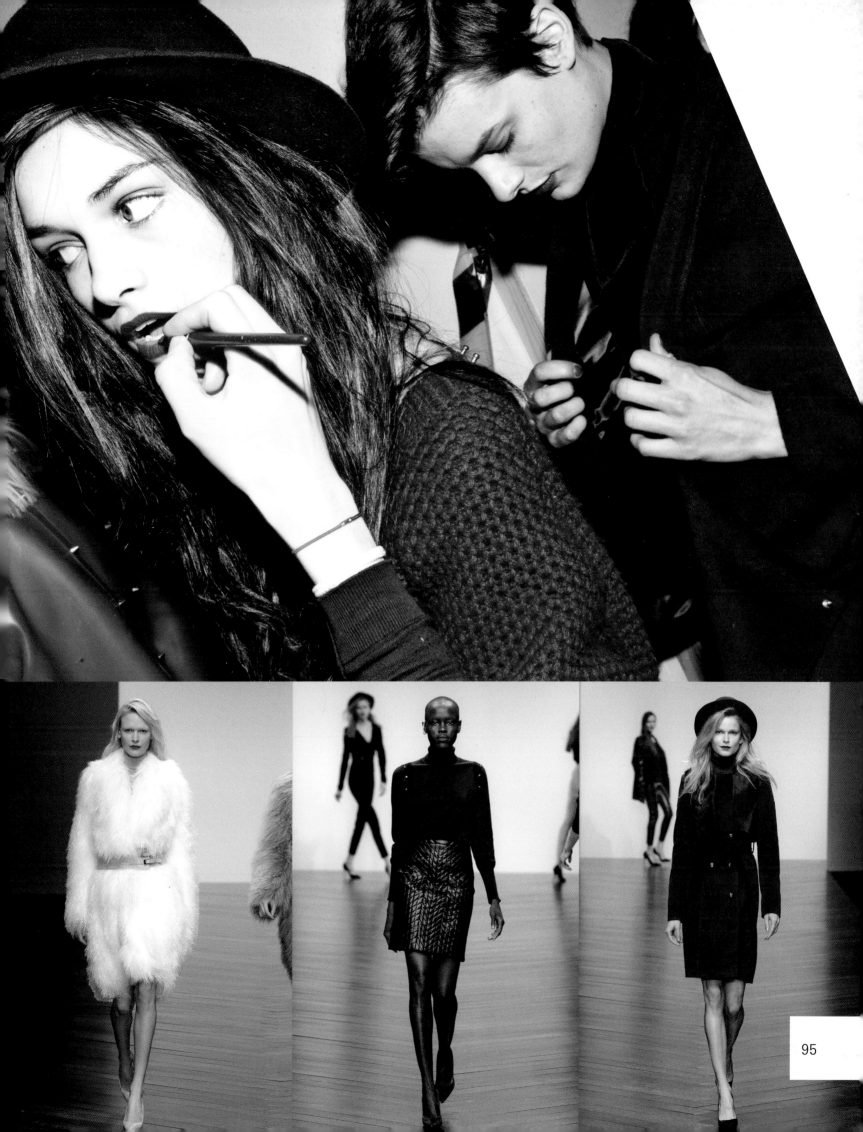

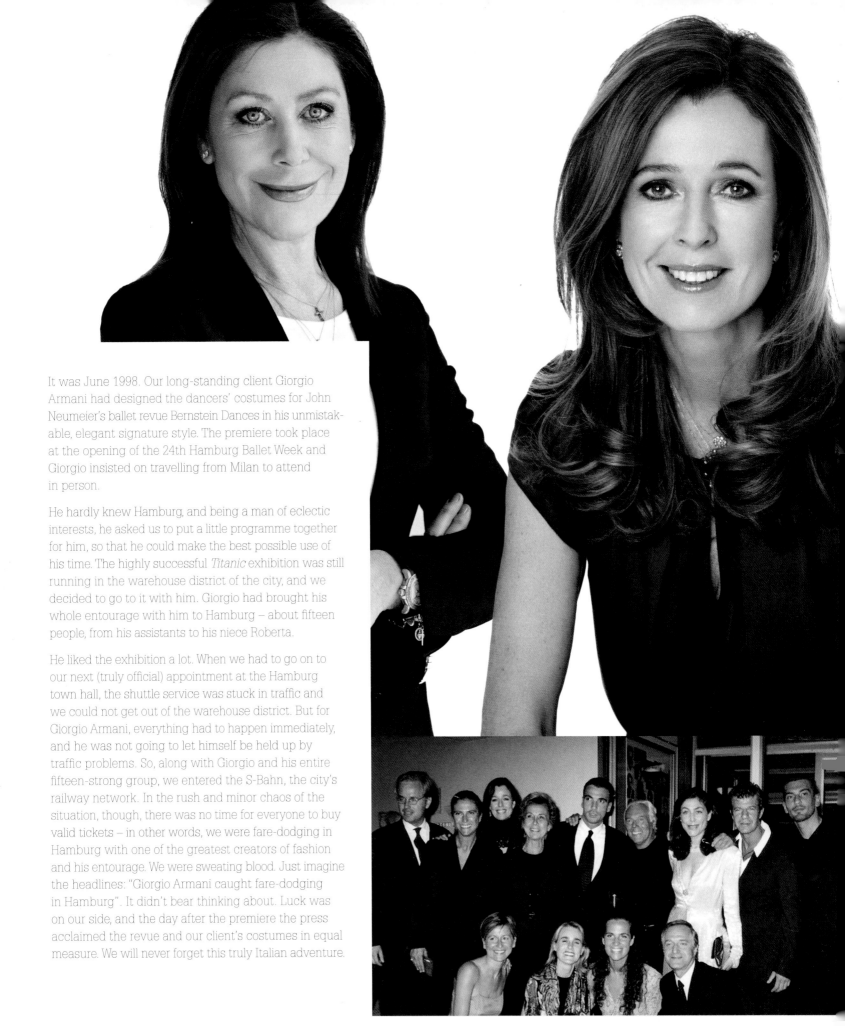

It was June 1998. Our long-standing client Giorgio Armani had designed the dancers' costumes for John Neumeier's ballet revue Bernstein Dances in his unmistakable, elegant signature style. The premiere took place at the opening of the 24th Hamburg Ballet Week and Giorgio insisted on travelling from Milan to attend in person.

He hardly knew Hamburg, and being a man of eclectic interests, he asked us to put a little programme together for him, so that he could make the best possible use of his time. The highly successful *Titanic* exhibition was still running in the warehouse district of the city, and we decided to go to it with him. Giorgio had brought his whole entourage with him to Hamburg – about fifteen people, from his assistants to his niece Roberta.

He liked the exhibition a lot. When we had to go on to our next (truly official) appointment at the Hamburg town hall, the shuttle service was stuck in traffic and we could not get out of the warehouse district. But for Giorgio Armani, everything had to happen immediately, and he was not going to let himself be held up by traffic problems. So, along with Giorgio and his entire fifteen-strong group, we entered the S-Bahn, the city's railway network. In the rush and minor chaos of the situation, though, there was no time for everyone to buy valid tickets – in other words, we were fare-dodging in Hamburg with one of the greatest creators of fashion and his entourage. We were sweating blood. Just imagine the headlines: "Giorgio Armani caught fare-dodging in Hamburg". It didn't bear thinking about. Luck was on our side, and the day after the premiere the press acclaimed the revue and our client's costumes in equal measure. We will never forget this truly Italian adventure.

/ALEXANDRA VON REHLINGEN AND ANDREA SCHOELLER/ SCHOELLER & VON REHLINGEN PR

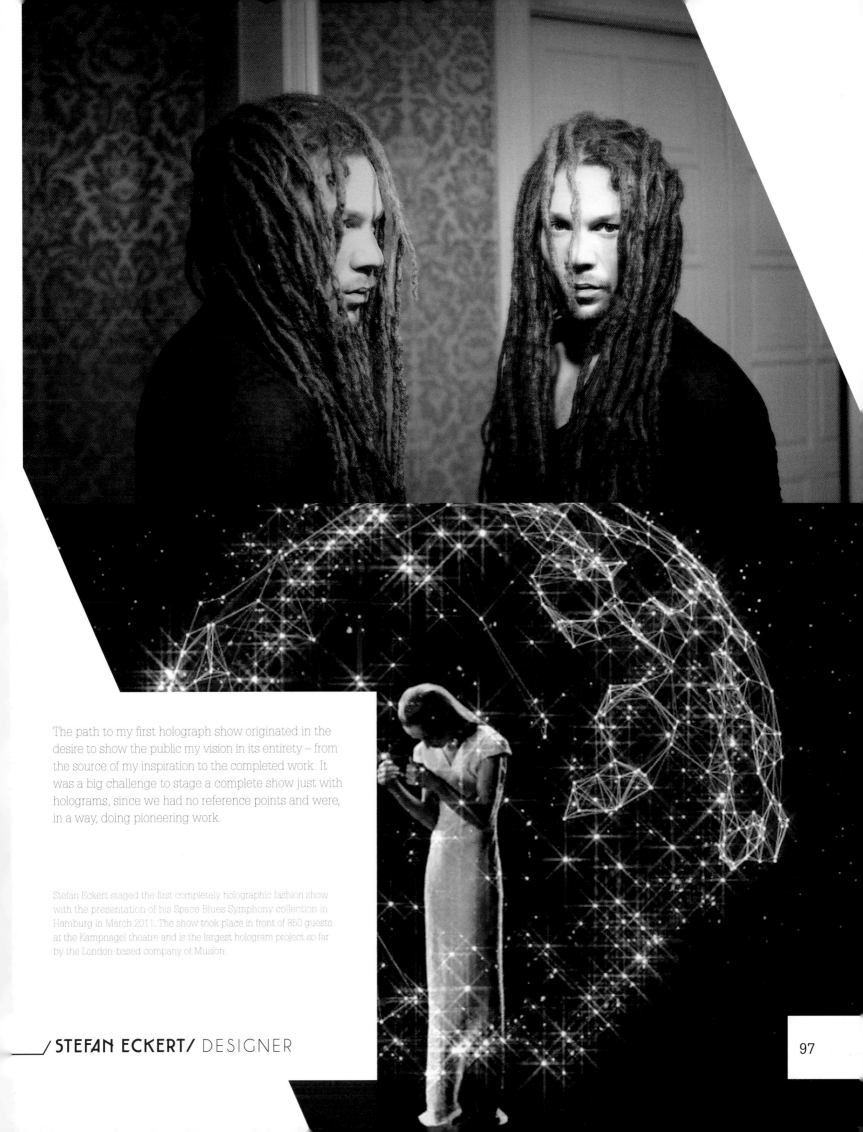

The path to my first holograph show originated in the desire to show the public my vision in its entirety – from the source of my inspiration to the completed work. It was a big challenge to stage a complete show just with holograms, since we had no reference points and were, in a way, doing pioneering work.

Stefan Eckert staged the first completely holographic fashion show with the presentation of his Space Blues Symphony collection in Hamburg in March 2011. The show took place in front of 850 guests at the Kampnagel theatre and is the largest hologram project so far by the London-based company of Musion.

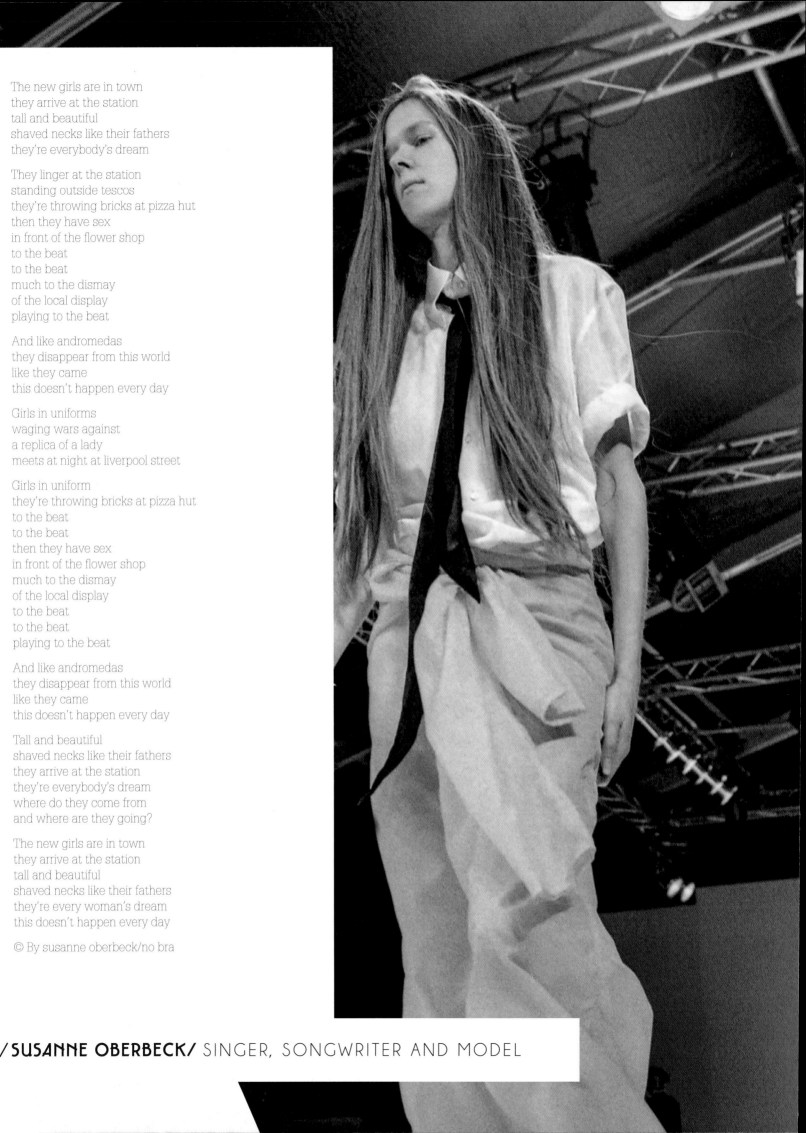

The new girls are in town
they arrive at the station
tall and beautiful
shaved necks like their fathers
they're everybody's dream

They linger at the station
standing outside tescos
they're throwing bricks at pizza hut
then they have sex
in front of the flower shop
to the beat
to the beat
much to the dismay
of the local display
playing to the beat

And like andromedas
they disappear from this world
like they came
this doesn't happen every day

Girls in uniforms
waging wars against
a replica of a lady
meets at night at liverpool street

Girls in uniform
they're throwing bricks at pizza hut
to the beat
to the beat
then they have sex
in front of the flower shop
much to the dismay
of the local display
to the beat
to the beat
playing to the beat

And like andromedas
they disappear from this world
like they came
this doesn't happen every day

Tall and beautiful
shaved necks like their fathers
they arrive at the station
they're everybody's dream
where do they come from
and where are they going?

The new girls are in town
they arrive at the station
tall and beautiful
shaved necks like their fathers
they're every woman's dream
this doesn't happen every day

© By susanne oberbeck/no bra

/SUSANNE OBERBECK/ SINGER, SONGWRITER AND MODEL

wears jacket Susanne's own. T-shirt and hotpants by **American Apparel**.

wears socks by **Topshop**. Shoes Susanne's own.

DUDE HERD FUCK HERD
AT THE SAME TIME

Previous page: Adam Chodzko
Meeting of people with statements to describe a fire, 2001

Opposite page. Susanne Oberbeck at the Alexander McQueen runway show 1996, photographed by Mark C O'Flaherty; this page top: i-D magazine 2007, photographed by Rebecca Thomas; bottom left: drawing by Brian Kenny, New York City, 2008; bottom right: photograph from the Ponystep magazine fashion shoot 2010, shot by Brett Lloyd

99

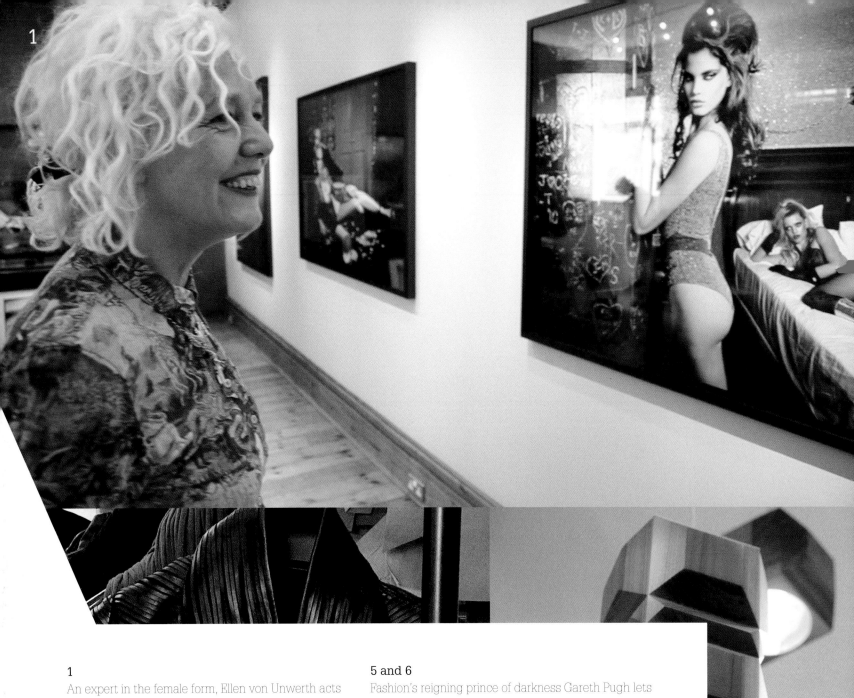

1
An expert in the female form, Ellen von Unwerth acts as tour guide for her own London exhibition.

2
The London-based designer and self-proclaimed giant lollipop Bethan Laura Wood shops her way through London's Spitalfields Market.

3
Detail of a Lee Boom signature crystal piece.

4
Simon Porte Jacquemus bares all backstage as his models show off pieces from his namesake fashion label.

5 and 6
Fashion's reigning prince of darkness Gareth Pugh lets Crane.tv into his studio.

7
Crane.tv turns the camera on fashion photographer Juergen Teller ahead of his exhibition *Woo* at London's ICA.

8
Hats by the much-loved milliner Stephen Jones.

9
Science and anatomy course through the veins of young London-based illustrator Katie Scott as she puts ink to paper in her Hackney studio.

/ **CONSTANTIN BJERKE** / CRANE.TV

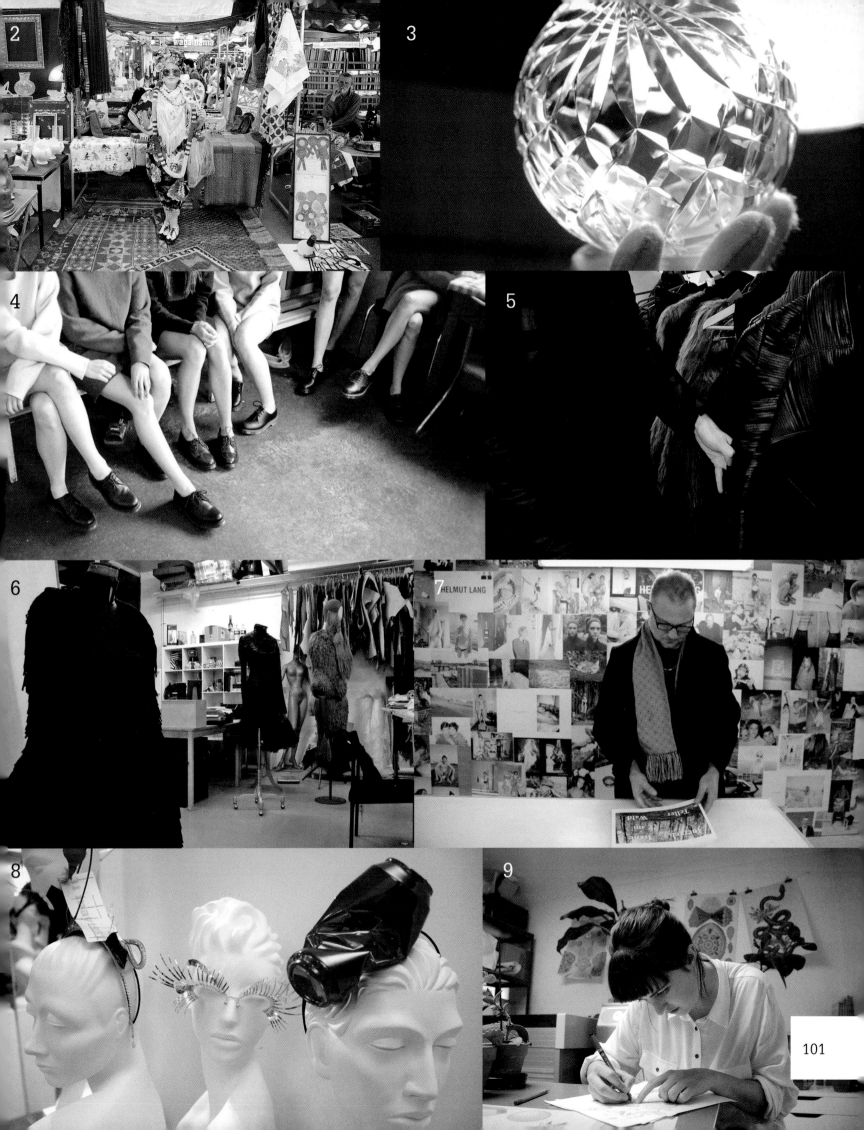

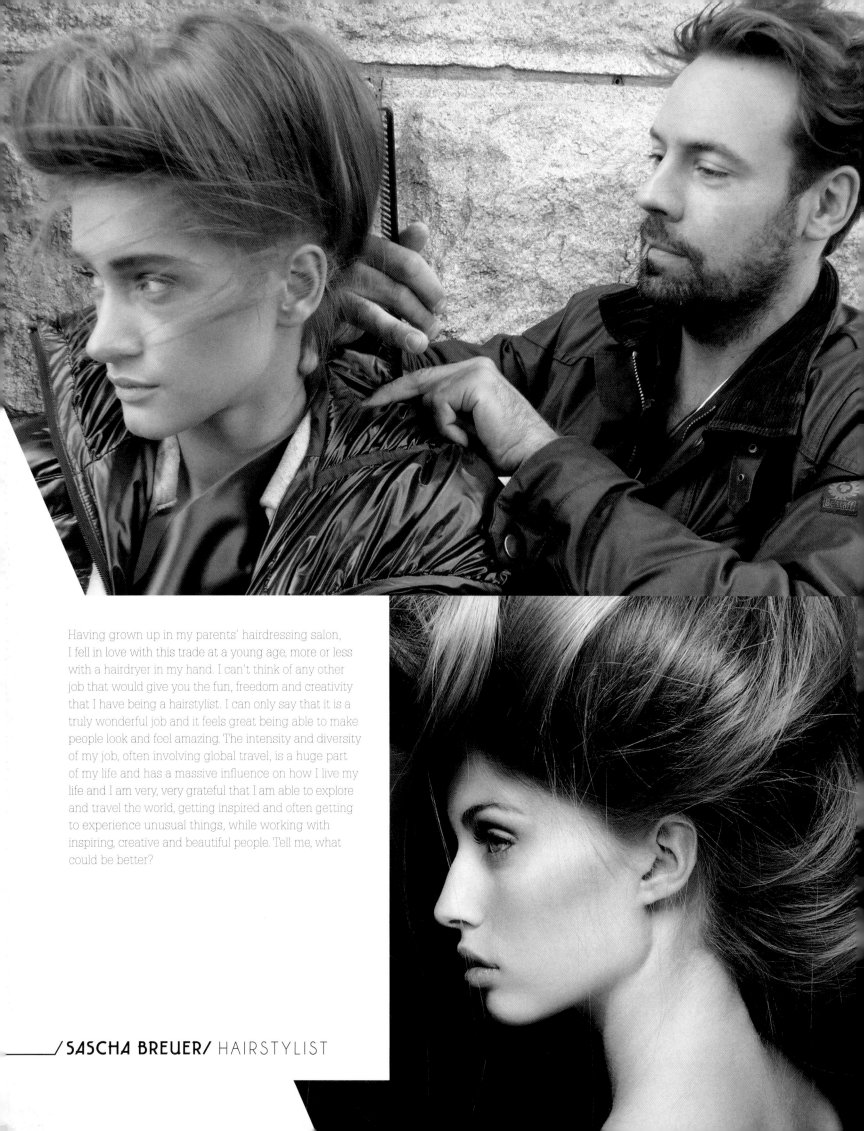

Having grown up in my parents' hairdressing salon, I fell in love with this trade at a young age, more or less with a hairdryer in my hand. I can't think of any other job that would give you the fun, freedom and creativity that I have being a hairstylist. I can only say that it is a truly wonderful job and it feels great being able to make people look and feel amazing. The intensity and diversity of my job, often involving global travel, is a huge part of my life and has a massive influence on how I live my life and I am very, very grateful that I am able to explore and travel the world, getting inspired and often getting to experience unusual things, while working with inspiring, creative and beautiful people. Tell me, what could be better?

/ SASCHA BREUER/ HAIRSTYLIST

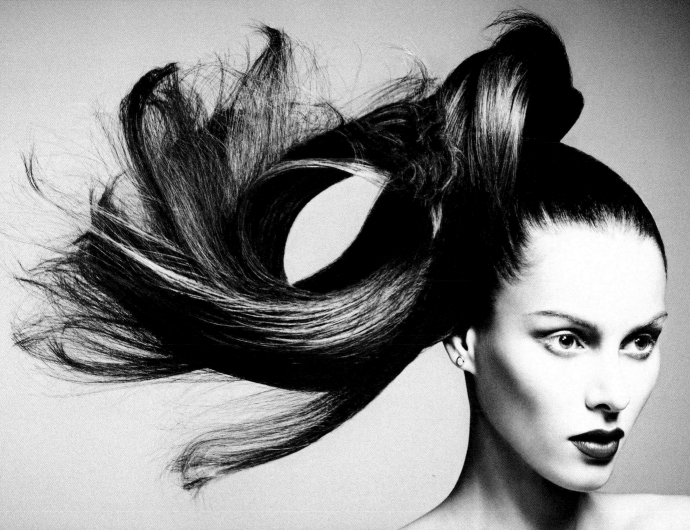

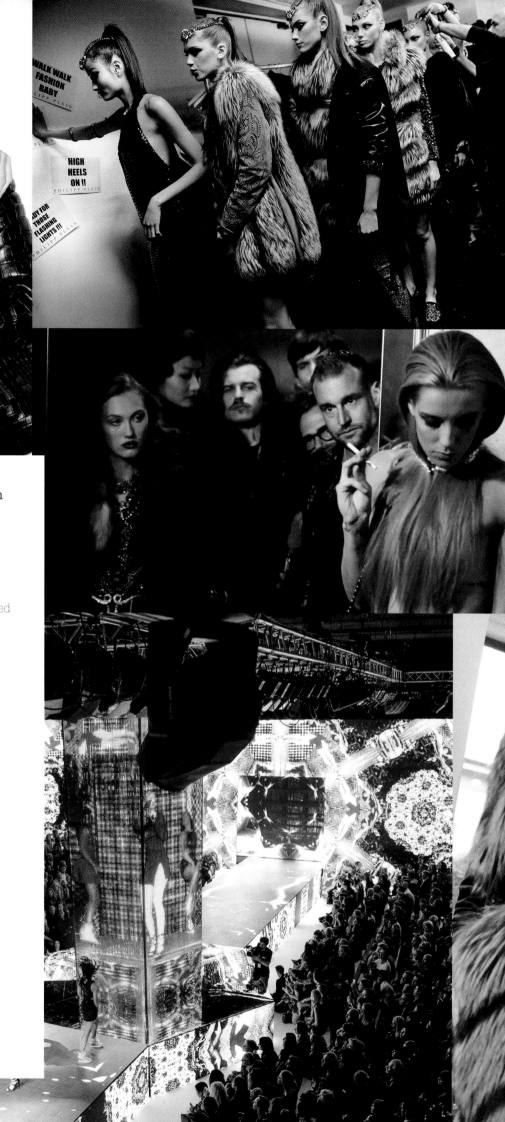

What's the first thing that springs to mind when you hear the words "fashion", "luxury" and "Germany"?
Fashion: a way of expression; luxury: a way of living; Germany: a way of thinking!

Who or what inspires you?
Everything can be a source of inspiration, you just need to open your eyes! As Matisse said: There are always flowers for those who want to see them.

What skills do Germans benefit from in the international fashion industry?
Longevity, creativity, organization!

Your personal fashion work highlight?
My fashion shows, the adrenalin, the pride of it!

What advice would you give German creatives wishing to break through into the international fashion industry?
Follow your dreams, be self-confident, never quit!

Do you have any insider tips on how to survive in the fashion world?
Be creative, challenge the trends, work!

/ PHILIPP PLEIN / DESIGNER

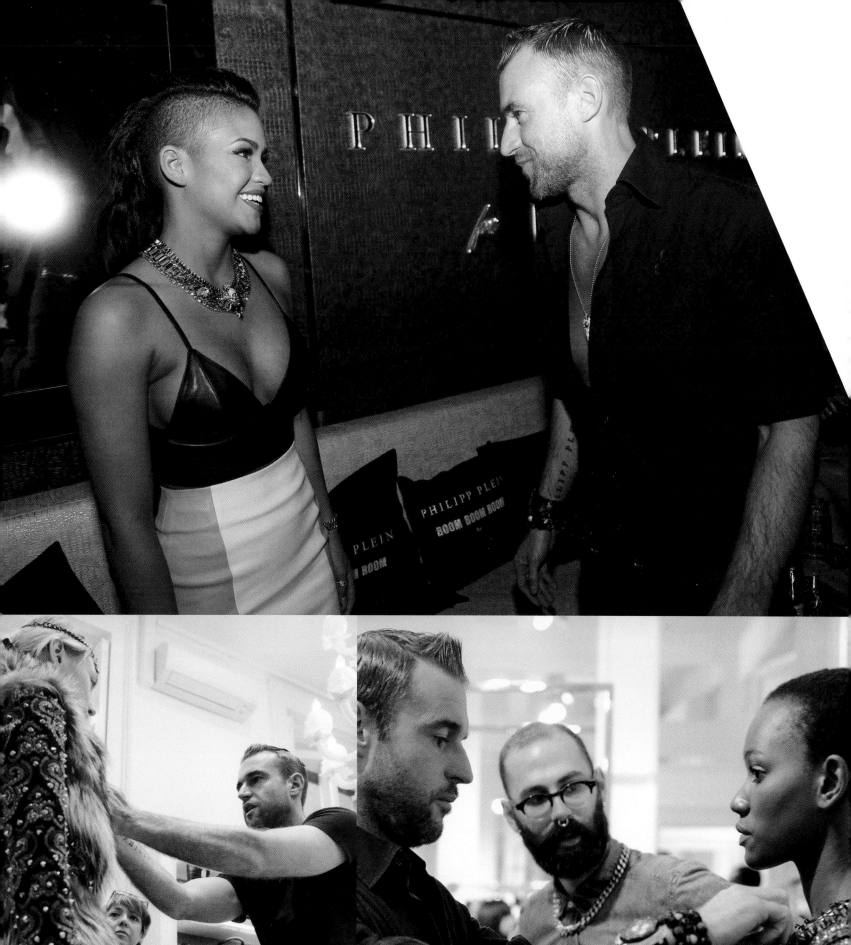

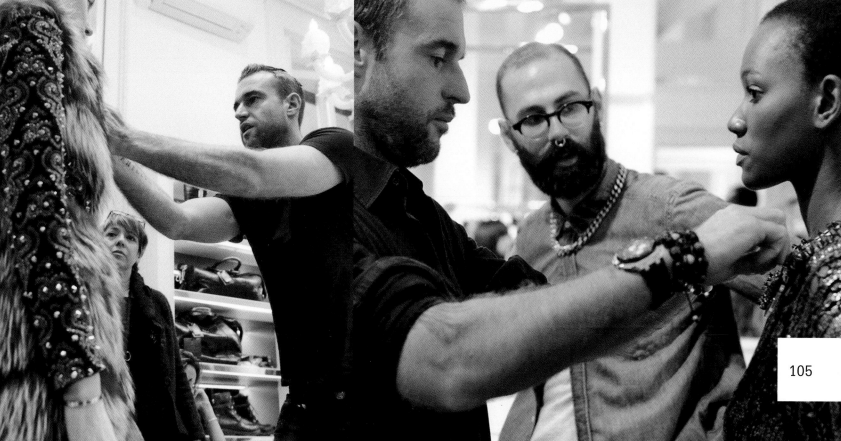

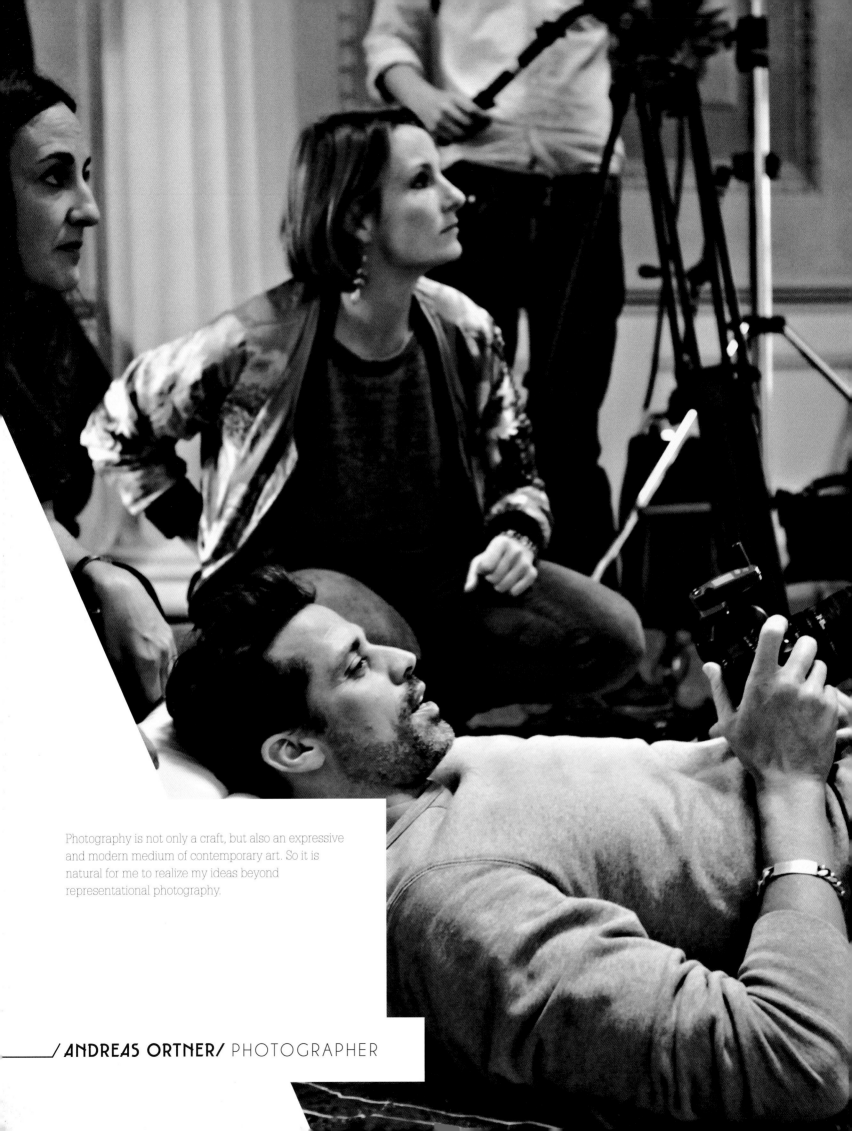

Photography is not only a craft, but also an expressive and modern medium of contemporary art. So it is natural for me to realize my ideas beyond representational photography.

_____/ ANDREAS ORTNER/ PHOTOGRAPHER

Anyone who, like Bettina Harst, grew up in the late 1970s and early 1980s in Würselen, near Aachen, wants only one thing – to get away. Away from political authority, social stuffiness, the grey haze that had neatly settled over postwar Germany on its last legs. First means of escape: youthful rebellion. Harst becomes a punk. School-leaving exam? No chance. Because she doesn't know what to do with her family's middle-class expectations, she would rather lose herself in youthful Weltschmerz and the morbid, angry sound of her idols, Joy Division. "Above all else, I wanted to be free. We were probably neither political revolutionaries nor bohemians. We were simply against everything," says Harst, recalling her youth. Radicalism? Basically a bluff, a means of shaking off the oppressive petit-bourgeois idyll. But all the same, it left its mark on Bettina Harst.

In 1982 she goes to Paris as a model. With no money, no plan, no training, only with the relief of knowing that she never has to return. But she still can't shake off her home – because La Grande Nation at first behaves just like one: "The French were very hard. We were constantly confronted with remarks about Nazis. And we were all supposed to be so clean, well behaved and punctual. I hated it – that was exactly why I left Germany." Harst travels a great deal, works in New York and Tokyo, but soon realizes that modelling is not for her. Just being beautiful is not enough in a world that in the mid-eighties is characterized by an American perfection, sculpted by workouts in the gym. "I ran away from home to become a different woman. I never wanted to conform to what others expected of me. In the modelling business I was probably just wrong," she sums up today. She would rather be a player in the business than a mere plaything. In the early nineties she goes to Elite Models as a model agent – Elite, the global power agency founded by John Casablanca, which turned mannequins into models, luxury globetrotters, objects of desire, about whose affairs more was written than the creations they showed. Elite had them all: the agency built up the careers of Naomi Campbell, Cindy Crawford and Linda Evangelista. "If you were at Elite then, even as an agent, all doors were open to you," she says today about that time.

She works with Juergen Teller, Corinne Day and Mario Sorrenti. "This new photography was simply amazing," Bettina Harst remembers, "and the energy, we worked hard, partied hard, everything was on the move." It was the decade of aesthetic shock, of the "waif look", far removed from previous ideals of beauty, which made women look more like Amazons and enraptured divas with "big hair" and plenty of rouge. Looking back, a new fashion decade was beginning.

At some point she herself recognizes that she has changed sides, but the system has not. "The business was controlled by men, and the girls themselves made no decisions. That annoyed me, I wanted to do things differently." In 1998 she goes to Viva Models Paris, where she works for fourteen years. And where she finds what she has always looked for: small structures, an informal atmosphere and in Cyril Brulé a boss who hates nothing more than the misanthropic concept of the model booker. "As though we were booking flights here, he said to me in our first conversation. I liked that." For the first time I saw that the girls were taking part in decisions, were being asked if they wanted to do the jobs or not. "It's not merely a question of fashion shoots here. These girls have just left school, they are beginning to look to the future, have only just moved away from home. You have to support them in everything, with every problem. You have to always be there for them." Anyone who has worked with Bettina Harst knows that it is precisely these personal moments that define her work. Natalia Vodinova lived with her when she came to Paris without any language skills; with some girls, Harst saw them through everything, from their first child to divorce. "It's a bit like a family. That's very important to me, perhaps because I'm a mother myself. This is what most people don't see in our work – the human element." The tabloid press would rather maintain the sex, drugs and rock 'n' roll image.

At the same time, probably no model generation has been more scandal-free than that of today. "We just wanted to get out of Germany; they want to get back home as soon as possible," Harst comments drily. She too, however, has long become closer to her home again, and takes pleasure in observing the new "German Fräuleins". She is particularly proud of her own German girls, mentioning names such as the Berliner Hanna Wähmer, who recently worked with Peter Lindbergh for German Vogue, Larissa Hofmann and Lena Hardt. "There is a sort of new German wave – not only in the modelling business. Germany always used to mean bad taste. But now I'm experiencing a new creativity. France has stood still compared with Germany," she says, wishing that

more German creatives would come to Paris. Despite all her euphoria about the new German lightness of touch, going back has never been an option. She enjoys the comfortable role of an observer, talks about an emotional family structure, influenced by her two fifteen-year-old daughters, and says that she sees herself more as an international cosmopolitan: "That's what you learn when you live abroad. You are not German, you are not French, you are simply open-minded. You have to be open, otherwise you are alone."

After fourteen years at Viva Models, Bettina Harst is moving to a new modelling agency in Paris for only one reason: she needed a change of scenery, which she has found as a booker at Nathalie Models.

Nicole Urbschat for the fashion magazine Achtung

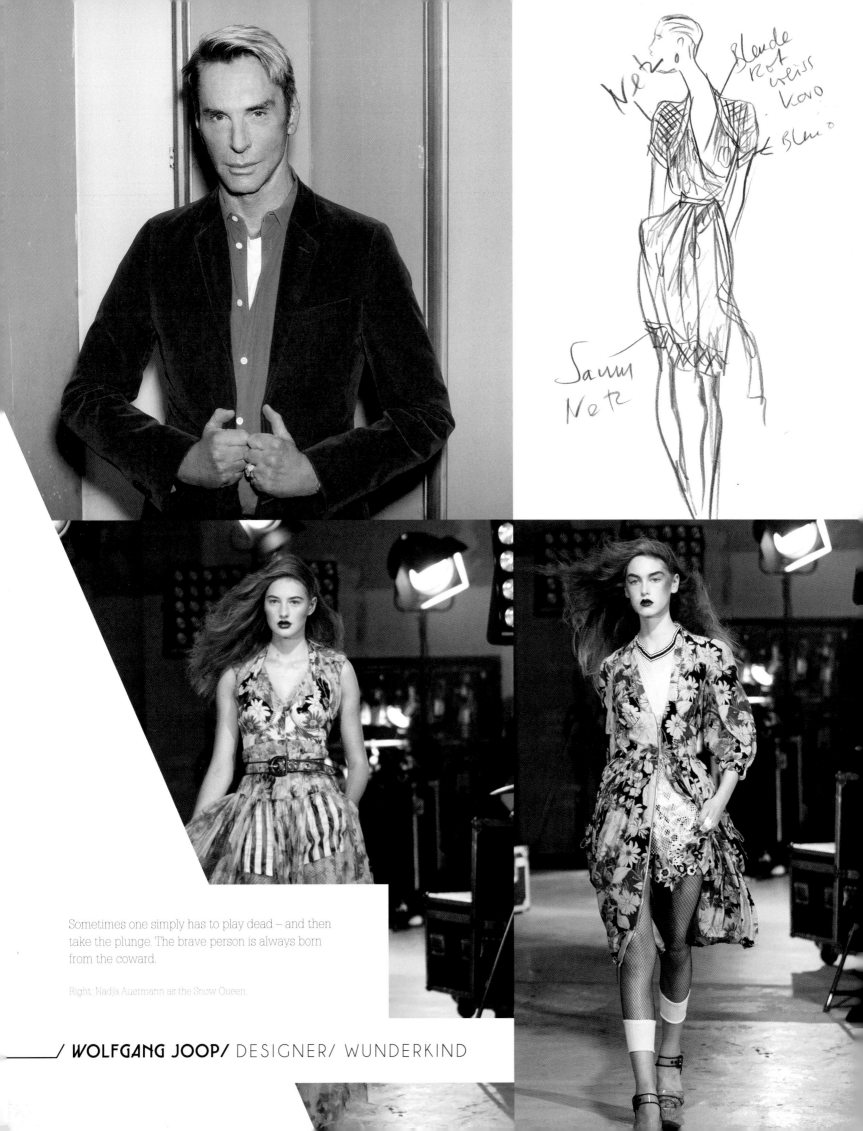

Sometimes one simply has to play dead – and then take the plunge. The brave person is always born from the coward.

Right: Nadja Auermann as the Snow Queen.

/ **WOLFGANG JOOP**/ DESIGNER/ WUNDERKIND

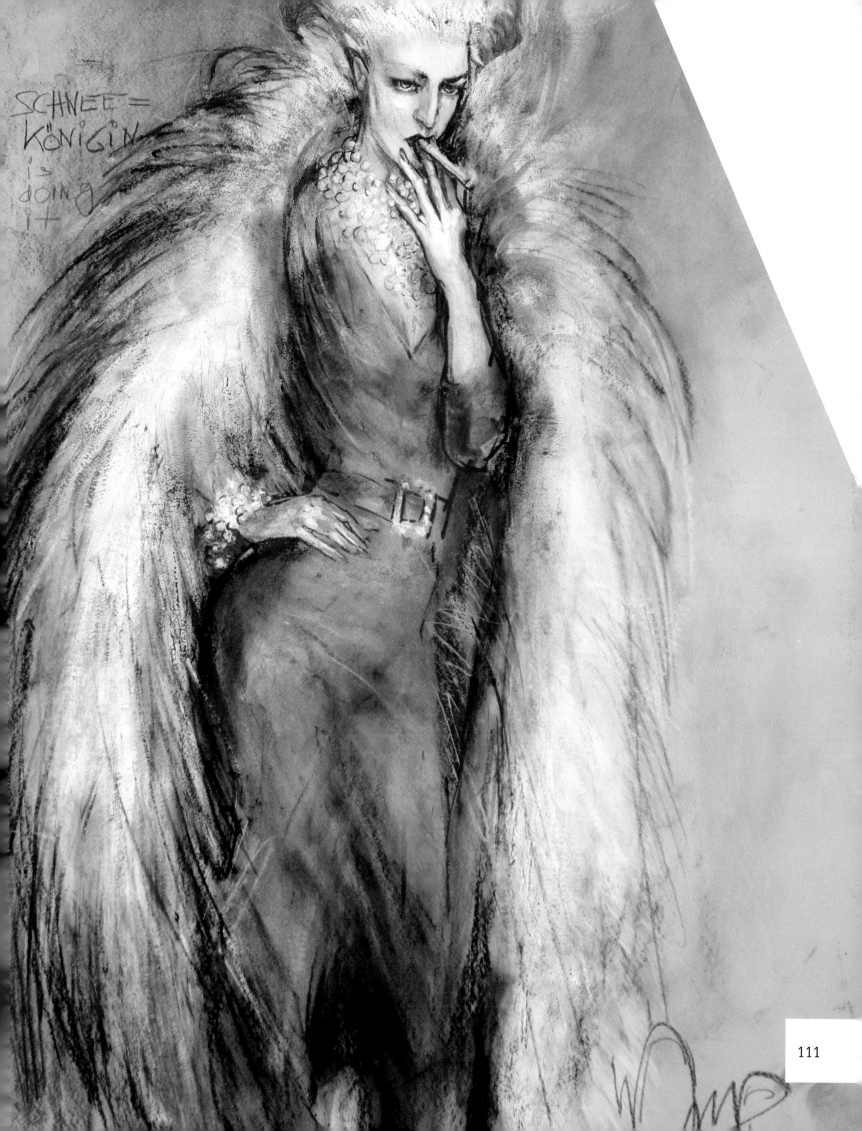

SCHNEE =
KÖNIGIN
is
doing
it

111

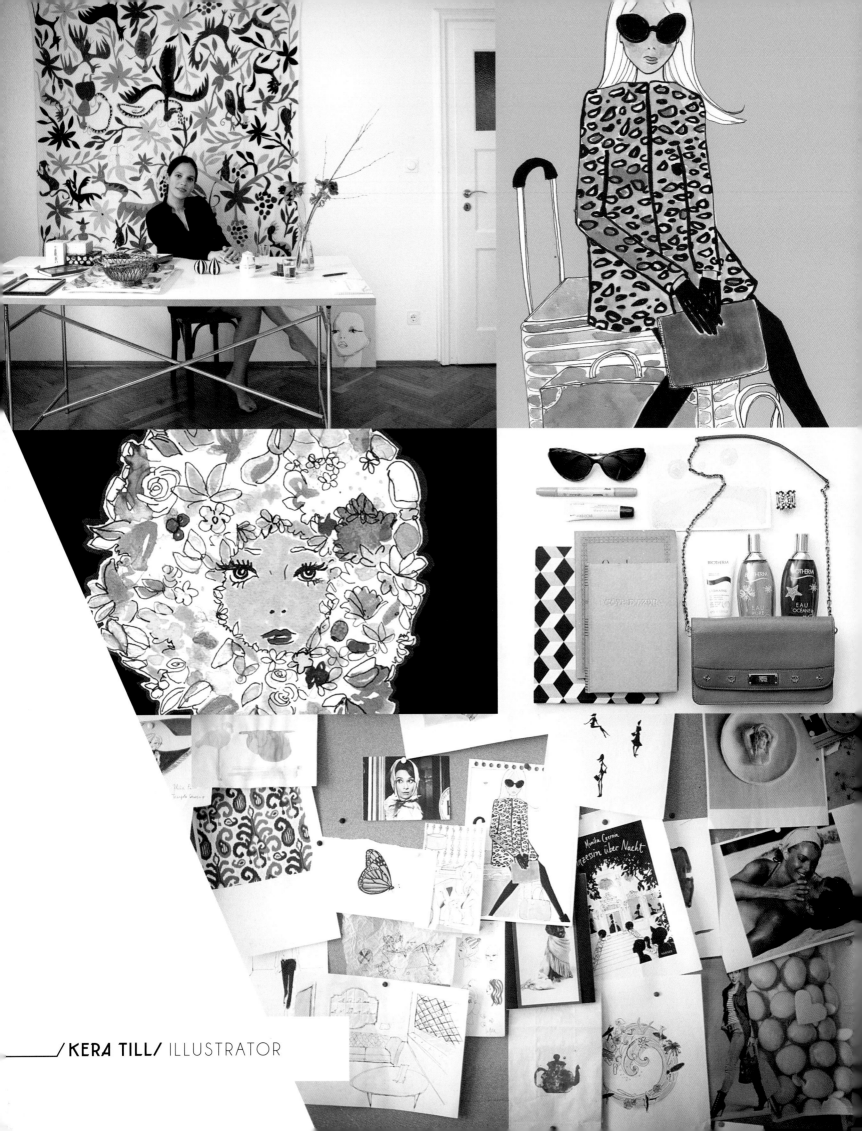

/KERA TILL/ ILLUSTRATOR

When I moved from Milan to Munich three years ago, I would not have believed that one day I would be all over the gossip columns of the local tabloid press because of my personal style. My look plays with gender boundaries, ranges between dandyism and glam rock. After all, fashion is supposed to be fun.

Admittedly, to have an eccentric appearance you need self-confidence, and this is something I wasn't born with. When I was discovered as a model, I was still a shy, ugly duckling. But with increasing success, my self confidence increased, as did my enjoyment of expressing myself through my clothes.

Which is not something you can say about Germans per se! Is it something to do with the German retail industry, which simply has nothing else to offer? Apart from some trendy stores in Germany, what is offered in the way of fashion seems to me rather conventional. Whether the consumer wears what he is offered, or the retailer offers what the consumer wants to wear, both sides are lacking in courage. This is one reason, among others, why I recently launched my own jeans label.

I miss innovation, avant-garde and eccentric positions. Business kills the imagination. What Germans are missing is a sense of the spectacle. Providing that is my job.

The status of fashion is growing among Germans. But Germany is still a long way from being a fashion nation. It's said that we should not keep leering at other countries, comparing ourselves with Paris, London and New York, but concentrate on our own strengths. But what are the strengths of German fashion creation? I hope to find the answer in this book!

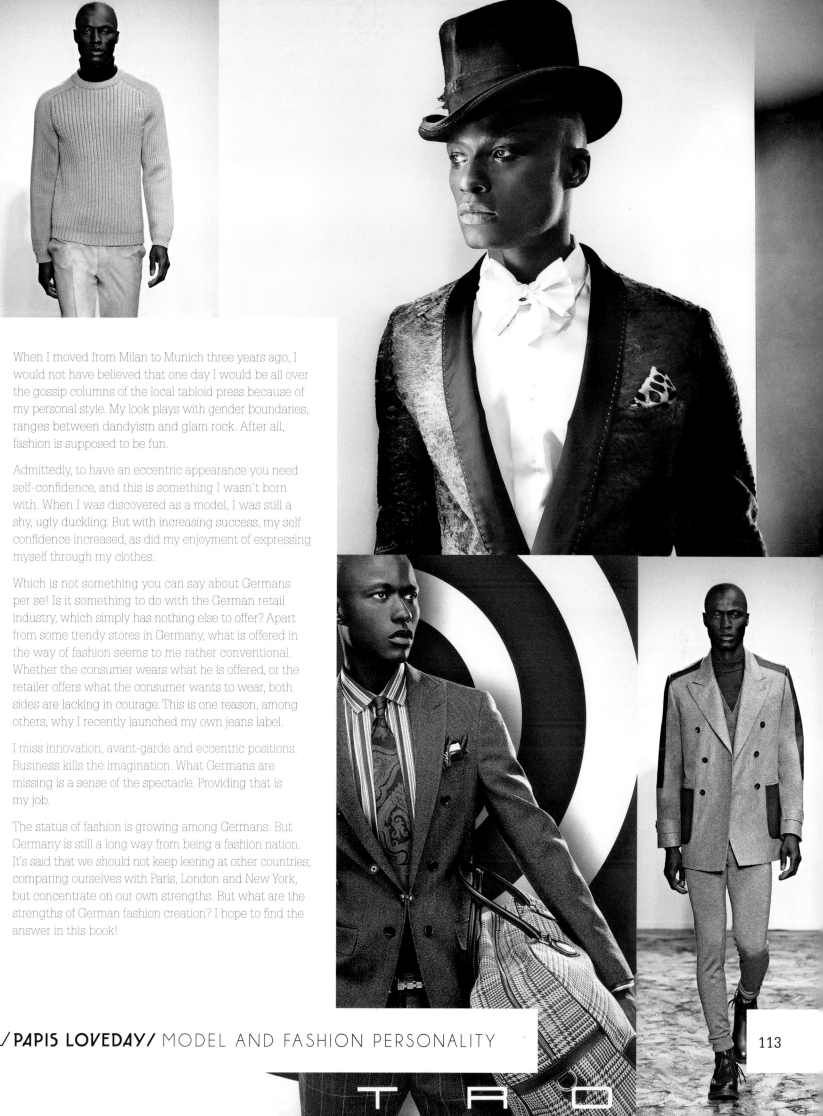

/ **PAPIS LOVEDAY** / MODEL AND FASHION PERSONALITY

TRÒ

Animal Collective

The rhythms of the avant-garde American band inspire the designer. "If I'm listening to their music while designing, I just can't stop," she reveals.

Burning impulse

Even after forty years in the fashion business, one thing above all drives the Berlin designer: constant rediscovery.

Chic

In the early seventies Skoda freed knitwear from its functional image and created fashion with it: transparent dresses made of sheer yarn, pieces with relief-like surfaces in stretch cotton – all in daringly bright colours.

Duderstadt

On 25 October 2013, in the Kunsthalle Duderstadt, on the occasion of the opening of the *Kippenberger Catwalk* exhibition, a second Skoda fashion show at this iconic venue took place: My Life as Claudia – one of the artist's most important works.

Experiment

At the start of her career, musicians, visual artists and film-makers were among Skoda's circle of friends. In 1972, with five of them, she founded the work group Fabrikneu in a 650-square-metre loft in Berlin's Kreuzberg district. As a collective, they supported each other in artistic projects. In 1976 Martin Kippenberger joined them. For a week, the artist photographed the new-style community and installed a floor with more than 1,000 images of the "Skoda family" in the work group. Skoda's first fashion show took place in 1977.

Fantastic

Her shows are real "happenings". She places her catwalks in unusual places such as the Egyptian Museum or the Martin-Gropius-Bau and has live music playing there, carrying off her friends (who include David Bowie and Iggy Pop) into magical worlds.

Great knits

Specializing in knitwear, Skoda occupies a niche that allows her to compete with the big fashion houses.

Handmade

The designer deliberately keeps her fashion business small. Mass production does not fit with her concept of freedom. For this reason her handmade creations in high-quality yarns are often only available as one-off items or in limited editions.

International

Skoda left for New York in the eighties, on the advice of her friend David Bowie. "Your fashion is more than Berlin," the musician said to her at the time. But here, too, the fashion creator did not allow herself to be diverted from her path, declining a contract from the renowned department store Bergdorf Goodman, which wanted to order some of her pieces in larger quantities. Instead, in 1982 she opened a small shop in Soho.

Jubilee

Skoda's desire for uniqueness is today greater than ever, and the list of her clients is as long as it is glamorous. Some of them, including Veruschka and the artist Sabine Franek, offered their Skoda pieces to the designer for her retrospective in October 2013.

Kippenberger

The designer met the artist in Ibiza. At that time she had travelled to the island with her first knitwear designs in her luggage, to sell them there. Martin Kippenberger was enthusiastic about the Berliner's extraordinary energy. He recognized her as a kindred spirit. For just like his art, Skoda's fashion arises from a spontaneous, instinctive impulse.

Longing for fashion

Career, money and success do not drive this former editor's creative activity. At first, self-taught, she designed fashion for herself, because the Berlin of the seventies did not offer what she liked in fashion. She endorses this principle to this day: "I create fashion that I long for myself."

Making her mark

As early as 1987 she was called back from New York by the Berlin Senate for a multimillion-dollar project in the German capital. In 1988 Berlin became the European Capital of Culture, and Skoda organized the opening ceremony with one of her legendary "happenings" at the Hamburger Bahnhof. When the Berlin Wall fell the following year, she decided to stay. "I just had to be there," she says.

Nostalgia

Skoda loathes the glorified view of old times. Her creativity is based on looking forward.

Opening up

In 1994 she opened her first shop in the Mitte district of Berlin. "I had the feeling at the time of moving into a totally new city, a real boost of energy," Skoda reveals.

Politics

In the sixties and seventies the Berliner joined forces with the revolutionary Left. She took part in a demonstration alongside the student radical Benno Ohnesorg, and was already living in a commune in Kreuzberg before the Fabrikneu work group.

Quirky

"New young designers should specialize in where their affinities lie," she advises. "Better to start small, even if it's just with an accessory. Uniqueness is the only thing that helps you to survive in the face of mass production."

Shift

The name of her new collection says it all: conventional proportions are suspended. When the sleeve of a dress is attached to the hip, new configurations come into being, which one often discovers only when slipping into the garment.

Underground

The unpredictability of Berlin allows the fashion designer to develop free from commercial pressures.

Volatile

For a presentation in Berlin's Kongresshalle, Skoda not only had an oversize birdcage built – her models, too, had to behave like real birds. Skoda arranged a visit to the zoo, so that they could observe the movements of their feathered friends.

Where's the fun?

"If I started to repeat myself, I would have to stop at once," she says. "Where's the fun in that?"

X marks the spot

During her time in New York, Skoda often used cross patterns in her creations – a special detail that she has made her trademark. Marc Jacobs, who used to visit Skoda's shop at that time, internalized this principle. His smiley-face sweaters have become the basis of an international career.

Yes …

… we can! Wolfgang Joop walks along a Skoda catwalk dressed as a woman, and she turns up at one of his shows in men's clothes. "At the time, we just did it," Skoda says. "Today, every fart is marketed straight away."

Zest for life

At sixty-nine, Claudia Skoda is still not planning for the future. Only one thing is certain: "I know that I have to keep moving."

Christine Korte for Interview.de

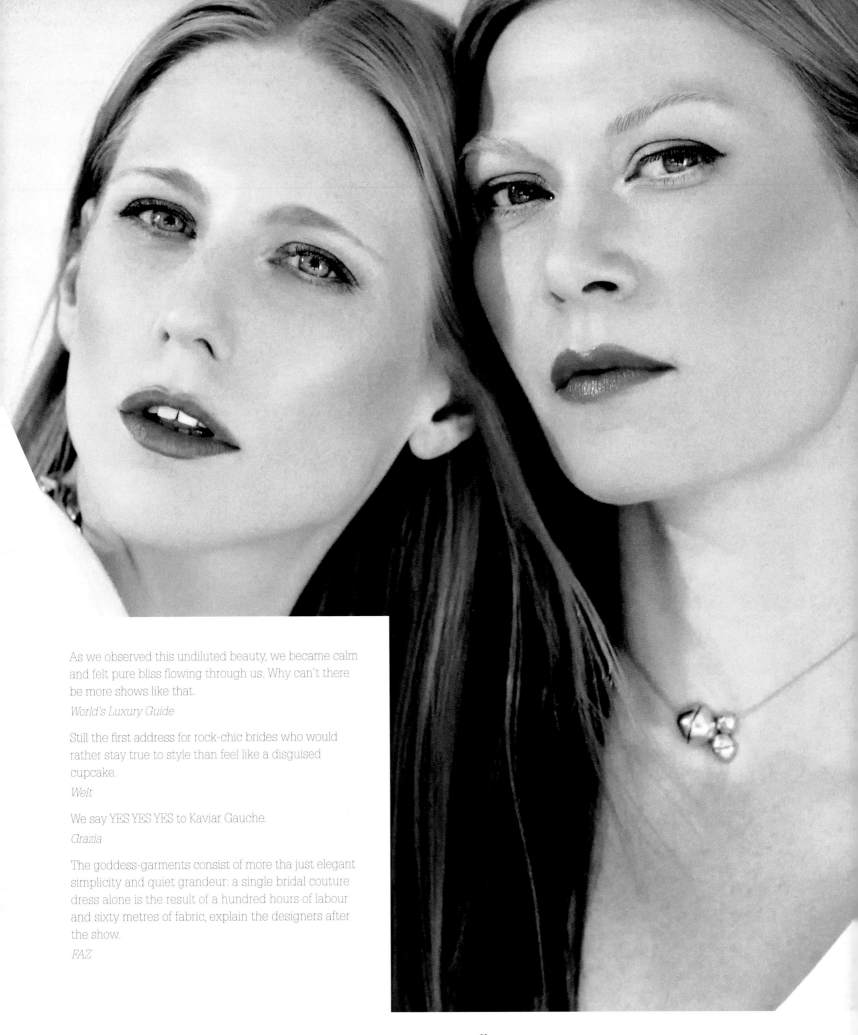

As we observed this undiluted beauty, we became calm and felt pure bliss flowing through us. Why can't there be more shows like that.
World's Luxury Guide

Still the first address for rock-chic brides who would rather stay true to style than feel like a disguised cupcake.
Welt

We say YES YES YES to Kaviar Gauche.
Grazia

The goddess-garments consist of more tha just elegant simplicity and quiet grandeur: a single bridal couture dress alone is the result of a hundred hours of labour and sixty metres of fabric, explain the designers after the show.
FAZ

_____/ALEXANDRA FISCHER-ROEHLER AND JOHANNA KÜHL/ DESIGNERS/ KAVIAR GAUCHE

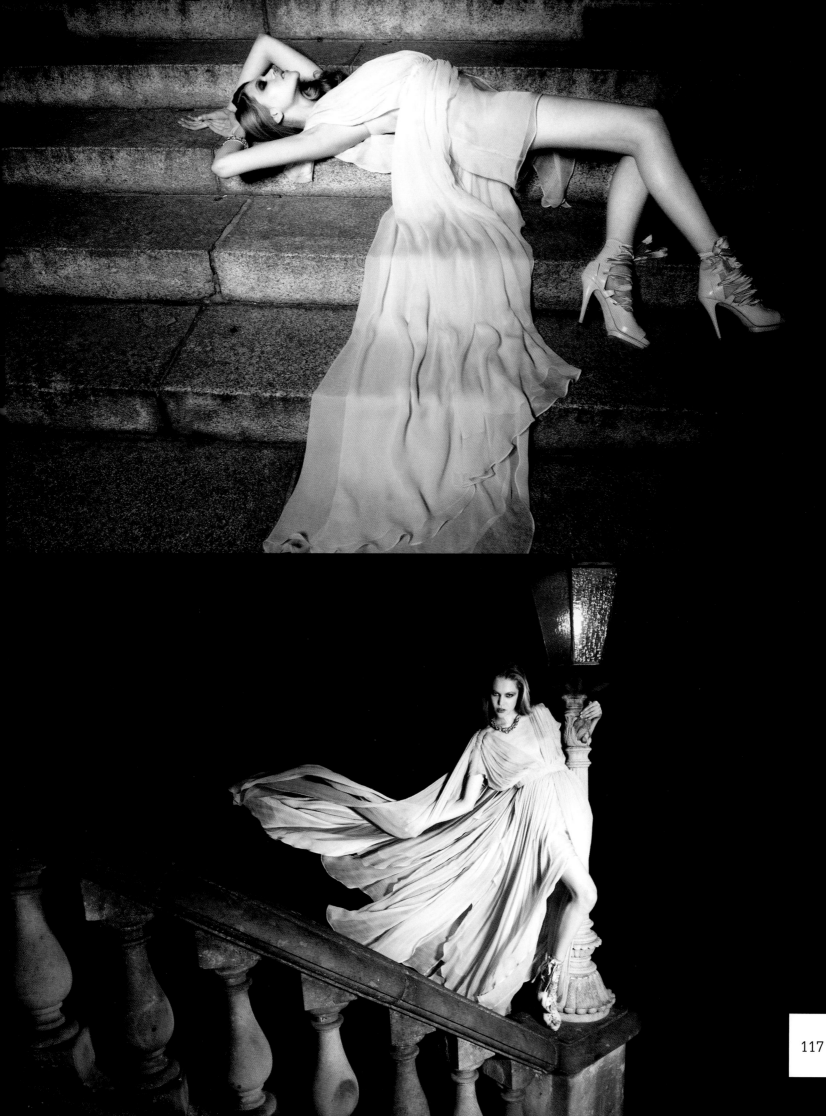

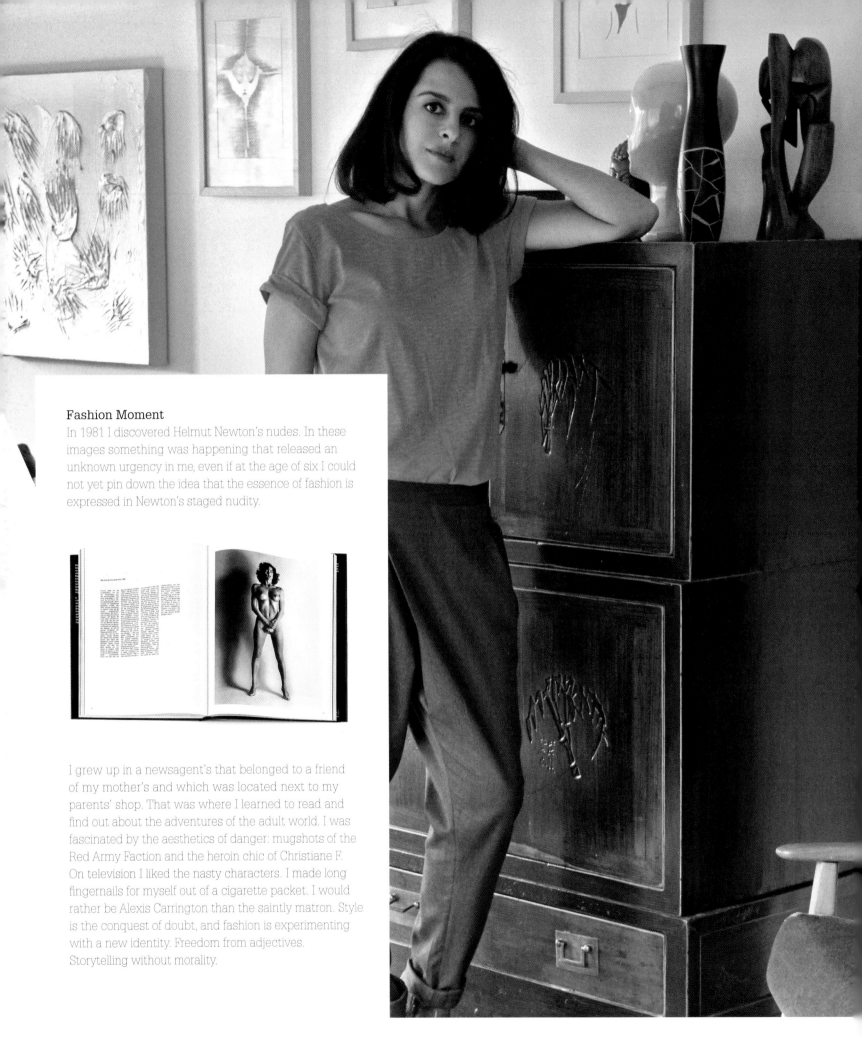

Fashion Moment

In 1981 I discovered Helmut Newton's nudes. In these images something was happening that released an unknown urgency in me, even if at the age of six I could not yet pin down the idea that the essence of fashion is expressed in Newton's staged nudity.

I grew up in a newsagent's that belonged to a friend of my mother's and which was located next to my parents' shop. That was where I learned to read and find out about the adventures of the adult world. I was fascinated by the aesthetics of danger: mugshots of the Red Army Faction and the heroin chic of Christiane F. On television I liked the nasty characters. I made long fingernails for myself out of a cigarette packet. I would rather be Alexis Carrington than the saintly matron. Style is the conquest of doubt, and fashion is experimenting with a new identity. Freedom from adjectives. Storytelling without morality.

_____/ESMA ANNEMON DIL/ AUTHOR, STYLIST AND DESIGNER/ ANAÏMON

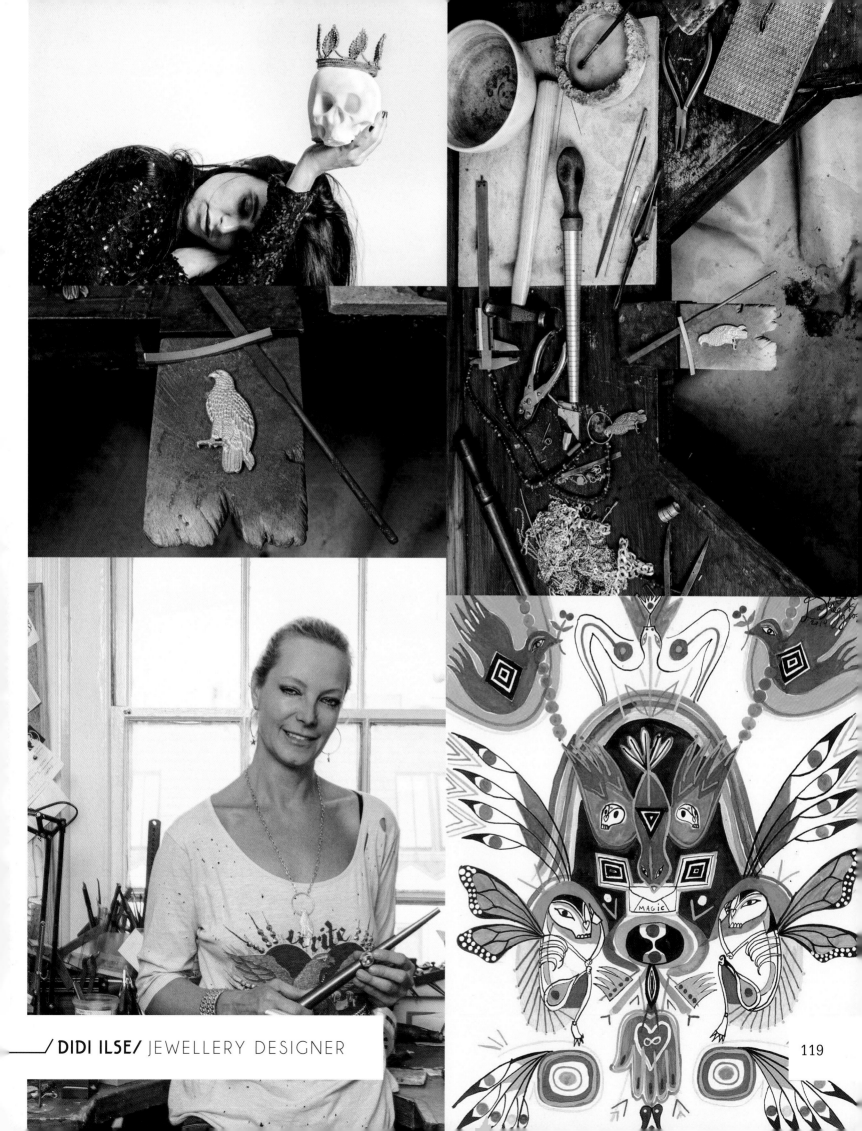

/ **DIDI ILSE/** JEWELLERY DESIGNER

A very normal blogger's year – or the fulfilment of my lifelong dreams, for fashion is the love of my life

January
Right at the start it's off to Florence, to Luisa Via Roma's famous Firenze4Ever, a gathering of international bloggers and designers. Then it's time for the haute couture shows in Paris, followed by the SIHH in Geneva. In between a quick beauty shoot in Paris with Dior.

February
The Fashion Weeks start with NYC. I have even trodden the catwalk myself in the American metropolis. From there, it's on to London and Milan. Sometimes there are scheduling conflicts, in which case I go to the Oscars in Los Angeles.

March
The F/W Fashion Weeks end with Paris, and that's a must for me every season. Usually there's not much time for a breather for London is calling with the Rodial Beauty Awards.

April
With Omega to Vienna for the presentation of the latest ladies' watch in the presence of Nicole Kidman. Then with Louis Vuitton to Munich for the opening of the new maison and to the photo session for the social media campaign of the long-standing French firm on the theme of the "Art of Packing". Good that Baselworld, the well-known watch and jewellery fair, is taking place nearby, so that I can fit in an interview for Profil.

May
As blogger host I'm doing a big photo shoot with MCM for the opening in Zurich. The Cannes Film Festival is coming up. As a guest of Chopard I enjoy a *montée des marches*, a number of parties, the most beautiful jewellery and a day on the yacht with Anna Netrebko and Petra Němcová. The crowning conclusion is the amfAR Gala at the famous Hôtel du Cap-Eden-Roc, where the Ultimate Gold Collection Fashion Show took place this year, curated by Carine Roitfeld.

June
In lovely, hot Florence the international blogger crowd is meeting again at Luisa Via Roma's Firenze4Ever and as always I'm looking forward to being there. My personal highlight: a private party at Cavalli's. Perfect timing: Gucci are opening their latest exhibition in the Tuscan city at the museum of the same name. Then more art at Art Basel.

July
For a month I travel throughout China, combining business with pleasure.

August
A big photo shoot in Berlin, several press conferences and short trips keep me on the go. Then I escape the hurly-burly for a week in Iceland. With my energy renewed I leave for the St. Moritz Art Masters, where I'm photographed by famous photographers such as Steve McCurry and Amedeo M. Turello. A pleasant change: a Night of Roses, with me as brand ambassador for Piaget, takes place in my garden.

September
Here we go again. The Fashion Weeks begin. But before I disappear to New York, I enjoy the Akris exhibition opening at the Bayerischen Nationalmuseum in Munich and celebrate the opening of Karl Lagerfeld's new boutique on the spot. In September it's one highlight after another: as the guest of Piaget at the Biennale des Antiquaires in Paris and just before that in Venice with Gucci, to interview Blake Lively.

October
The fashion shows come to an end in Paris. In the middle of the month the first T-shirt designed by me for Closed is launched. Three days of sniffing the mountain air with La Prairie in Interlaken. Then a quick flight across the pond for forty-eight hours, to celebrate H&M's latest fashion collaboration in NYC.

November
In Switzerland the Mercedes-Benz Fashion Days take place in Zurich, where I am a regular visitor in the front row. Next, I fly with Hermès for four days in Greece. End of the month, I host a dinner with Bobbi Brown to launch the new Caviar & Oyster make-up collection in my home, and I have a photo shoot on the theme of table decorations.

December
One of the greatest moments in my blogging career: Montblanc launches its Bespoke Limited Edition ink "Sandra Berry", the first ink to be dedicated to a person by the long-established Hamburg firm. Then a quick trip to Gstaad with Louis Vuitton for the opening of the new store, before I disappear to the warm climate of Qatar.

With love, Sandra

/SANDRA BAUKNECHT/ EDITOR-IN-CHIEF OF L'OFFICIEL SWITZERLAND AND EDITOR

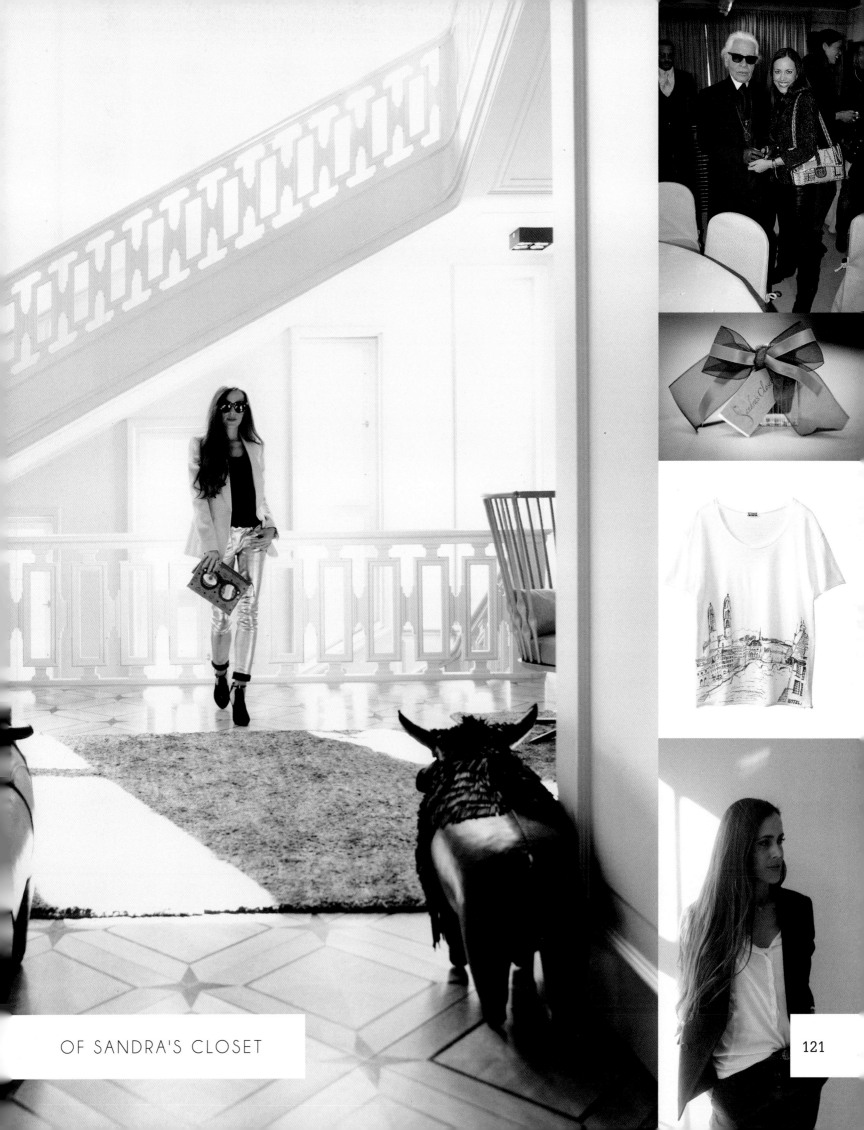

OF SANDRA'S CLOSET

How did you get into fashion?

Alexx: I have always had two passions in life – food and fashion. After graduating as a chef in Germany, I started to work on cookbooks, which brought me to New York City. There, I was able to utilize my culinary background to finance my life abroad, and began to work for a fashion design team called AsFour. It was amazing to experience NYC as a place that pushes people to their limits, while giving them the opportunity to realize their dreams and aspirations without any literal "Proof of Purchase," so to speak. This is when I decided to always follow my inner voice and to never stop embracing new challenges for personal development.

Anton: At eighteen, I had just ended a dance contract in Hamburg and travelled back home to New York where a friend and now a fashion director told me I needed to meet a certain stylist, Patti Wilson. I did not know at the time what being a stylist involved. When I went to meet her on the set of a shoot in progress, I remember telling her in a direct yet humble manner that the Claude Montana jacket she had chosen was rather awful; from that moment on she said I would be her "eyes"! We continued the working relationship for slightly over six years.

What do you two stand for (in three words)?

Alexx and Anton: Sophistication. Authenticity. Emotionality.

Describe each other.

Alexx: Anton carries a deep love of beauty in general, breathing style into every singular aspect and situation of his life.

Anton: Alexx possesses a great deal of passion and tends to lead with his heart. That being said, getting him to alter his opinion is like trying to topple a fortress with a feather.

In your opinion, the German fashion industry stands for ...

Alexx and Anton: In truth, sometimes we believe the German fashion industry seems to stand for practicality! We find it a bit of a shame that in Germany many float amidst a void of lust, emotion and infatuation for fashion. It has too often been brought to our attention that clothes are just that, clothes by German standards. Ingenuity, respect and admiration is often left for the automotive industry and science, leaving not much interest for fashion outside of function.

For what international clients do you work?

Alexx and Anton: We have worked for a while with Prada and have done special projects for Hermès, Thomas Burberry and The New York Times Magazine.

Do you work with other Germans in the fashion industry, and if yes, who?

Alexx and Anton: Being based in Berlin, it is a necessity to work within a local environment, yet with a global approach. Our German fashion clients have ranged from Marc O'Polo to Apropos – The Concept Store.

What makes you happy?

Alexx and Anton: What makes us happy is the concept that we have moved and/or touched someone even minimally merely through an image or the telling of a story.

/ALEXX AND ANTON/ CREATIVE DIRECTION AND PHOTOGRAPHY

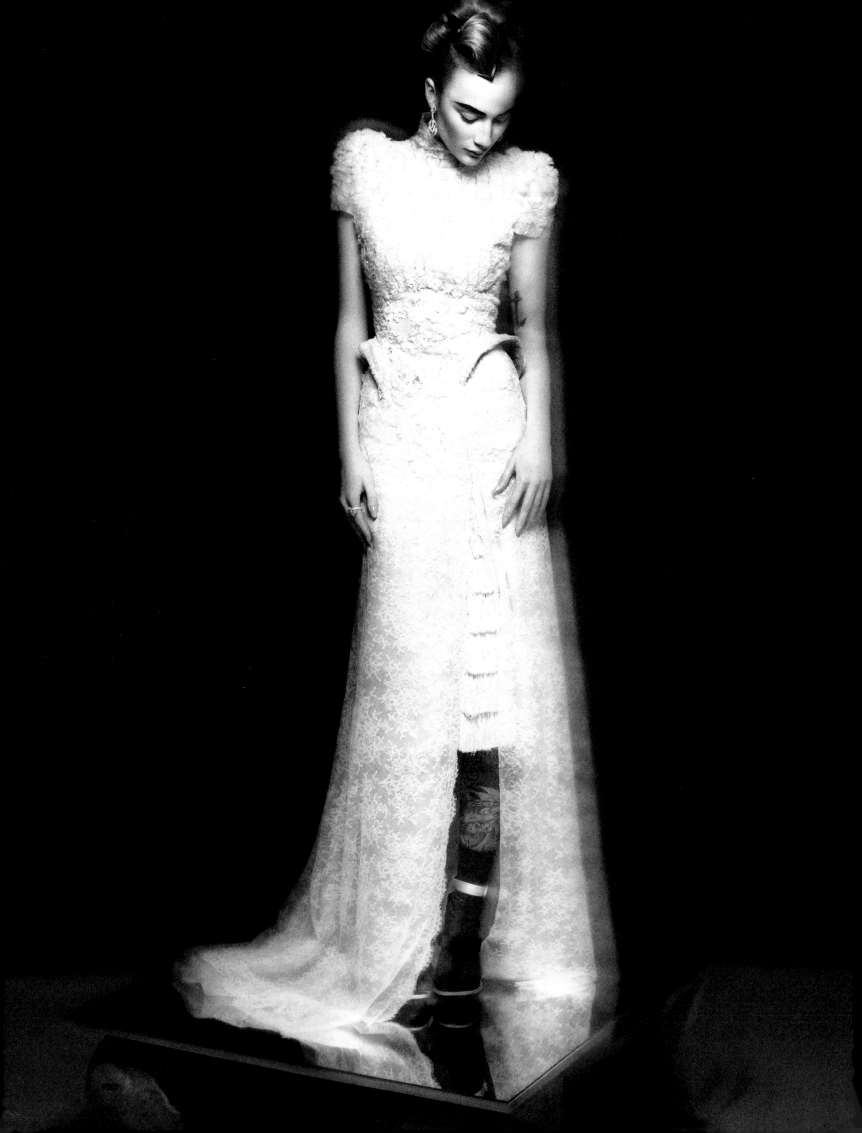

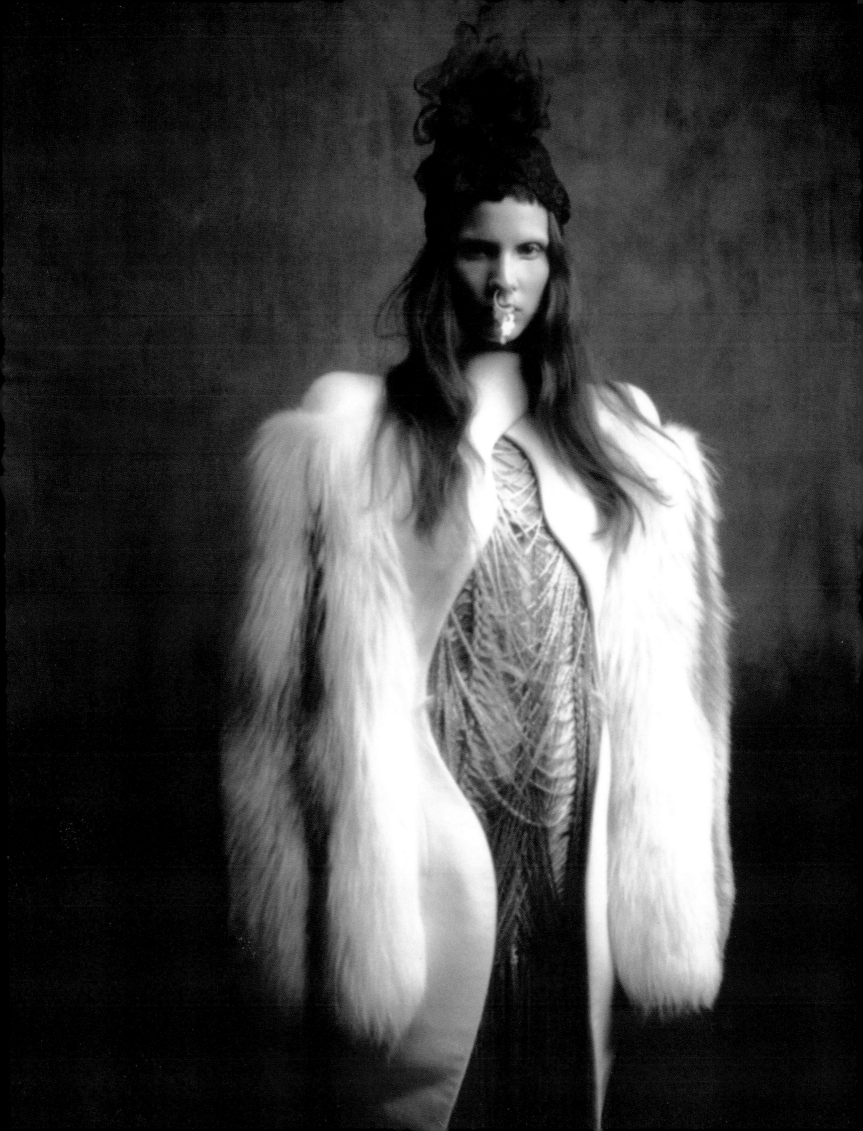

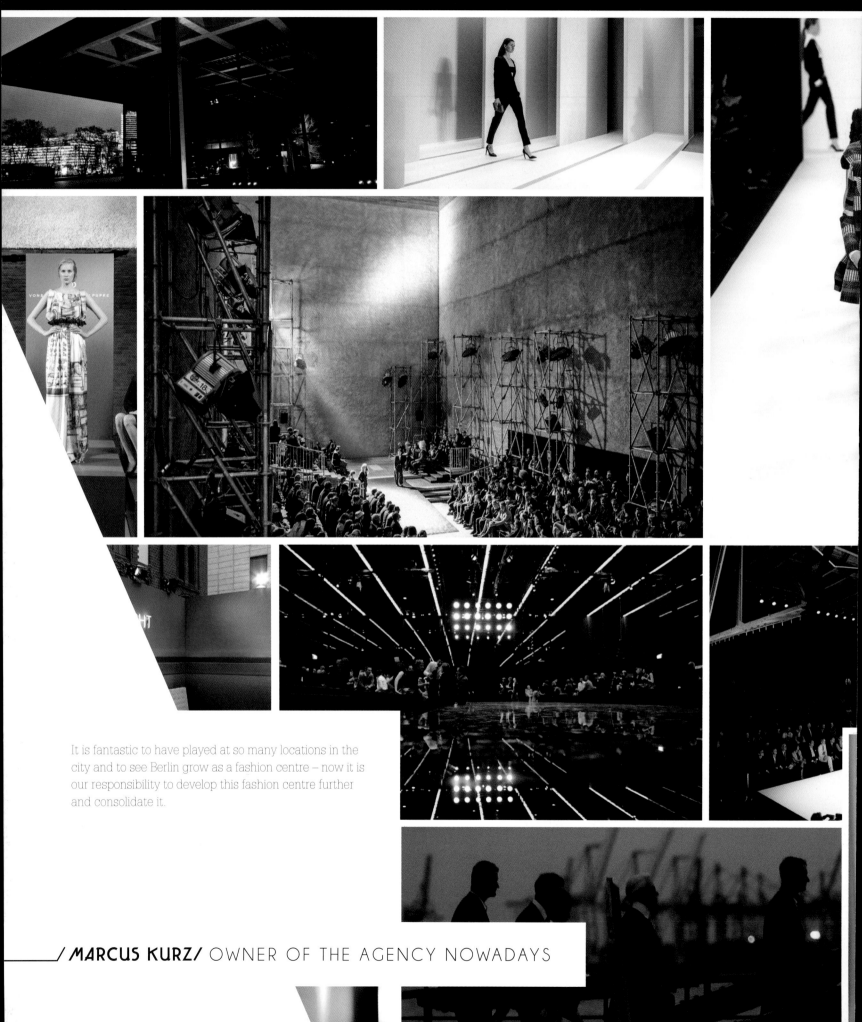

It is fantastic to have played at so many locations in the city and to see Berlin grow as a fashion centre – now it is our responsibility to develop this fashion centre further and consolidate it.

/ MARCUS KURZ/ OWNER OF THE AGENCY NOWADAYS

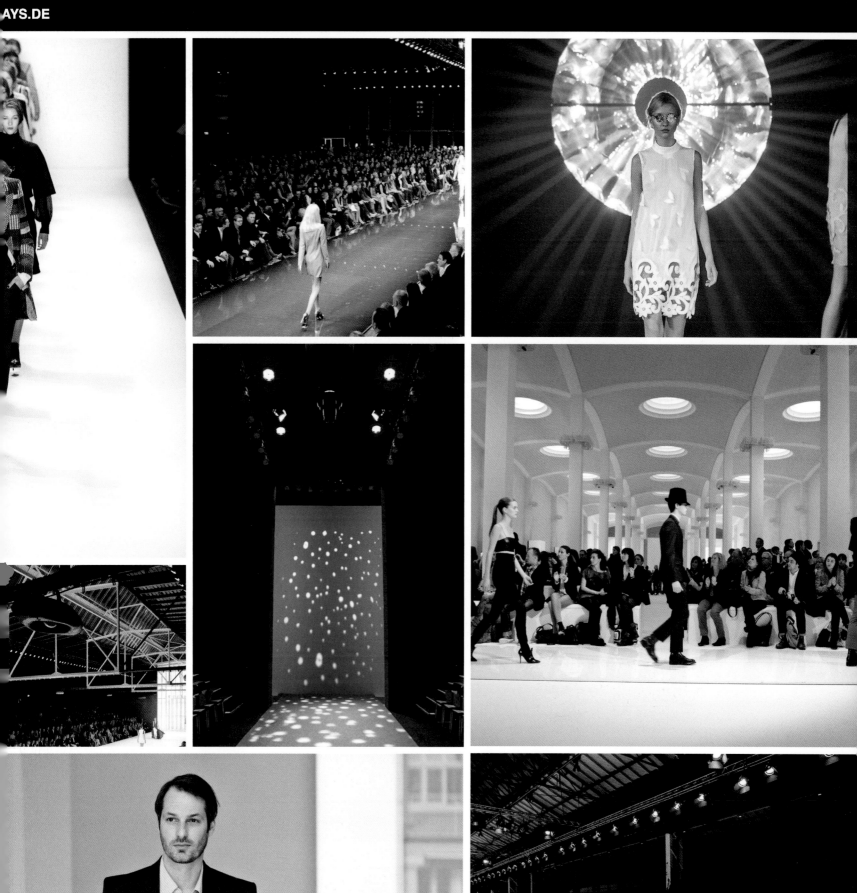

127

A/W 2013/14
Burak Uyan

S/S 14 Burak Uyan

/BURAK UYAN/ SHOE DESIGNER

S/S 14 BURAK UYAN

S/S 14 BURAK UYAN

S/S 14 BURAK UYAN

129

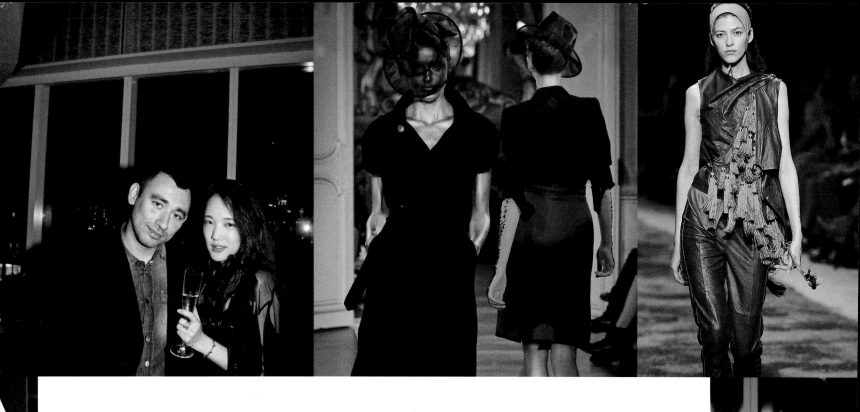

Certainly my first years in fashion at the renowned Paris-based agency Totem have been the most incredible, fascinating and influential years of my life. The very environment was an antidote to the boredom of any office job, the "nine-to-five" kind that many of my friends in Germany had to live through every day. In those first few years, through working closely with the likes of Raf Simons, A.F. Vandevorst, Veronique Branquinho and many more, I discovered what fashion meant to me personally: an artistic means of self-expression and authenticity; clothes, through editorials, fashion shows and film, became a means to convey a certain mood to the wearer; film, show music, hair and make-up all contributed towards expressing a certain feeling, an attitude, maybe even a political statement, a rebellion against existing closed systems, or the status quo.

Fast forward: I finished my art studies and very soon there was a decision to be made about my career: art teacher versus full-time fashion PR agent.

Please note that this was pre-*The Devil Wears Prada*, at a time when backstage was still backstage. There was no Twitter, and social media and celebrity cults had not yet invaded the fashion spreads, and for that matter "working in fashion" seemed somewhat obscure to many.

In this time of doubt I recalled some wise words my old maths teacher, a totally "unfashionable" lady, once said to me: "Fashion makes people dream. Think of it this way: you contribute to elevating people's minds away from their daily worries. When they look at a fashion editorial, they can dream. Fashion is important."

At the time her words helped me make an important decision: they validated in the bigger picture that fashion was not just superficial. Nowadays, her words seem more like relics of a long-forgotten time. Fashion has fully embraced its role as a commercial entity, making people buy rather than just dream, and of course the power is with the almighty advertising brands; not much space is left for the really creative designers.

However, a good ten years later and on the other side of the Atlantic with Nouveau-PR under my belt since 2007, it is still my belief that fashion can be about dreaming, authenticity and self-expression, even if we're surrounded by fast fashion and conglomerates and the rules that govern the so-called fashion industrial complex.

Top left: Nicola Formichetti and Suhyun Son; centre: AF Vandevorst, runway spring 2013; right: AF Vandevorst, runway spring 2012; bottom right: Corinna Springer

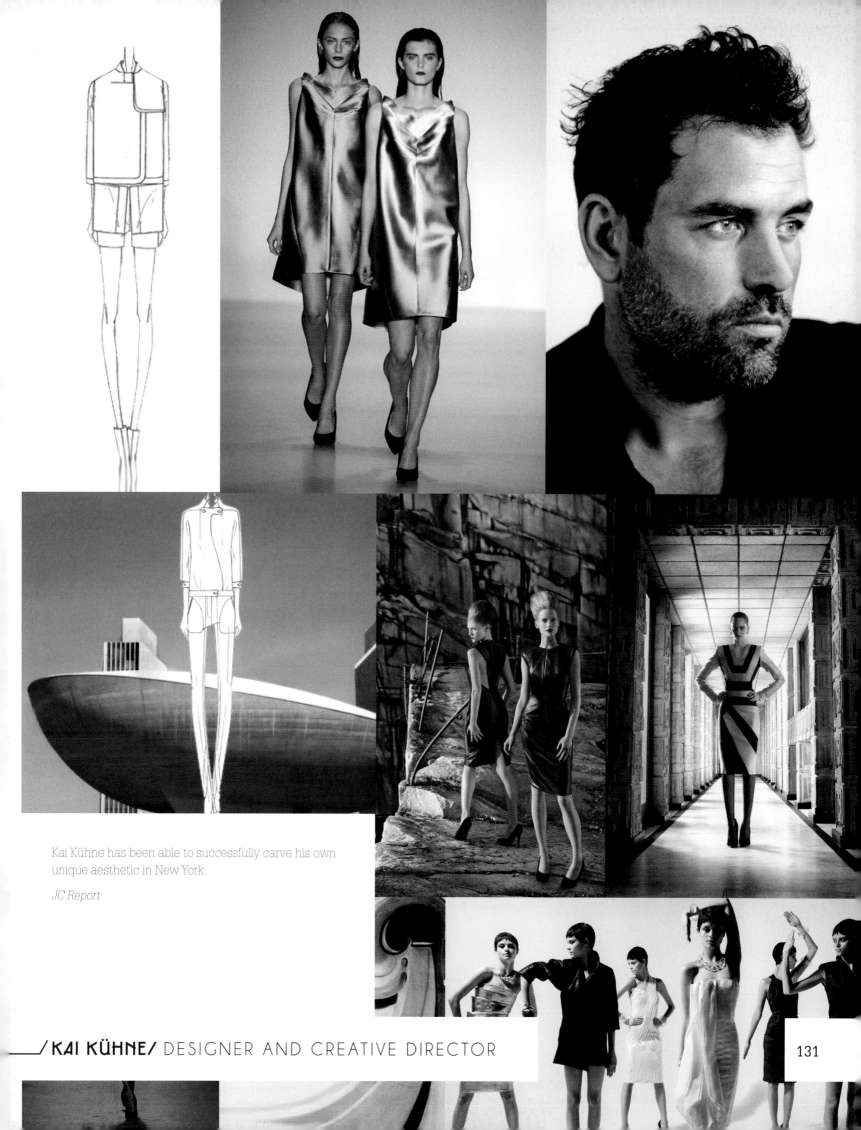

Kai Kühne has been able to successfully carve his own unique aesthetic in New York.

JC Report

/KAI KÜHNE/ DESIGNER AND CREATIVE DIRECTOR

Fashion is an industry that reflects, and sometimes dictates, the Zeitgeist of our times, yet beneath this avant-garde standard lies a conservative framework. Young, original designers and image-makers will find themselves facing old-fashioned publications and business partners, who often stand in the way of innovation. Fashion has pushed society's boundaries over and over again, yet there are still very clear taboos to avoid and rules that those governed by them are expected to operate.

I have been very fortunate to work in a creative place that isn't restrained by financial targets or advertising agendas. A rarity of its kind, Nick Knight's SHOWstudio in London is free of corporate restrictions, being indepeently owned, and far removed from the mundanity of running a business. SHOWstudio is our work space, a photographic studio as well as a gallery, a meeting and drop-in point for image-makers, designers, artists and other colourful characters who regularly visit for tea and cake and stories.

Part of the beauty of this set-up is that we can accommodate projects that would not otherwise find a house elsewhere and work with artists who are deemed too risky for most publications or websites.

In 2013, SHOWstudio, which was founded in 2000 by Knight to promote the new and exciting genre of fashion film, launched a new concept for its yearly fashion film season entitled "PUNK". We asked our contributors to create short films that explore the fundamental DIY spirit of punk under the theme of "Dressing to Provoke". Yet what is provocative today? A girl in fishnet stockings will not get the same reaction she would have elicited in 1975 Bromley. It seems as if fashion has hardly anything left that can truly outrage.

I then came across Courtney Stodden. For anyone who missed her shameless publicity campaign, Courtney is a nineteen-year-old American starlet who rose to instant fame when, at the age of sixteen, she married actor Doug Hutchinson – who was fifty-one at the time. Now, three years along the line, and a divorce and boob job later, Stodden is a household name in the tabloid circuit. She cleverly built on her initial tabloid fame by keeping the public outraged on a daily basis. Her overly sexual demeanour and revealing clothes became her selling point – and got the public reacting with disgust. Stodden is famous for being hated – her first "music video" has 96 per cent dislikes on YouTube – yet it has almost seven million views. Stodden dresses to provoke and has marginalized herself from a shocked society. She is as punk as it gets these days.

I wanted to film her for my own contribution to the punk film series so I got in touch with her team, which consists of her mother and now ex-husband, who were exceptionally friendly and helpful. Eight weeks later, Stodden came to SHOWstudio and I spent the day filming her in her element: dressed in tight latex, running in slow motion, seductively licking a lollipop.

Stodden was everything I hoped and expected. She is extreme and unapologetic, beautiful and bizarre, and she was very clear about her self-image. She politely refused black lipstick ("I am no Lady Gaga") and laughed off my attempts to demonstrate the "Marilyn Monroe pose" ("Honey, I know these by heart").

I wanted to make a film that celebrates Stodden for what she is. My film is not supposed to be a judgement of her. I don't wish to express my approval or dismay of her. It staggers me that she has to deal with so much hatred. One might like or dislike her, but does this call for such extreme backlash? Who are we to judge? Stodden and her team are some of the friendliest people I've ever had the pleasure to work with. Contrary to her public image, she is also one of the few models I've filmed who hasn't wanted to show her nipples on camera. However, because Stodden isn't Kate Moss, because her aesthetics and style are classified as "tacky", many in the fashion industry who see themselves as harbingers of taste and elegance seem to think they have a right to judge and condemn her. We love to hate her because it makes us feel better about ourselves. We love to point out that she is famous for doing nothing and having no talent. Yet it's us who made her famous and we're the ones who keep her current in the tabloids.

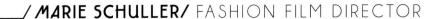

___/ MARIE SCHULLER/ FASHION FILM DIRECTOR

I'm editing the film now and I'm well aware that it will be ripped apart upon release. It seems surreal that the most punk subject I could find is a nineteen-year-old sexualized Barbie doll, but working with Stodden has proved my point – not only are we too quick to pass judgement, but also we should ask ourselves: Who has the power to dictate what's tasteful or acceptable?

Fashion is the most basic form of self-expression, yet the industry carefully stays away from characters like Stodden – she is not someone the typical high-fashion-wearing editor wants to be associated with. However, Stodden has her own personal style and represents a side of fashion that cannot be ignored – one that is highly visually and culturally interesting. I think we would all benefit from accepting and celebrating various ideas of beauty, fashion and style. It makes our world much more interesting and colourful. And to all the people who feel it necessary to comment negatively about starlets like Stodden, I would suggest that their world would be just a little more boring without her.

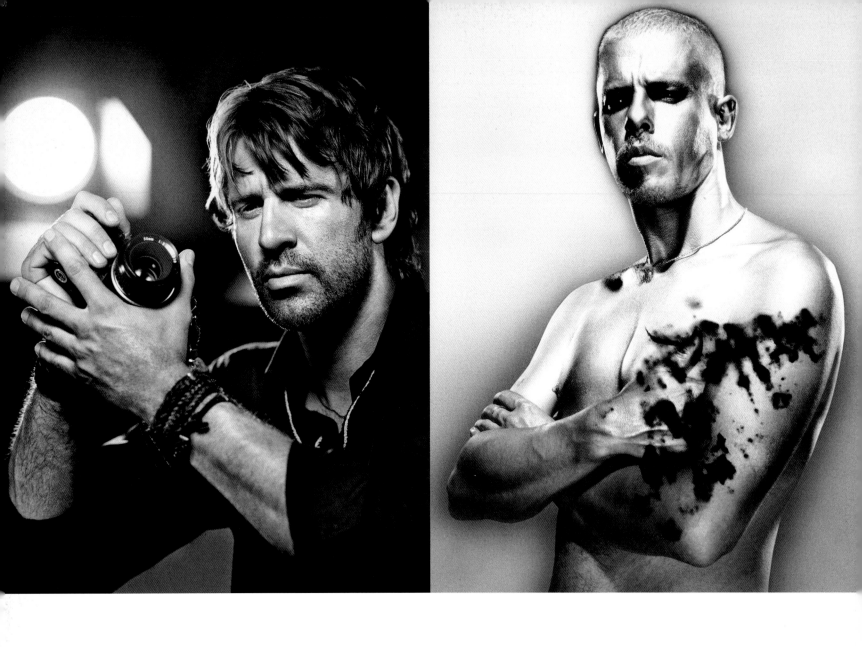

___/VINCENT PETERS/ PHOTOGRAPHER

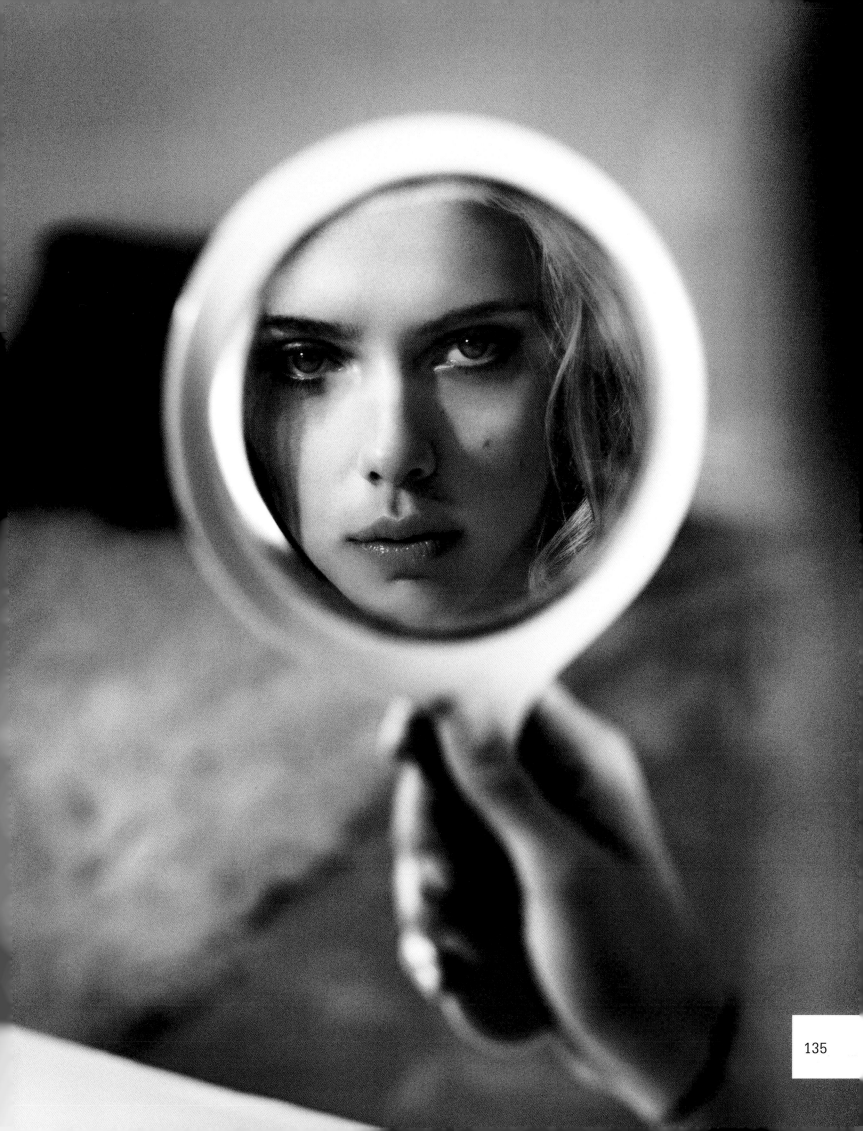

enmeshed

when you have finished with me and
kicked me out of your life and have long
been seeing someone else
touching up your lips and
kissing him bitterly when the
vortex there in your hair the mystery
that it always was no longer casts
its tangled shadow you will lose
not a word more between
my lines and will run away from
your mesh with seven-mile strides
where I carried you on empty hands
what remained of your silhouettes of the
fabric from which love drips I hung on
you the remnants in which you wrapped
and stuffed me the red thread for your
glow the line you drew like a zipper
across the collarbone left me
lying there like a broken heel you are
no longer at your best darling you cost
me dear I will go I lay on the catwalk and
your legs grew into the sky your eyes
two clouds so enormous above passed
on with the wind from the woods the night
wove itself into your golden strands and I
held the sunset tight in my fist like
a pledge lost my reason naked happiness
the cold crept back like the snake from the
shadow on the afterglow of the
stone indistinguishable from it
in the darkness through which I ran
seeking traces of your luminosity
the woods are lovely dark and
deep and with my heartbeat racing rubbed
a hole in the pastel sweater you lent to me
it's not over before it's over or
you pull your second skin over
my twisted head with a magic word
as a knot and intertwine the
threads again and so we
dream ourselves on your lips
until the wound closes on and on

promise

when I have finished with you
when I succeed and force myself
with my head high
out of the dead end of your love
pressing the sun visor cry
in front of the windscreen
don't cry I am singing
revving the engine
my foot on the gas my collarbone
wound up the speedometer needle
tattoos the bags under my eyes
I race with spinning wheels
through ex-love's killing fields
you have brought me onto
this route pierced high heels into
my heart as though I was a
vampire who must be impaled
as though my blood had not
flowed instead of your tears
drops of crocodile leather
and a belt buckle to cut off
my air supply just don't move
I wanted to seduce you, abduct you,
touch you and not feel the
metal tube in the cavity of my
mouth the course of things
as they came and I too
late to get away with my
dream which you perforated
with bullet holes hardly to be
counted and pink ribbons on the
fracture points these sensitive
souls you knew how to
torture me as though I had seven
lives but none to share with you
the table with the axe the bed
set on fire you wanted to
burn your sex is on fire and I
am behind barbed wire the old
story the devil take you he is
a scavenger and will certainly
eat out of your hand when I
have long been on my way into
the hinterland where I am going
where probably to the next best
wall

Albert Ostermaier

/ANDREA KARG/ CASHMERE DESIGNER/ ALLUDE

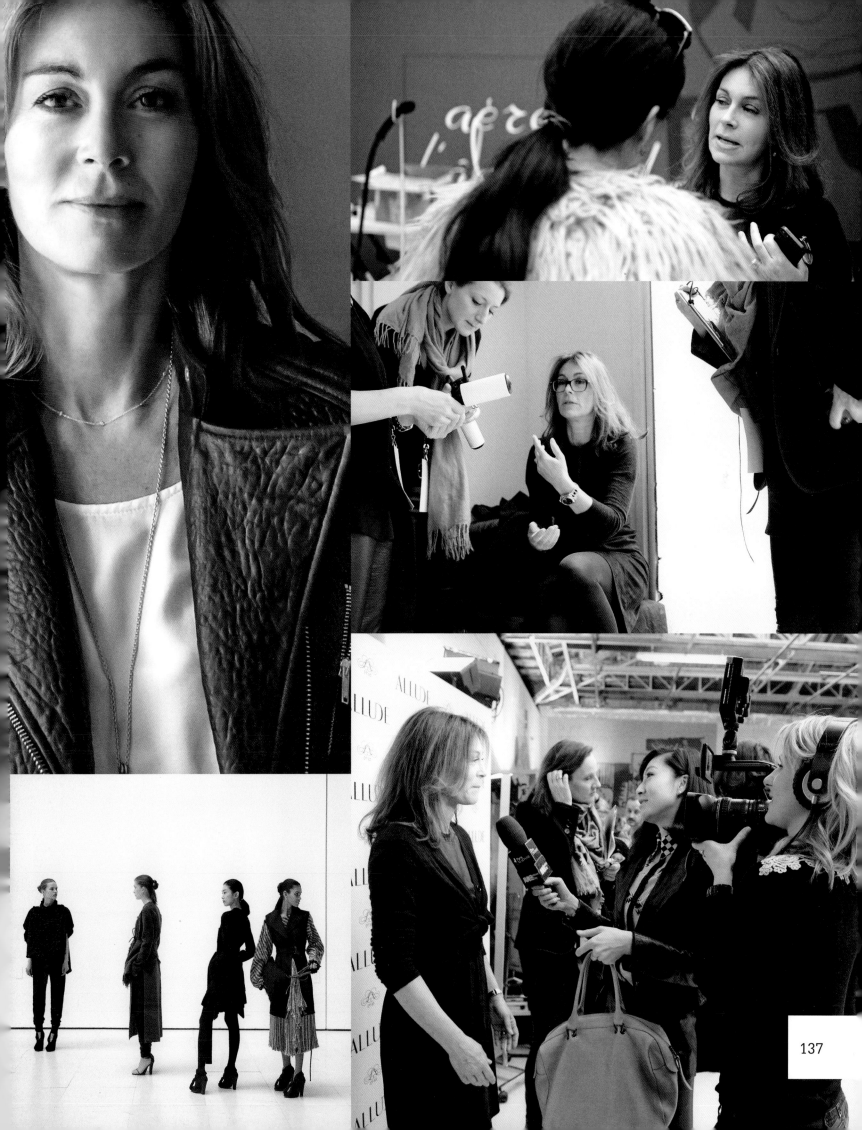

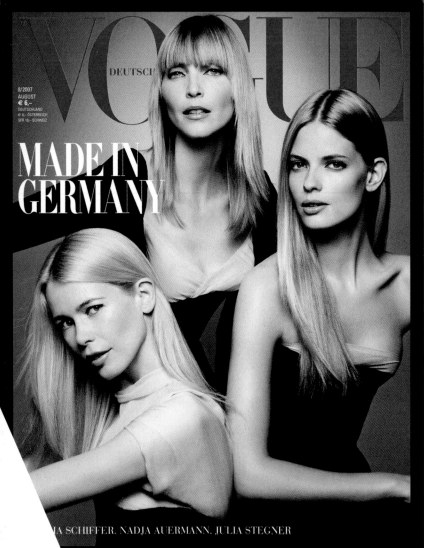

MADE IN GERMANY

...IA SCHIFFER. NADJA AUERMANN. JULIA STEGNER

Julia Stegner was five feet nine inches tall at the age of fourteen, and her slender figure instantly impressed me. It quickly became clear to me that she was perfect for the international market. Julia's first casting trip led her with her mother to America, where she was immediately approached to be a face for Revlon Cosmetics — however, Julia went back to school. Her first test shoot in Paris also became her first cover for French Elle.

EL LIBRO AMARILLO

STILO TOTALMENTE PALACIO
...MAVERA·VERANO 2013

—————/LOUISA VON MINCKWITZ/ OWNER OF LOUISA MODELS

JULIA STEGNER

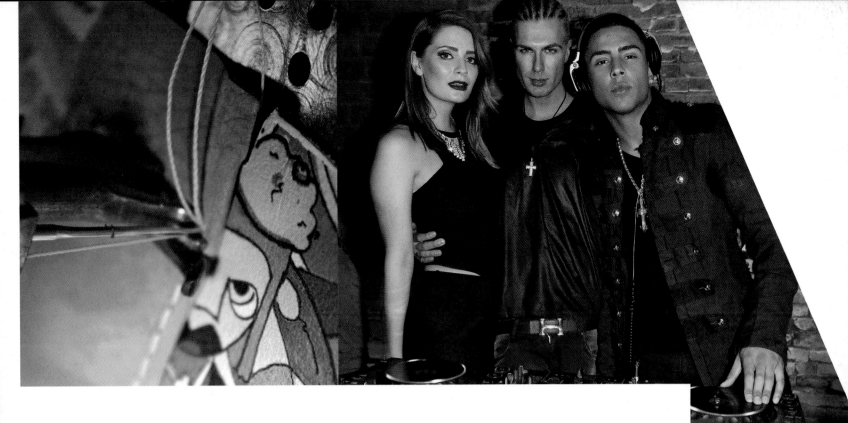

What comes to mind when you hear the words "Germans" and "fashion"?

Germans have a very structured and efficient mindset, and this focus and drive have made Germany innovators in many fields. We associate "Made in Germany" with technology and efficiency, not necessarily creativity and conceptuality. Therefore the first thing that many people think of in association with "Germans" and "fashion" is, basically, socks and sandals – an efficient and practical combination. I believe that there is more potential in the German fashion market.

In your opinion, the German fashion industry stands for ...

Satisfaction and expectation. Germany has a high standard of expectation in the world. We are reliable and correct and always deliver. But shouldn't we exceed expectations and surprise people with something new? I feel this process is slowly and steadily coming along in Germany.

What kind of women/men do you design for?

The André Borchers client is not defined by age, race or gender – the new luxury consumer we cater to chooses exploration over stagnation. We want our client to make a bold fashion statement without losing the aspect of heritage and tradition.

What obstacles do you face as a designer?

The initial reaction of people is to reject the unknown. My style and personality are unique and often polarize opinions. For me, it's twice as hard to receive recognition for my work because people have to look beyond their prejudices and their fixed values to embrace the unknown and see the uniqueness.

What meaning do collaborations with young artists (for example your charity projects) have for you?

It means a lot to me. I'm currently on my way to building up a street-art foundation to give creative people the chance to show their art in a legal way. I had a lot of luck in my life and I want to pass that on to others.

Who inspires you?

I'm not inspired by specific individuals – I respect people for their achievements, but I seek my inspiration in the intangible rather than the tangible. I look to nature, society, social movements or culture for new ideas and a new way of thinking. When we combine something that isn't meant to be together, we can find new and exciting ideas for inspiration.

Top right: Mischa Barton, André Borchers and Quincy Brown

At first glance, the contrasts could not be greater – on the one hand, a glamorous, glitzy world, entirely concerned with external appearance, apparently carefree, fast-moving and a little superficial. On the other hand, charity, which is concerned with social issues, illness and death, and refuses to close its eyes to social ills and problems. And yet Martina Rink asked me to write about "Fashion and Charity". A wonderful task!

I am firmly convinced that it is possible to build a bridge between these two worlds. How? It's a question of finding the right balance, of keeping one's feet firmly on the ground and not losing one's grip on reality.

Fashion and commitment to others determine my life today. And so I would like to take you on a little journey – into the glittering world of fashion, where "looking good" is part of daily business. And into a world where appearance plays quite a different role, a therapeutic one.

Even as a young girl living in Holland I was enthusiastic about the fashion world. My favourite reading was Vogue, my heroine was Lauren Hutton. I was shy, insecure and nevertheless dreamed of a career on the catwalks of the fashion metropolises. This dream was fulfilled several years later, but the path to it was far from straight. In an early version of *Germany's Next Topmodel*, only without cameras and not presented by Heidi Klum, I was armed for the catwalk with books on my head, and had my first commissions in Germany, a contract in Paris. But my parents advised me to be sensible and get an education. Many, many years later – having in the interim established a career in Holland as regional manager at a temporary employment agency, moved to Hamburg for the sake of love and ready to tackle new tasks – my past caught up with me. "Why don't you work as a model again?" my husband suggested. Model in my late forties? Start afresh in a business where you can be on the scrap heap in your mid-twenties?

I was actually given the chance. Today I am in my mid-fifties, feel very comfortable in my skin, am able to enjoy my life creatively as a model, and to regularly slip into various roles. It is precisely the transformation that appeals to me in this profession. Through working as a photographic model one sees oneself with the eyes of others, keeps discovering new sides to oneself and is often speechless at what make-up and hair artists can make of one in collaboration with visionary stylists.

That is one side of my profession. But there is another task that has become possible as a result of my life as a model. A sort of mission, in which I gladly invest my time and

which constantly brings me back down to earth. For two years I have been an honorary ambassador for DKMS LIFE. Once a month, together with a make-up artist and a psychologist, I supervise a make-up seminar for women with cancer who are undergoing chemotherapy. For a whole morning we show the participants how they can make themselves up despite having lost their hair, eyebrows and eyelashes. Here the perfect make-up is not a question of trends; it's not a case of looking perfect. It's only a matter of giving back a little normality to sick women and strengthening their self-esteem. Many of these patients have absolutely no self-confidence any more, because everyone can see straightaway that they are sick and are defined only by their sickness. And this is where we want to help them. We want them to feel strong again and to be able to go out in the street confidently and with heads held high. At the end of the day, these women need to look in the mirror again and be able to say to themselves: "I am beautiful."

Of course everyone has their own idea of beauty, but today beautiful people are everywhere in the media, and much is defined by good looks. Countless conversations have taught me how difficult it is for these women when they are perceived as sick people and not as women. At DKMS LIFE we want to help mitigate the outward effects, because we are convinced that visual beauty helps them to allow their inner beauty to shine out as well. Studies show that confidence and high self-esteem can help the healing process. Of course this does not put the world to rights straightaway – that would be absurd. But many participants have reported very positive effects in their environments.

When I am able to be with these very different women, some vulnerable, some strong, I am not the model: I am entirely there for them as a person, trying to help them with the means available to me. I would like to give every single woman the feeling that she is not identified by her illness, so it is important to meet them on an equal footing.

All right, you may be saying to yourself. Petra models and she gets involved with women with cancer, and applies her experience from the fashion world in matters of make-up and self-confidence. But, you may object, these are still two completely separate worlds. My answer is yes and no. Because beyond the personal balancing act between glamorous job and often heartrending experiences, I would like to use my popularity to draw attention to one world from the other. When I return to the world of glamour, I transform back into the model Petra van Bremen.

___/ PETRA VAN BREMEN/ MODEL AND CHARITY AMBASSADOR

Just before I step onto the red carpet, I grow tense and my heart begins to race. I quickly tug at my dress one more time, gather my thoughts and then off I go.

As soon as the photographers call my name and the flashbulbs begin to pop, my nervousness seems to fly away and the routine begins, with a smile and a good pose for the photographers. It's a practised and professional interaction. For the photographers it's important to get a good picture, and for me, that beautiful images are in circulation, because these are the be-all and end-all of my reputation. Then I dedicate myself to the journalists and reporters. That is the precise moment when I can talk about DKMS LIFE and try to use my popularity to get more attention for this enormously important project and reach a larger public through the media. Even if seeing and being seen is at the centre of such events, and many guests focus on small talk and drinking champagne, I also use this opportunity to talk about DKMS LIFE. Of course not everyone wants this. And sometimes it makes me sad. Certainly it's easier to talk about more cheerful subjects, and I understand that not everyone can do that. All the same, I would sometimes like more open-mindedness and less superficiality. But I also experience at least as much that is positive in the fashion world, specifically in the context of charity. Many businesses, personalities and designers commit themselves financially and do a lot of good without publicizing it.

Whether it is ecological concerns, involvement in the fight against disease and social ills, or standing up for the weakest in our society, charity work is increasingly a "must-have" in the fashion world. But what troubles me is when people just talk and don't take action. When people use their name to campaign for something but never invest any time in taking part in the projects.

For me, the balancing act between show and seriousness is not difficult. I can only say that it's not all black and white. I am not only a model and an ambassador for DKMS LIFE, but also a wife, daughter, aunt and stepmother. It's a question of finding the right balance between the different areas of life. But this also means sharpening your view of reality. With all the glamour, the beautiful clothes, the perfectly styled hair and flawless faces, one can easily get lost. This makes a stable environment that much more important. I can count myself lucky that I have people around me who ground me and shape me, like my husband, my family and good friends. And then it's the work for DKMS LIFE

that shows me each day how valuable life is, even if it's not always easy to keep a professional distance. These women's fortunes affect me very deeply. Especially when I have seen many seriously ill patients or young girls, it's hard to find my way back into my own everyday life. I try to turn off my thoughts and return to my own world. At the same time I am grateful for the experience and realize how good it is to pass on part of one's own good fortune to others.

In my business, as an older model, I am almost already considered to be in possession of the wisdom of age. And so I would like to encourage you, too, to get involved. Financially, by all means. But beyond that, preferably also personally. Real commitment does not automatically have to do with a lot of money. It has to do with time, awareness and attention. Time is valuable – I know. But that's exactly what it's about in my eyes: to deal intensively with a project, to sweat blood over it and to try to get other people involved as well – that's what counts.

Each time I talk publicly about DKMS LIFE, I wish with all my heart that I am able to touch other people with it. It's not a question of me, but about the women who need help. I go there anyway – I am there for them.

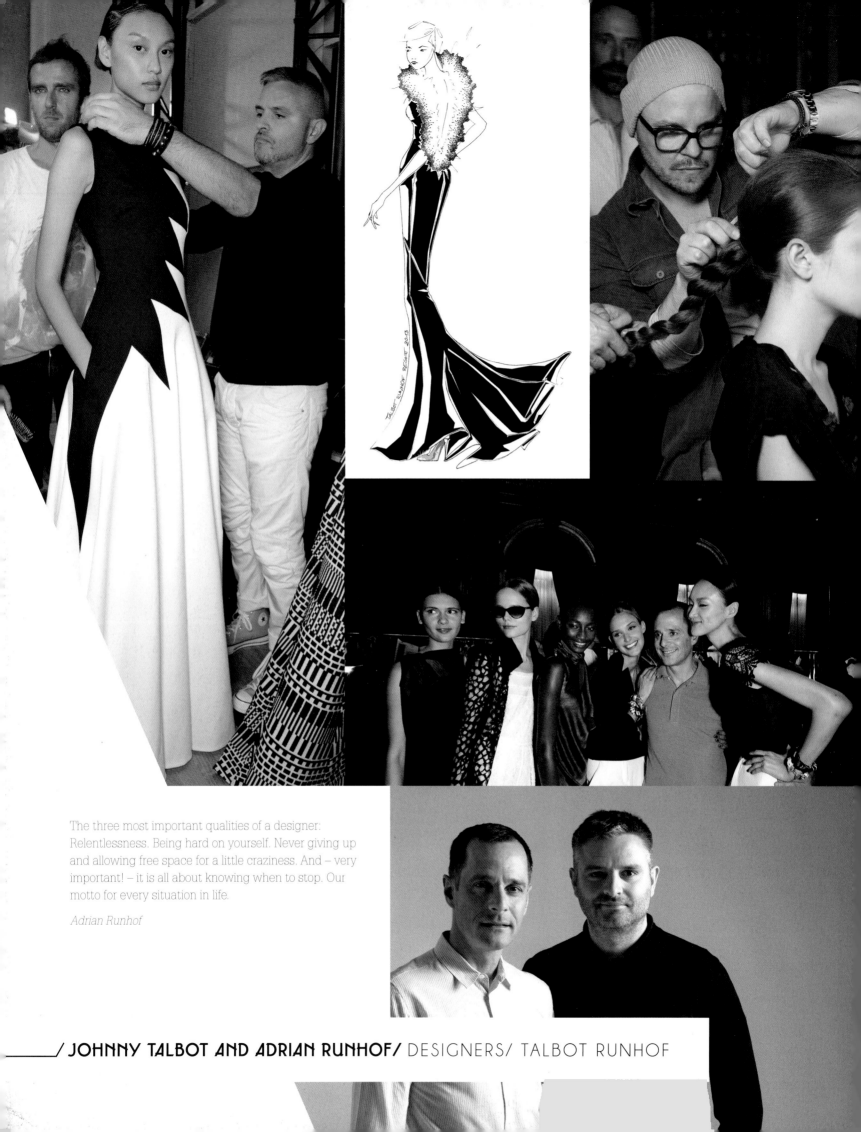

The three most important qualities of a designer: Relentlessness. Being hard on yourself. Never giving up and allowing free space for a little craziness. And – very important! – it is all about knowing when to stop. Our motto for every situation in life.

Adrian Runhof

_____/ **JOHNNY TALBOT AND ADRIAN RUNHOF/** DESIGNERS/ TALBOT RUNHOF

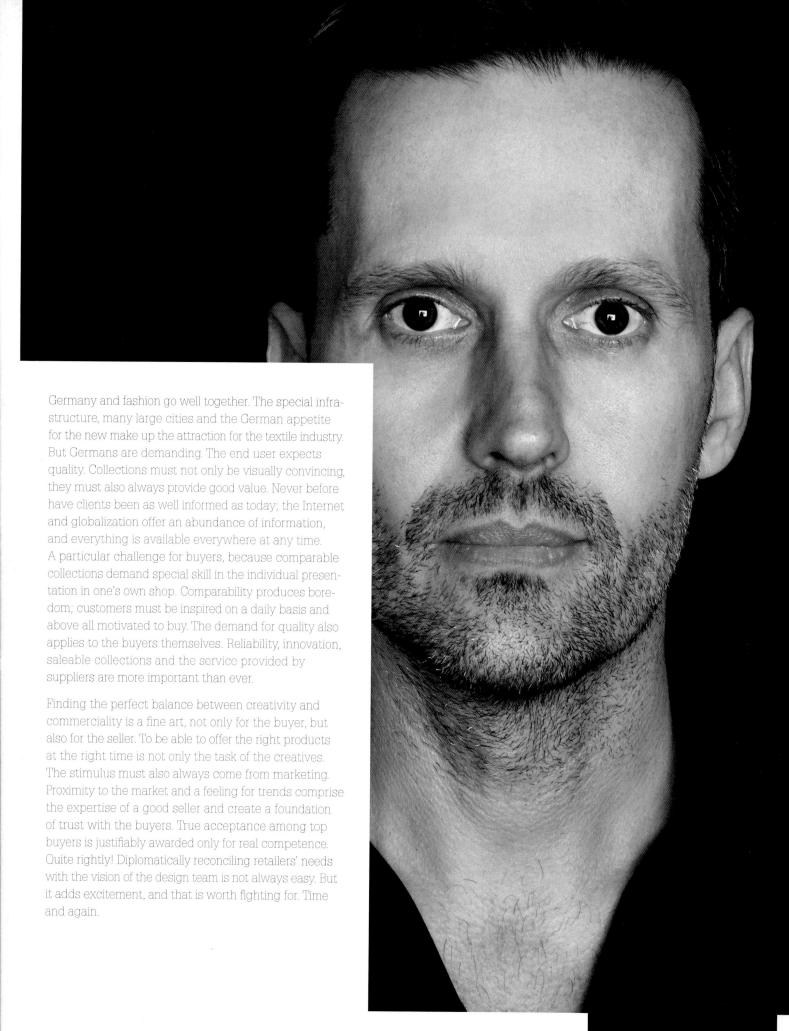

Germany and fashion go well together. The special infra-structure, many large cities and the German appetite for the new make up the attraction for the textile industry. But Germans are demanding. The end user expects quality. Collections must not only be visually convincing, they must also always provide good value. Never before have clients been as well informed as today; the Internet and globalization offer an abundance of information, and everything is available everywhere at any time. A particular challenge for buyers, because comparable collections demand special skill in the individual presentation in one's own shop. Comparability produces boredom; customers must be inspired on a daily basis and above all motivated to buy. The demand for quality also applies to the buyers themselves. Reliability, innovation, saleable collections and the service provided by suppliers are more important than ever.

Finding the perfect balance between creativity and commerciality is a fine art, not only for the buyer, but also for the seller. To be able to offer the right products at the right time is not only the task of the creatives. The stimulus must also always come from marketing. Proximity to the market and a feeling for trends comprise the expertise of a good seller and create a foundation of trust with the buyers. True acceptance among top buyers is justifiably awarded only for real competence. Quite rightly! Diplomatically reconciling retailers' needs with the vision of the design team is not always easy. But it adds excitement, and that is worth fighting for. Time and again.

/ **MARCO STEIN** / SALES DIRECTOR/ 7 FOR ALL MANKIND

AFRICAN PICTURES

JOHANNES HUEBL
April 17th 2013
UNITED NATIONS

What comes to mind when you hear the words "Germans" and "fashion"?
I think Germans are very fashionable people with a good overview of European and worldwide trends, adapting many things from various cultures and incorporating them into their own interpretations.

Even if they haven't set any major trends in fashion yet, the street style of cities like Berlin and Hamburg is certainly being recognized worldwide.

In your opinion, the German fashion industry stands for ...
Producing great talents, housing the most educational infrastructure for design graduates in Europe, supporting the development of green, eco-conscious fashion, and also representing clean-cut designs and visions inspired by pioneers like Karl Lagerfeld and Jil Sander.

How did you get into fashion?
At the age of seventeen I was approached during my boarding school year in Dublin by Boss Models London. Later, during my last two years at school, I was signed by Promod Model Agency. After I moved to Hamburg to study business economics at the university, Promod started managing my career and connected me to agencies worldwide.

Describe your work in three words:
Lights. Camera. Action.

What is your secret to becoming one of the world's most interesting male models?
Discipline, hard work, patience and a tad of luck.

What have been your favorite modelling jobs so far?
I've had many memorable moments as a model, but if I had to pick one, it was probably a short film for a Dunhill perfume that we shot in various locations in Brazil, from the favelas in Rio de Janeiro to deserted beaches – in which I played an 007 agent ... What guy would say no to playing a James Bond-type character?

What city is the fashion capital of Germany in your opinion?
Clearly Berlin. People will have a hard time arguing that.

Of the people you've met in the fashion industry, who has inspired you the most?
Valentino Garavani

What advice would you give a young man who wants to become as successful an international model as you?
Have a back-up plan.

The future will bring ...
More interesting photography projects, design collaborations and setting up my own brand. Or was this a philosophical question?

Right: Johannes Huebl is more and more often to be seen behind the camera. This photograph is from the series *African Pictures*.

_____/ **JOHANNES HUEBL**/ MODEL AND PHOTOGRAPHER

_____/ ANNELIE AUGUSTIN AND ODÉLY TEBOUL/ DESIGNERS/ AUGUSTIN TEBOUL

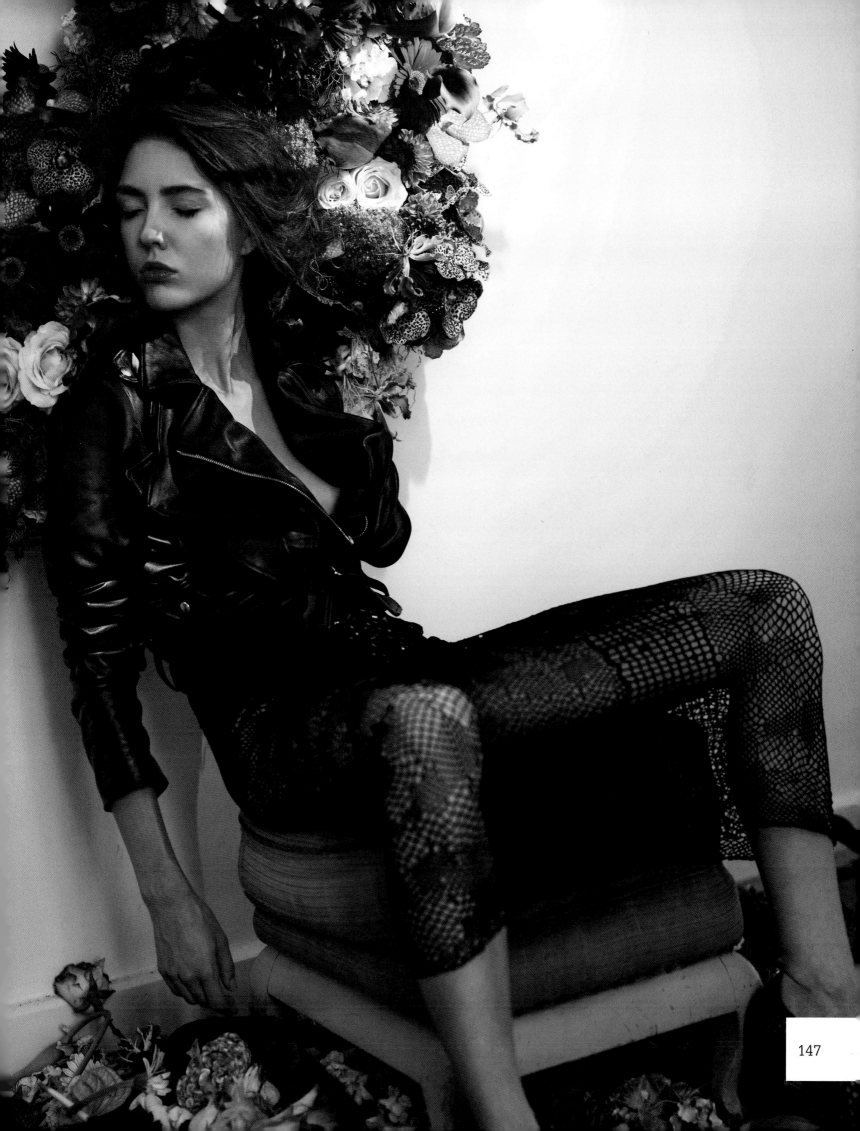

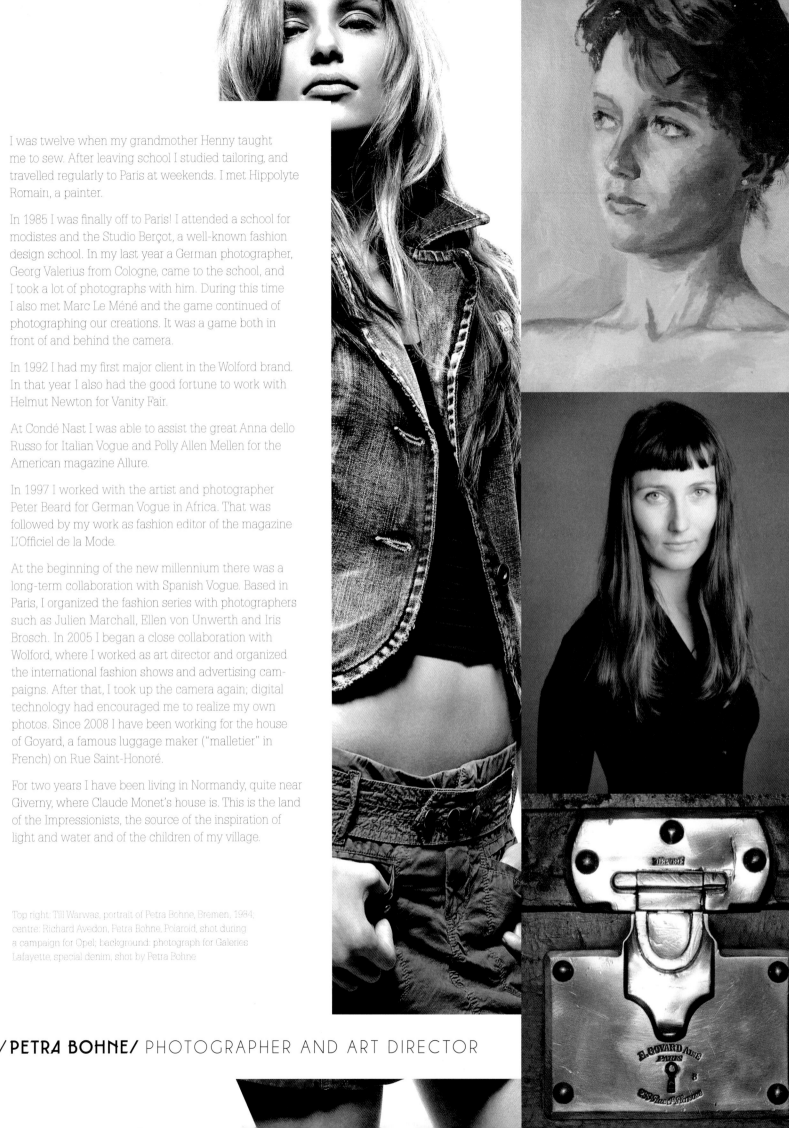

I was twelve when my grandmother Henny taught me to sew. After leaving school I studied tailoring, and travelled regularly to Paris at weekends. I met Hippolyte Romain, a painter.

In 1985 I was finally off to Paris! I attended a school for modistes and the Studio Berçot, a well-known fashion design school. In my last year a German photographer, Georg Valerius from Cologne, came to the school, and I took a lot of photographs with him. During this time I also met Marc Le Méné and the game continued of photographing our creations. It was a game both in front of and behind the camera.

In 1992 I had my first major client in the Wolford brand. In that year I also had the good fortune to work with Helmut Newton for Vanity Fair.

At Condé Nast I was able to assist the great Anna dello Russo for Italian Vogue and Polly Allen Mellen for the American magazine Allure.

In 1997 I worked with the artist and photographer Peter Beard for German Vogue in Africa. That was followed by my work as fashion editor of the magazine L'Officiel de la Mode.

At the beginning of the new millennium there was a long-term collaboration with Spanish Vogue. Based in Paris, I organized the fashion series with photographers such as Julien Marchall, Ellen von Unwerth and Iris Brosch. In 2005 I began a close collaboration with Wolford, where I worked as art director and organized the international fashion shows and advertising campaigns. After that, I took up the camera again; digital technology had encouraged me to realize my own photos. Since 2008 I have been working for the house of Goyard, a famous luggage maker ("malletier" in French) on Rue Saint-Honoré.

For two years I have been living in Normandy, quite near Giverny, where Claude Monet's house is. This is the land of the Impressionists, the source of the inspiration of light and water and of the children of my village.

Top right: Till Warwas, portrait of Petra Bohne, Bremen, 1984; centre: Richard Avedon, Petra Bohne, Polaroid, shot during a campaign for Opel; background: photograph for Galeries Lafayette, special denim, shot by Petra Bohne

/ **PETRA BOHNE** / PHOTOGRAPHER AND ART DIRECTOR

In my work I see the image as a whole and like to combine minimalism with contemporary and natural elements. Probably my greatest inspirations are Art Nouveau, Art Deco, Bauhaus, Wabi-sabi, Dadaism, geometric patterns and nature.

What interests me most of all at fashion photo shoots is the creative teamwork, the fusion of different ideas. It is in this way that I work with photographers like Karl Lagerfeld, Ellen von Unwerth, Stefan Milev, Claudia & Stefan, Camilla Akrans, Ben Hassett, Lachlan Bailey, Karim Sadli, Serge Leblon, Liz Collins, Koto Bolofo, Alexi Lubomirski and Giampaolo Sgura.

In addition I regularly work with labels in the luxury and fashion field, such as Azzedine Alaïa, Christian Dior, Chanel, Louis Vuitton, Pierre Balmain, Giuseppe Zanotti, Carolina Herrera, Costume National, Triumph, Cartier.

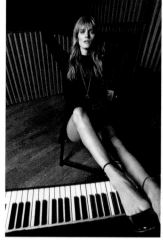

In my art installations I represent the primordial feeling above all through the senses. I create small, accessible, self-contained universes, always with the goal in mind of allowing a journey through beauty, modernity and nature to take place.

Here, too, interesting collaborations can arise, as with Vestoj magazine at the Palais de Tokyo (Paris), Augustin Teboul at L'Eclaireur (Paris), Nja Mahdaoui, Marios Schwab and Bernard Delettrez at Galerie El Marsa (Tunis) and with Kira Lillie at Curve (New York).

I work above all with natural aromas such as rosemary, sandalwood, thyme and white lilies, and also prefer materials such as wood, earth, water, crystal, metal and mirrors. In this context, my work is repeatedly accompanied by mirror reflections, as well as kaleidoscopes and the typical Bauhaus elements – triangle, square and circle.

At present, apart from some fashion shoots, I am concerned with designing furniture in recycled wood and metals, and, in addition to some installation projects in Berlin, Paris and Dubai, I am also working on my "Glasshouse" design project – a series of tetrahedrons of faceted glass and mirrors, which includes natural elements such as stones, spices and plants.

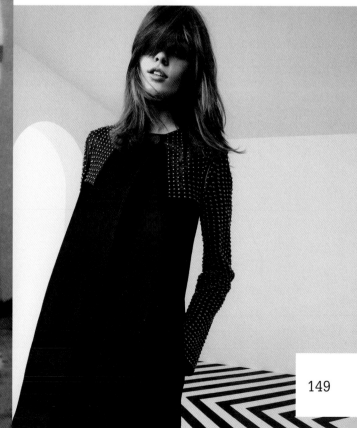

/ NINI GOLLONG/ SET DESIGNER

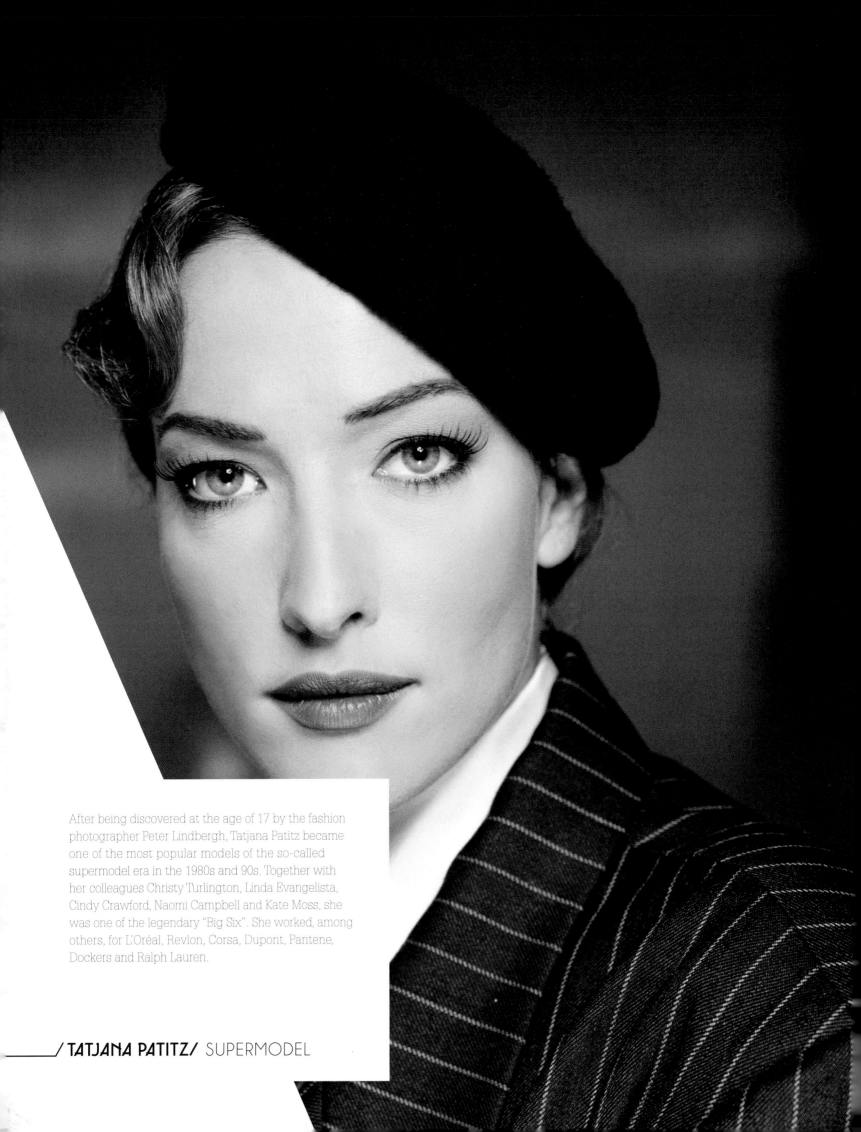

After being discovered at the age of 17 by the fashion photographer Peter Lindbergh, Tatjana Patitz became one of the most popular models of the so-called supermodel era in the 1980s and 90s. Together with her colleagues Christy Turlington, Linda Evangelista, Cindy Crawford, Naomi Campbell and Kate Moss, she was one of the legendary "Big Six". She worked, among others, for L'Oréal, Revlon, Corsa, Dupont, Pantene, Dockers and Ralph Lauren.

/ **TATJANA PATITZ**/ SUPERMODEL

What comes to mind when you hear the words "Germans" and "fashion"?

I think of the Bauhaus project of merging art and design, but also of the influence of Protestantism and its preference for understatement. The current fashion industry in Germany is commercially oriented, but then there was Jil Sander with her conceptual, minimalist vision, and there is Berlin's subculture of today. At Strenesse, I try to bring those two traditions together.

In your own opinion, the German fashion industry stands for:

Modernity, realism, wearability, quality and research, technical know-how and reliability. Decentralized hubs, diversity, more and more start-up design brands.

How did you get into fashion?

I always knew that I wanted to become either an architect or a designer. Then I enrolled at the Chambre Syndicale de la Haute Couture in Paris, and everything followed from that.

What kind of women/men do you design for?

My ideal customer is the intelligent woman who feels alert to the Zeitgeist. But I would like to dress or consult every woman I see.

Describe your work in three words:

To be observant and attentive to changes, conscious of fashion's past and capable of translating the present mood into my designs.

What is your secret cult brand?

I think, the impact of Yohji Yamamoto and Comme des Garçons is still unique in Western fashion.

Who or what inspires you?

I am inspired by everything, the Internet, great films and charismatic actors.

What has been your most interesting moment in the fashion industry?

Maybe the first Paris show of my label in 1992. That was before the Louvre. The show took place in a hotel; Nadja Auermann was one of the models.

What advice would you give to German fashion designers and creative directors?

I would like to see us communicate more and work together.

The future will bring ...

Surprises, first of all in fashion.

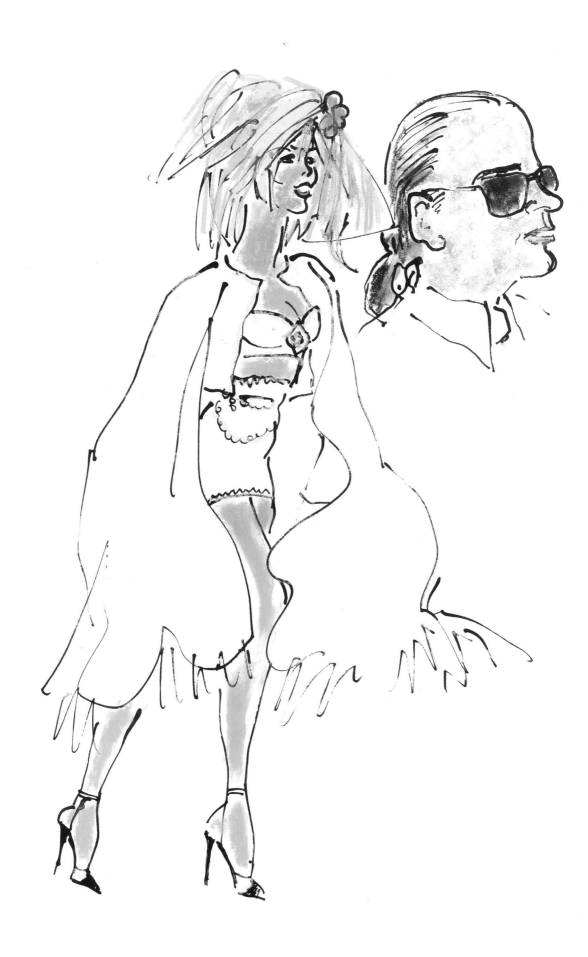

Klaus Stockhausen attracted attention even before he helped the Hamburg club FRONT to international fame as a DJ in the early 1980s. His special style had already earned him jobs with Thierry Mugler and Claude Montana. Since the early nineties Stockhausen has concentrated entirely on fashion. At that time he was already working for the magazines Stern, ID and Tempo and was responsible for the cover production of the first issue of Amica. This smoothed the way for him to become fashion stylist for MAX, the most sophisticated German magazine of the mid-nineties both visually and in fashion terms. Over the ten years that followed, he decisively shaped its visual language, discovered photographers such as Ralph Mecke and Giampaolo Sgura for his productions, and worked with, among others, Terry Richardson, Peter Lindbergh and David Bailey, as well as the top models Cindy Crawford, Linda Evangelista, Helena Christensen, Naomi Campbell and Claudia Schiffer. Even John Galliano insisted on him for the styling of his spectacular outfits in which he paced the catwalk at the end of every show.

In 2004 the Condé Nast publishing house appointed him fashion director of German GQ. The positive response to his productions was so great that the firm employed him first as fashion director and later as deputy editor of the offshoot GQ Style. He transformed the biannual glossy magazine into a popular vehicle for advertising, letting it swell to the thickness of a telephone directory, and thus provided the blueprint for all international editions of GQ Style. In 2012 the German edition of the cult magazine Interview, originally founded by Andy Warhol, was launched with Klaus Stockhausen as fashion director. With his reliance on a style that is invariably eye-catching but never exaggerated, Stockhausen is considered an interesting mix of star stylist and fashion expert.

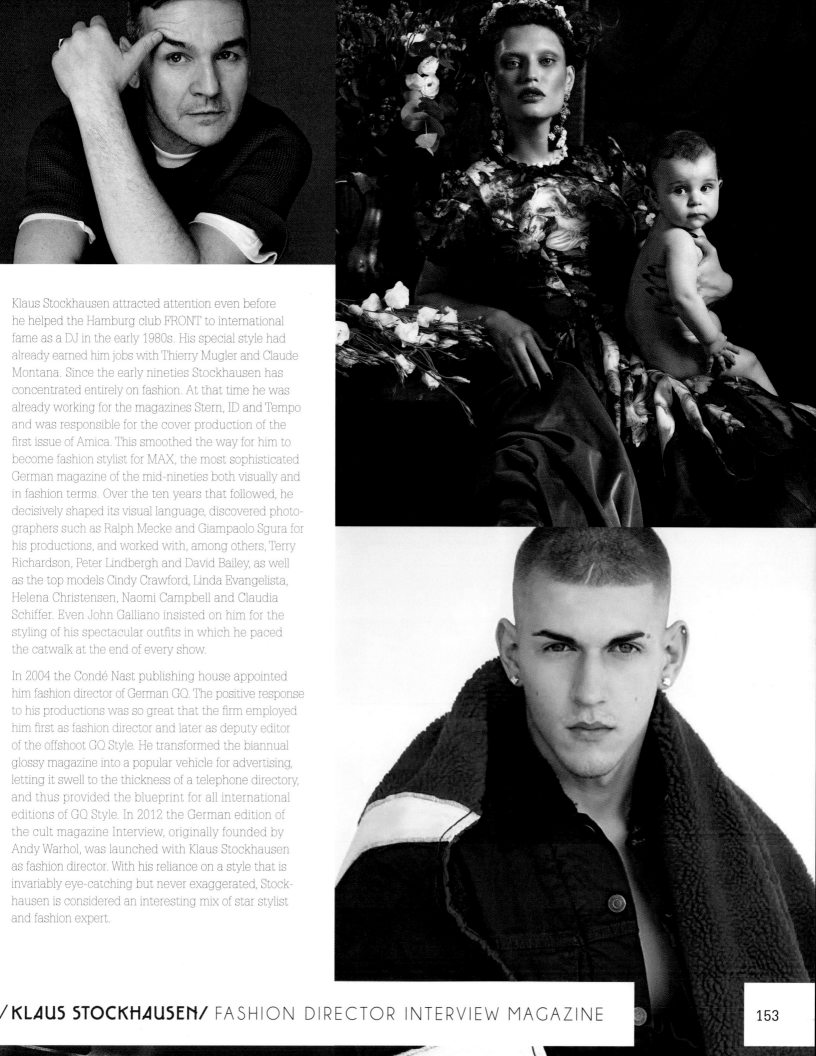

Tanktop, DIESEL, Je

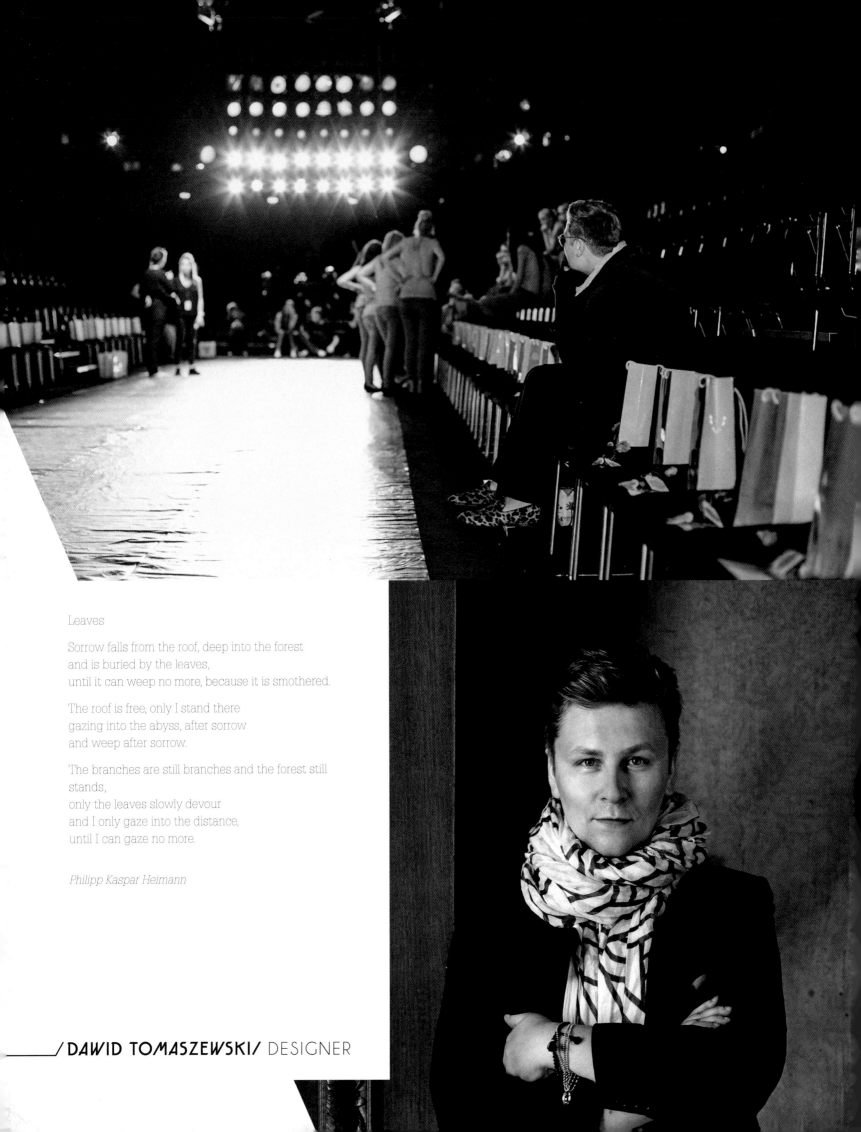

Leaves

Sorrow falls from the roof, deep into the forest
and is buried by the leaves,
until it can weep no more, because it is smothered.

The roof is free, only I stand there
gazing into the abyss, after sorrow
and weep after sorrow.

The branches are still branches and the forest still
stands,
only the leaves slowly devour
and I only gaze into the distance,
until I can gaze no more.

Philipp Kaspar Heimann

/ DAWID TOMASZEWSKI/ DESIGNER

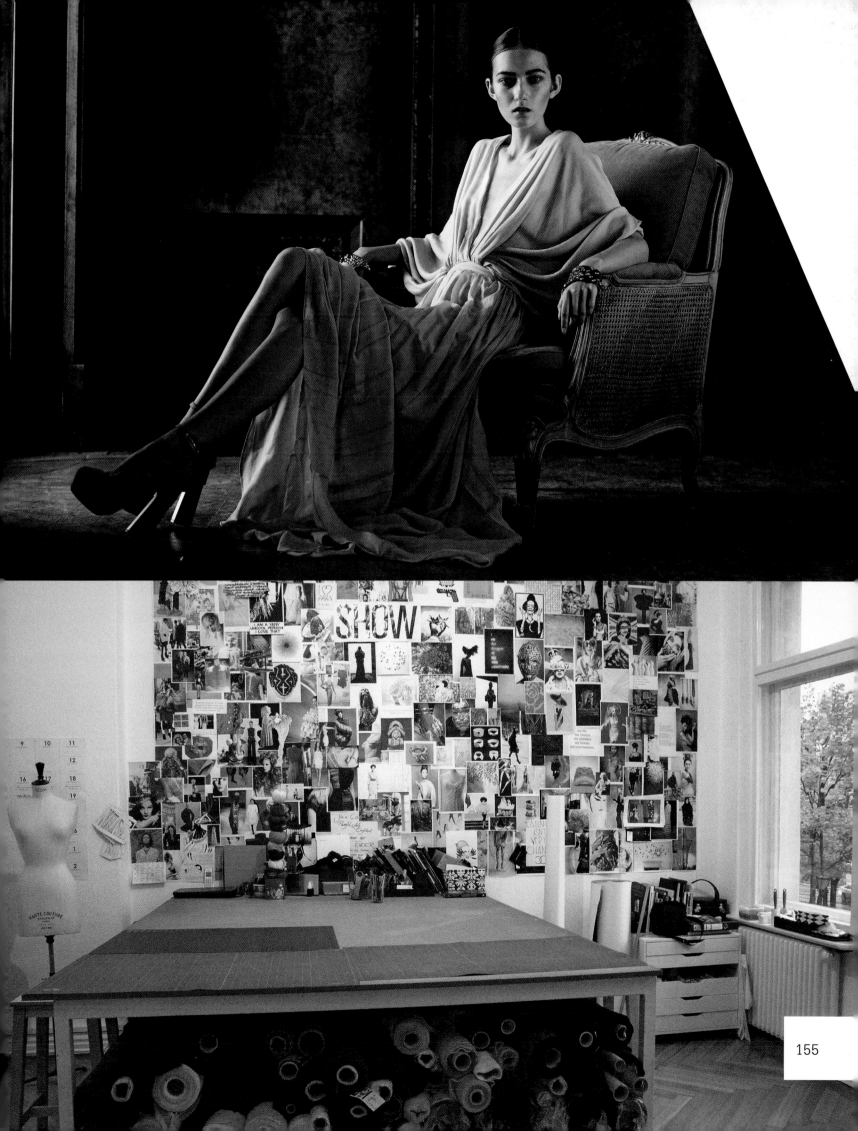

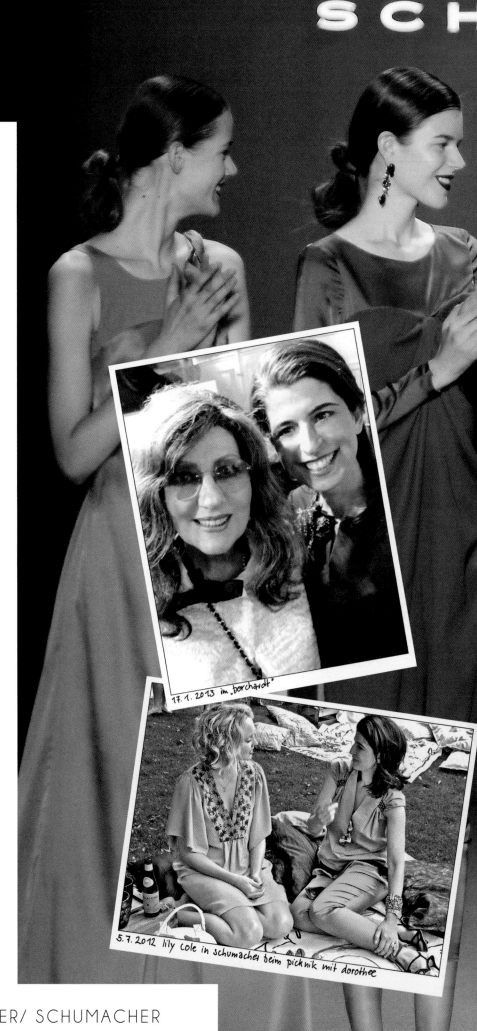

There is a fashion that is everybody's darling, safely and successfully on the path of the Zeitgeist. The new is what is desired. Adaptation rather than revolt. Success design.

Dorothee's designs are successful in Europe, Asia, America. The world loves her. Flags of provocation and revolt fly elsewhere. She belongs to that rare class of fashion-maker who runs neither too far ahead nor follows behind, who causes neither shock nor déjà-vu.

When I sat before her runway for the first time, I was overcome by a feeling of familiarity and empathy that I very rarely sense in the vortex of news and trends, of well-known and contemporary effects. Dorothee's fame proves that I'm not the only one who feels this way: this has been designed and realized for you! The question of the brand new or the traditional does not arise (nor does it, indeed, with all important works and products). I have to resort to old-fashioned words to describe the emotion that Dorothee Schumacher's designs – even the most modern among them – arouse in me: security and comfort.

"Be realistic – believe in miracles" is one of her slogans. That sounds both transgressive and utopian. Anyone who encounters Dorothee – familial, grounded, structured – knows that there is an earthly, absolutely human utopia. And what is there is refined towards a feminine, never lofty, poetry.

Her success story began with T-shirts, given an innovative, romantic touch with imaginative appliqués. This, amongst the power suits and functional looks of the 1980s, was no strident fashion revolution; it indicated that while every garment was made for this world, another possibility indeed existed: that there is something above and beyond success-driven utility.

Since then, every Schumacher collection has been a virtuoso balancing act between reason and vision. Wonderfully fitting, in both senses of the word, and from the same material that dreams are made of.

Angelica Blechschmidt

17. 1. 2013 im „borchardt"

5. 7. 2012 lily cole in schumacher beim picknik mit dorothee

17.1.2013 backstage

7.7.2011 mein lieblingskleid - handbestickt !

7.7.2011 die stickerei im close up

How did you get started in this industry?

I had a pretty traditional start when I trained to be a hairstylist as a teenager in Germany. Soon after, make-up artistry needed to be added, as German clients tended to book only the package deal ... I almost instantly preferred the make-up and when I started with the airbrush in New York a bit later, I never touched a comb or hairpin ever again. Airbrush make-up is my all-time most beloved product. When I was living in New York I experimented with airbrush make-up on fashion photo shoots for several years. Initially, I was excited by the many options, traditional and experimental, that this tool offered. Soon I realized I was achieving amazing results when called upon to apply the fashionable "natural look" in demand on many of the shoots. And when some of my more conservative advertising clients started asking me to apply make-up to their own faces, I knew I was on to something. I decided it was time to develop a tool that could be used easily by everyone, both in and out of the fashion industry. That was the go-ahead for uslu airlines. And, as they say, the rest is history.

Describe uslu airlines in three words.

Beauty. Make-up. Supersonic.

Who or what inspires you?

I get inspired by all sorts of things. Definitely nature, colours, meeting creative people, collaborating and travelling to foreign countries. All uslu airlines products and colours have airport names. We like to call our products "destinations" and therefore use the global aviation three-letter-code system for our product organization ... We pick the names by heart, by sound, by love; there are many categories. Some are big, well-known, and often travelled (like JFK or CDG, for example). Others are very small (like TUY) or very boring (like SIR).

What comes to mind when you hear the words "Germans" and "fashion"?

The name that instantly comes to my mind is Jil Sander. Her designs are clean, minimal, with a twist, which I love and admire. It's her natural and discreet vision of female beauty that was my key motivator to develop the uslu airlines airbrush system. I wanted to offer in beauty what she offered in garments. The woman I had in mind while designing our airbrush is the woman who would rather not wear any make-up at all. I like to refer to her as the Jil Sander woman.

Other great German designers are my friends and long-time collaborators Bernhard Willhelm and Tillmann Lauterbach, both based in Paris.

Bernhard is the master of patterns and crazy experimental fashion. Tillmann's garments are timeless and, as he puts it, of an "elegant rawness".

I find them both very inspiring and ahead of our time.

In what stores can we find your products?

uslu airlines products are available at the best store in every big city. We are at Colette in Paris, Storm in Copenhagen and WUT Berlin in Tokyo. Now we are expanding our market and are available in Stockholm's NK Department Store.

What is the secret behind uslu airlines becoming a cult brand?

uslu airlines will bring you a new cosmetic experience. I think it's all about being creative, always wanting to be one step ahead, and of course no other beauty brand has an entire airline!

Our products will make you look great and feel good without painting all over your face. You will look naturally beautiful and hardly anyone can tell how you achieved that.

uslu airlines has an innovative approach to beauty. Whether you use cosmetics on a regular basis or only on special occasions, it could permanently alter the way you think about make-up and the frequency with which you use it.

What have been uslu airlines' highlights with regard to business?

We had a very strong impact with the development of the first easy-to-use and sexy airbrush system for make-up in the beauty industry in 2003. Since the demand is still very high we have now developed an even sexier update of the airbrush system that will launch at the beginning of 2014.

uslu airlines

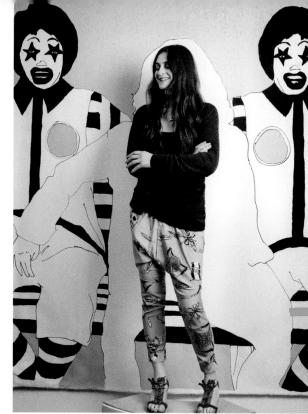

Aside from that, we have been accused of introducing "non-wearable" and allegedly "non-sellable" nail polish colours since 2006 ... which have now all been copied to be kind of standards at your next-door Duane Reade or Douglas. Don't worry, we shall continue to impress and extend our playgrounds to also revolutionize our other product groups such as lipstick and lip gloss.

Regarding our business development, we are growing slowly but strongly. We choose our business partners very carefully and we try to work with only the best shops and concept stores that represent our high standards of creativity and design. Since we are well represented in most of the European countries, we are now entering other interesting markets all over the world. Following the same strategy in finding the right ambitious partners is a process we work on carefully. Our latest highlights have been the successful entrance into the Swedish and Russian markets.

What have been uslu airlines' highlights with regard to creativity?
Recently, we started a whole new line: USL by uslu airlines. Twenty-four gorgeous nail polish colours in our new slender bottle. As always, it's available at our long-time partner Colette, but also at other selected concept stores.

We are also really proud of all our collaborations; it's a great means of self-expression and a way to push one's

boundaries. We have a whole Bernhard Willhelm nail polish line that keeps growing every year, not to mention our DJ collaborations, which have been a constant source of inspiration and a creative boost for our brand over the years.

Your favourite fashion moment?
There are so many. I will tell you about my future dream fashion moment. As I travel a lot, it would be great to be at a hotel one day and see our AOP airbrush system in every room, as an integral and indispensable part of the beauty equipment every woman (and man!) needs.

The future will bring ...
Many more collaborations with fascinating people and expansion to surprising new markets.

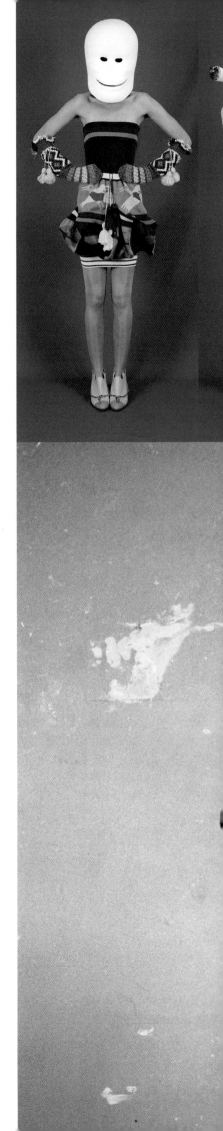

WHAT WE LOVE
BIRDS FLYING TOWARDS US
AND THEN FLYING AWAY AGAIN
THE MOMENTS BETWEEN MOMENTS
WHEN YOU ARE HAPPY
CAFÉ WITH TWO GUESTS
AND A DOG
STREETS MADE OF GOLDEN SUNLIGHT
MEAT AND DUMPLINGS AT HOME
THE HIGH OF SEX
A LOT OF MONEY WHEN WE EARN
IT NOT LATER WHEN WE SPEND IT
ART IN THE MOMENT ITS CREATED
SOMETHING TOO EXPENSIVE
THAT WE CAN AFFORD
A CERTAIN SMILE
ELEPHANT SHOWERS
DEATH AS LONG WE ARE NOT DYING
JAPANESE BREAKFAST

BERNHARD WILLHELM MARCH 2012

Top: drawing by Carsten Fock; top right: designs from
the autumn/winter collection 2007/2008; bottom right:
Bernhard Willhelm, photographed by Juergen Teller

/ BERNHARD WILLHELM / DESIGNER

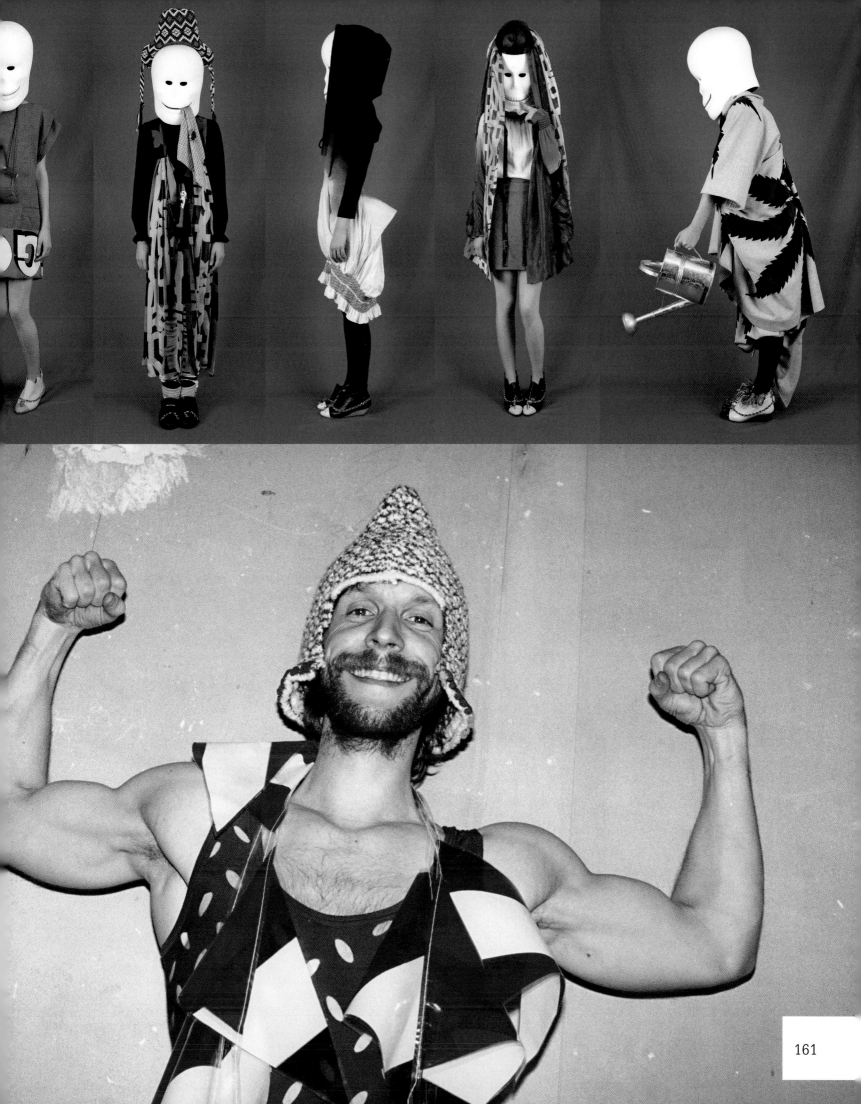

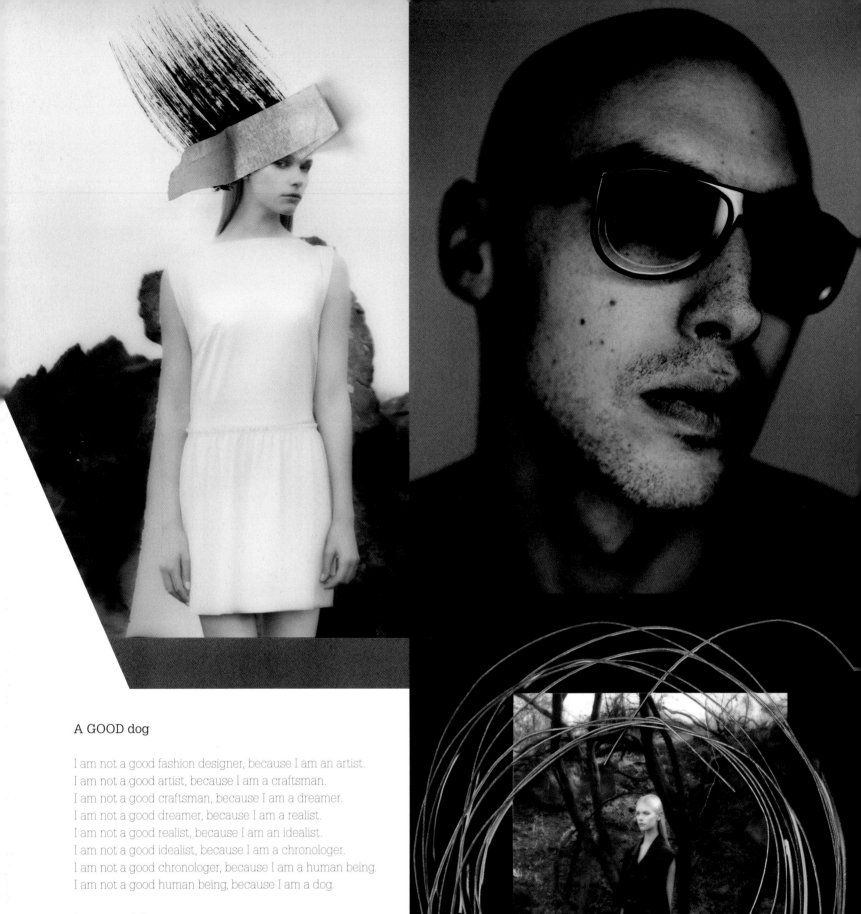

A GOOD dog

I am not a good fashion designer, because I am an artist.
I am not a good artist, because I am a craftsman.
I am not a good craftsman, because I am a dreamer.
I am not a good dreamer, because I am a realist.
I am not a good realist, because I am an idealist.
I am not a good idealist, because I am a chronologer.
I am not a good chronologer, because I am a human being.
I am not a good human being, because I am a dog.

I am a good dog.

/TILLMANN LAUTERBACH/ DESIGNER

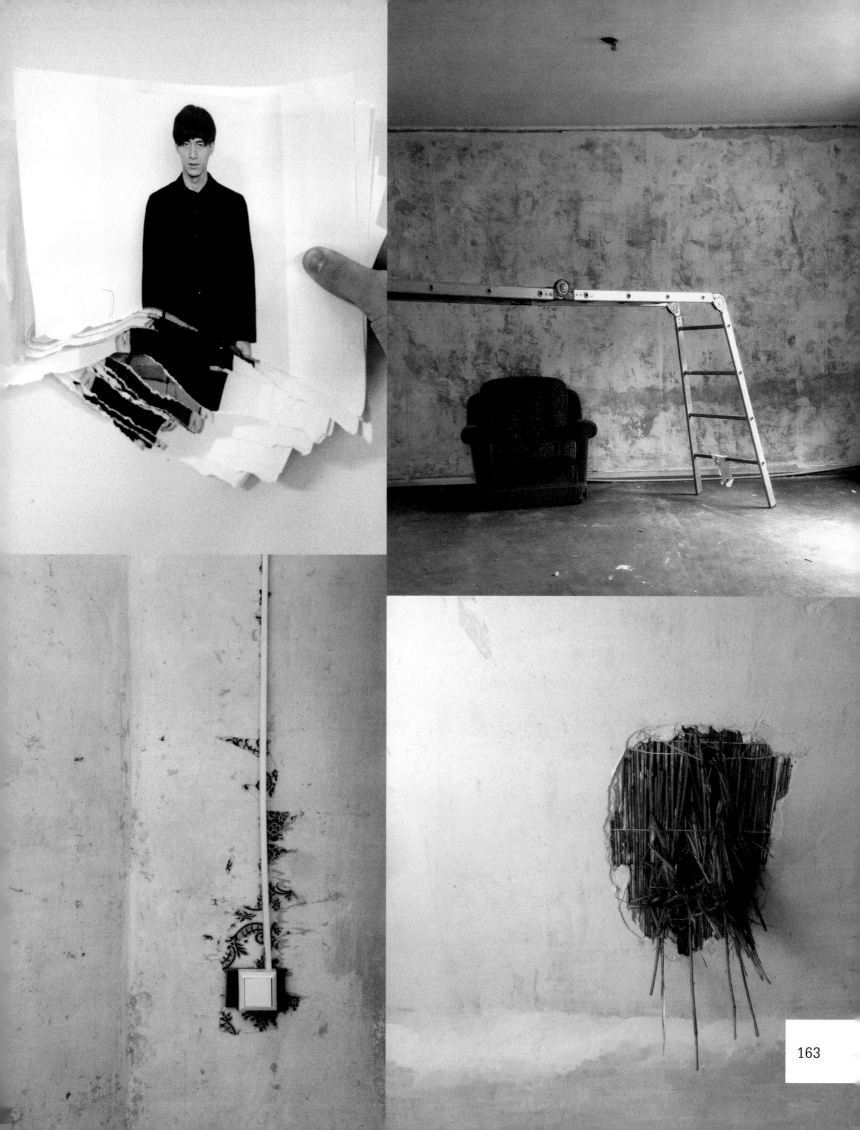

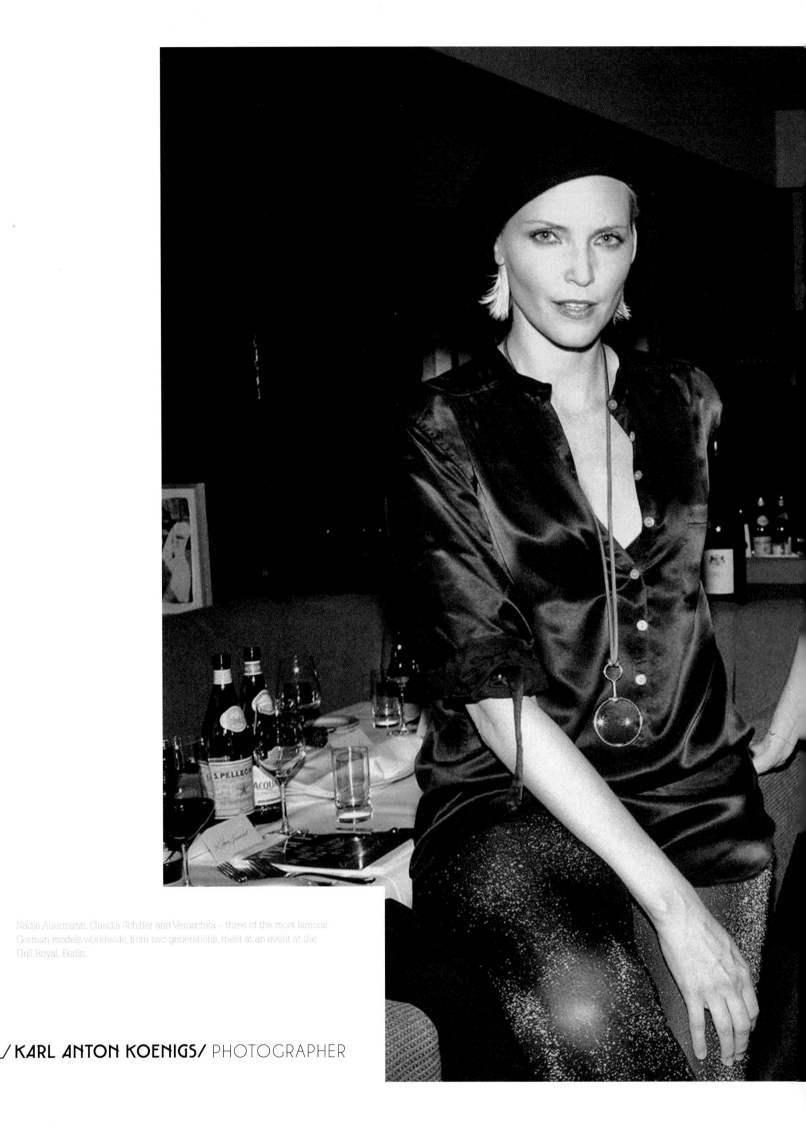

Nadja Auermann, Claudia Schiffer and Veruschka – three of the most famous German models worldwide, from two generations, meet at an event at the Grill Royal, Berlin.

/ **KARL ANTON KOENIGS**/ PHOTOGRAPHER

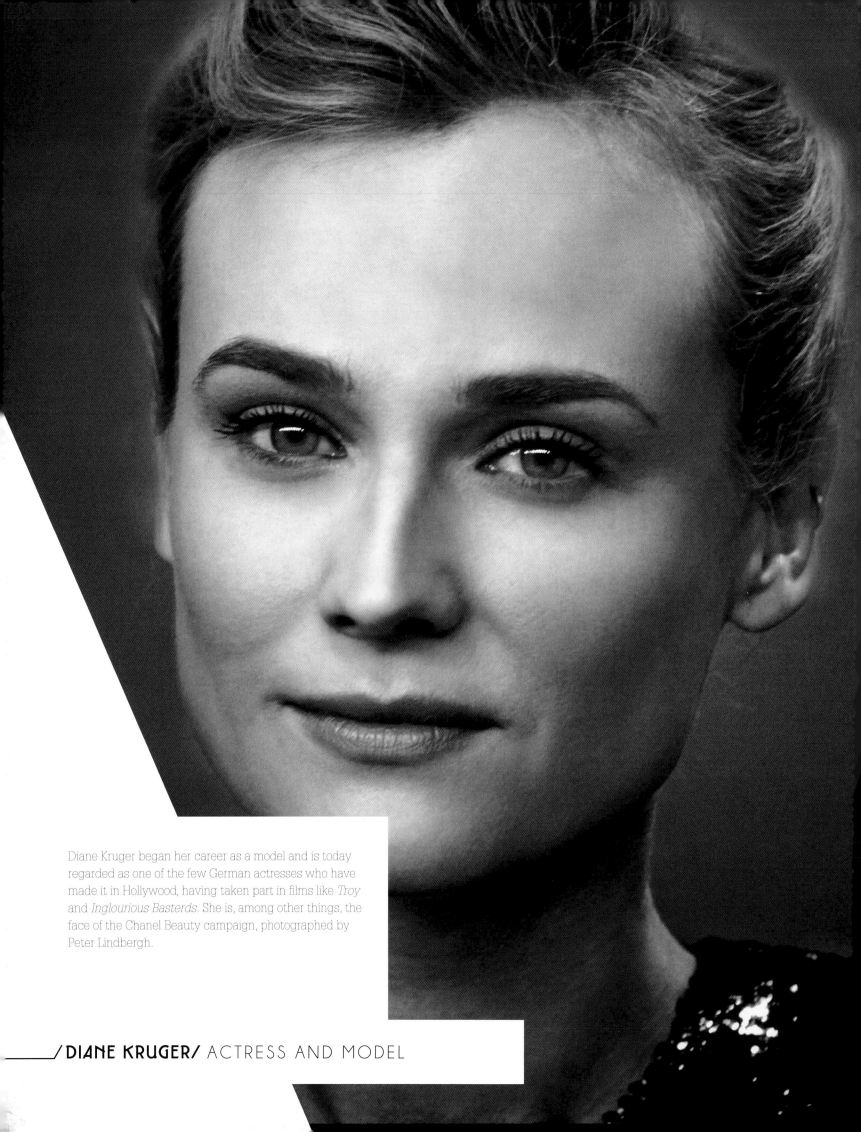

Diane Kruger began her career as a model and is today regarded as one of the few German actresses who have made it in Hollywood, having taken part in films like *Troy* and *Inglourious Basterds*. She is, among other things, the face of the Chanel Beauty campaign, photographed by Peter Lindbergh.

/ DIANE KRUGER/ ACTRESS AND MODEL

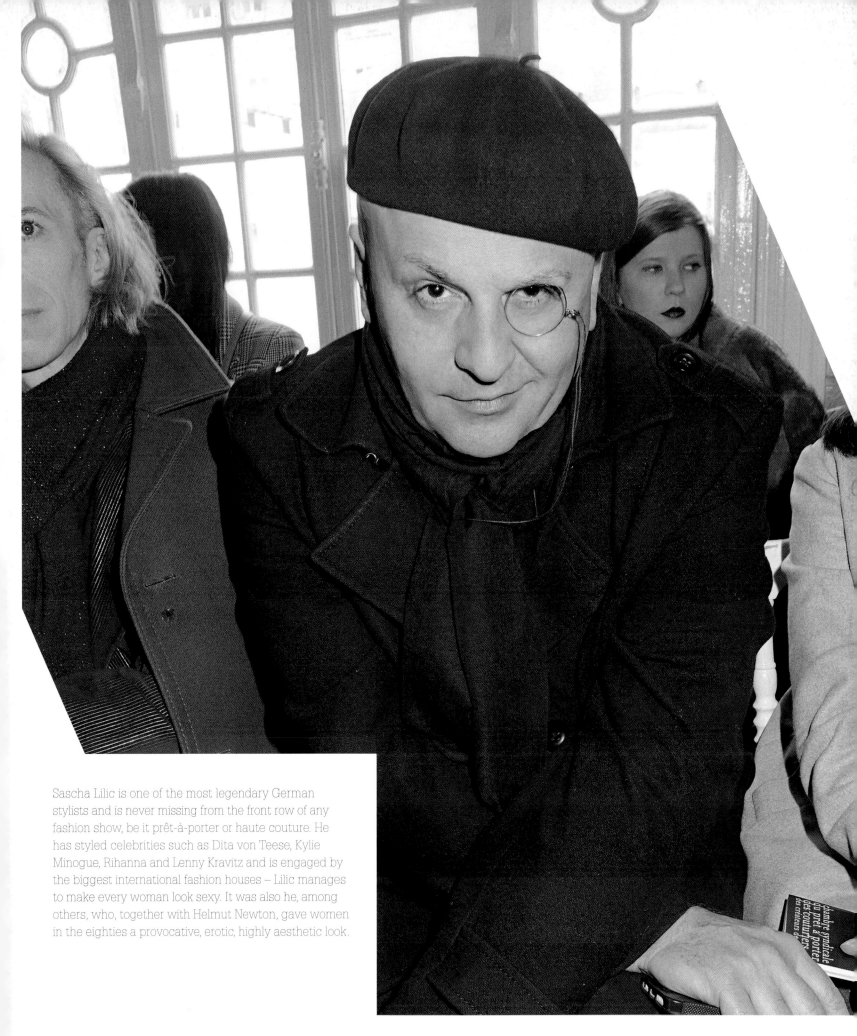

Sascha Lilic is one of the most legendary German stylists and is never missing from the front row of any fashion show, be it prêt-à-porter or haute couture. He has styled celebrities such as Dita von Teese, Kylie Minogue, Rihanna and Lenny Kravitz and is engaged by the biggest international fashion houses – Lilic manages to make every woman look sexy. It was also he, among others, who, together with Helmut Newton, gave women in the eighties a provocative, erotic, highly aesthetic look.

/SASCHA LILIC/ FASHION CONSULTANT, STYLIST AND CASTING DIRECTOR

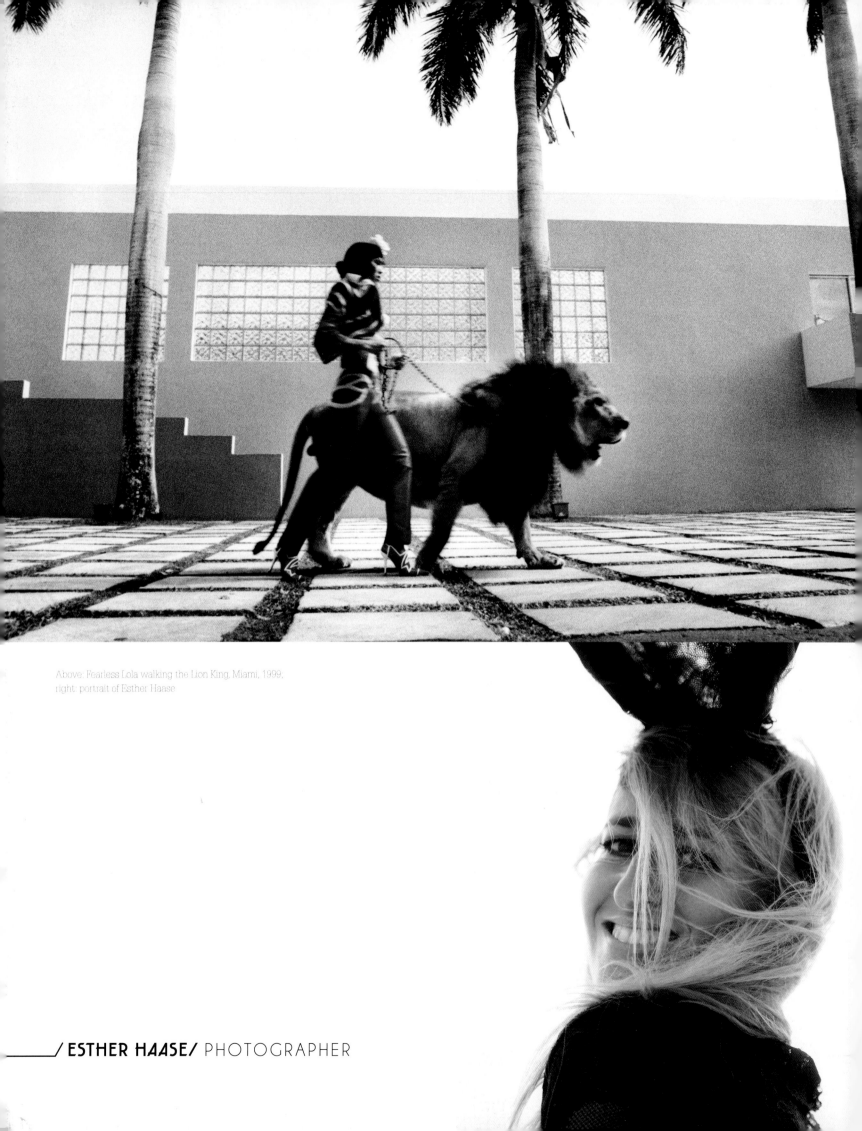

Above: Fearless Lola walking the Lion King, Miami, 1999,
right: portrait of Esther Haase

_____/ ESTHER HAASE/ PHOTOGRAPHER

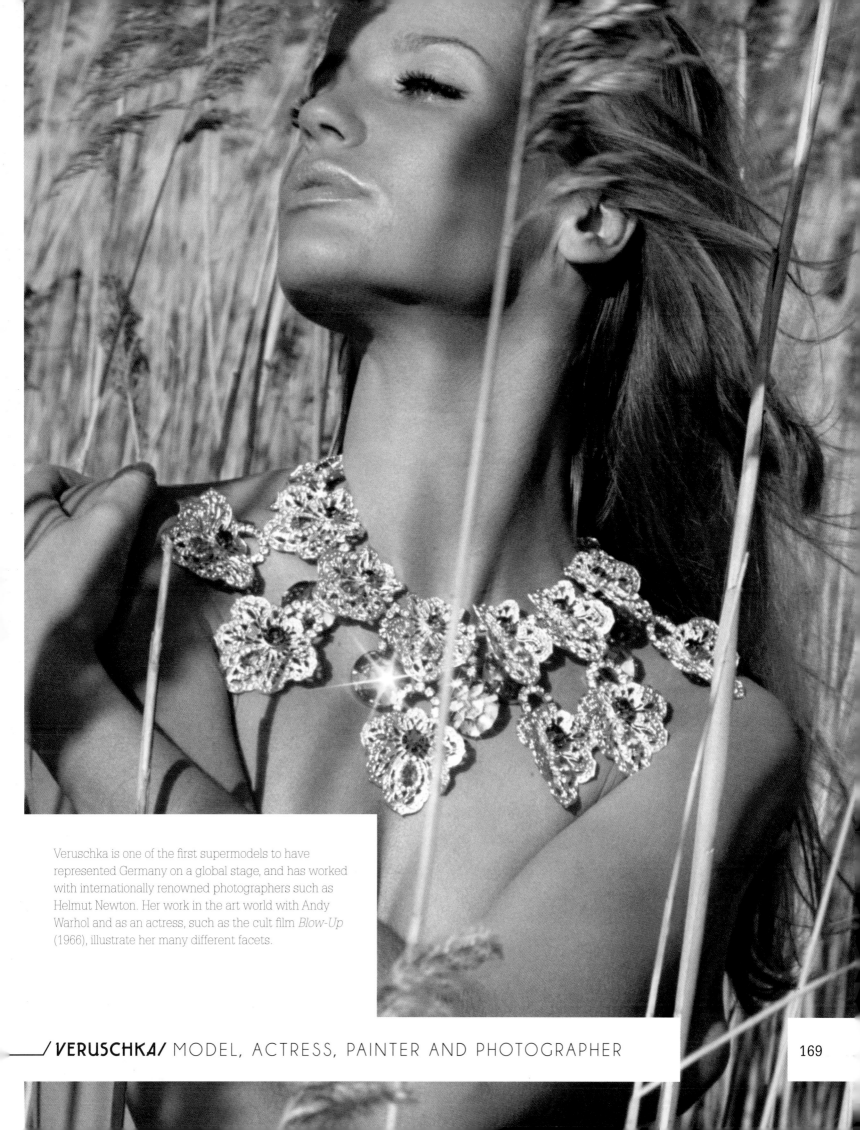

Veruschka is one of the first supermodels to have represented Germany on a global stage, and has worked with internationally renowned photographers such as Helmut Newton. Her work in the art world with Andy Warhol and as an actress, such as the cult film *Blow-Up* (1966), illustrate her many different facets.

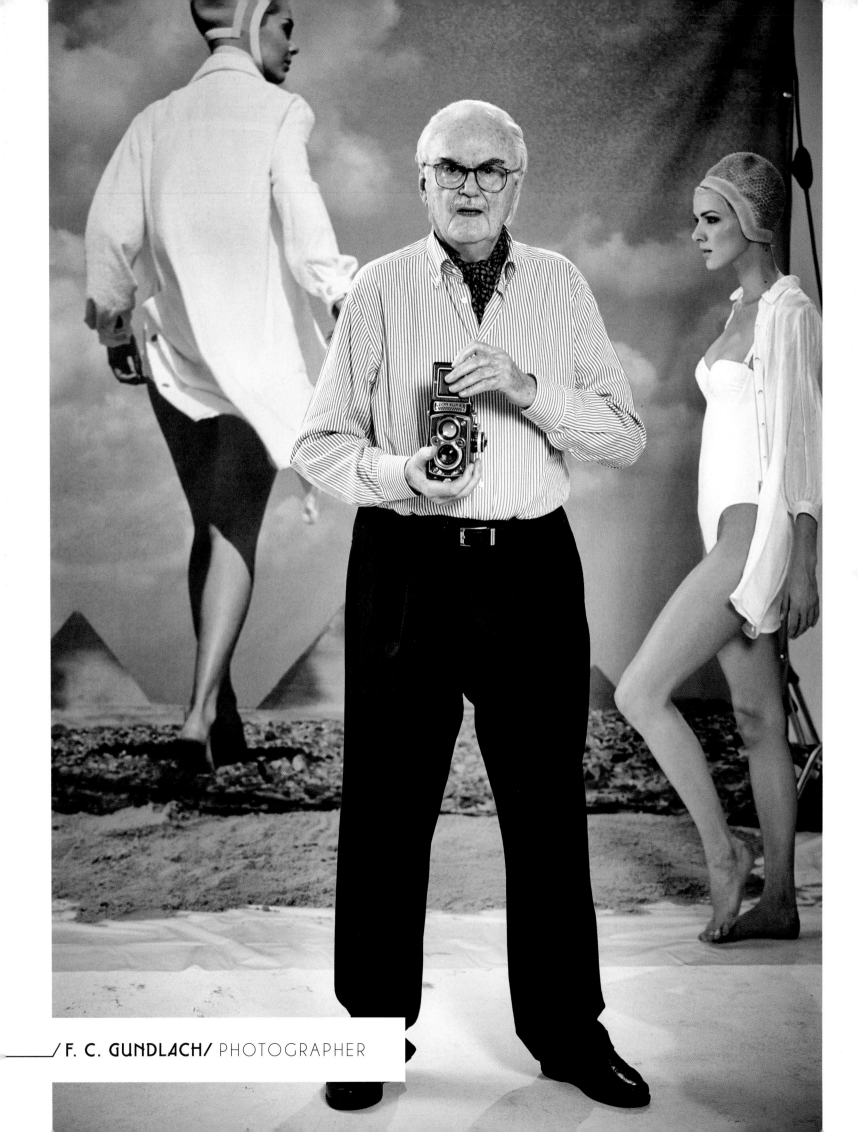

/ F. C. GUNDLACH/ PHOTOGRAPHER

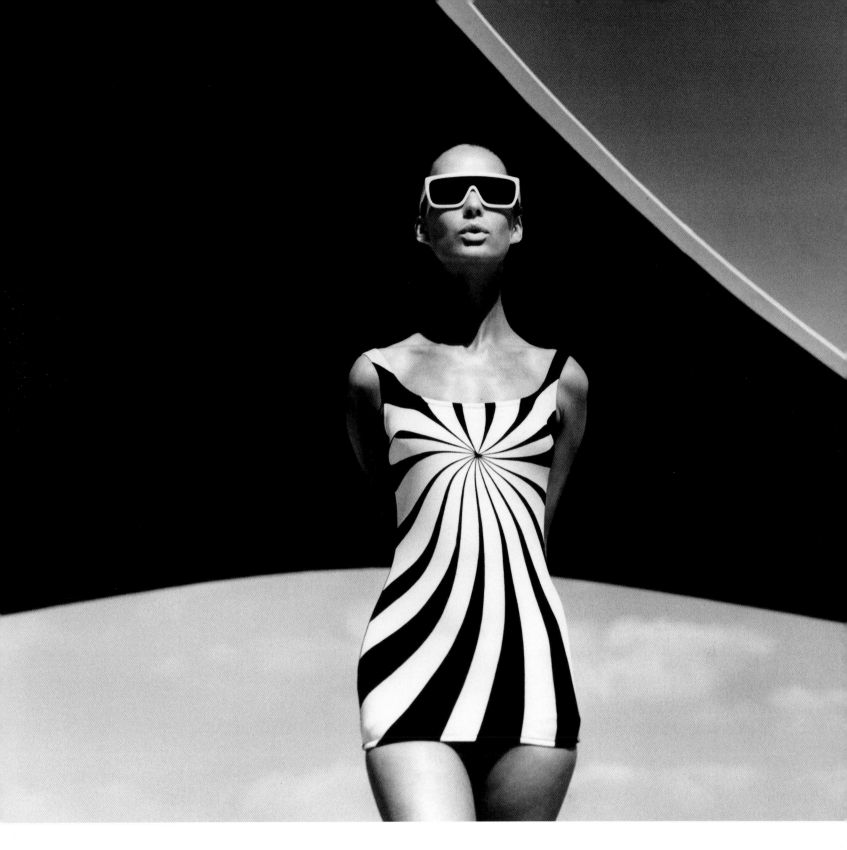

Left: F. C. Gundlach; top: Op-Art Fashion, Brigitte Bauer, Athens, 1966

What comes to mind when you hear the words "Germans" and "fashion"?

Both good things and sad things. It's still pretty sad to live amid this common disinterest in fashion and style on the streets of Germany. But it's also great to recognize how modern fashion and lifestyle have become more established in major German cities during the last few years. One can enjoy cultural scenes in cities like Cologne, Hamburg, Munich and mainly – of course – Berlin!

In your opinion, the German fashion industry stands for ...

That makes me think of the great and successful German designers, such as Jil Sander, Karl Lagerfeld, Wolfgang Joop ... and some of the many young labels and brands, like Patrick Mohr, Damir Doma and the entire rapidly growing fashion industry in Berlin. My impression is that the German fashion industry stands for classical elegance and qualities rather than fun and fast fashion.

How did you get into fashion?

Through a strong and personal passion for vintage clothing. I started wearing 1960s' suits and dressing as a mod when I was sixteen years old and changed a few years later, in my early twenties, to the most elegant menswear – originals from the 1920s, 1930s and 1940s. Opening my own boutique of vintage clothing in Hamburg was the beginning of my professional fashion career in 1996. After some years of this self-taught "education", I felt the need to create my own line. My older sister was already teaching fashion design at the University of Copenhagen at this time and helped me on my way.

I was studying all her papers intensely for half a year and started to make my own patterns and sewing samples. Over the years I was able to work out larger collections and continuously learn more and more about the technical construction of garments.

What has been the greatest project your company, Herr von Eden, has launched or worked on and why? And is there any big future project we should look out for?

Several projects have been absorbing all my efforts, creative power and energies, so it's hard to point out a single one. I'm doing a lot of clothes for various musicians, and even Hollywood actors such as Willem

Dafoe and the late Philip Seymour Hoffman have been outfitted by our atelier. Right now I am designing all the costumes for a beautiful theatre production produced by Chilly Gonzales (composer) and Adam Traynor (director) at the Schauspiel Köln.

Describe your work.

I was very lucky to be born with the gift of pretty good eyes and extraordinarily good taste. I sell elegant and classical style rather than fashion. The scope of my daily work is wide. Creative direction. Strategic planning. Marketing and PR. Financial responsibility. Administration. Sixty hours a week is standard.

What has changed since your relaunch, what have you taken from the past and what have your experiences taught you?

During the past ten months I was able to restructure the company. I had to discontinue the women's line and close our bespoke atelier. The entire controlling part got professionalized. I have reduced everything to the max and put the focus on my strengths, which is elegant menswear!

How would you (re-)define Herr von Eden?

The boy has grown, become a man and is still loving tradition and provocation.

Who or what inspires you?

Meeting strong personalities – both friends and strangers. Travelling and thereby discovering new and old.

What is your secret for survival in this ever more rapidly evolving fashion industry?

Keeping focused on my path.

The future will bring ...

Luck and success.

/BENT ANGELO JENSEN/ DESIGNER/ HERR VON EDEN

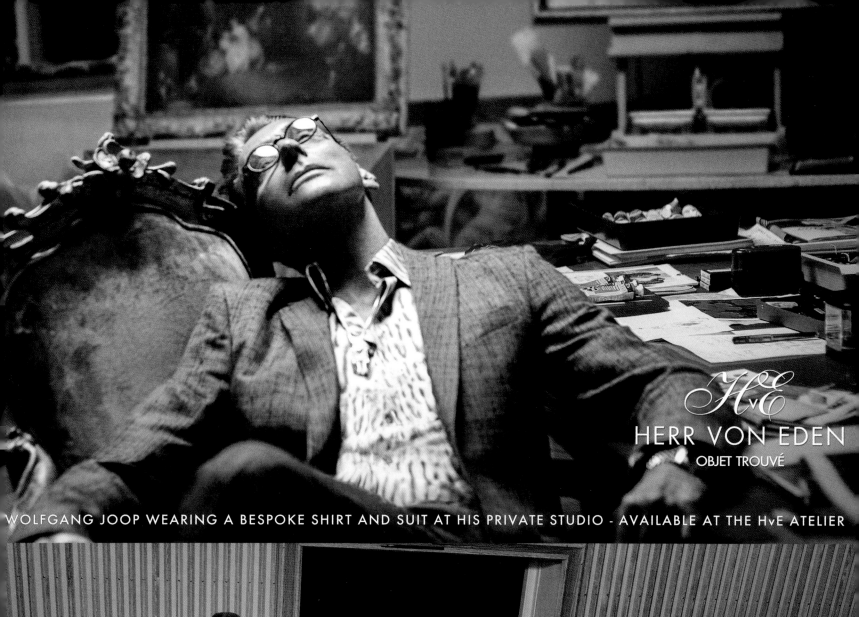

WOLFGANG JOOP WEARING A BESPOKE SHIRT AND SUIT AT HIS PRIVATE STUDIO · AVAILABLE AT THE HvE ATELIER

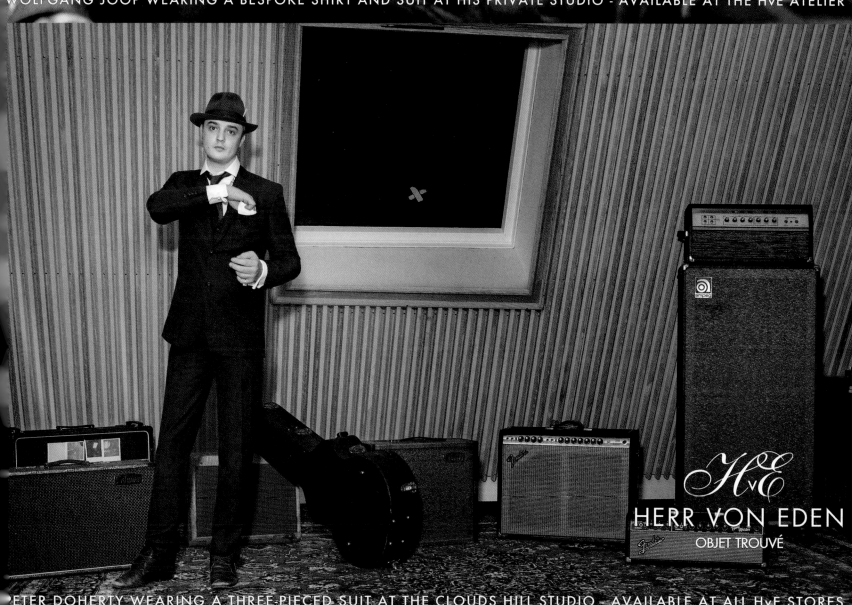

PETER DOHERTY WEARING A THREE-PIECED SUIT AT THE CLOUDS HILL STUDIO · AVAILABLE AT ALL HvE STORES

TOM REBL
shocking radiance

Wohin mit den Blumen ...

Gerade sitze ich gemütlich an einem Strand und genieße die Sonne. Es ist Ende Januar. Trotz paradiesischer Kulisse ist meine Stimmung nachdenklich. Ich denke zurück an die Modenschau zur Mailänder Modewoche vor zwei Wochen. Alles war groß. Die Location, die Bühne, der Aufmarsch, die Party. Ja, auch die Models waren diese Saison ein paar Zentimeter größer als sonst.

Wie es sich für einen Designer gehört, habe ich mich am Ende der Show, nachdem alle meine Jünger noch mal über den Laufsteg defiliert sind, vor dem einschlägigen Publikum präsentiert. Mit einem Gefühl von Erleichterung und Stolz gab es eine tiefe Verbeugung. Darin steckte auch ein wenig Dank im Voraus an die Gäste, die ja anschließend ausgiebig berichten sollen. Als ich wieder aufrecht stand, gab es einen kurzen Moment, wo ich gehofft hatte, dass mir jemand einen Strauß Blumen auf dem Laufsteg überreichen würde. Was natürlich kaum möglich war, da ja das ganze Spektakel auf die Sekunde genau durchgeplant war. Für mich gab es also auch diesmal keinen Blumenstrauß.

Stattdessen habe ich die Blumen, die ich gerne selbst entgegengenommen hätte, an einige wichtige Vertreter der Presse mit einer persönlichen Danksagung geschickt. Wo die Oma des Punk oder ein solariumgebräunter Créateur, der stets auf Rot setzt, schickt niemals die Bühne ohne einen gebührenden Blumenstrauß verlassen würden, schickt die Designergeneration 2.0 nun die edlen Gewächse an die Regierenden der Medien. Ist es ein Designer, der Mode macht, die erwähnenswert ist? Oder sind es die Chefredakteure der Modeblätter, die einen Designer als erwähnenswert betiteln? Ist denn der Teufel, der immer noch Prada trägt, tatsächlich so mächtig? Dabei war es doch Prada selbst, das den Teufel erst soweit gebracht hat.

Wieder zurück auf dem Liegestuhl in der Sonne ziehe ich Bilanz. Die Fashionshows, die sich alle sechs Monate wiederholen, sind sozusagen ein Barometer, das anzeigt, an welchem Punkt man sich gerade im System der Mode befindet. Dabei fühlt es sich manchmal so an, als wäre man eine Aktie auf dem freien Markt. Es wird regelrecht gehandelt mit deinem Namen. Hier geht es aber nicht um Zahlen oder ähnlich Konkretes. Es geht um den Beliebtheitsscore. Wie beliebt ist man als Marke und wie beliebt wird man, wenn man eine bestimmte Marke trägt? Ist diese Beliebtheit auf eine Person übertragbar? Oder stellt man sich einfach als Fashion-Victim zur Schau? Würde es denn meinen Beliebtheitsscore verändern, wenn auch ich Prada tragen würde?

Kurz vor meiner Abreise kam der erste Post-Show-Pressespiegel auf den Designtisch. Auch dieser war groß, sowohl in Bezug auf den Umfang als auch auf den Inhalt. Und wie durch Zauberhand hat man plötzlich schon wieder das durchgearbeitete Weihnachtsfest und die kurz gehaltene Silvesternacht vergessen. Es ist sogar schon wieder ein leiser Drang nach Neuem entstanden. Der Blumenstrauß, auf den ich vergeblich am Ende der Show gehofft hatte, wurde also einfach auf der After-Show-Party in Vergessenheit gefeiert.

Und eben diesen Strauß Blumen werde ich mir nun selbst auf den Tisch stellen, wenn ich wieder zurück im Studio bin und mich auf die nächste Runde vorbereite ...

Viva la moda,

[Unterschrift]

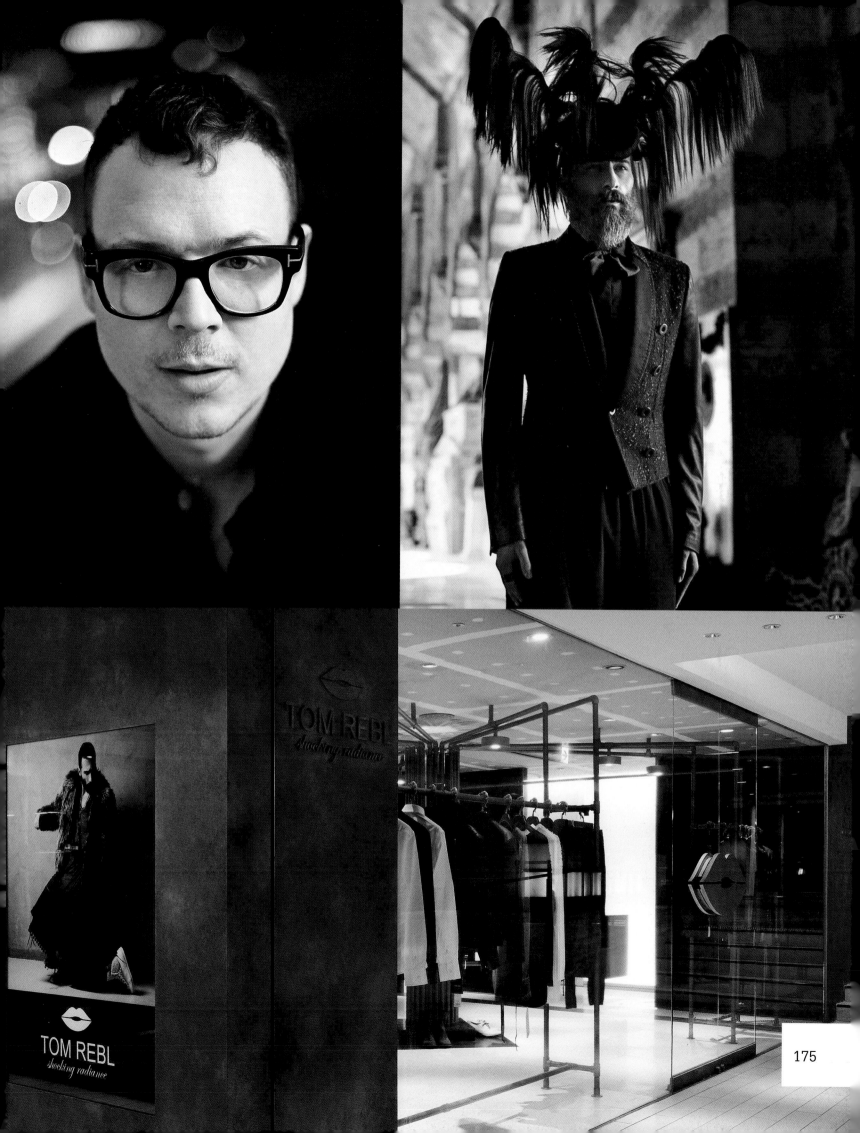

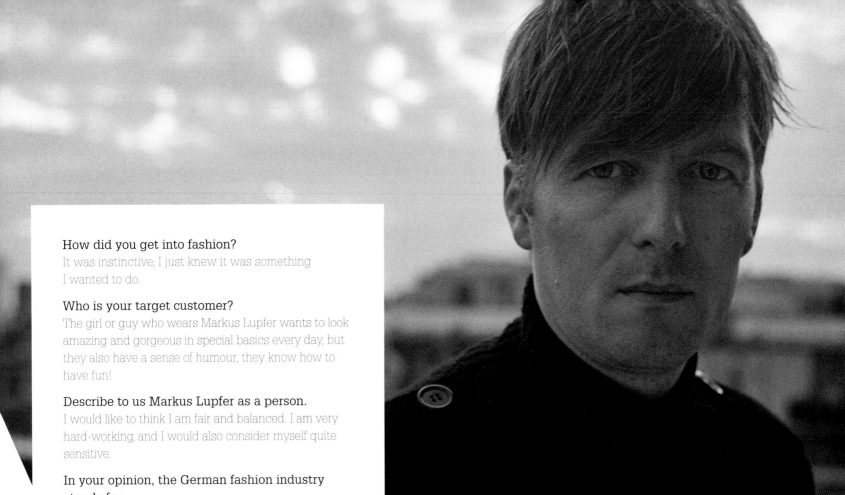

How did you get into fashion?
It was instinctive, I just knew it was something I wanted to do.

Who is your target customer?
The girl or guy who wears Markus Lupfer wants to look amazing and gorgeous in special basics every day, but they also have a sense of humour, they know how to have fun!

Describe to us Markus Lupfer as a person.
I would like to think I am fair and balanced. I am very hard-working, and I would also consider myself quite sensitive.

In your opinion, the German fashion industry stands for ...
It's often precise, clean and very considered.

Do you work with other Germans in the fashion industry, and if yes, who?
Yes, we have worked with German Vogue, Petra magazine and various German photographers.

Who inspires you?
My friends often inspire me.

What do you treasure most in your career?
My favourite time every season is right at the beginning, when all the creative ideas are getting started.

I also love travelling with my job, and how this means I get to see so many exciting countries.

What makes you happy?
I love waking up in the morning, whilst on holiday, in the middle of nowhere, and looking out at a really fabulous view. It's just tranquil and quiet; that is when I'm really calm and happy.

What was your first fashion faux pas?
I did once own a brown corduroy blazer – it wasn't the best look!

What was your most successful fashion highlight?
I think one of them has to be meeting Anna Wintour at her office in the US.

_____/ MARKUS LUPFER/ DESIGNER

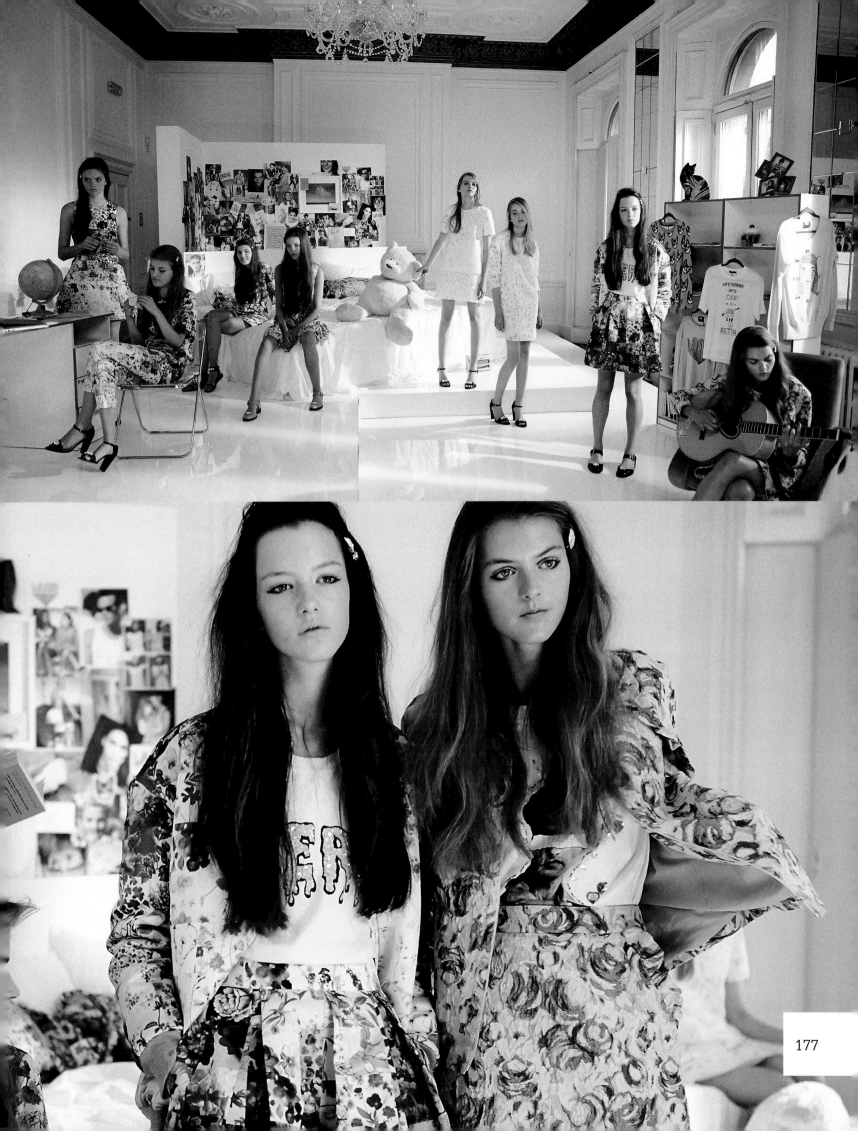

THE BRANDMAKER

Karla Otto is the most powerful German in the fashion world. For twenty-five years this PR consultant has successfully advised creators such as Jil Sander, Miuccia Prada and Jean Paul Gaultier.

At the moment everything, once again, is all about fashion. The show marathon is on. New York, London, Milan, Paris. For Karla Otto, this means that the next four weeks will be: a little kiss to the left, a glance behind, a smile, a handshake to the right. Lunch with clients, tea with the press, in between every so often a show, and events every evening.

Karla who? Karla Otto! That's her name and also that of her offices. She is the most influential PR and image adviser of the best-known fashion labels worldwide, and for twenty-five years she has been advising creators such as Jil Sander and Miuccia Prada. Or today Jean Paul Gaultier, Viktor & Rolf, Hussein Chalayan, Marni, and so on. The list seems endless. But even if none of her clients leaves women indifferent, her own name hardly means anything to anyone, and so she confesses right at the start that this is the first time she has given an interview about herself.

The one-woman empire

Today she is wearing Marni. A sleeveless silk top, a short skirt and ballerinas. Her facial expression is relaxed, sometimes even almost girlish. As though her career had left no scars on her. She wears her brown hair shoulder-length. Her deep voice sounds soft. She is friendly, laughs a lot and even switches off her Black-berry during the interview. "If I switch off my phone, it's almost as if I'm on holiday," she says, and begins to tell her own story: how a young, petite woman from Bonn created a PR empire that she still runs on her own today.

After her school-leaving examinations in 1973, Karla Otto did what so many do at that stage – she went on a long trip. A year, to be precise. From Europe to Asia; through Persia, Afghanistan, India and Nepal all the way to Japan – and on her own. Her final destination became her new home. And she had a handful of friends there already: a year earlier, during the Olympic Games in Munich, she had made friends with a Japanese theatre group. Karla Otto is not particularly interested in sport, but she is in culture. And that was why she had travelled to Munich.

When she arrived in Tokyo, she decided to stay. She joined the theatre group, enrolled at the university to study Japanese and paid for her studies with modelling jobs. Although Karla Otto grew up in a good middle-class family, with two sisters and a brother, she began to pay her own way at an early age. "And that's how I came to fashion," says Karla Otto, "and to Milan." As so often happens, her sideline quickly became her main occupation, and before long the model agency sent her to Milan. "There, I quite soon met Fiorucci, and he asked me if I would do his PR work for him," says Karla Otto, who from then on said goodbye to Japan and a model's life.

Elio Fiorucci was twenty-two – about the same age as Karla Otto at the time – and he had just taken over the family business. With his very rich father behind him, he brought London youth culture in the form of T-shirts, jeans and accessories first to Italy, and then from there to the whole world. Fiorucci made, for example, fashionable accessories out of ordinary functional objects, such as sandwich boxes. The two angels, one blonde, the other dark, with the inscription "Fiorucci" in pink became the logo of a whole generation: the Poppers. This was the first global mass trend for whose marketing Karla Otto was responsible. And that at a time when no one knew precisely how to market trends and images. Karla Otto was there at the beginning of this learning process. As a teacher, so to speak. One of her first lessons was how to make a worldwide label out of a modest Hamburg fashion house – but we will get to that.

Nothing happens without a show

After her success with Fiorucci, in the early eighties Karla Otto became self-employed with her own press office in Milan. A little earlier, during the fashion shows in Paris, she had met Jean Paul Gaultier, who asked her to look after his press work for the Italian market. "At that time the fashion world was just beginning to think globally," she says. Until then, fashion magazine editors had to come to the designer's location to see the collection. Now the Milan editors could see Jean Paul Gaultier's designs hanging in Karla Otto's office.

She decided who could come and she also decided who could borrow what for which fashion production – and in this way she could guarantee control over the label's aesthetic environment. But now back to the Hamburg fashion house – Jil Sander.

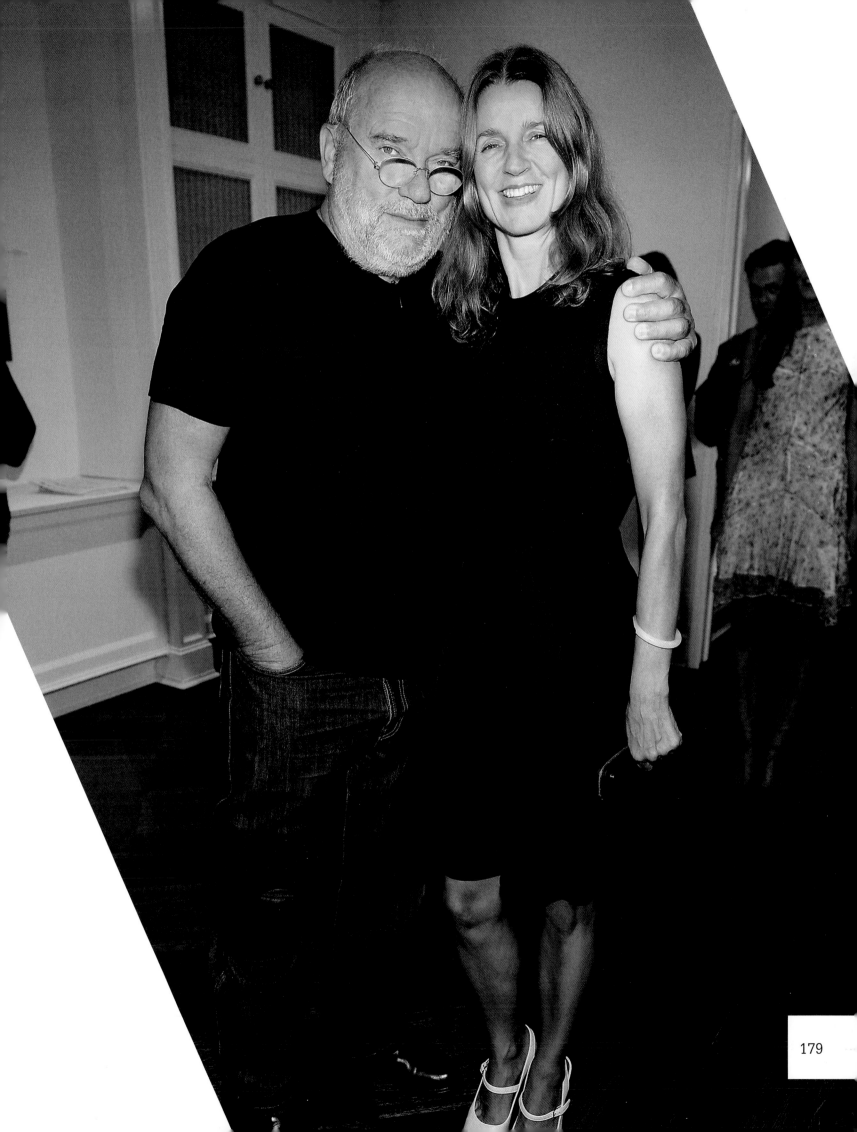

She had heard of Karla Otto and telephoned her. Otto flew to Hamburg. One day later, on her return flight to Milan, she already had the contract with her new client in her bag. "That was pretty amazing," says Otto, "that Jil had the courage to trust me. Above all because at the beginning we were not always in agreement. In Germany Jil Sander was very well known, but internationally the label was known only as a label. No one knew who Jil Sander was because she never had a show. Jil was absolutely against shows. But even if until today everyone is still trying to find an alternative to the fashion show, if you don't do a show you are simply not there. No matter how good your stuff is. No one is interested in you," says Otto, who managed to persuade Sander to have a fashion show in Milan.

The disappointed Pradas

The show was a success and overnight Jil Sander became an international star of the fashion business. From then on Sander and Otto developed everything together, apart from the collection: concepts for worldwide boutiques, advertising campaigns, what products would be promoted in what media. And even if Sander's talent and the fact that she is one of the most remarkable designers of our time are beyond question, it is not too bold a statement to say that Karla Otto was a decisive participator in the building up of the label.

Which was also the case with her next big coup: Prada. Known above all for bags and shoes, Miuccia Prada had just started her first prêt-à-porter collection when her husband, Patrizio Bertelli – the person, by the way, who later bought up Jil Sander and Helmut Lang, only to drive both designers out of their own businesses – rang Karla Otto. "That was my first global client. Everything that had nothing to do with the design of the collection itself, we developed together, Miuccia and I": the image of the label, the campaigns, what photographer should be engaged and what art director. What the flagship stores should look like worldwide. First only for Prada, and later also for Miu Miu.

Then came the big step across the Atlantic. Karla Otto persuaded Miuccia Prada to put on shows in New York as well, which finally brought her great worldwide fame and an award as the best international designer. A close collaboration and a close friendship resulted, which continued for eleven years. "Then Bertelli made me a tempting offer," says Otto. He wanted to buy her – just as he had already bought Jil Sander and Helmut Lang. In the meantime Karla Otto had opened her second office in Paris and wanted next to gain a foothold in London. She refused Bertelli's offer: "I have managed on my own so far, I didn't want to give up my offices and above all my independence."

The Pradas were disappointed. They had not bargained for this. The collaboration ended. This decision has not done Karla Otto any harm – quite the contrary. To this day everything belongs to her 100 per cent, and her name works as a magnet even more than before; from luxury businesses such as Roberto Cavalli, Alberta Ferretti, Pucci and Fendi to sports labels like Nike – they are all represented by Karla Otto. Even Karl Lagerfeld, who since last season has been trying to market his own jeans label. For even if the world has not been waiting for jeans from Karl Lagerfeld, if anyone can succeed in getting these jeans celebrated, then it is Karla Otto, who this year herself has something to celebrate – the twenty-fifth anniversary of her firm. To mark this occasion she has opened an office in New York: a loft in Chelsea, balanced according to the rules of feng shui, the doctrine of wind and water. There is no lack of either here, on the twelfth floor of Chelsea Art Towers, completely glazed with a view of New Jersey across the Hudson River.

Otto helps achieve world fame

A pile of loose papers and a telephone. Nothing else is to be seen on her desk. This is not what one would have expected in the office of the most influential PR and image adviser in the world. From here, Karla Otto wants above all to build a bridge for the Turkish designer Hussein Chalayan and the Dutch house of Viktor & Rolf, who are still known only in Europe. But to achieve world fame, they must conquer America – and Otto is going to help them. Exactly as she last did with Marni – a little furrier's business from Italy, which swapped its fur collection for bewitchingly cut silk tops and dresses and so became the favourite label of the luxe bohemians and the stars.

Karla Otto is supported by about sixty employees worldwide. She herself commutes back and forth between her offices, while her apartment is in London. "I wouldn't call it my only home," she says, "because I feel at home wherever I am." In Switzerland, too, where her sixteen-year-old son is at boarding school. "When he leaves school, I want to move to New York," she says. That might perhaps bring a bit more calm into her life. At least that is currently the plan, but realizing it cannot be considered right now. For when the shows are over, that is when Karla Otto's work really begins – after all, her clients' collections have to be marketed worldwide.

Jina Khayyer for Süddeutsche.de, October 2007

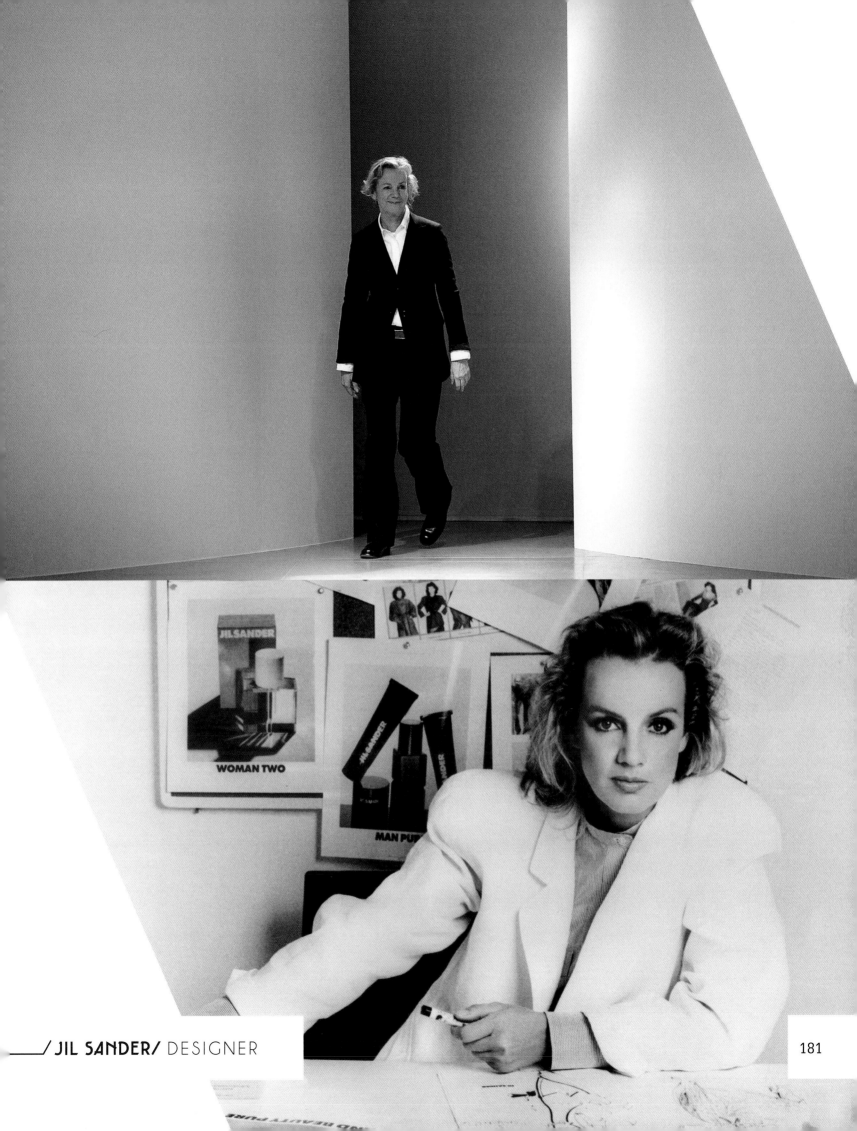

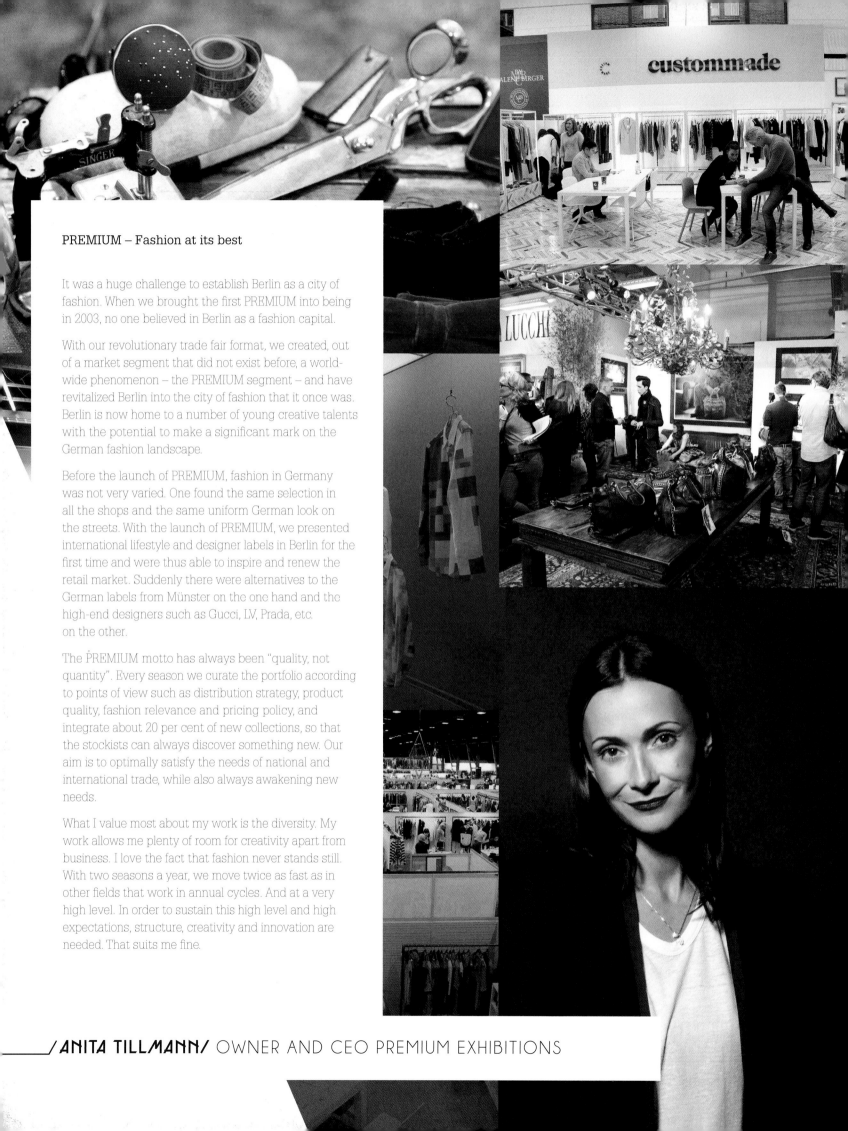

PREMIUM – Fashion at its best

It was a huge challenge to establish Berlin as a city of fashion. When we brought the first PREMIUM into being in 2003, no one believed in Berlin as a fashion capital.

With our revolutionary trade fair format, we created, out of a market segment that did not exist before, a worldwide phenomenon – the PREMIUM segment – and have revitalized Berlin into the city of fashion that it once was. Berlin is now home to a number of young creative talents with the potential to make a significant mark on the German fashion landscape.

Before the launch of PREMIUM, fashion in Germany was not very varied. One found the same selection in all the shops and the same uniform German look on the streets. With the launch of PREMIUM, we presented international lifestyle and designer labels in Berlin for the first time and were thus able to inspire and renew the retail market. Suddenly there were alternatives to the German labels from Münster on the one hand and the high-end designers such as Gucci, LV, Prada, etc. on the other.

The PREMIUM motto has always been "quality, not quantity". Every season we curate the portfolio according to points of view such as distribution strategy, product quality, fashion relevance and pricing policy, and integrate about 20 per cent of new collections, so that the stockists can always discover something new. Our aim is to optimally satisfy the needs of national and international trade, while also always awakening new needs.

What I value most about my work is the diversity. My work allows me plenty of room for creativity apart from business. I love the fact that fashion never stands still. With two seasons a year, we move twice as fast as in other fields that work in annual cycles. And at a very high level. In order to sustain this high level and high expectations, structure, creativity and innovation are needed. That suits me fine.

_____/ANITA TILLMANN/ OWNER AND CEO PREMIUM EXHIBITIONS

You have been on the move a lot in the fashion world – now you have arrived at Porsche Design.
Yes, and it's wonderful. The brand is very fascinating, timeless and modern at the same time. Its roots lie especially in the industrial and manufacturing sectors. Now fashion is a logical next step. We want our lifestyle to appeal to people who value good design.

Are you becoming more open? Do you want to please everyone?
No, we don't want to be everybody's darling. Nevertheless, our aim is to appeal to a wider target group. "You have to give people what they don't know they want yet." I think this phrase by Diana Vreeland, the legendary editor-in-chief of US Vogue, is amazing and I adhere to it in my work.

You work with very minimalist design. Earlier you were at Elie Saab ... where things were in no way minimal.
That's not quite right. Elie's current ready-to-wear collection is minimalist. At that time, I was hired because I understand the visual language of luxurious understatement. Transferring the philosophy of haute couture to prêt-à-porter is a big challenge.

And now you have travelled from the Seine via New York to Germany. Is this the order of the day now, in terms of fashion?
All the Germans who have been successful in fashion have gone abroad. Now, there are a number of complicated reasons for this. Fashion has quite a different status here. In the thirties and forties there was a powerful fashion scene in Berlin. But it was always cities such as Paris, New York and Milan that were really considered the fashion capitals. Many German designers who work for fashion labels abroad are highly valued precisely for their special devotion to quality.

Can Germans appreciate luxury as the French and Americans do?
In Germany there are hardly any luxury lifestyle brands like Hermès or Prada, which have a similar history. That alone makes it truly amazing for me to work for an established luxury brand like Porsche Design.

But you still don't show your collection in Berlin.
In Berlin we have our "trend office", where the whole fashion team is located. I see Berlin Fashion Week as a springboard for young designers rather than as a showplace for a traditional and "opulent" brand. But Berlin does offer me a great deal of inspiration.

What has been the most positive surprise for you in Berlin?
The reliability. I missed that in the US and in Paris. You can rely on a colleague's word. In Paris they always say "no, no, no," and in New York "let's do it." In Berlin – "let's talk about it." That's what I really value here. Maybe it's the reason why Germany has survived so many crises. Responsibility, down-to-earthness – these are important qualities.

Who inspires you?
There are a lot of amazing designers and creatives ... Alber Elbaz, Elie Saab, Helmut Newton. Japanese designers – Yohji Yamamoto, Rei Kawakubo ... Peter Lindbergh has always fascinated me with his strong images, but also women like Carine Roitfeld.

/ **THOMAS STEINBRÜCK** / CREATIVE DIRECTOR PORSCHE DESIGN GROUP

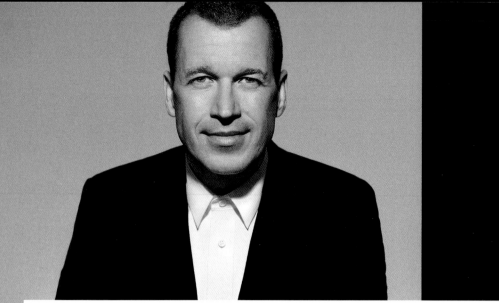

Brand identity, fashion ID and brand IQ – Porsche Design stands for ...?

Iconic style. Our timeless, functional and puristic signature, together with minimalist style elements, give our products that clear and unmistakable look. The combination of first-class design, innovative functionality, perfect craftsmanship and the use of the highest-quality materials allows us to unite the aesthetics and elegance of modern forms with forward-looking technology. Whether in the field of fashion or with our other lifestyle products, Porsche Design has defined its own category of luxury. We call it "engineered luxury" – and that's how we have always interpreted the Zeitgeist of modern design.

In your opinion, what does German fashion stand for?

Classical modernism with innovative design. It is precisely in the luxury sector that the German fashion and lifestyle business conveys an uncompromising understatement, which is reflected in an unmistakable design language. Made in Germany stands for a lifestyle that combines cosmopolitan influences with classical elements – exclusive and stylistically confident at the same time, combined with the highest quality, craftsmanship and cutting-edge design.

What do you value most about your work?

Our customers and working with them. The task is unique: to lead the brand into the future together with our international clientele, our global team and our iconic design, which is quite simply thrilling. The timeless aesthetic that has characterized us since 1972 still remains exceptional and forever modern. It is a principle we guarantee, for the future as well, in all our product categories.

What bothers you most about your work?

Waiting for patterns and prototypes. Just imagine, you have developed a new idea, in your mind or on paper, and the whole team are convinced by it. So you don't want to wait and lose time. You want to work on the details and finally see it in the customers' hands. But patience is all part of the business.

Who inspires you?

Professor Ferdinand Alexander Porsche, the founder of our luxury label. That may sound banal, but it isn't. With his ideas and thoughts he was quite simply ahead of his time. For him, design was not an end in itself, but was rigorously scrutinized, with the aim of getting to the heart of the function and giving a meaning to the products. So he succeeded in combining purist styling and functional quality. Porsche Design and our products have had and always will have relevance in the market.

What makes you happy?

My children's smiles. And when I meet clients while travelling who are wearing our products.

What was your first fashion faux pas?

[laughs] Fashion faux pas exist only in the eye of the beholder.

Your most successful fashion experience?

Our first runway show with the Porsche Design Spring/Summer 2014 collection at New York Fashion Week was a very special event. A lasting impression. Not only because fashion greats like Carine Roitfeld were sitting in the front row, but also because it was an important and extremely emotional step for our label. Fashion is our newest product category. Our successful appearance in New York and the consistently positive

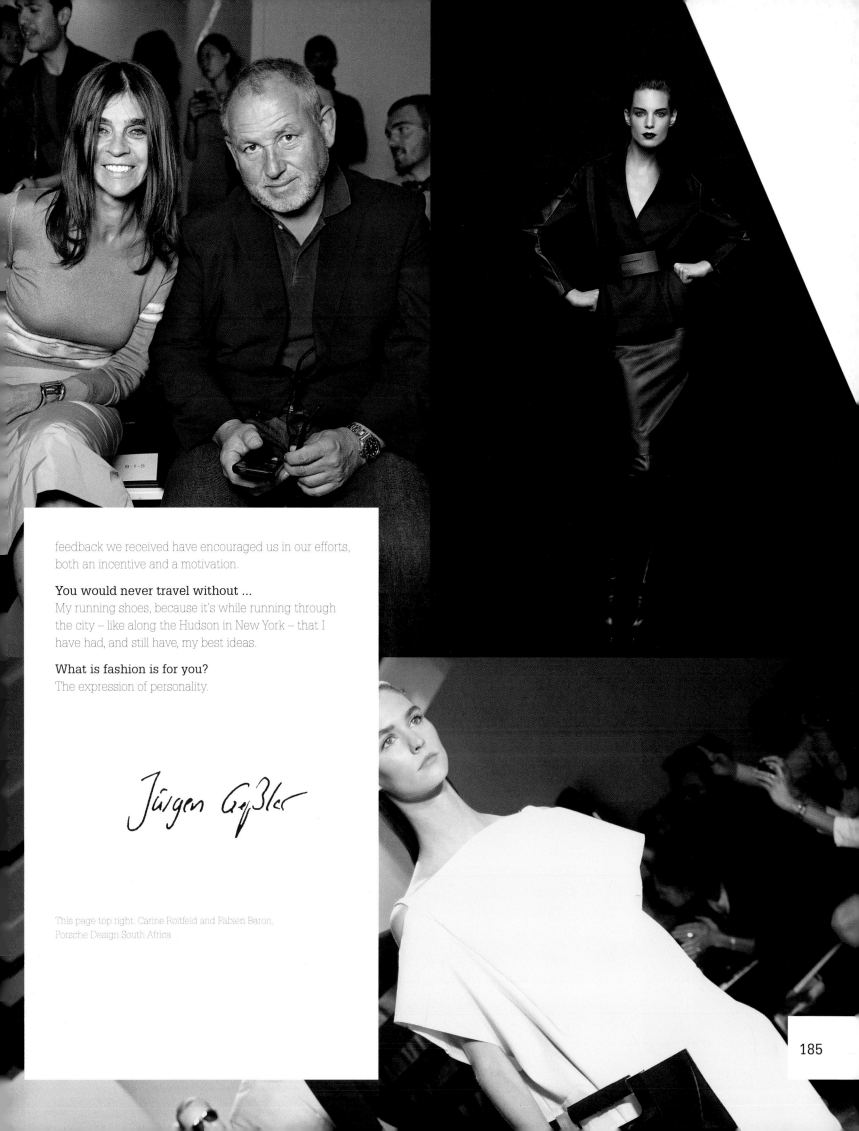

feedback we received have encouraged us in our efforts, both an incentive and a motivation.

You would never travel without ...
My running shoes, because it's while running through the city – like along the Hudson in New York – that I have had, and still have, my best ideas.

What is fashion is for you?
The expression of personality.

Jürgen Gaßler

This page top right. Carine Roitfeld and Fabien Baron, Porsche Design South Africa

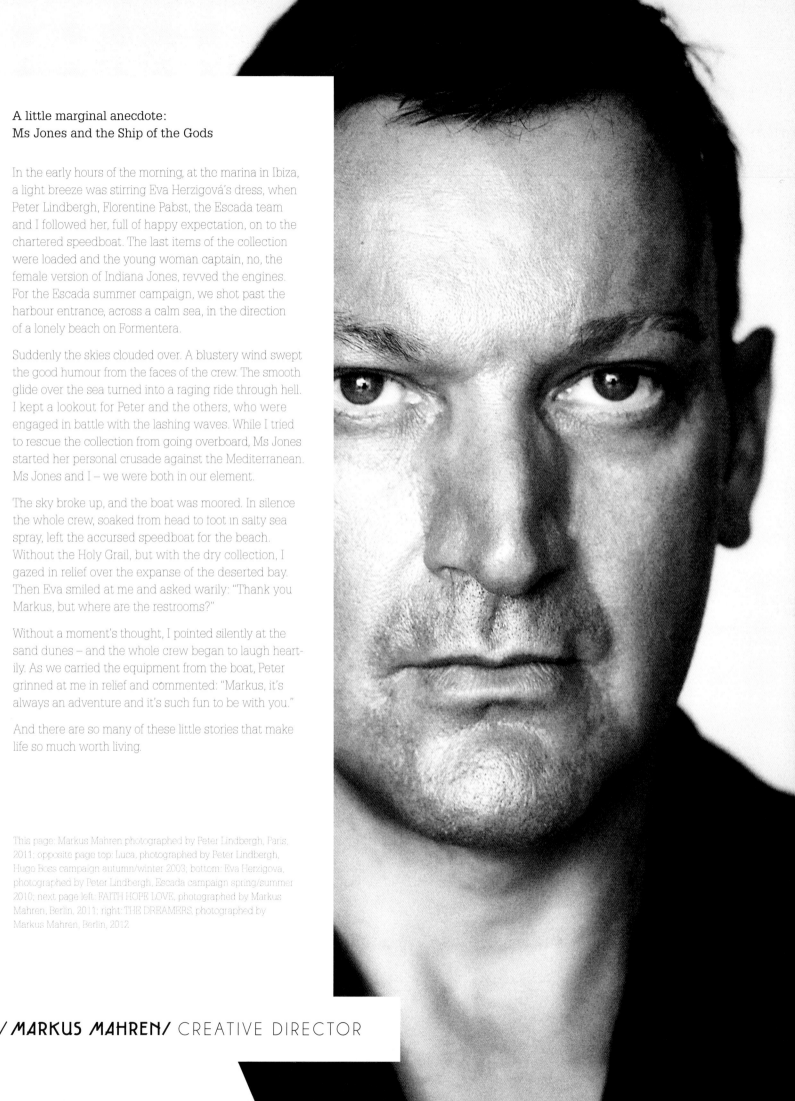

A little marginal anecdote:
Ms Jones and the Ship of the Gods

In the early hours of the morning, at the marina in Ibiza, a light breeze was stirring Eva Herzigová's dress, when Peter Lindbergh, Florentine Pabst, the Escada team and I followed her, full of happy expectation, on to the chartered speedboat. The last items of the collection were loaded and the young woman captain, no, the female version of Indiana Jones, revved the engines. For the Escada summer campaign, we shot past the harbour entrance, across a calm sea, in the direction of a lonely beach on Formentera.

Suddenly the skies clouded over. A blustery wind swept the good humour from the faces of the crew. The smooth glide over the sea turned into a raging ride through hell. I kept a lookout for Peter and the others, who were engaged in battle with the lashing waves. While I tried to rescue the collection from going overboard, Ms Jones started her personal crusade against the Mediterranean. Ms Jones and I – we were both in our element.

The sky broke up, and the boat was moored. In silence the whole crew, soaked from head to foot in salty sea spray, left the accursed speedboat for the beach. Without the Holy Grail, but with the dry collection, I gazed in relief over the expanse of the deserted bay. Then Eva smiled at me and asked warily: "Thank you Markus, but where are the restrooms?"

Without a moment's thought, I pointed silently at the sand dunes – and the whole crew began to laugh heartily. As we carried the equipment from the boat, Peter grinned at me in relief and commented: "Markus, it's always an adventure and it's such fun to be with you."

And there are so many of these little stories that make life so much worth living.

This page: Markus Mahren photographed by Peter Lindbergh, Paris, 2011; opposite page top: Luca, photographed by Peter Lindbergh, Hugo Boss campaign autumn/winter 2003; bottom: Eva Herzigova, photographed by Peter Lindbergh, Escada campaign spring/summer 2010; next page left: FAITH HOPE LOVE, photographed by Markus Mahren, Berlin, 2011; right: THE DREAMERS, photographed by Markus Mahren, Berlin, 2012

/ MARKUS MAHREN / CREATIVE DIRECTOR

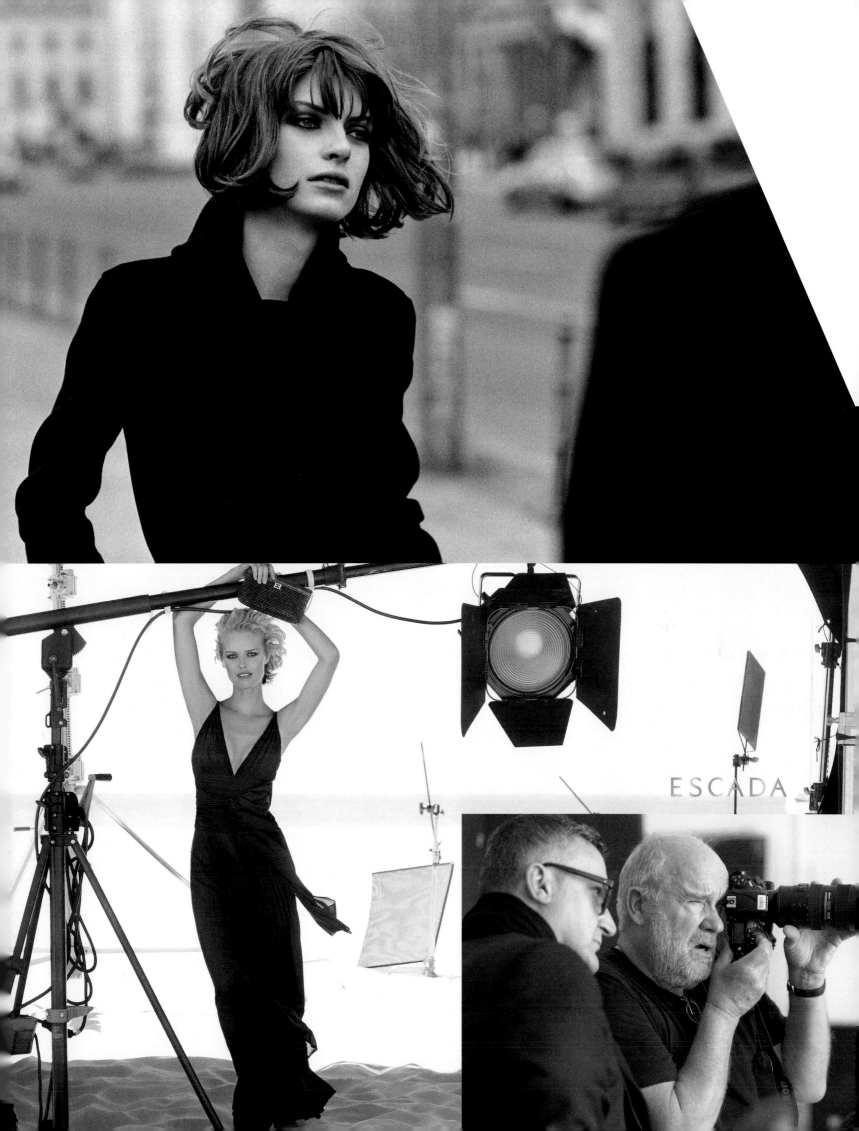

ESCADA

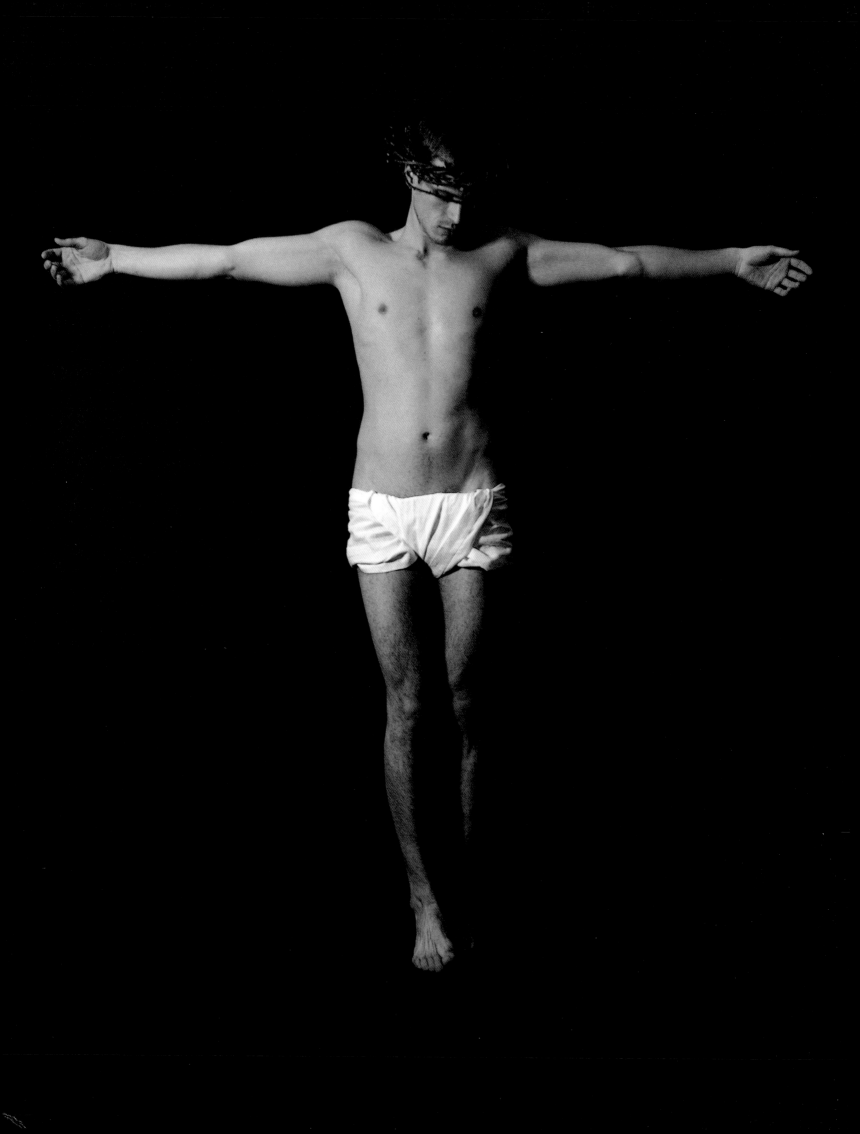

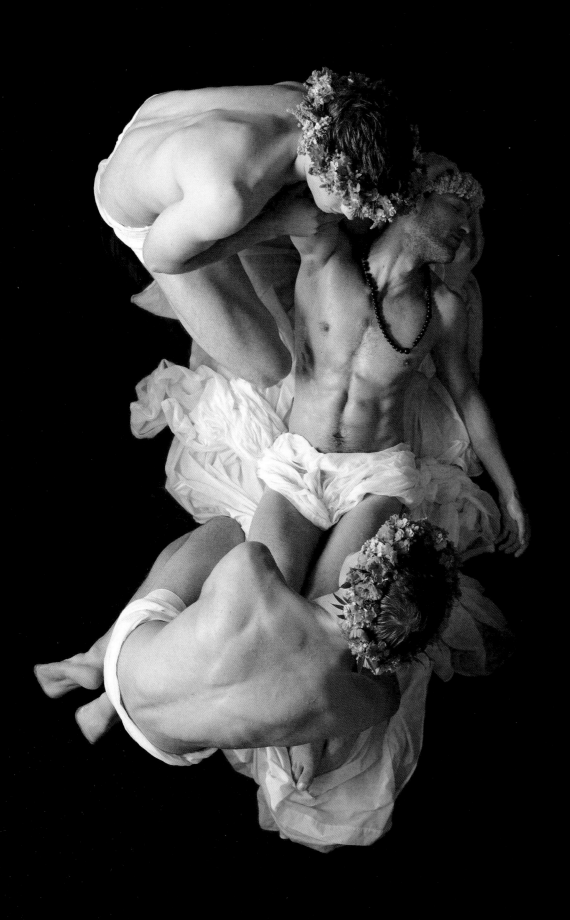

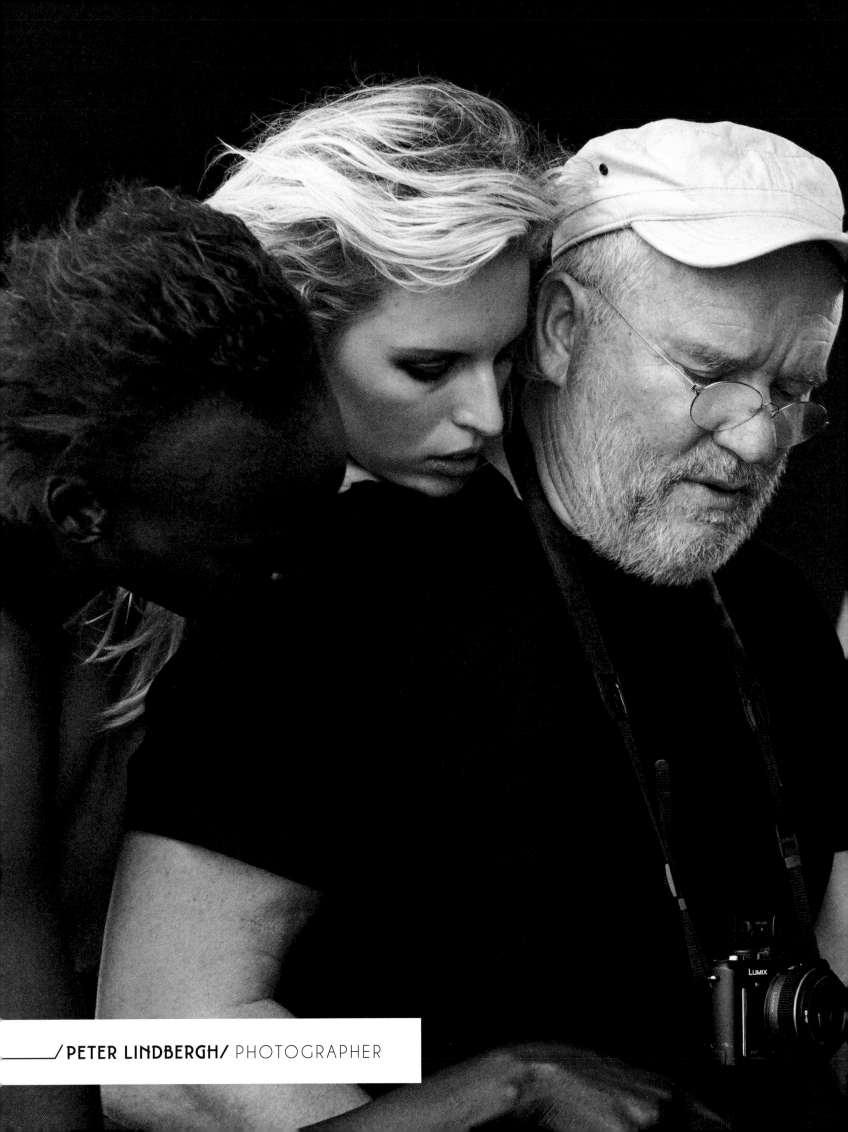

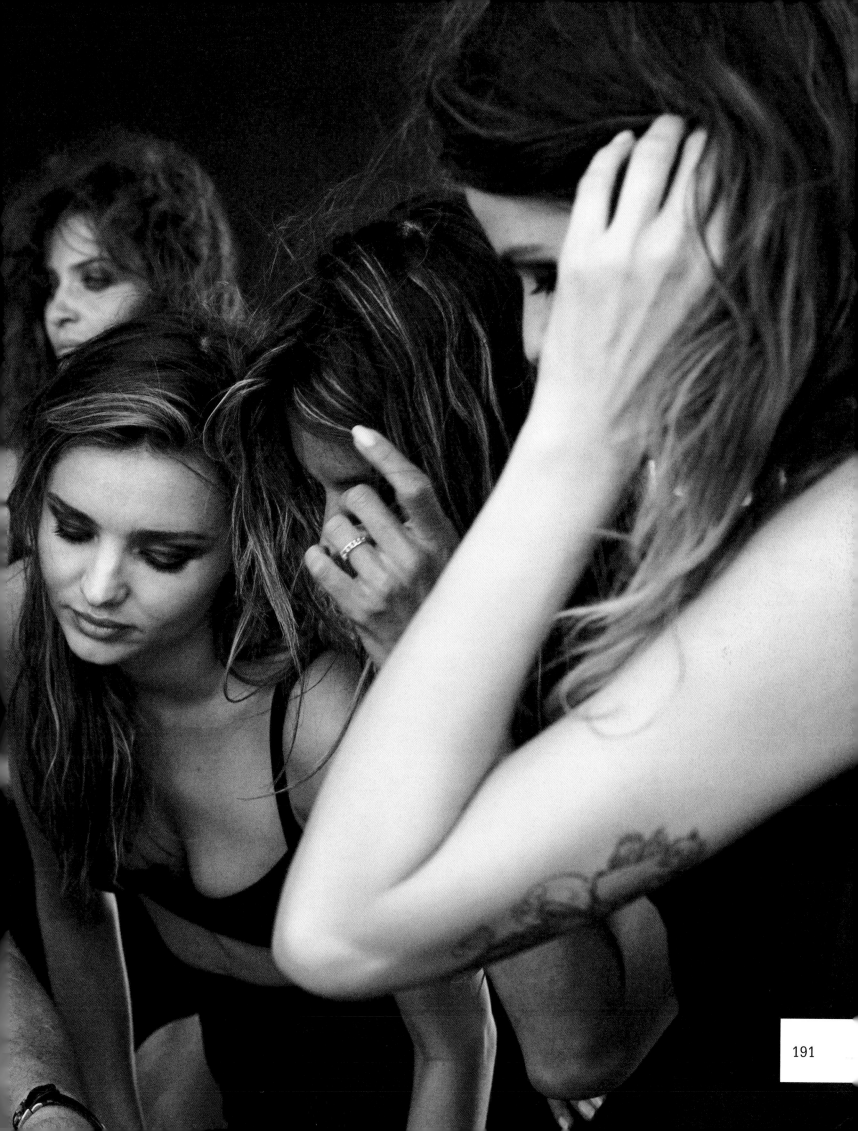

When mentioning these words; fashion, luxury, Germany,
what comes first to your mind?

*Karl Lagerfeld, Mercedes and Wim
Wenders' Movie "Wings of Desire" my
favorite Movie of all times...*

Nothing ever has more inspired me than this film, a magic and spiritual portrait
of postwar Germany.

Who/what inspires you?

*Everything you see everyday
is meant to inspire you...*

Every situation you allow yourself to get into, with all your sensibility and your eyes open,
might inspire you and show you the way to understand who you are and the right way
to express yourself.

What skills do Germans benefit from in
the international fashion industry?

*Germans could bring a new area to
the international fashion circuit:*

They could prove to the international fashion society, that a show could start exactly
on time!

What is your advice to German creative people who would like
to break through in the international fashion industry?

*As sad as it is, I would say you have to
show outside of germany...*

Like Jil Sander did, as probably the most international German designers of the last two decades.
I have not put Karl Lagerfeld in this place, because he has become a worldwide fashion and
photography multitaskmaster, and you cannot compare anyone or anything with him. I also
would not consider him German any more, but rather a global genius by default.

What is your personal fashion work highlight?

The January 1990 Cover for British Vogue, considered as the birthday certificate of the later called "Supermodels"

This cover united Linda Evangelista, Christy Turlington, Cindy Crawford, Naomi Campbell and Tatjana Patitz. Being shot for the first time together, it was an attempt to define a new and independent woman to appear in fashion photography.

Is there anyone who you admire but have not shot yet?

A few days ago Werner Spies came to visit me in my house in Paris.

He brought a small book with him, called "Dark Splendor", a book he and David Lynch did together and it is just about to come out. I am halfway through the book and deeply touched. I admire David Lynch more than anybody I know, as a filmmaker, painter, musician and for his spirituality. He would be the person I would love to photograph, hoping he would become transparent and would let us see the inside of this wonderful man.

What is your secret to survive in the fashion world?

To appreciate this world from a healthy distance.

Do not go to any fashion parties unless you have to and try to learn rather from the incredible fantasy and talent of some designers, and you can do that without being part of the fashion circus.

Lindbergh

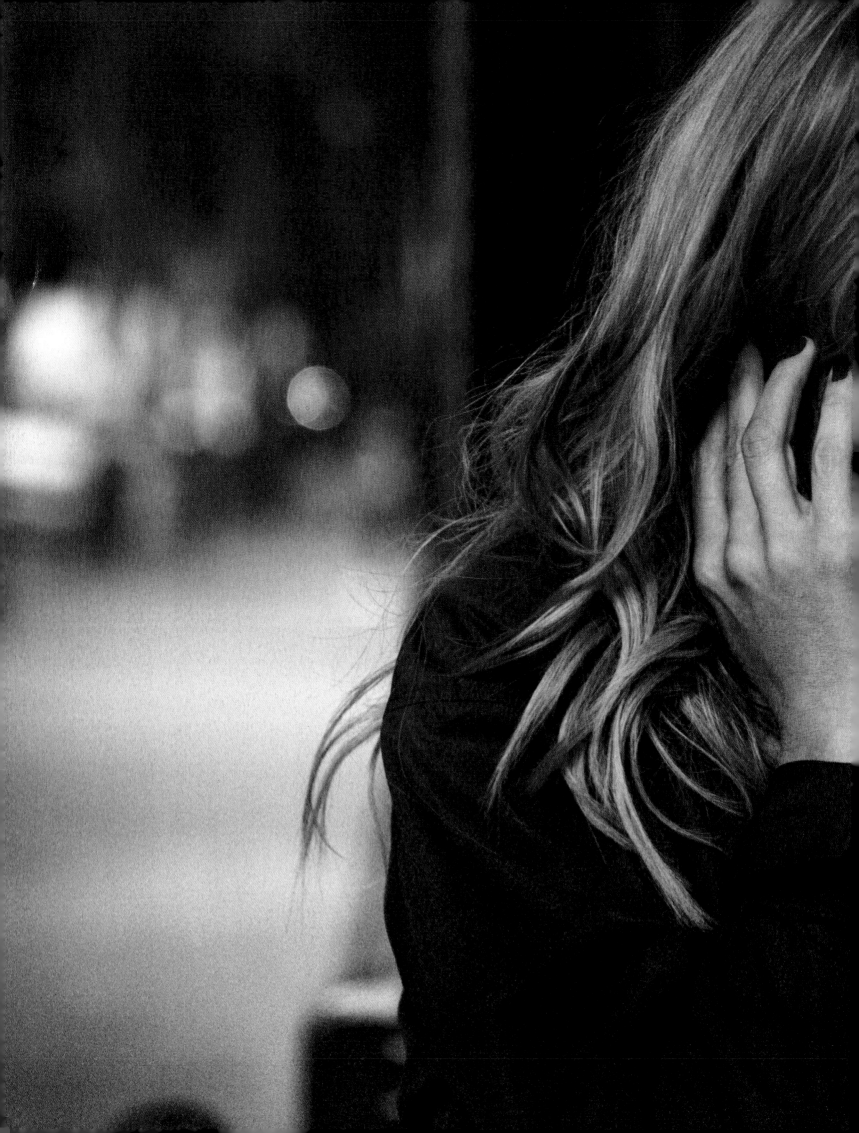

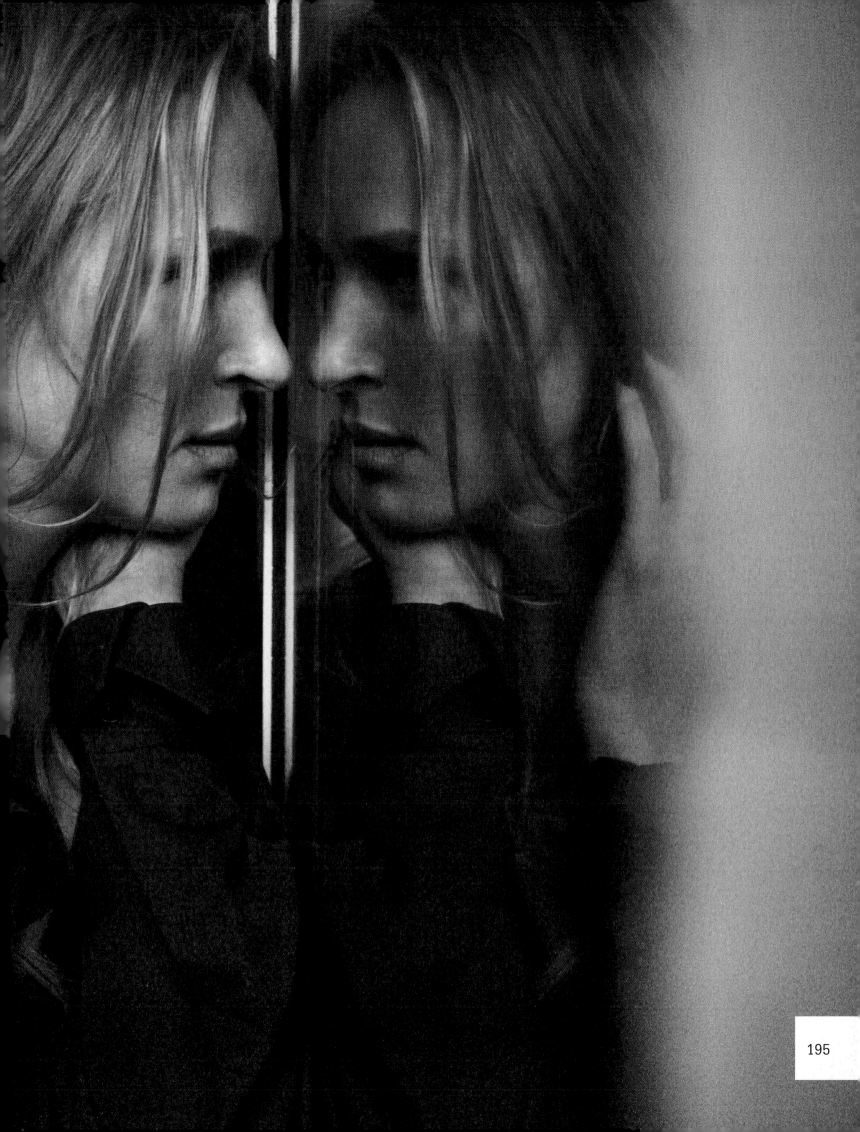

APPENDIX

Natalie Acatrini (Strenesse)

After studying at the Chambre Syndicale de la Haute Couture in Paris, Natalie Acatrini created her own brand (1990–2002) while working as a designer and consultant for a broad range of international brands, including as head of design at Jil Sander and Hugo Boss Women. She is currently engaged as creative director at Strenesse.

Christoph Amend (ZEITmagazin)

Christoph Amend is the editor-in-chief of ZEITmagazin and editor of the two magazines Weltkunst and Kunst und Auktionen, published by ZEIT Kunstverlag. A trained journalist, he was responsible for the Sunday supplement of the Berlin Tagesspiegel and was deputy managing editor of the Süddeutsche Zeitung's Jetzt magazine. In 2012 Amend published the book *Ein Jahr, ein Leben* with the actress Iris Berben. His book *Morgen tanzt die ganze Welt – die Jungen, die Alten, der Krieg* was awarded the Hermann-Hesse-Nachwuchspreis in 2004. He lives and works in Berlin.

Annelie Augustin, Odély Teboul (Augustin Teboul)

The Augustin Teboul label, founded in 2010 by Annelie Augustin and Odély Teboul, positions itself between prêt-à-porter and haute couture. Both designers completed their studies in fashion design at the Esmod International fashion school in Paris in 2006, with special distinction. While the French-born Teboul worked for Jean Paul Gaultier in Paris until 2009, her German business partner assisted Tillmann Lauterbach, also in Paris, and then designed for adidas for two years in Yohji Yamamoto's design team for the Y-3 label.

Anna Bauer

New York-based photographer Anna Bauer is known for her intimate portrait work of top figures throughout the fashion community. When she is not shooting for a major publication or a top designer, she is travelling the world with her 4x5 in tow. She has exhibited internationally and is a National Portrait Gallery Photographic Portrait Prize winner. In 2012, *Anna Bauer: Backstage* was published by Angelika Books.

Sandra Bauknecht (L'Officiel Switzerland/Sandra's Closet)

Sandra Bauknecht is the editor-in-chief of L'Officiel Switzerland for both the German and French editions. She is also the publisher of the fashion and lifestyle blog Sandra's Closet, which is read in more than 140 countries worldwide. She started her online magazine, which covers topics such as art, interior design and beauty, in November 2009. In addition, she writes a monthly column for the Swiss SI Style magazine. Parallel to her blog, she was also in charge of the fashion section of Weltwoche Stil from 2010 to 2012. Prior to this, Bauknecht was based in Chicago, where she started her freelancing career. Before her move to the US, she had been a fashion editor for German Marie Claire in Munich. Bauknecht studied fashion design at the renowned Esmod International fashion school. In 2011 she was the advertising face for Closed and launched a limited edition T-shirt in collaboration with the German brand in 2012. In December 2013 Montblanc created a Bespoke, Limited Edition ink, "Sandra Berry", for Bauknecht, something the company had never previously done.

Emmanuel de Bayser, Josef Voelk (The Corner Berlin)

In 2006 the fashion executive Josef Voelk and the cosmetics marketer and advertising expert Emmanuel de Bayser opened The Corner, often described as Berlin's answer to the Paris boutique Colette. The concept store stocks Balenciaga, Nicolas Kirkwood, Chloé and Yves Saint Laurent, and sells fashion, design articles, accessories, perfumes, light fiction and fashion magazines. The Corner Berlin regularly organizes fashion events like Vogue Shopping Night and book launches, and welcomes prominent guests such as the actor John Malkovich, who presented his fashion line Technobohemian there in 2010.

Thomas Bentz, Oliver Lühr (Achtland)

Oliver Lühr and Thomas Bentz set up Achtland in Berlin in mid-2011. They had met in London in 2006, and setting up their own high-end prêt-à-porter label had been a long-standing vision. Lühr, a Central Saint Martins graduate, had previously worked at Chloé, Balenciaga and the Japanese house Hiroko Koshino, while Bentz holds a masters degree in politics and business. Achtland was chosen to participate in Christiane Arp's Vogue Salon during Berlin Fashion Week for four consecutive seasons from 2012. In 2013 Achtland received the Bunte New Faces Award and in 2014 was invited to be part of Vogue Italy's The Vogue Talents Corner.com. In April 2014 the Achtland studio relocated from Berlin to London.

Natasha Binar

Natasha Binar was first part of the London fashion scene before moving to Berlin. She founded her own PR agency and eventually began to write for trade and lifestyle media. Binar regularly publishes profiles and reportages in various English-language magazines, with the focus on the historical and social context of fashion. She studied social psychology at the London School of Economics and produced for British Sky Broadcasting before discovering her passion for fashion and art. Today, she lectures at the AMD Akademie Mode & Design and writes for the blogzine Nahtlos! – among others. Her first book, *Berlin Catwalks*, was published in June 2011.

Vanessa von Bismarck (BPCM)

Since 1999 Vanessa von Bismarck has run the full-service agency BPCM with her business partner, Carrie Ellen Phillips. BPCM is among the most influential PR and communications agencies worldwide, with branches in London and Los Angeles and its headquarters in New York. They look after fashion, lifestyle and high-end luxury brands, with clients such as Helmut Lang, Lanvin, IWC, Krug and Hermès.

Constantin Bjerke (Crane.tv)

Founded in 2010 by German-born Constantin Bjerke, Crane.tv is an idea whose time has come: a contemporary culture video magazine with offices in London, New York and Rio de Janeiro. The magazine, which boasts contributors from all over the globe, casts a wide net across culture, focusing on influential minds in the worlds of fashion, design, arts, travel and food. On the well-established fashion front, A-listers like Paul Smith, Gareth Pugh, Stephen Jones, Juergen Teller and Ellen von Unwerth are among the many to have been interviewed by Crane.tv.

Angelica Blechschmidt

Angelica Blechschmidt was with German Vogue when its first issue appeared in August 1979, and rose to the position of editor-in-chief in 1989. After studying at the Meisterschule für Mode in Hamburg, she worked as a photographer for ten years in Milan, Paris and New York, capturing great fashion world moments that she occasionally published in Vogue under the title 'flash!'. Blechschmidt participated in the creative development of her protégé Wolfgang Joop's label Wunderkind, and brought many international names including Mario Testino, Tom Ford and Juergen Teller – to Germany. For more than ten years she has lived in Potsdam, working on her own artistic projects. The former Vogue fashion boss is still much in demand as a speaker in panel discussions on fashion, art and society.

Julia von Boehm

German-born stylist Julia von Boehm rose through the ranks of fashion at Vogue Paris while assisting then editor-in-chief Carine Roitfeld. After four years, von Boehm earned her credit as fashion editor-at-large at Vogue Paris, moved to New York City, and began contributing as well to Vogue Japan and Vogue China. Von Boehm's personal style and reputation as a styling expert scored a number of new clients, including design consultancies for Rodarte, Theory and DKNY. Today, von Boehm contributes regularly as a stylist for

the full family of Vogue editions, as well as an increasing list of international fashion magazines, including Harper's Bazaar and V Magazine. She has also consulted on collections for designers like Trussardi, Rachel Roy, Richard Chai, J Mendel and MaxMara, and style advertising for clients like Bulgari, YSL, Jil Sander, Y3, H&M, Tom Ford and Maybelline. She currently lives in NYC with her husband and two daughters.

Petra Bohne

Petra Bohne moved to Paris in 1985 to work as a stylist and fashion journalist for German fashion magazines and international glossies. She worked as art director for companies such as Wolford. In 2005 she published her first photos under the title Französische Verführung (French Seduction) and obtained her first commission for an advertising campaign for Galeries Lafayette. Since 2008 Bohne has worked for the house of Goyard, a well-known luggage maker on Rue Saint-Honoré. For the last two years she has been living with her partner in Normandy, near Giverny, where they are renovating a bed and breakfast.

André Borchers (André Borchers)

André Borchers is a fashion designer who was born into a business family. He commutes between Paris, Hamburg and New York and supports a variety of charity projects. Borchers attended high school in his home town and boarding schools in Sydney, Madrid and Barcelona, after which he studied management and design at Akademie JAK in Hamburg and at Parsons in New York. He is known for his extravagant look and for his exclusive high-end bags and leather accessories with points of sale in Europe and the US. Borchers has numerous collaborative partners, including Otto, the world's largest mail order company, and Blaken, with whom he created his own collection for Rolex. Regarded as a new trendsetter of the fashion and lifestyle scene, Borchers has been turning heads worldwide.

Mirko Borsche (Bureau Mirko Borsche)

Mirko Borsche studied graphic design in England and then communications design at the University of Applied Sciences in Augsburg. In the nineties he worked as a freelance art director at Start Advertising for clients such as Levi's and MTV before taking up a position as art director with the agency Springer & Jacoby. Magazine design was always present: several editions of SZ-Magazin, Neon and ZEITmagazin are the result of the creative concept and realization of Mirko Borsche and his team. In 2006 Borsche was named one of the 100 most creative personalities and thus earned a place in a special exhibition at the Historisches Museum in Berlin. He also received a LEAD "Visual Leader of the Year" award. Bureau Mirko Borsche, with its main office in Munich, implements countless projects, including magazines, books, typography, industrial design, exhibition design, films and websites.

Petra van Bremen

German-born Petra van Bremen grew up in Holland. After her studies she worked in the temporary employment industry and eventually assumed a managerial position. Love brought her to Hamburg, from where she has been working successfully for several years now as an older model. She is actively engaged in the charity DKMS LIFE, which organizes and runs cosmetics seminars for women with cancer.

Sascha Breuer

Sascha Breuer was born virtually with a blow-dryer in his hand. The son of two hairdressers, his early start provided him with the intuition of a seasoned stylist and a unique point of view. He moved at a young age from his native Germany to London, determined to develop his talent and teach others what he knew. This enthusiasm has blossomed into a global career working with industry leaders like Rankin, Peter Lindbergh, Liz Collins, Steve Hiett and Simon Emmet, crafting exceptional styles for magazines such as Vogue, Numéro, Vanity Fair, Harper's Bazaar and Another Magazine. Combining his vision for fashion and beauty and his strong sense of sensuality, he has established Breuer as the go-to stylist for fashion, celebrity and European royalty alike. His impressive roster includes Anne Hathaway, Cameron Diaz, Sienna Miller, Naomi Campbell, Eva Herzigová, Elle Macpherson and Victoria Ingrid Alice Désirée, Crown Princess of Sweden. Breuer is currently based in Los Angeles.

Saskia Diez (Saskia Diez)

After training as a goldsmith, studying industrial design and working with artist Hans-Jörg Voth, designer Christian Haas and at the design studios of Rosenthal and Konstantin Grcic, Saskia Diez founded her eponymous label in 2007. In addition to jewellery, she also designs accessories, partly in collaboration with her husband, the designer Stefan Diez, which are produced by e15, Nobel Project and the Stählemühle. Diez presents her new collections each season during Paris Fashion Week, and then sells them in international fashion and concept stores, direct from her own studio and online. Saskia Diez lives and works in Munich.

Esma Annemon Dil (Anaïmon/Vogue)

Esma Annemon Dil painted at an artists' workshop for a year before she began her studies and relocated several times (including Berlin, Paris and Istanbul). She did research in New York on her uncompleted dissertation on fashion and multiculturalism while also working as an assistant to Monique Pillard, director of Elite Model Management, and later wrote freelance for the Frankfurter Allgemeine Zeitung, the Süddeutsche Zeitung and Stern, where she met Christiane Arp. She began working for German Vogue in 2002, first as features editor in Munich, then as contributing editor in Los Angeles, her present adoptive home. She co-authored the short story collection Foreign Affairs and developed the concept for the TV series Fashion Week. She now also works as a consultant and stylist, and paints and designs for her label Anaïmon, worn by, among others, Emma Watson, Steven Tyler and Kate Moss.

Rike Döpp (Agency V)

Founded in 2006, Agency V specializes in retail-oriented public relations out of offices in Berlin, Copenhagen and New York City. Rike Döpp and Julia Menthel use their varied backgrounds in distribution, design and PR to run an agency that delivers strategic positioning from a designer s perspective. Rike Döpp was educated at the Paris-based PR agency Girault-Totem. After three years as a PR consultant at Totem, she worked in store management for brands such as A.P.C. and Acne.

Magomed Dovjenko

Mago Dovjenko, a self-taught, Russian-born artist, now lives in Germany, where he has been working as a fashion designer, illustrator, graphic designer and art director for more than six years. A prominent figure in Germany's design industry, career highlights include his being invited twice to Germany's top late-night talk shows, including TV Total on Pro7 and Stern TV on RTL. He has also made numerous other TV appearances on talk shows and documentaries. Various musicians have already spotted Dovjenko's work, including G-Dragon, Wiz Khalifa, A$AP Rocky, Swizz Beatz.

Stefan Eckert (Stefan Eckert)

Stefan Eckert worked for Alexander McQueen in London, attended the master's course at the renowned Central Saint Martins College and presented his first collection exclusively at Galeries Lafayette Berlin. In March 2009 he fulfilled a long-awaited dream and opened his own fashion salon in Hamburg.

Annette and Daniela Felder (Felder Felder)

Felder Felder was launched by identical twin sisters Annette and Daniela Felder while they were still studying at Central Saint Martins College in London in 2006/07. Starting with the support of key press and opinion formers, including features in Vogue, Elle, i-D and the Sunday Times Style, Felder Felder has developed a cult following. The sisters established a signature style with their feminine rock 'n' roll aesthetic, which was quickly embraced by singers and actresses, including Rihanna, Gwyneth Paltrow, Florence and the Machine, and Allison Mosshart. Their bold yet modern and

sensual aesthetic has won Felder Felder the respected New Gen Award for three consecutive seasons, a nomination for the British Fashion Awards 2008, a celebrity following and the support of the most sought-after stores in the world.

Alexandra Fischer-Roehler, Johanna Kühl (Kaviar Gauche)

Kaviar Gauche is an award-winning label based in Berlin. The designers, Alexandra Fischer-Roehler and Johanna Kühl, both graduated in fashion design from Esmod before going on to found their ready-to-wear and accessories label in 2005. The line's signature fuses dynamic cuts and patchwork with fluid feminine accents first realized in the Lamella bag. Celebrated for an effortlessly chic aesthetic, the label enjoys a passionate Berlin-powered hype and a loyal following of devotees with high-profile fans, including Heike Makatsch, Florence Welch and Rosie Huntington-Whitely.

Julia Freitag (Styleproofed.com)

Julia Freitag has worked as a fashion director for magazines such as Vogue Business, Glamour and Vanity Fair, and as a stylist she has created perfect looks for stars like Diane Kruger. She has produced photo series and taken over the styling for such magazines as Stern, Z-Magazin, Sleek and Zoo. Together with her colleague and journalist Silke Wichert, she founded the online magazine styleproofed.com – a platform that presents fashion and trends, testing and rating them and providing links them to the corresponding online shops.

Jürgen Geßler (Porsche Design Group)

The sales expert Jürgen Geßler has been in charge of marketing for Porsche Deutschland GmbH since 2002, and CEO of the Porsche Design Group since 2007. After completing a degree and doctorate at the University of Karlsruhe in 1991, Geßler began his professional career in a junior management development group of Mercedes-Benz AG. A year later he moved to the marketing department of BMW AG's Motorrad division. From 1994 to 1998 he was product manager for accessories at Porsche AG. After positions as head of marketing for the Chrysler brand and managing director of the Düsseldorf-based advertising agency U5, he returned to Porsche in 2002. Since 2011 Geßler has been executive vice president of the China Luxury Industry Association, Shanghai.

Jen Gilpin (Don't Shoot the Messengers)

For the Berlin-based Canadian designer Jen Gilpin, black remains the core of her bewitchingly elegant and seductive label Don't Shoot the Messengers, DSTM for short. Leather and silk are other consistent keynotes in the collections and her sculptural cuts are striking yet realistic. DSTM is known for its highly erotic advertising campaigns, which are photographed by Gilpin's husband, Maxime Ballesteros. Her clients include Lady Gaga, among many other international rock and pop stars.

Nini Gollong

Nini Gollong began her fashion career in 2003 as a stylist in Germany. In 2008 she went to Paris to work as a set designer and prop stylist in the international fashion business. Among her clients in the editorial world are various national editions of Vogue, German Harper's Bazaar, Italian Vanity Fair, Glamour, InStyle US and GQ Style. Gollong has worked with photographers like Karl Lagerfeld, Ellen von Unwerth and Camilla Akrans, and has realized projects for, among others, Christian Dior, Chanel, Louis Vuitton and Pierre Balmain. She has been living in Berlin and Paris since 2013.

Esther Haase

Esther Haase trained in classical dance and after two years of stage experience studied graphic design with a focus on photography. Since 1993 she has been "dancing" through the world with her camera; international magazines and advertising clients, films, exhibitions, books and awards testify to her success. Haase lives in Hamburg and London.

Mumi Haiati (Bureau Haiati)

Mumi Haiati's keen eye for design and a desire to travel led him around the world from a young age. He has lived and worked in London, New York, Paris, Berlin and Barcelona (where he studied fashion communication at IED Barcelona). Haiati cut his teeth in fashion PR at the top press office Totem in Paris, where he honed his brand-building skills by working together with renowned designers. After stints at several different agencies, Haiati decided to branch out on his own in 2007 and work with the then unknown German avant-garde designer Boris Bidjan Saberi. Boris was in the early stages of creating his eponymous menswear brand and Haiati helped to develop the label's identity by linking fashion to other art forms. Collaborations with DJs, artists and top musicians helped to construct a dimensional image for the label, which is now sold in some of the world's most exclusive stores and worn by celebrities such as Kanye West, Hugh Jackman and Beth Ditto. Haiati believes it is important to reach out beyond fashion to develop a label's image, and his unique talent is in creating multidisciplinary events that are tailor-made. He also works closely with the exclusive Parisian members' club Silencio. He has created unique pop-up events at Miami Art Basel, Berlin Gallery Weekend and the Cannes Film Festival. Haiati's understanding of contemporary fashion culture and its influences is intuitive and extensive. He has just founded his own Berlin-based PR firm and will use his skills and experience to give talented German designers a bridge to the international fashion industry.

Olaf Hajek

Olaf Hajek is one of the most internationally renowned and sought-after illustrators and visual artists. His stylistically unique work can be seen in publications such as The New York Times, The Guardian and Vogue, as well as on stamps for the United Kingdom's Royal Mail. His personal work has been exhibited in solo exhibitions in London, Berlin, New York, Atlanta and Buenos Aires.

Bettina Harst

Bettina Harst moved to Paris at a young age to try her luck as a model, later commuting successfully between Paris, Tokyo and Milan. She then worked as a model booker for the renowned model agency Elite in Paris and looked after top models like Naomi Campbell, Cindy Crawford and Linda Evangelista. It was here that she found her vocation, and has since worked as a booker for other top model agencies such as Viva Models and, currently, Nathalie Models.

Deycke Heidorn

Hair artist Deycke Heidorn has been a contributor to the fashion and beauty industry for more than eighteen years. She has established a solid career styling hair for Fashion Weeks and working for the most prestigious magazines. Her sense of shape and texture is extraordinary. Constantly inspired by her surroundings on location and in studios, she discovered still photography to be her passion. Fascinated by the texture of hair and the way it reflects the light inspired her to specialize in photographing this fragile material. Besides her long-term experience in the beauty industry, her sensibility to light and technical precision as a hairstylist makes Heidorn an extraordinary artist in this new field of hair beauty photography. Her unique artwork has been published worldwide in magazines like Cosmopolitan and most recently by beauty giant L'Oréal Paris. After living in Paris for five years, Heidorn has been based for the past seven years in New York, where she works in her daylight studio space.

Yasmin Heinz

Yasmin Heinz, who grew up in a family of artists, is an internationally renowned make-up artist. She has worked with designers such as Chanel, Dior and Sonia Rykiel and photographers such as Helmut Newton, Rankin, Ruven Afanador and Felix Lammers, and has made up numerous celebrities, including Dita von Teese, Carla Bruni and Toni Garrn. After spells in New York and Paris, she now lives in London. Her book Geschminkte Wahrheit (Painted

Truth), in which she exhibits her most outstanding work and reveals her make-up secrets, was published in 2013.

Johannes Huebl
After studying applied cultural science at the University of Lüneburg, Johannes Huebl moved to New York to pursue his modelling career, working with leading fashion photographers from Peter Lindbergh to Peggy Sirota. He has travelled the world with his work, taking his fashion experience into the field of photography. In April Huebl's photography work was auctioned at Pikolinos' fundraising gala at the United Nations in support of the Maasai tribe and ADCAM NGO's schooling project. More recently, he was named Royal Salute Polo Ambassador and member of Mr. Porter's prestigious Style Council.

Didi Ilse (Didi Ilse)
Based in London for the past twenty years, Didi Ilse is a contemporary jewellery designer. She trained as a jeweller in Germany and then studied jewellery design in London at the John Cass Faculty of Art and Design. Ilse's jewellery design is distinctive, extremely funky and very individual, inspired by wild nature and the extravagant visual wildlife references from her travels to exotic places in the world and antiques pieces discovered on her adventures. Her thought-provoking designs are executed in the highest-standard solid silver and gold-plated silver with semi-precious stones and impeccable attention to detail and finish. After years of designing bespoke jewellery for private clients and small collections, she took the decision to expand commercially to the general fashion market in 2012.

Bent Angelo Jensen (Herr von Eden)
Born in Denmark to German-Danish parents, Bent Angelo Jensen became interested in fashion and clothing at a young age. At first he leant towards the style of the English mods of the 1960s. Then he discovered the clothing culture of the 1920s and 1930s and experimented with the fashionable eccentricity of the 1980s, finally developing a unique signature from the bits and pieces of past eras. With his fascination for fashion, Jensen developed himself into a designer in the process.

Wolfgang Joop (Wunderkind)
Wolfgang Joop worked as a fashion illustrator, journalist and freelance designer before making his international breakthrough in 1978 with a fur collection. In 1981 he founded his own label, JOOP! and the following year he showed his first women's prêt-à-porter collection. Wolfgang Joop made his name a trademark and from then on, women's and men's collections, accessories and perfume were available under the JOOP! label. In 1985 he was made an honorary professor in fashion design at the Universität der Künste in Berlin. In 2001 he left the JOOP! label and in 2003 founded the Wunderkind label, which was launched internationally in September 2004 at New York Fashion Week; since 2006 the collections have been presented in Paris. Apart from his work as a fashion designer, Joop has also won international recognition as an artist. His drawings, paintings and sculptures can be found at numerous museums of contemporary art. In 2011 his exhibition *Eternal Love* was presented at the Venice Biennale.

Andrea Karg (Allude)
Andrea Karg's career as the internationally successful creative director of Allude began the moment she first touched an article of clothing made of cashmere. And she has never lost her fascination with the sensuality of this fabric. In Allude she has found a niche that she has successfully occupied for the past twenty years, with new luxurious creations every season. Allude's collections can now be found in more than thirty countries.

Raoul Keil (Schön! Magazine)
Raoul Keil is editor-in-chief and creative director of Schön! Magazine. Keil's mission to create an epicentre for talented artists to gather in led him from his native Germany to London, where he launched Schön! Magazine in 2010 in print. In only three years, Schön! has gained a strong international following, and is now sold in print in thirteen countries and read online in 197. Schön! is a provocative and innovative quarterly publication offering stunning photography and in-depth features and interviews. The magazine covers not only fashion, but also art, illustration and conceptual photography, and features iconic personalities like Naomi Campbell, Coco Rocha, Rihanna and The Queen, to name but a few, as well as talent from film, music and other creative industries.

Jina Khayyer
Jina Khayyer has been living in Paris since 2006. She is a journalist, consultant, lecturer and writer and has made a name for herself in the international fashion industry. She works as Paris correspondent for German publications, but also writes in English for international magazines such as 032c, Gentlewomen, Fantastic Man, V Magazine, Pin-Up, GLU and W Magazine. In Germany she writes for Monopol, The Germans, the FAZ, for ZEIT Online and ZEITmagazin. In Paris Khayyer works for the daily newspaper Libération and its supplement Libération Next.

Jasmin Khezri (irmasworld)
After studying fine arts in Paris and Los Angeles at the Otis Art Institute of Parsons School of Design, Jasmin Khezri worked as art director for renowned publications such as Süddeutsche Zeitung Magazin and Marie Claire. She won numerous awards for the Süddeutsche Zeitung s youth magazine, Jetzt, which she founded and shaped visually. Parallel to her work as creative director for the German fashion retailer Peek & Cloppenburg, in 1999 Khezri thought up the illustrated figure of IRMA, named after her grandmother Irma, the wife of the German sculptor Carl Vilz and the muse of the Düsseldorf art world. IRMA is depicted as a young woman travelling the world, forever in search of new ideas.

Kai Kühne (As Four/Kai Kühne/Myself/Hasbeens & Willbees)
Based in New York, Kai Kühne works internationally as a creative director. He is best known as a founding member of the design collective As Four, creator of the labels Myself and Kai Kühne, partner in the new auction house Hasbeens & Willbees, and creative consultant to internationally renowned fashion labels. His clientele ranges from avant-garde icons such as Yoko Ono and Björk to Hollywood legends like Cate Blanchett, Tilda Swinton and Chloe Sevigny. Kühne's collections and projects are found in trendy stores worldwide, such as Barneys, Colette and The Corner, as well as in large museums, including the Metropolitan Museum of Art and the Victoria & Albert Museum.

Marcus Kurz (Nowadays)
Marcus Kurz heads Nowadays as owner, managing director and creative mastermind. He founded the Berlin-based, full-service photo production company in 2001, working with photographers like Mario Testino, Peter Lindbergh, Terry Richardson, Karl Lagerfeld and Mario Sorrenti. In the years that followed, Nowadays became a highly recognized partner for event production, communication and design, focusing on fashion and lifestyle brands. Today's portfolio includes international fashion brands such as Dolce & Gabbana, Versace, Adidas, JOOP!, Hugo Boss, Armani and Yoshi Yamamoto, and, since the beginning in 2007, the Mercedes-Benz Berlin Fashion Week as the production partner for IMG.

Felix Lammers
Felix Lammers discovered his love of photography as a child. After studying in Berlin and years of working as an assistant in Europe, he began his career in the nineties in his native Hamburg, after which he worked in Paris, London and New York as a fashion and beauty photographer for international clients. His images appear in magazines like Harper's Bazaar, Elle, Vogue and Glamour, and he counts L'Oréal, Jil Sander and Louis Vuitton among his advertising clients. He has shot portraits of celebrities such as Cate Blanchett, Uma Thurman, Diane Kruger and Sophie Marceau.

Tillmann Lauterbach (Tillmann Lauterbach/JNBY)

Tillmann Lauterbach is based in Paris. His atelier is located in a nineteenth-century terraced house near the Buttes Chaumont gardens. In 2004 he launched Tillmann Lauterbach womenswear with a fusion of understated, luxurious design and artisanal technique. In 2007 a small menswear range was started with a first show for summer 2007. While he began by teaching himself how to sew, Lauterbach refined his design approach in Paris, where he has steadily forged close relationships with fine craftsmen and creative artisanal ateliers while working in parallel as an artist. The result is a collection of deceptively simple pieces with a rough elegance combining artisanal technique, the finest fabrics and free form. Since 2009 Lauterbach has been creative director of Croquis, JNBY's menswear collection. JNBY is headquartered in Hangzhou, China. Established in 1984, it has quickly become a powerhouse in creative fashion from China, currently selling its men's and women's collections through 500 brand stores in China, Japan, Hong Kong and Canada.

Peter Lindbergh

Peter Lindbergh's path to photography was an unusual one. After leaving school at fifteen, his life was marked by odd jobs until he began studying art and, in his early thirties, held a camera in his hands for the first time. His career began as a commercial photographer in Düsseldorf. In 1978 he moved to Paris and began receiving commissions for different national editions of Vogue, in addition to working for The New Yorker, Vanity Fair, Allure and Rolling Stone. His mainly black-and-white photographs impress with their minimalism and a fresh, unusual approach to the subject. Lindbergh's captivating photographs of famous models such as Linda Evangelista, Naomi Campbell and Stephanie Seymour contributed to the phenomenon of the supermodel in the early nineties.

Papis Loveday

As a youngster, Papis Loveday pursued a career as a professional track athlete. He moved to Paris to study information technology and was discovered by a photographer during the preparations for the World Championships in Athletics. The pictures landed on the desks of two leading international model agencies, and Benetton booked him for a worldwide advertising campaign – laying the foundation stone for Loveday's modelling career. He is now regarded as one of the most internationally successful black male models.

Markus Lupfer (Markus Lupfer)

Markus Lupfer graduated in 1997 from London's University of Westminster with a first-class honours degree. This was followed in 2001 by the British Fashion Council's New Generation Award, a platform that enabled him to begin showing on an international level the label that bears his name. Lupfer was a regular on the London Fashion Week schedule before becoming design director at Spanish fashion house Armand Basi in 2006. In 2008 Lupfer was named Best Designer of the Year at the Prix de la Mode Awards in Spain. Lupfer's talent and expertise have created opportunities for collaborations and consultancy projects with international brands such as Ruffo, Cacharel, Mulberry and, of course, Armand Basi One, which under Lupfer's direction was a must-see London Fashion Week show. The Markus Lupfer brand has evolved to include extensive day- and eveningwear collections, and since the autumn/winter of 2010 has also included internationally successful menswear collections bearing all the Markus Lupfer hallmarks and their characteristic blend of wit and playfulness.

Markus Mahren

Markus Mahren is a creative director with long-established experience in advertising campaigns, fashion shows, interior design concepts, visual merchandising and high-end corporate events. As a former full-time employee and now freelance consultant, he has successfully shaped the global image of iconic brands such as Hugo Boss, Escada and Porsche Design and played an important part in the discovery of German supermodels such as Lars Burmeister, Luca Gajdus and Julia Stegner. Over the years Mahren has worked closely with fashion visionaries like Peter Lindbergh, Mario Testino and Bryan Adams, and has also paved the way to an international career for young photography talents.

Tomas Maier (Bottega Veneta/Tomas Maier)

Tomas Maier is the creative director of the Italian luxury lifestyle brand Bottega Veneta. Since he joined in 2001, he has presided over an extensive but deliberate expansion, establishing Bottega Veneta as one of the world s premier luxury goods houses. Maier was raised in a family of architects and attended a Waldorf school as a child before heading to Paris to train at the Chambre Syndicale de la Haute Couture. His professional experience includes designing for some of the most prestigious fashion and luxury houses in France, Italy and Germany, including Guy Laroche, Sonia Rykiel, Revillon and Hermès. In addition to his role at Bottega Veneta, he oversees his namesake brand, Tomas Maier.

Kai Margrander (Harper's Bazaar)

Kai Margrander began his career as a journalist in 1997 at Condé Nast Publishers, and from 2000 on was an editor at GQ magazine. He later moved to become deputy fashion director at Glamour and ultimately took over the reins of the fashion department. Margrander has twice been elected a member of the CFDA Fashion Awards Guild in New York. He is at present the fashion director of the German edition of Harper's Bazaar.

Marko Matysik

Most of Marko Matysik's youth was spent travelling the world with his Anglo-German hotelier parents and absorbing the minutiae of jet-set life. It was years later, after graduating with honours from St Martins School of Art in London, that he quickly went on to dress real-life princesses at the Victor Edelstein atelier, the preferred couturier of Diana Princess of Wales. Since forming his own label, Marko Matysik, in 1995, Marko has worked in Paris and London in the world that is his passion: couture. He continues to work for many private haute couture clients internationally under this label. His line of one-off accessories are made of antique ribbons, fabrics and buckles from the fifteenth to eighteenth centuries, which he "matchmakes" to create super-lux unique pieces, collected and treasured by Karl Lagerfeld, Madonna and Daphne Guinness, to name but a few. He currently also works as contributing beauty editor for Condé Nast International.

Louisa von Minckwitz (Louisa Models)

In 1981, after completing her studies in communication science, Louisa von Minckwitz founded Louisa Models in Munich, followed in 1990 by the opening of a branch in Hamburg. The agency represents German and international models, as well as stylists and hair and make-up artists. In 1999 Louisa von Minckwitz discovered fourteen-year-old Julia Stegner, who today is in the elite of international top models. Louisa Models has contributed the careers of various German celebrities, among them Eva Padberg, Catherine Flemming, Erol Sander, Christiane Paul, Valerie Niehaus and Andrea Kempter. From the start, Louisa Models has also represented international stars, such as Monica Bellucci, Elle Macpherson, Izabel Goulart and Daniela Pestova.

Armin Morbach (Tush Magazine/Ballsaal)

With position instead of pose and a reduced and elegant composition that continuously toys with the subconscious, Armin Morbach's photos are attracting a growing international audience. His conceptual aesthetic, the way in which he plays with exaggeration and leaves nothing to chance, both surprises and provokes. For the past two decades, Morbach has been an in-demand stylist, defining an international look and a universal understanding of beauty. He has worked with the best photographers, including Michel Comte, Patrick Demarchelier, Ellen von Unwerth and Peter Lindbergh. Driven by a desire to continue developing his artistic expression and to perfect his visions in presentation – his visual language – five years ago he took the

next logical step and picked up a camera. Today, he can already boast an impressive portfolio. Accepted into F. C. Gundlach's photographic collection in 2011 and also included in Gundlach's curated exhibitions, his work has also been seen at the NRW-Forum in Düsseldorf and the Deichtorhallen in Hamburg. As the publisher and editor-in-chief of TUSH magazine, Morbach has a regular platform that reflects his visual language, his imagination and his realities.

Torsten Neeland (Torsten Neeland Studio)

Following his studies in industrial design at the Hochschule für bildende Künste in Hamburg, Torsten Neeland set up his office for industrial and interior design in 1991. In 1997 he moved to London, where he now lives and works, establishing Torsten Neeland Studio for Industrial and Interior Design. With a particular focus on contemporary design, he has been developing his design experience from corporate interior branding to product design for manufacturers such as Audi, Dornbracht, Donna Karan Home and WMF.

Susanne Oberbeck (No Bra)

At the age of twenty-two, Susanne Oberbeck moved to London, where she started making short films, wrote for the satirical fashion magazine Blow and played in the band Windscale, among other things. She later studied film directing at Columbia University in New York, and continued to make short films and music videos. She is now most known for her band, No Bra, which she started in 2003, and her confrontational, topless live performances. Oberbeck has modelled for designers Alexander McQueen, Shayne Oliver (Hood by Air), Anne-Sofie Back, Noki and others. No Bra has been covered in numerous magazines, and photographed by Wolfgang Tillmans, Hedi Slimane and Nick Knight, to name just a few, as well as inspiring visual artists like Brian Kenny and Christophe Chemin.

Andreas C. Ortner

Andreas C. Ortner has worked in the fashion industry for more than twenty years. This "self made man" began working as a photographer in 2005, when he bought his first camera, an analogue Pentax, at a flea market in Brooklyn, New York. Ortner has travelled and photographed extensively throughout the US, Europe, Canada and Asia, and on his journeys he had the chance to work with inspiring personalities such as Steven Klein and Terry Richardson. He currently shares his time between Munich, New York and Paris. Among his clients are Baldessarini, Bogner, Lacoste, Jung von Matt and Grey International, and his work has been published in many international fashion magazines, including Vogue, Elle, Harper's Bazaar and Cosmopolitan. He has launched several exhibitions, such as *Un hommage à la passion*, at the W Hotels all over Europe, and at the Art Basel in Miami and Tokyo.

Karla Otto (Karla Otto)

A former model herself, Karla Otto has for more than two decades been one of the most important PR advisers in the industry. Few have represented such a diverse range of renowned clients with as much success as Karla Otto has. She has been instrumental in the careers of Miuccia Prada and Jil Sander, and her PR agency continues to grow, with locations in Milan, London, Paris, New York, Los Angeles, Hong Kong and Beijing. Karla Otto is among the most experienced and respected fashion personalities on the international stage.

Vincent Peters

Vincent Peters moved to New York in 1989 and pursued his goal of becoming a photographer. After working as an art photographer for a few years, he decided in the late nineties to change to fashion and portraits. Through collaboration with Giovanni Testino, he quickly established himself among the world's leading fashion photographers. Over the years, Vincent has worked for numerous prestigious fashion magazines such as Vogue (Italy, US, Spain, Germany, Russia, Japan, China), GQ (UK, Italy, Germany, Spain), the Sunday Times, Numéro and Esquire, and clients such as Louis Vuitton, Miu Miu, Céline, Moncler, Yves Saint Laurent, Armani, Bottega Veneta, Lancôme, Hugo Boss, Cartier, L'Oréal and many more.

Leyla Piedayesh (lala Berlin)

The creative mastermind behind lala Berlin is Tehran-born Leyla Piedayesh. After studying business administration, she first came into contact with fashion professionally as editor of "Designerama" at MTV Berlin. In 2003 she began exploring her design talent by making her own knitted accessories, and in 2004 she launched her acclaimed debut collection at the Premium fashion fair in Berlin. The concept of a symbiosis of urban cool and elegant chic based on high-quality knitwear took off; lala Berlin was born. In 2010 the British fashion critic Suzy Menkes declared: "I like lala Berlin!"

Philipp Plein (Philipp Plein)

Philipp Plein's strong interest in art, architecture and foreign cultures was shaped early in life through the extensive travels of his family, providing exposure as a child to the world's most important museums and cultural exhibits. In 1998 he entered the world of design by producing exclusive furnishings in steel and leather, initially for family and friends, which soon became a full-time professional activity. His involvement in leather craftsmanship led him to experiment with leather garments and accessories, and finally to launch his own fashion brand in 2004. According to Franca Sozzani, editor-in-chief of Vogue Italy, "Philipp Plein is unique because he has a joy of life. He doesn't want to be a fashionista; he makes fashion because he loves women. This is a specific, special attitude because he is one of the few."

Tom Rebl (Tom Rebl)

Tom Rebl's talent was discovered and developed while studying at Central Saint Martins College of Art and Design in London, the world's most prestigious institution for fashion. In 2008 the eponymous label established its headquarters in Italy, where the entire collection is designed and produced. The mixture of superb technical skills and Rebl's captivating creativity give his collections their extraordinary twist and international appeal.

Alexandra von Rehlingen, Andrea Schoeller (Schoeller & von Rehlingen PR)

Andrea Schoeller and Alexandra von Rehlingen founded their agency, Schoeller & von Rehlingen PR, in Munich in 1986. Schoeller studied communication sciences and began her career as PR director with Willy Bogner. Von Rehlingen studied Sinology and art history, attended the Parsons School of Design in New York and, before setting up the agency, worked as a freelance interior designer. In 1988 von Rehlingen moved to Hamburg, where she opened the agency's second office. Then, in 1999, having settled in Berlin, von Rehlingen together with Schoeller established a third office, and today they have a total of forty employees in the three media capitals. Schoeller & von Rehlingen PR specialize in brand communication in the fashion and lifestyle sectors and in the organization of high-end events. Among their clients are renowned companies like Montblanc, Etro, Rena Lange and IWC, and new labels like 7 for all mankind, and Mango.

Adrian Runhof, Johnny Talbot (Talbot Runhof)

Adrian Runhof and Johnny Talbot met in Munich in 1991. At this time Talbot was still working as a programmer and Runhof as a sales agent for various Paris designers. Soon they began to develop collections together for different brands. In 2000 they founded their own fashion label: Talbot Runhof. Apart from their 350-square-metre boutique in Munich, Talbot Runhof's fashions now appear in stores worldwide, including Bergdorf Goodman, Neiman Marcus and Saks Fifth Avenue in New York and Los Angeles. Since 2006 Talbot Runhof has been a regular feature at prêt-à-porter shows in Paris.

Donald Schneider (Donald Schneider Studio/H&M)

Donald Schneider is the creative director of H&M, responsible worldwide for all aspects of the brand. He initiated the first designer collection with Karl Lagerfeld and then worked with, among others, Versace, Marni, Margiela, Isabel Marant and David Beckham. From 1994 to 2002 Schneider was art director of French Vogue and Vogue Hommes International in Paris.

Between 1985 and 1994 he was art director on the magazines East Village Eye and Fame in New York, as well as Tempo in Hamburg and German Vogue in Munich. Schneider is the founder and creative director of Donald Schneider Studio, first in Paris and now based in Berlin. Among the clients of his creative agency for art direction and design are Brioni, Cartier, Hugo Boss and Karl Lagerfeld. Schneider studied graphic design at the Kunstgewerbeschule in Zurich and Basel.

Dirk Schönberger (adidas)
As a graduate of the renowned Esmod fashion school in Munich, he took on his first job as personal and managing assistant of menswear designer Dirk Bikkembergs in Antwerp and Italy. After three years he felt disposed to build up his own label: Dirk Schönberger men & women. In his nearly ten years as an independent designer in Antwerp and Paris, Schönberger has successfully earned recognition and built a reputation in the fashion industry, and in January 2007 he decided to take off for a new challenge at JOOP! in Hamburg. He became creative director of the German fashion label, overseeing the entire creative output of the label, including product, advertising, PR and retail strategies. After leaving his unmistakable mark at JOOP!, Schönberger moved to the international headquarters of adidas AG in Herzogenaurach, starting as the new creative director of the Sport Style division in June 2010.

Kristian Schuller
Kristian Schuller is a New York-based photographer. Born in Romania, Schuller emigrated with his family to Germany at an early age. He studied fashion design with Vivienne Westwood and photography with F. C. Gundlach at the University of the Arts in Berlin. After his initial introduction by Isabella Blow to Condé Nast Publications in London, Schuller has continued working internationally with various fashion magazines and commercial clients.

Marie Schuller
Marie Schuller is a London-based film director specializing in fashion content. Her films are marked by the surreal and abstract and offer cinematic, provocative and unsettling imagery. Since 2010 Schuller has been working for Nick Knight's SHOWstudio in London, where she holds the position of head of fashion film. Her directing work has been screened internationally from the Kunsthalle in Vienna to the Centre Pompidou in Paris and the Fashion and Textile Museum in London, and in 2012 she was awarded the Best Director of Fashion prize at ASVOFF Barcelona. Schuller was raised in Germany and resettled to England in 2004. She studied film-making at the UK's National Film and Television School and completed her master's in photography at University of the Arts London.

Dorothee Schumacher (Schuhmacher)
Modern femininity, luxurious materials and a glamorous nonchalance form the soul of Dorothee Schumacher's ready-to-wear collections. Her style is also defined by how she plays with contrasts. Delicate and strong are not contradictory – they reflect the true nature of female charisma. Dorothee Schumacher creates fashion for women who – just like her – expect a great deal from life, who grab their opportunities, who live and love with passion. As a cosmopolitan creative, successful entrepreneur and mother of four children, she intuitively hits upon the modern woman's attitude towards life. Together with her team she transcends all borders, and with exceptional attention to detail she designs beloved pieces that give every woman that "made for you" feeling.

Claudia Skoda (Claudia Skoda)
Claudia Skoda was working at a publishing house when she took up knitting with a passion for unique fashion. She lived out her creativity in Berlin at the same time as Martin Kippenberger and David Bowie. Through her experimental knitting art Skoda has risen to the ranks of the most influential members of the fashion avant-garde. Her creations are worn by celebrities and personalities from Berlin to New York to Hollywood.

Corinna Ellen Springer (Nouveau-PR)
Corinna Ellen Springer moved to Paris in 1994 to study French literature and fine arts. Always passionate about fashion, she began working at the Totem press agency. One year after graduating she moved to New York to take on a PR position at the cult denim label Rogan. In January 2007 she went on to direct the relaunch of the now Theory-owned Helmut Lang label, before opening her own press office, Nouveau-PR, in October 2007. Since its inception, Nouveau-PR has grown into a high-end boutique PR agency, with a strong focus on menswear and international womenswear designers, as well as accessories.

Schohaja Staffler
The Munich-born photographer Schohaja Staffler lives in Paris and signs her pictures with her first name: Schohaja. In addition to editorial lookbooks and campaigns she is known for her atmospheric backstage pictures. Staffler works for international magazines such as T magazine of The New York Times, V magazine, V Man, French Vogue, Vogue Hommes International, Numero, Crash and Elle Collections UK, and for fashion houses like Sonia Rykiel, Dries van Noten and Burberry, as well as Mytheresa and Lane Crawford in Hong Kong.

Marco Stein (7 for all mankind)
Marco Stein is sales director for 7 for all mankind (VF international) with responsibility for marketing in northern Europe. Stein gained years of international experience with designer labels such as TSE Europe, Donna Karan and Diesel. He has also worked as advertising manager at Condé Nast in Munich for magazine titles such as GQ, AD and Vogue.

Thomas Steinbrück (Porsche Design Group)
In October 2011 Thomas Steinbrück took over the newly created position of creative director and coordinator for customer experience at the Porsche Design Group. One of his roles was promoting Porsche Design's market repositioning as a luxury brand for fashion and accessories. Most recently, Steinbrück was responsible, as vice president of collections, for the design and brand identity of Elie Saab. From 2005 to 2008 he was vice president of merchandising and design for Kenneth Cole New York. He began his career as an assistant designer to Gianfranco Ferré at Christian Dior, after completing his studies at Studio Berçot and the École de la chambre syndicale de la couture in Paris. In 2000 Steinbrück received the Moët & Chandon Fashion Fall Award as Best New American Designer, and in 1999 he was awarded the Timmy Award as Best New Designer.

Klaus Stockhausen (Interview Magazin)
As a DJ in the 1980s, Klaus Stockhausen was already setting the tone, and today he is among the most renowned German stylists, with years of international experience and a special feeling for bringing fashion to a German public. He has helped numerous international magazine titles, including GQ and Interview, gain acceptance on the German market.

René Storck (René Storck)
René Storck acquired a passion for fashion in his childhood from his mother. After leaving school he trained as a dressmaker and, among other things, worked with the jeweller Thomas Sabo. In 1991 Storck founded a label under his own name in Frankfurt and built it up over the following years through word of mouth. In 2007 he opened his flagship store, also in Frankfurt. His collections focus on high-quality fabrics and leather; his style is simple yet sensual, calm yet emotional.

Susanne Tide-Frater (Victoria Beckham/Farfetch)
Susanne Tide-Frater is a brand consultant specializing in fashion and retail – she calls herself a "brand doctor". She is fashion director for Victoria Beckham and has been involved in building the brand and the product offer since the beginnings of the ready-to-wear line in 2008. As creative director of Harrods (2004 to 2006), Susanne Tide-Frater played an important role in the store's creative strategy. Her last project was Harrods Terminal 5.

Previously, Susanne worked as creative director for Selfridges and played a major role in the turnaround, under Vittorio Radice, of the once dusty retailer. Tide-Frater sits on the New Gen Panel of the British Fashion Council and is a jury member of the Vogue Fashion Fund. She is a director of the Venture Board of the Whitechapel Art Gallery and has been external examiner of the Central Saint Martins master's programme in fashion and textile design since 2007.

Kera Till
The political science graduate Kera Till has made her passion, illustration, her profession. Living in Paris and Munich, she creates for renowned international clients such as Ladurée, Hermès, Vogue, Glamour, Elle and Tatler. Since 2012 her illustrated journal has appeared at Vogue.de.

Anita Tillmann (Premium)
Anita Tillmann is the director of the Premium – International Fashion Trade Show, which she founded more than ten years ago with Norbert Tillmann and Florian Bachelin. She is also the sole executive director of Premium Exhibitions, which organizes editions of the fair in Düsseldorf and Munich in addition to Berlin. At Premium, all areas of the fashion industry – ladies' and men's collections, sportswear, jewellery and shoes – are shown in an interesting mix in a single place. Premium has almost 1,000 brands with more than 1,500 collections in its portfolio and opens its doors at Gleisdreieck in Berlin to more than 60,000 trade visitors.

Dawid Tomaszewski (Dawid Tomaszewski)
Dawid Tomaszewski is a Polish-German fashion designer of the eponymous Berlin-based label. After studying at the London College of Fashion, the University of Fine Arts in Pozna, and the Akademie der Künste in Berlin, he gained practical experience at Sonia Rykiel in Florence and Alexis Mabille in Paris. In 2009, after a stay abroad as design assistant to Rei Kawakubo at Comme des Garçons in Tokyo, he founded his own label, which since his debut collection is being eagerly followed by media such as Vogue, Elle and Vanity Fair. Since then he regularly presents his purist and extravagant collections at, among others, Mercedes-Benz Fashion Week in Berlin.

Feride Uslu (uslu airlines)
Feride Uslu was born in Söke, Turkey, and raised in Germany. She started her make-up career in Madrid and then moved to New York, where she worked with all the top names of the fashion and beauty industry. By 2003 she had started her own airline and cosmetic brand, uslu airlines, with partner Jan Mihm. The micronized liquid airbrush make-up is her first and most beloved product. It is available in a variety of shades and can be used as foundation, rouge, eyeshadow and lip colour. The names for all those colours are just as creative: each is christened with a three-letter airport code from sometimes the most remote corners of planet Earth. The brand is inspired by an amazing and ever-growing line-up of sexy collaborators: Parisian concept store Colette, fashion designer Bernhard Willhelm, Berlin sunglass mavens Mykita or good old American shoemaker Nike, for example, have all explored new destinations with uslu airlines.

Burak Uyan (Burakuyan)
Paris-based fashion designer Burak Uyan, formerly the creative mastermind behind Giambattista Valli's clothing and accessory line, left the label to develop a shoe brand under his own name: Burakuyan. As a child, his favourite pastimes were drawing, architecture and interior decoration. His inspiration from the world of fashion were the innovative designs of Helmut Lang – with their graphic and minimalistic designs and his mixture of materials. Stimulated to study fashion, Uyan left his German home town for Vienna in 1997, attending the same fashion institute where Lang had trained. After graduating, Uyan moved from Vienna to Paris in 2001, where he befriended designer Alberto Marani. The two bonded over their mutual love for Helmut Lang, and Marani, who to this day collaborates with Carine Roitfeld as a consultant for different labels, offered him the creative assistant position at his notable label. A few years later, he left for a position at Givenchy as part of the design team. However, it was his chief position as head designer at Giambattista Valli that elevated his name in the fashion world. Responsible for the clothing and the accessory line, it was at Valli that Uyan had his first experience with accessories and, above all, shoes. After half a decade Uyan left Valli in 2009 to start a new creative chapter in his career: his own line, Burakuyan. The architecture-inspired designs, mixed with a high dose of glam and the wearability of the four-inch-plus heels, have made the Burakuyan brand flourish rapidly in the fashion world.

Alexx Weber, Anton Cobb (Alexx and Anton)
Alexx and Anton is an intimate fashion-based style collective with well over ten years' experience in the fashion industry. We bring our knowledge of style into every aspect of our work, be it editorial fashion shoots, advertising, consulting, fair stands and presentations or window displays. Our portfolio of collaborators allows us to provide the appropriate services for diverse fashion-related endeavours. An acute awareness of both the past and present culminate in an aesthetic language that reads as timeless for all creative concepts delivered. "Create your own visual style … let it be unique for yourself and yet identifiable for others." – Orson Welles

Silke Werzinger
Silke Werzinger lives and works as a freelance illustrator in Berlin. In 2008 she completed her design studies in Nuremberg, and her diploma thesis, "Pimp My Life", was awarded the 2008 Red Dot Design Award, Gold in the Gute Gestaltung 09 awards and the Junior ADC Award for 2008. Since 2006 she has worked for national and international clients such as Cosmopolitan, Condé Nast, DIE ZEIT, L'Oréal and Marie Claire. In 2011 Werzinger was nominated for the German Designpreis.

Alex Wiederin (Buero New York)
Alex Wiederin is a creative director, graphic designer and typographer. He has been, among other things, creative director at AnOther Magazine, 10 Magazine, Vogue Hommes International and BIG Magazine, and is at present creative director at Italian Elle. Together with his design agency Buero New York he develops trends in the industry and assists his clients in giving give voice to their unique personality.

Bernhard Willhelm (Bernhard Willhelm)
During his studies Bernhard Willhelm assisted Walter Van Beirendonck, Alexander McQueen, Vivienne Westwood and Dirk Bikkembergs. He received his diploma in fashion design with honours in July 1998 at the Royal Academy of Fine Arts in Antwerp. Straight after leaving college he founded a company together with Jutta Kraus to launch his first women's collection, which was shown at Paris Fashion Week in March 1999. Since 2009 Willhelm has been head of the fashion department at the University of Applied Arts in Vienna.

TOM REBL

Where have all the flowers gone?

I am just sitting comfortably on a beach, enjoying the sun. It is the end of January. Despite the paradisal backdrop, my mood is pensive. I am thinking back to the fashion show at Milan Fashion Week two weeks earlier. Everything was big. The location, the stage, the procession, the party. Yes, even the models were an inch or so taller this season than before.

As is appropriate for a designer, at the end of the show, after all my disciples had filed along the catwalk one last time, I presented myself to those in attendance. With a feeling of relief and pride, I made a deep bow. This had an element of thanks in advance to the guests, who were subsequently to report extensively on the event. As I straightened up there was a brief moment when I had hoped that someone would offer me a bunch of flowers on the catwalk. Which of course was hardly possible, as the whole spectacle had been precisely planned down to the last second. So for me, once again, there was no bouquet.

Instead, I sent the flowers that I myself would have gladly accepted to certain important representatives of the press with a personal expression of thanks. While the grandmother of punk or a solarium-tanned créateur, who always bets on red, would never leave the stage without the appropriate bouquet, the designer generation 2.0 now sends the noble plants to the media dignitaries. Is it a designer who makes fashion that is worth mentioning? Or is it the chief editors of the fashion magazines who make a designer worth mentioning? Is the Devil, who still wears Prada, really so powerful? It was after all Prada itself who brought the Devil to this point.

Back on the deckchair in the sun, I take stock. The fashion shows, repeated every six months, are a kind of thermometer that shows where exactly one is at that moment in the fashion system. Sometimes it feels as though one were a share on the open market, where one's name is simply something to be traded on. But here it is not a question of figures or anything as concrete. It is a question of popularity. How popular is one as a label and how popular does one become when one wears a certain label? Is this popularity transferable to a person? Or does one simply place oneself on show as a fashion victim? Would it alter my popularity if I, too, wore Prada?

Shortly before my departure, the first post-show press review landed on my design table. This, too, was big, in terms of both scope and content. And as if by a magic hand, the whole Christmas holiday through which I had been working, and the abbreviated New Year's Eve, were forgotten. I even began to sense a mild longing for the new. So the bunch of flowers for which I had hoped in vain at the end of the show was simply celebrated in oblivion at the after-show party.

And it is just this bunch of flowers that I will place on my own table when I am back in the studio and preparing for the next round ...

Viva la moda,
Tom Rebl

—————/ **PICTURE CREDITS**

Thank you to every person who worked with me on this book!
Thank you to everyone who contributed and thus helped me to
create this snapshot of German fashion culture.

A special thanks to:

Adrian J. Margelist · Alexander Werz · Andrew Hansen · Angelica Blechschmidt
Anja Parfum · Brigitta, Axel and especially my husband Jan Schekatz · Christian
Rieker · Christiane Arp · Clara Held · Claudia Stäuble · Daniela Armbruster · Ellie
Kouremenou · Eva Kästle · Eva, Alexander and Günther Schulte · Fiona Da Rin · Ines
Thomas · Ingrid Hedley · Jasmin Khezri · Josef Voelk & Emmanuel de Bayser · Karla
Otto · Markus Mahren · Natasha Binar · Patricia Riekel · Paul Sloman · Peter Lindbergh
Pia Werner · Robert Joost · Salvo Nicosia · Sammy Hart · Sascha Lilic · Sebastian
Warschow · Tanya Ernst · Ursula & Norbert Rink · Wolfgang Pfefferle · Yasmin Heinz

Thank you to:

Alois Loews · Angel Galbert · Christian & Heidi Kitzmüller · David Reichert · Detmar Blow
Dominique Gourcouff · Felix Lammers · Fred Verney · Harriet Verney · Herr Mader · Janina
Hoschek · Julia Delves Broughton · Kai Kühne · Kirsten Müllenbrock · Laura Schlöter
Lavinia Verney · Marko Matysik · Michael Nickel · Michel Hakimian · Mumi Haiati · Patrick
Lazhar · Peter Gray · Peter Grossmann · Philip Treacy · Roxane@Tush · Sandra Stocker
Simona Parik · Stefan Strumbel · Susanne Schumacher · Thorleif Griess-Nega · Tracy
Sedino-Jablon · Veronika Nitzl · Yves Guy Coulter

… and the late Isabella Blow

Front cover: © Andreas Ortner, see pages 106/107

© Prestel Verlag, Munich · London · New York 2014

© for the photos and works of art by the artists, photographers or their legal
successors. For detailed picture credits see page 206.

Prestel Verlag, Munich
A member of Verlagsgruppe Random House GmbH

Prestel Verlag
Neumarkter Strasse 28
81673 Munich
Tel. +49 (0)89 4136-0
Fax +49 (0)89 4136-2335

Prestel Publishing
900 Broadway, Suite 603
New York, NY 10003
Tel. +1 (212) 995-2720
Fax +1 (212) 995-2733

Prestel Publishing Ltd.
14-17 Wells Street
London W1T 3PD
Tel. +44 (0)20 7323-5004
Fax +44 (0)20 7323-0271

www.prestel.de

www.prestel.com

www.prestel.com

Library of Congress Control Number is available; British Library Cataloguing-
in-Publication Data: a catalogue record for this book is available from the
British Library; Deutsche Nationalbibliothek holds a record of this publication
in the Deutsche Nationalbibliografie; detailed bibliographical data can be
found under: http://www.dnb.de

CONCEPT STUDIO
MARTINA RINK
SPECIAL BOOK PROJECTS & CREATIVE CONCEPTS

Concept: Martina Rink

Editorial direction: Claudia Stäuble
Assistance: Dorothea Bethke
Assistance for Martina Rink: Ellie Kouremenou
Translation: Christine Shuttleworth
Copy-editing: Jonathan Fox, Barcelona
Proof-reading: Danko Szabo, Munich
Design and layout: +SUBTRACT
Production: Friederike Schirge
Repro and prepress: ReproLine Mediateam, Munich
Printing and binding: TBB, a.s., Banská Bystrica

FSC
www.fsc.org
MIX
From responsible
sources
FSC® C022120

Printed in Slovakia

ISBN 978-3-7913-4889-6

Verlagsgruppe Random House FSC® N001967
The FSC®-ceritifed Profimatt paper used for this publication
was provided by Igepa, Germany